The Education of the Eye

The Education of the Eye

PAINTING, LANDSCAPE,
AND ARCHITECTURE IN
EIGHTEENTH-CENTURY
BRITAIN

Peter de Bolla

STANFORD UNIVERSITY PRESS
STANFORD, CALIFORNIA
2003

Stanford University Press
Stanford, California

© 2003 by the Board of Trustees of the Leland
Stanford Junior University. All rights reserved.

Printed in the United States of America,
on acid-free, archival-quality paper.

Library of Congress Cataloging-in-Publication Data
de Bolla, Peter
The education of the eye : painting, landscape, and
architecture in eighteenth-century Britain / Peter
de Bolla.
 p. cm.
Includes index.
ISBN 0-8047-4455-6 (cloth : alk. paper)—
ISBN 0-8047-4800-4 (pbk. : alk. paper)
1. Aesthetics, British—18th century. 2. Visual
perception—Social aspects—Great Britain—
History—18th century. I. Title.
BH221.G7 D4 2003
709'.41'09033—dc21 2002152900

Original Printing 2003

Last figure below indicates year of this printing:
12 11 10 09 08 07 06 05 04 03

Designed by Janet Wood
Typeset by BookMatters in 11/14 Adobe Garamond

For John Barrell
and Norman Bryson

Contents

Illustrations

Acknowledgments

This book has its origin in a paper delivered to the eighteenth-century graduate seminar in Cambridge in 1982. The paper was on Hogarth's engravings, and I remember the audience on that occasion being very kind and indulgent toward a novice in matters visual. The paper became a book project eight years later when I began to research the topic full time. Since then, many papers associated with the project have been delivered, some bearing a very close resemblance to parts of this book, others, now jettisoned offcuts, remaining only in the traces of those spoken deliveries. I have, however, benefited enormously from the kind attention and careful interrogation offered by all those audiences, and I would like to thank my hosts on all those occasions: John Bender, Stanford; Christine Bernier, Musee d'Art Contemporain de Montreal; Simon Goldhill, Faculty of Classics, University of Cambridge; the late Michael Kitson, The Paul Mellon Centre for British Art, London; Charlotte Klonk, Department of Art History, University of Cambridge; Michael Podro, the University of Essex; Chris Prendergast, CUNY and the University of Copenhagen; the late Bill Readings, Rochester University and the Université de Montréal; Mark Redfield, Pomona College; and John Richetti, the University of Pennsylvania.

Although I can hardly believe it, I gave the entire book as a series of lec-

tures in Siegen, Germany, in 1991. My hosts on that occasion at the Graduertenkolleg were Eric Mechoulan and Ludwig Pfeiffer, and I am extremely grateful to them both for the opportunity they gave me to lay the entire thesis out in public for the first time.

Parts of the book have been published, mostly in very different forms, as "The Visibility of Visuality," in *Vision in Context: Historical and Contemporary Perspectives on Sight*, ed. Teresa Brennan and Martin Jay (London, 1996); "The Charm'd Eye," in *Body and Texts in the Eighteenth Century*, ed. Dorothea von Mucke and Veronica Kelly (Stanford, 1994); "The Visibility of Visuality: Vauxhall Gardens and the Siting of the Viewer," in *Vision and Textuality*, ed. Bill Readings and Stephen Melville (Basingstoke, 1995). I am grateful for permission to republish the common materials contained therein.

During the now considerable time this project has been with me, I have had the great good fortune and privilege to be based in Cambridge and, more specifically, to be a fellow of King's College. Since 1995 the research carried out for this book has informed my teaching in a variety of contexts, but it has fed in most directly to two courses sponsored by the faculty of English: The Culture of Enlightenment and Literature and Visual Culture. I would like to thank all the students who have listened politely to my thoughts and have, through their pertinent inquiries, helped me make my ideas more user friendly.

During the years of most intense research, 1989–91, I was fortunate to supervise two Ph.D. students, Richard Hamblyn and Charlotte Grant, both of whom were at the time working on aspects of eighteenth-century visual culture. Although I was supposed to be teaching them, I liberally helped myself to their knowledge and expertise, and I thank them both for the extraordinarily stimulating supervisions we had together. Four and five years later I was lucky to be asked to supervise two research students based in London, Nick Flynn at the Courtauld and Eugenie Shinkle at the Slade, and the same can be said about them. I thank them too.

It has taken longer for this book to reach its audience than I expected, and it has been read, not always particularly helpfully, by a number of people. One of those readers stands out for his enthusiastic reading and generous support: David Solkin. All students of eighteenth-century British visual culture owe a significant debt to his publications; I owe something more because without his kind encouragement this book may never have seen the light of day.

I dedicate the book to two of my teachers. Both John Barrell and Norman Bryson blazed a trail in the late 1970s and early 1980s, each in their different ways working out of literature and embracing the visual. It was Norman who first asked me to speak in public about painting while I was supposedly studying for part 1 of the English Tripos, and it was John who provided me with a powerful example through his scholarship, teaching, conversation, tastes, and interests of how to begin thinking about eighteenth-century culture. I take responsibility for everything in this volume, both good and bad, but I am sure they will recognize something of their teaching in the following.

The Education of the Eye

The Education of the Eye

> In the year 1760, the first exhibition of the artists of Great Britain
> was made, and another the year following; but as every member
> of the society was at liberty to distribute what number of tickets
> for admittance he thought fit, that which was intended only as
> a polite, entertaining and rational amusement for the publick,
> became a scene of tumult and disorder.
>
> —John Gwynn, *London and Westminster Improv'd*

The first public exhibition of paintings by living artists in Britain took place in late March and early April 1760 at the premises on the Strand of the Society for the Encouragement of Arts, Manufactures, and Commerce.[1] The exhibition lasted two weeks, and 6,582 catalogues were sold. Three hundred were required each day for the first week and between 600 and 800 per day for the second. Given that the sale of catalogues is likely to represent only a portion of actual visitors, it has been estimated that the total audience for this first exhibition was over twenty thousand people.[2] This figure seems staggering (and almost certainly inaccurate), but even the undisputed number of catalogues sold is in itself remarkable. What attracted crowds on this scale to an art exhibition? What continues to attract visitors to the museums and galleries around the world, those palaces of culture, on a daily basis? What is the lure of visual culture?

Any answer to this last question will inevitably beg many more. It asks in the first instance about the shape, form, or focus of the "visual." Is it to be understood as everything constituting the seeable world or as only those things seen under certain conditions, according to certain lights? Second, it makes a conjunction between the visual and "culture" that cannot be left unexamined: is culture segregated or partitioned off into various domains,

some visual, others auditory, and so forth? Furthermore, do we currently operate the same conceptual manifold labeled "culture" as our forebears over two hundred years ago? It is often said that modernity finds one of its foundations in the visual, but such a statement requires at least gentle qualification.[3] Does "the visual" refer to a historically insensitive set of practices, institutions, representations, and theoretical elaborations that in combination remain (relatively) fixed over time; or, alternatively, is the visual historically sensitized? Does it change at a particular moment (or moments) in the past? Have we always looked or seen in the same way?

This book starts from the assumption that looking is a cultural form, even if seeing may not be. Here I want to make a distinction between optics—the scientific analysis and description of sight and light—and the various activities of seeing—looking, observing, spectating, surveying—that take center stage in the following discussion. Although I will have almost nothing to say about the ways in which optics might also be understood historically—the narratives of proof, contestation, refutation, and promotion of various hypotheses and theories governing light and sight—I do not mean to imply that the emphasis I place on activities of looking necessarily yields a better answer to the question I have just posed.[4] This slant on the visual derives from the fact that my central interest lies at the margins or in the folds and creases of the history of optics, looking and seeing because my topic is the subject. This book, then, continues an argument I began in *The Discourse of the Sublime*, where I set out to examine the ways in which a discourse, of the sublime, constructed a set of positions or "envelopes" within which the subject might be produced or appear, may take on coherence and consistency.[5] The discussion in that book was not particularly attuned to the agential criteria bearing down on the definition and construction of the subject since there I was concerned to demonstrate the ways in which the concept "subjectivity" was itself a discursive product.

My aim in this book is to outline the ways in which an activity—looking (which, as will become clear, is not a single activity at all)—gives shape or focus to a human agent, thereby enabling and giving access to specific modes of behavior, be they predominantly understood as social, cultural, or political. And I will be concerned to demonstrate how such agency in the period on which I am focusing—say, the central fifty years of the eighteenth century in Britain—is deeply embedded in "the visual." And here what I mean by "the visual" includes optics or opticality but is not confined to them; it comprises the modes of address human agents take to different objects in the

visual field—representations, the landscape, other human beings, architectural forms, and spaces—the techniques of seeing and decoding the optical information received by the cerebral cortex, the grids or templates used to make sense of what is "seen," the technologies of reproduction and production of visual materials and the varying significance attached to objects seen, visualized, or imagined (that is, the cultural bases for visibility). In short, what I mean to refer to is *visuality.*

The dominant theme throughout the following chapters is historical in emphasis, but it is accompanied by a pretty constant ground bass that is theoretical in orientation. I will spend the remaining pages of this introduction outlining those historical emphases, but before doing so I want to sketch out the theoretical accompaniment. This book presents a set of interconnected and interrelated arguments, but, in common with my earlier attempt to construct arguments in the mode of polyphony found in *The Discourse of the Sublime,* I make no attempt to resolve these many strains to a single narrative line. In this way I hope to respect the complexity of the terrain I have studied: in effect I have attempted to present an argument in more than one dimension so that the strength of attraction between elements may vary depending on the viewpoint we take to each. This means that more than one argument is running at any one time—I am tempted to use an analogy taken from our current technologies of writing, whereby computational programs are enabled to run in tandem—but particular strains may be more to the fore than others. Just as one may "see" much more than one attends to in the visual field at any one moment, it is possible to articulate and (I very much hope) follow more than one argument at a time.

The theoretical ground bass that runs throughout is concerned with a field of inquiry that is nowadays pretty easily identified as "visual studies" or "visual theory."[6] And within that field the concept of "the gaze" has been the object of consistent attention.[7] Although I will say little about the theoretical articulation of this concept, since the literature is by now very well known, the impulse for the current work was provided in part by the dissatisfaction I felt with the historical sensitivity of the models of the gaze and "seeing" or "looking" in a general sense commonly used in contemporary visual theory.[8] This book is, therefore, in part an attempt to subject some of our current models of understanding visuality to a historicizing stare. But my larger aim, in conjunction with the dominant theme of the book, is to contribute to a theoretical elaboration of the subject, which I hope, through my attention to and discussion of the subject positions created in and by var-

ious activities of looking understood historically, will begin to gain complexity through the lens of historical inquiry.

I now turn to the detail of my historical emphasis. At its furthest remove my historical argument is both ambitious and, perhaps, absurdly simplistic. Very little attempt will be made to uphold the following general hypothesis in any detail, although I consider the exploration of it to be an ongoing and continuing project of which *The Discourse of the Sublime* was a first installment. That hypothesis may be crudely put in the following way: what we have come to understand and recognize as our own modes and forms of subjectivity were first fully articulated—that is the shape and contours of the modern concept of "self" or "subject" were first intelligible as such—in the middle decades of the eighteenth century in Britain. Even more specifically—and for many I suspect outrageously—I think this time frame can be further diminished or made even more precise. It can be reduced to the 1760s. Now this is clearly a microhistorical focus of bizarre and unworkable proportions, and I will certainly not spend any time trying to justify it. But it will help—if only as a heuristic device (and what could such specific attempts at historical location be other than this?)—in mapping or tracing the lineaments of the multidimensional argument I am going to present.

The more continuous topic for attention throughout the following chapters is connected to this first historical frame and concerns what I want to propose as the birth of visual culture. And, once again, I am proposing that this birth took place during the middle decades of the eighteenth century in Britain. Of course, I am not claiming that "the visual"—either in the sense of the entire cultural matrix referred to above or, more narrowly, in the sense of the production and consumption of visual materials—began in eighteenth-century Britain. That would be absurd. But I am claiming that something recognizable as precisely a *culture* based on the visual, on modalities of visualization, the production and consumption of visual matter (representations, maps, diagrams), as well as any number of mechanical objects intended for use in some form of looking, observing, surveying, spying, and so forth, all requiring and producing various modes of address, attention, or forms of understanding—that all this did come together in ways that theretofore had not resulted in a coherence or coalescence such that it became possible to identify something called visual *culture*. This of course begs the question of how one might isolate and identify a culture since, once again, it would be absurd to claim that culture did not exist in earlier times and other locations. Or would it? In the conjunction of the terms *visual* and *culture* I mean to sig-

nal that the latter, a domain of social and political interaction that can be described as a public form, takes on its peculiar modern dress (what Habermas identifies as "the public sphere") only in reference to and in the light of the visual (by which I do not mean those things within the domain of the visible but the grammars determining both how we see and what is seen). And I will argue that this conjunction is first *fully made* in the period in question. It is at this moment that a series of institutions, social and political practices, technologies of production and reproduction (many of which may have singly or in concert existed at earlier moments and in different places) come into alignment with a set of conceptual forms (worked out over a very long time and not only in the context of British culture) that open up the terrain that is going to be inhabited by "culture" in the largest sense and by "visual culture" in the narrower sense. My contention is, then, that it was at this moment when, for the first time in any way susceptible of a coherent and consistent identification, the kind of looking I will outline became a publicly available (and, as we will see, controllable, legislatable) form—an activity (or rather set of activities), set of gestures, attitudes, psychic modes or modalities, in short a practice that could be properly said to be in the general domain of culture and at the same time instrumental in the formation of culture itself. I call that culture the "culture of visuality," and I take it as axiomatic that to all intents and purposes it has remained the dominant form of cultural assembly down to the present day. I mean to suggest that we also inhabit its rooms and corridors.

What I mean by the general domain of culture and the possibility of its discovery as a coherent form—its visibility—can be gleaned by considering some very germane facts succinctly put in an essay by John Brewer entitled "Cultural Production, Consumption, and the Place of the Artist in Eighteenth-Century England."[9] "In 1660," Brewer notes, "literary and artistic endeavour was largely confined to a royal court whose patronage was severely constrained by lack of funds, a church whose Protestantism militated against the making of music and the display of art, and a publishing industry which was cramped by prior censorship and legal monopoly" (7–8). This, in effect, meant there was no culture in the sense of a public domain in which what we think of as high cultural production—painting, music, literature, and so forth—had any visibility. As Brewer notes: "Culture was starved for lack of funds"; hence, "there were no concert series, operas, public art exhibitions, and precious little theatre; no daily newspapers, weekly journals and reviews; no critics, theatrical and operatic impresarios, no pic-

ture dealers, almost no publishers, professional authors, artists, and musicians and therefore no public, in the modern sense of the term, and no market for culture" (8).

Brewer goes on to draw the contrast with the state of things a hundred or so years later in which the situation had totally transformed: "The market for the visual arts flourished as never before: numerous classical antiquities, as many as 50,000 paintings, and half a million etchings and engravings were imported from Italy, France, and Holland. Over 100,000 pictures passed through the newly established auction houses and into the hands of specialist dealers and collectors" (8). And if one follows this line of argument into the other arts of music and literature, the same pattern emerges. Brewer notes a common set of features across all these arts in respect to their amazing growth. First is "the growth in the audience for culture, stimulated by greater capacities for reproducing and disseminating culture"; second is "the importance of certain cultural spaces or places for cultural activity"; and last is "the subversion or dilution of classical and academic hierarchies in the face of rampant commercialism" (11). I will have something to say about all of these in my concluding remarks. What I wish to take away from Brewer's extremely suggestive essay is the notion that culture begins during this period of "artistic" expansion in Britain—say, roughly, the first half of the eighteenth century. And I want to press the precision of this observation, or at least propose the hypothesis that one might be able to locate the moment when the culture of visuality for the first time became fully visible.

This book attempts to provide or construct an archaeology of that moment. It aims to sketch out the forces at work in the cultural production of what I will call the "sentimental look." I do not think that this form of looking is so well defined in the period as to allow a programmatic description since it is, in ways I will comment on in my concluding remarks, a *cultural* form (and the implications of that are the pretty constant topic of investigation throughout my text). In this respect it shares in common with two other terms I use throughout—the regime of the picture and the regime of the eye—a quality we might understand as a proleptic coherence. For this reason terms that have a descriptive function in my own analysis take on analytic powers in a posited historical context: the eighteenth century did not operate with precisely these terms, either as descriptors or as analytic concepts. Nevertheless, I take them to be deeply embedded in the period in ways that will, I hope, become very clear. As each chapter progresses, I will build on the coherence and conceptual function of these terms so that an

architecture begins to emerge, enabling the identification and observation of what I take to be cultural forms. And they are historically specific, even if, for the period in question, they were buried in a dispersed set of arguments, discussions, programmatic statements, or scientific and social experiments—in brief their articulation remained, substantially, a possibility. These forms were only ever glimpsed at the time, as it were, *in potentia*.

The historical project undertaken in this book is slightly unusual in that I propose to write a history of an activity. But the activity I have in mind—looking—rather like, say, eating—leaves very little trace in the archive. People did not write down how they went about the business of looking any more than they did of eating (although they did, as we will discover, write down what they looked *at*). But, as I have outlined above, I am less interested in this activity in and for itself—this is not a contribution to the history of optics or even the forms of everyday life during the eighteenth century—than in how it may help us understand in greater detail the modern formation of the subject. It tells a story about how we came to be viewers in the culture of visuality. Throughout I try to determine how different practices of looking, and different inflections of the same practice, determine not only how historical agents in the past looked but also how they began to understand themselves as lookers, viewers, or spectators and, therefore, how they began to shape (and be shaped) and give coherence to themselves as subjects, that is, enfranchised individuals able to participate in the commercial, political, and psychic environs of culture. Thus, as will become clear, in becoming a viewer one not only stakes a claim to be able to "see" the objects of cultural regard; one also makes a bid for entry into the domain of the visible, makes one's self visible, into an object of regard, a citizen in the demos of taste.

Although I do not mean to exclude any cultural objects from the purview of my argument, on theoretical grounds the following chapters keep substantially to a very narrow range of items: what might be called "aesthetic" objects. Throughout this book I will focus almost exclusively on paintings, gardens, and architecture. This is for a good reason: because a major strand of the argument concerns the creation of the cultural sphere, evidence for how this came about is much more plentiful in regard to these objects than less frequently studied or touted materials (as precisely objects of culture) within the cultural domain. Furthermore, my argument has it that the formation of culture, in the sense I have been using it, is conditional on the theoretical elaboration of the aesthetic. In the period I will be concerned with

the hard questions in respect of this formation are all prompted by and proposed as ways of understanding what we now call artworks (or high cultural artifacts). The actors in my story, although far from indifferent to, say, clothing, did not see vestments as objects of aesthetic interest (although we may do so, both in our own contemporaneity and also through the lens of history; that is, their clothes may be aesthetically interesting to us). This does not necessarily mean that they *were not* subjected to the aesthetic gaze but that any attempt to uncover such a mode of attention will need to work through indirection and modes of hypothetical argument. Since these working methods are already mobilized in respect to my historical recovery of an activity, it would have become unbearably complicated and possibly unintelligible had I turned my attention to less well formed (and self-advertised in the period) aesthetic objects.

It is helpful, then, that eighteenth-century agents *did* write down their experiences of looking at paintings, exploring landscape gardens, and visiting country estates. Although they did not frame these remarks in terms of the phenomenology of looking—they are certainly unaware of the interest I bring to their accounts—it is possible with a little ingenuity to extract from both firsthand accounts and the surrounding literature (by which I mean the many treatises and essays bearing on the viewing of artworks, construction of landscape parks, and designing of houses) a sense of how these viewers looked. In trying to understand this activity as a *technique*, or technology, producing subjectivity, I have, as it were, looked all around this looking. I have been particularly sensitive to the environments in which these specific acts of looking took place, and those environments are not only the now common fare of cultural history—the discursively reconstructed social, economic, or political terrain—but also the *material* contexts for such activities. I have, then, been very interested in the physical environs as well as the discursive, an approach that I hope sheds new light on the ways we might begin to understand eighteenth-century architecture, and this is explored most fully in the fourth chapter, on Kedleston Hall.

That chapter raises a set of issues about how one might begin to look in history, as it were, how we might look from our own contemporaneity with eyes belonging to a past era. As such it opens up historiographical questions, as well as a number of arguments about how we should address the material remains of a past culture: heritage. These issues are only ever subdominant in relation to the concerns of the book as a whole, yet they are increasingly important in the world we currently inhabit. Garden historians, perhaps

more than any other professionals concerned with material histories, are acutely aware of the ironies attendant on the notion that we might "restore" an object to its past form, since gardens are constructed in a temporal dimension predicated on notions of change, alteration, decay, growth, and so forth. One can design a garden only in prospect. I say more about these issues in my concluding remarks.

Although my mode of argument is polyphonic, there is a sequence to it that is designed to be accretive. I begin by outlining the problems and difficulties eighteenth-century commentators faced when they attempted to understand and control the rapid growth of a general culture of the visual arts that occurred in the first half of the period primarily in response to the then novel exhibition of paintings, sculptures, architectural models, and so forth— the submissions for the yearly shows that began in the early 1760s. In order to understand how the culture of visuality took hold and became the dominant form for visual culture, we need to follow the arguments made on behalf of distinct approaches or attitudes to these works of visual art. The first chapter, then, sets out to describe those arguments and to extract from them the two regimes—of the picture and of the eye—that I claim governed both how things were seen and what seeing them meant to and for eighteenth-century viewers.

Since these modes of address to the visual field are visible to us only in the context of the particular historical inquiry embarked on, it is difficult to provide hard-and-fast definitions for them; consequently, I will attempt to characterize the differences between the two regimes more than once and in more than one way over the course of this book. Here I will make a preliminary stab at sketching the major distinctions between the two. The regime of the picture develops a grammar of looking at artworks that utilizes nonvisual material. It is based on what one knows—say, a narrative in the Bible or taken from history, or a history of a particular genre of painting, or intimate acquaintance with the development of a specific artist's oeuvre—and enables one to see or recognize what one has, in effect, already seen. It could be said to be textual in its operation. The regime of the picture utilizes the knowledge, competencies, and curiosities developed in the practice of looking that we commonly associate with the appreciation of high cultural artifacts.

The regime of the eye, on the other hand, is developed within a grammar of the phenomenology of seeing. Both the optical and the haptic function in this regime to provide and help formulate the rules governing how the eye

decodes objects in the visual field. And in respect to those high cultural arti-
facts it allows the image, sculpture, or whatever to lead the eye toward its
resting point in understanding. Although I will make this contrast in very
stark ways at certain points in this book, I do not want to give the impres-
sion that these two regimes are separable to the extent I may have just
implied. The regime of the picture is clearly dependent on, indeed grounded
in, seeing or optics. And there is no "naive" position occupied by the eye—
it too has prior knowledge, grids that overlay the evidence of light rays hit-
ting the retina that it formulates in nonvisual as well as visual ways.

In addition to these two regimes I outline two further conceptual articu-
lations that I refer to as "scopic techniques," and these are identification and
recognition. In the following chapter I will spend some pages detailing how
these techniques work and their mobilization within the two scopic regimes.
These terms have, of course, resonances within contemporary theoretical
speculation (most obviously in psychoanalytic theory), and although it
would be impossible to restrict or impede these resonances, I should point
out that I understand the primary location of these concepts to be historical:
as they are operated in the following argument, they have been derived from
the archival material that forms the basis for this study. In the story I have
to tell, identification and recognition are modes of address or access to the
visual domain that are developed most consistently in response to portrait
painting during the first half of the eighteenth century in Britain. These
scopic techniques are not, of course, to be found only there and then.
Indeed, a fascinating history could be written detailing their fluctuating for-
tunes in respect to the subject's insertion into the visual domain. But that is
not the topic of the present book.

It will appear at times that I regard the regime of the eye as worthy of
emulation—as a "good" way to structure and police visuality—and the
regime of the picture as a repressive or "bad" way. The vectors here are to a
great extent produced by the arguments made by my cast of eighteenth-
century commentators. But, as becomes clear by the second chapter, my
story is more complicated than this stark opposition between the different
regimes implies. As I hope to show, for a brief moment in the midcentury—
and almost certainly produced by the pressure of the debate around the
founding of the Royal Academy—there came to fruition a heterogeneous set
of practices of looking and discourses of analysis and description of aes-
thetic forms that were all concerned in their different ways to elaborate and
build on the education of the eye. My contention is that the houses, gardens,

and exhibitions discussed in the course of this book all conspire to help generate a style of looking (which is, of course, much more than a style) or mode of address to visuality, which takes what it needs from both regimes and produces, albeit for the lifetime of a shooting star, a third regime: the sentimental look.

This way of looking, the central topic for *The Education of the Eye*, works in and out of the scopic techniques of identification and recognition, jams both the regime of the picture and of the eye into a common articulation of visual address. In the terms used by our own contemporary visual theory this sentimental look could be distinguished from the two modes of address to the visual field that have preoccupied studies over the last thirty or so years: the gaze and the glance.[10] I have set out to give a historical dimension to these theoretical concepts and to show how they operate within eighteenth-century discussions of the visible world. There, in that context, we will find a distinction between the studious gaze in its aim to decode the visual sphere, approaching the image as if it were a sign, and the glance, which seeks instantaneous gratification in its rapid movement over surfaces, delighting in the play of forms.

Neither gaze nor glance, the sentimental look operates via a fully somatic insertion into the visual field. It makes the body present to sight, folding it into a set of gestures or attitudes that enable the viewer to feel his or her presence in the visual sphere, feel the self in sight, and in so doing it stimulates the cognitive process of affective response. Where the gaze objectifies things seen and the glance skids off them, the sentimental look presents the viewer to the object and to vision, allows the viewer both to recognize itself in the place of the seen and to identify with the process of seeing. It is, then, a technique of the subject.

As will become clear, this scopic regime is formed with reference to the domain of inquiry now called aesthetics. It is a way of looking with the artwork—both open to the knowledge brought to the practice of viewing and directed by the drives of the eye—which creates an affective response in the viewer—hence the "sentimental" tag. This results in what might be called the presentation of the aesthetic subject, and insofar as there is a "pure" realm of affect, it encapsulates a specifically aesthetic attitude to the artwork. These comments are intended to sound out another harmonic to my argument, that found in the philosophical literature on aesthetics. Part of my story, therefore, connects with a historical account of the aesthetic; and although I do not intend to assert that the protagonists in the following chapters were

major players in that other story, I do mean to suggest that the emergence of the culture of visuality is a significant chapter in the history of aesthetic speculation. This will also be commented on further in my concluding remarks.

It only remains to say something about the locations, topics, or materials I have selected for discussion in the main body of this work. In the second chapter I investigate Vauxhall Gardens since, among the many garden entertainments produced in London during the eighteenth century, this remarkably popular and enduring attraction provided the focus for a number of the discrete forces swirling around in the general vicinity (both historical and, as it were, locospecific) that, when combined at Vauxhall, give the first clearly identifiable expression to the culture of visuality. I do not mean to suggest that elements of its presentation were not in evidence elsewhere or even that other sites did not in their different ways begin to participate in this cultural form, but I do think that Vauxhall gives us the best fix.

I then turn to landscape because the one aesthetic form Britain claimed to have invented during this period was the art of landscape. As the culture of visuality took shape, arguments about the purpose and use of large tracts of land given over to (primarily) aesthetic pleasures were connected to discussion and debate about other art forms, especially painting. The creation of landscape as an aesthetic form is therefore a crucial plank in the story I am telling. And in order to focus my inquiry more carefully on my major theme, the history of an activity, I have taken the accounts written by Joseph Heely of his visits to two gardens, Hagley Park and the Leasowes. The latter has a particular significance in relation to my account of the sentimental look.

In the fourth chapter I take a house, Nathaniel Curzon's Kedleston Hall, and set out to demonstrate how the address to the visual field I have called the sentimental look actually works, as it were, in situ. This chapter also has things to say about architecture's contribution to the culture of visuality, as well as the role that one man, Robert Adam, played in the formation of the sensibility that sustained that culture. In my brief concluding chapter I return to the overarching theme of the book and trace one of its extensions into the nineteenth century. In this chapter I am most concerned to revisit my opening questions in order to ask again about the lure of visual culture, our continuing fascination with and interest in works of visual art. How do we enter the culture of visuality, and once there how are we shaped by its interests? What constitutes the education of the eye?

The chapters that follow attempt to answer these questions, often by indirection and via digression, but the central purpose of the argument is

never far from the surface: that purpose is to redirect our attention back to the artwork, to once again inhabit the spacings of the look, to recapture the positive senses of connoisseurship, and to open up visual culture to all those prepared to learn to look with the work itself. Looking, as I understand the activity, is both a historical form and a way of being with the artwork, being with its knowingness. The present book seeks to provide a genealogy of looking, to give some historical depth to an outline of how we came to looking and to a view of culture that supports and sustains a particular version of that activity. Above all it exhorts us to listen more intently to the desires of the eye and to explore more insistently that uncomfortable place that is being with and in the cognitive spacing of the artwork. It asks us to look at looking again and allow the artwork to educate the eye once more.

The Culture of Visuality

In 1747 paintings by living artists, among them William Hogarth, were for the first time exhibited in what we would today understand as a public exhibition space. This first Foundling Hospital exhibition was relatively modest, and it was not until the 1760s that public exhibitions of art became a regular feature of contemporary metropolitan life.[1] These exhibitions were immediately popular, attracting large numbers of people from across the social and economic spectrum.[2] Given the social heterogeneity of these first audiences for art exhibitions, it is likely that many of these visitors were looking at "artworks" for the first time. At the very least the experience of looking at paintings, sculptures, and other objects within the context of an exhibition space would have been completely unfamiliar to them.[3] I want to begin by asking how this largely innocent audience set about looking at those objects presented to them? What might enable the viewer to "see" the paintings, sculptures, architectural models, and other artwork as, precisely, objects for aesthetic appreciation? What might prevent one from "seeing" in this way? Did one need to know something of the history of art, at least Western art from the Renaissance on, in order to look on these representations with "propriety"?[4] If one did not need to know this, then perhaps one required another, more intimate, knowledge of the process of production of

such images. Perhaps one could only "see" them with the eyes of a painter. Questions of value also intrude: if, by the very fact of display, these artifacts are assumed to have value, then who or what confers such value on them? How can one distinguish the good from the bad, the ethically pleasing from the distressing, the aesthetically complex from the trivial? Such questions inevitably raise further issues of propriety, of personality, of person: can a laborer make judgments that will withstand scrutiny next to those made by a lord? How educated must one's eye be to see?

It is slightly misleading to claim that these questions were suddenly raised for the first time in the 1760s, prompted by the rush of exhibitions. By the middle of the eighteenth century a substantial body of work existed in which the question of taste was addressed in very similar ways to those set out above, and this discussion of taste was embedded in the discourse on the sublime, precisely the location for the beginning of what we now term aesthetics.[5] However, the practical and, above all, social aspects of these first exhibitions presented heretofore unencountered difficulties. Of immediate concern was the degree of access to the exhibition room: should the qualification for entry be merely the ability to "see," that is open one's eyes no matter whose eyes or what the nature of the object gazed upon; or should some kind of admission price, financial or otherwise, be levied? Debates through the 1750s and into the next decade concerned with the founding of a national academy for art touch on this issue of rights of access.[6] From the angle of such debates the creation of the Royal Academy was proposed as an attempt to bring an unruly social practice to heel.[7] It was variably successful in doing this, but the intervention made by the foundation of this royal institution was to prove decisive.[8] In effect it declared: you need to be someone in order to see. Against this academic view a number of contemporaneous voices spoke for the autonomy of the eye. Here is one such voice of opposition:

> Taste [is] a facility in the mind to be moved by what is excellent in an art; it is a feeling of the truth. But, science is to be informed of that truth, and of the means by which its effects are produced. It is easy to conceive, that, different as these principles may be in their setting out, they must often unite in their decisions: This agreement will occasion their being mistaken one for the other, which is the case, when it is affirmed, that no one but an artist can form a right judgment of sculpture or painting. This maxim may hold indeed with respect to the mechanick of an art, but not at all as to its effects; the evidence and force of which, are what determine both the value of the art, and merit of the artist.

The text from which this passage is taken, Daniel Webb's *The Beauties of Painting*, is a kind of primer for the visual arts intended to give instruction to those young men who would be forming the public taste on their return from the grand tour.[9] In reaching to the vocabulary of sentimentalism, the assertion that taste is a *feeling*, and at the same time proposing that "science" plays some role in the domain of culture, Webb is plotting the course between what I will argue constitutes two poles in the debate over visual culture. On the one hand we find a commitment to an egalitarian politics of taste. This argument, in contrast to the high cultural elitism of the Royal Academy, states that if I can look at an artwork and *feel* its power, then I become, in effect, enfranchised within polite culture, within the demos of taste. But, as will become apparent, this enfranchisement does not merely enable one to see the works of the great artists; it also grants one access to the exhibition room, thereby allowing one to see and be seen for what one is, a subject within the society of visuality. In other words what is at stake is who has the right to look and be looked upon, to see and be seen, to be a viewer. On the other hand, then, is the now familiar investment in the superiority of the knowing viewer, the eye that has been properly "tooled up," trained in the correct ways of looking and legitimated by the institutions of cultural evaluation. It is, of course, the case that these two poles continue to define arguments on behalf of taste and cultural value: at least in this neck of the woods there is little that is new under the sun.

Webb is making a case for the eye itself. In this respect he is claiming that all who have eyes to see can enter the domain of culture, and he is making his case against those who would claim that it is not what one sees that counts but what one knows, that is against those who value the beauties of the understanding over the beauties of the eye. In claiming this he is not, however, suggesting that the eye should remain "naive," since his purpose is to provide a set of strictures for how the eye might be educated. It is this insistence on the eye itself that I want to highlight in order to distinguish between different kinds of looking activity prompted by distinct scopic regimes. A scopic regime provides the envelope within which practices of looking play out their variations; it gives shape and form to aesthetic productions, orders the relations between the artwork and the viewer, and gives definition to the subject who looks. Such regimes are not always hegemonic, nor are they always antagonistic to different ways of ordering visuality—and indeed more than one regime may operate at a given time. This is indeed the case at what I think of as the birth of visual culture, where both the regime

of the eye and of the picture interact with each other. Such interactions often produce conflict, at least insofar as they construct subject positions through the scopic techniques of identification and recognition.

This is to note that there is more at stake in these two regimes than just looking, since the attitude one takes to the visual sphere is necessarily implicated in a set of markers that distinguish person. Thus, in the case of the regime of the picture what one "sees" or recognizes is a name—of a style, genre, painter, or, in the case of a portrait, sitter—and this recognition of an artistic tradition of masterworks enables the viewer to identify with a particular subject position, a particular sociocultural space of knowingness and expertise. That expertise and subject position have a name: connoisseur; and the activity of looking within the envelope of the regime of the picture is constructed on the process of matching what one sees with what one has already seen, of recognizing what one knows.[10] This mode of insertion into the domain of the socioscopic is familiar to us from visits to the great galleries of the world, those repositories of the taxonomy of art, where we unthinkingly adopt the posture of the connoisseur as we thread our way through the textuality of visuality, stopping here to inspect a label, there a brushstroke, here a genre, there school. It is a particular form of recognition—that's a Matisse!—that leads to the pleasurable identification of the looker with the cultural domain and enables the self-recognition of the connoisseur: I am a cultured viewer; I am immersed in culture itself. I take this modern form of an eighteenth-century viewing practice to be a sociocultural *technique* grounded in a set of social and political practices, as well as in class and gender differentiation, and as such it must be learned. Perhaps the most efficacious way of learning it is to look—at paintings, sculpture, and architecture, for example—hence the return to the eye and the complementarity of its regime. But this return to the regime of the eye is balanced by an antagonism over the ordering and sequence of the scopic techniques of recognition and identification, and of the resulting politics of the cultural domain that follows on from the attempt to resolve that antagonism. The regime of the eye privileges identification over recognition; it gives way first to the impulse to be in the plane of representation—to occupy the space of visibility, where vision *is*—and only subsequently makes that identification over into a self-recognition. This terminates in a very different subject position, and the envelope that is the regime of the eye generates a very different sociopolitical and psychic spacing within which visuality is played out. What is at stake here is the capital of prestige: who does one need to be in order to recognize oneself

as a connoisseur; what does one need to know in order to recognize a good from a bad painting; who is allowed to identify him- or herself as a subject within the polis of culture? To what extent is the plane of representation given over to self-reflection or, alternatively, to the ghosting of the other?

It is important to note that both these regimes give shape to the subject who looks, and they are both enmeshed in practices of looking. In this sense they both depend on optics and therefore on the organ of sight, the eye (and to this extent my nomenclature is potentially misleading), since one learns to see under both regimes by entering into a particular socioscopic. But in the case of the picture the technique of looking via recognition comes first: the eye is educated through the process of comparing what one sees with what one knows, and this, *in effect*, dampens down the regime of the eye. It is also important to note that the image or artifact itself leads the eye toward recognition or identification since the different scopic regimes also determine, to varying extents, the production and consumption of the artwork. In the case of the regime of the eye the process of recognition is suspended while identification takes place. Here again one can learn how to look only by looking itself—hence the common dependence on optics—but the process of entering the socioscopics produced by the regime of the eye resists the urge to match what one sees with what one has already seen in favor of an identification with the space or process of representation. This does not mean that under the regime of the eye no "training" of how to look takes place (or that such "training" is resisted), nor does it imply that the eye is naive—if one has never seen an artwork of a particular kind, say an abstract painting, it is unlikely that one's first encounter with it will instantaneously allow access to its representational forms or space. The regime of the eye, then, shares common ground with that of the picture in its dependence on exposure to the objects "seen," which in this context is to aesthetic forms. If, as will become clear, the most common route of access to the domain of the aesthetic and visual culture more generally is via portraiture, these two regimes and the scopic techniques of recognition and identification have considerable force in the construction of subjectivity itself. This is simply to note that the subject-in-sight, or the "looker"—the "viewer" or "spectator"—takes a leading role in the articulations of self.[11]

During the early decades of the eighteenth century the exposure to aesthetic forms took place within the context of the grand tour, that semiserious induction of the first sons of the gentry into the world of polite learning. Toward the last decades of the century grand tour activity was relegated

to a secondary role in the cultural education of the ruling class as England began to assert its own native powers of artistic production and to look toward its own resources for aesthetic education.[12] In the case of Nathaniel Curzon, Lord Scarsdale, who will occupy our attention in Chapter 4, the education of his eye was almost entirely accomplished by looking and traveling in Britain. This did not mean that stereotypical "grand tour" images were unavailable to him, either as images to be seen or as works to be purchased, since the structure of the art market ensured that a regular supply of "grand master" pictures was made available to those who wished to own them and could afford to purchase them.[13] Curzon did so wish, and he built a palace of art in rural Derbyshire to display his collection and, what amounted to the same thing, his taste.

The young Curzon was, however, slightly out of step with his contemporaries in that his only exposure to non-British culture was a short trip to the low countries. Nevertheless, the culture of the grand tour was so persistently and deeply embedded in a particular socioeconomic segment of eighteenth-century British life that this hardly seemed to matter. Curzon's palace of art shared with other grand houses, such as Holkham Hall, the seat of Thomas Coke, a common pursuit: the presentation of culture itself, and this will be explored in detail in Chapter 4. The sociocultural technique I referred to above developed in response to and in tandem with a new set of spaces designed for looking. The purpose-built gallery house was one such space, but there are others that will take center stage in turn in the following chapters: the exhibition room, the pleasure garden, and the landscape garden. All of these spaces have one thing in common: they were public places in which being a member of a public was made highly, perhaps all too highly, visible.

Given this premium on visibility, the issue over one's rights to enter visuality takes on a high profile since looking, say at art, is coincident with being seen, seen as a viewer. The implications of this can be explored by considering the first public exhibitions of paintings. For practicing artists in the middle decades of the eighteenth century the question that most exercised their minds was the ease with which their paintings might be seen by potential buyers. Was it necessary to police this new public space—the exhibition room—and to what extent would the space itself—its physical disposition alongside the socioeconomic composition of the crowd—determine how one should look, that is both look like as well as look *at* the images presented?

This immediately raises the question of the boundary between high elite culture and a popularizing democratic public sphere: how permeable is this

boundary, and how desirable is such permeability? Are these realms in tension, and if so how much friction is caused by their interaction? These issues are of some importance to the mid-eighteenth-century artist since he (or rather less often she) depended increasingly on a market, a commercial network of exchange, rather than on the private channels of patronage.[14] These artists could hardly claim that only an "educated" eye could judge their efforts because in doing so they would diminish their potential market. Yet, to make the opposite claim, that anyone with eyes and the appropriate entry fee can "see," diminished the "art" they were attempting to promote and market just as it decreased the social standing aspired to by the "artist," the perpetrator of a liberal not a *mechanick* art.[15] One solution to this problem was to create a hierarchy of images in which some forms were to be understood as "low," requiring a relatively untutored eye, and some were "high" and could be appreciated only by those who had been exposed to the great paintings of the Western art tradition. This kind of argument took place within what I will term the "high cultural" environment of academic theory. Its most renowned apologist was Sir Joshua Reynolds.

But, as will become evident, Reynolds's "theoretical" prescriptions were inconsistent with even his own practice; here the commercial imperatives governing the production and consumption of images, of both a "high" and a "popular" cultural form, outweigh the desire to see the art of painting elevated from a mechanick to a liberal art. Consequently, painters during the middle decades of the eighteenth century were deeply ambivalent about the extraordinary popularity of the early exhibitions: on the one hand they recognized that some form of "education" was necessary for any who would gain entry to the domain of visuality, yet on the other they were flattered and delighted by, if not dependent on, the universal appeal of the exhibitions, which provided cultural capital and potential for a respectable income.

One strategy in the face of the mob conditions surrounding these early exhibitions was to charge for entrance. This immediately placed the consumption of the image within a particularized economic sphere: if one could not afford the "academy shilling," one was denied access to the paintings.[16] In this sense Reynolds and his academicians were engaged in a well-focused policy of creating an elitist high-cultural context for the production and consumption of visual forms.[17] It was precisely for the same reason that the Academy in its advertisement for submissions for its yearly exhibition stated, "No Copies whatever, Needle-work, artificial flowers, Models in coloured Wax, or any Imitations of Painting, will be received."[18] This was the means

by which the Academy signaled its distance from other institutions, such as the Royal Society for the Encouragement of Arts, Manufactures, and Sciences, which also held yearly exhibitions that were open both to copies of grand master paintings and to such curious productions as portraits made from human hair.[19]

Visual culture for the period, as for our period, constituted a specifiable set of objects, activities, structures of consumption, and production of representations for which particular arguments needed to be made and on whose behalf particular policing strategies needed to be set in motion. In making these arguments and policing this site of public production and display a whole range of ideological commitments were either silently or openly articulated. I will examine a number of these arguments below; in shorthand the division of opinion can be understood in ways that are familiar to our own period through the distinction between high and low or popular culture. For the period in question, the middle decades of the eighteenth century, this distinction is particularly fraught since the concept of the cultural domain was itself a site of contest. Thus, where we might describe certain cultural forms as "popular" (without perhaps fully acknowledging why we do so) and others as "high," such a demarcation would have seemed unnatural for eighteenth-century commentators since what was at stake was precisely the formation of something that might in the first place be called "culture."[20]

It is, then, more helpful to understand the division of opinion as falling between the notion that one must be educated in some shape or form in order to be able to "see" the works of culture and the notion that any response as long as it be in some sense "genuine" is as valid as any other. This kind of argument also has a familiar ring to it given that it has dominated discussions of philosophical aesthetics ever since; it is the kind of argument one finds commonly repeated in the face of nonrepresentational art, in which the viewer has no ground of *vraisemblance* (verisimilitude) to stand on in order to direct the eye. The point of division, therefore, occurs around an affective response, howsoever this is made apparent, versus an educated and usually classifying gaze: the regime of the eye versus the regime of the picture.

In the case of the former the middle decades of the eighteenth century witness an extraordinary experiment in conceptualizing and promoting affective vision, what might also be termed "sentimental vision." It is far from coincidental that this experiment coincides with the vast increase in volume of activity around the display, production, and marketing of paintings. But it would be wrong to assume that the socioscopic associated with

affective vision is focused exclusively on high-art images, especially painting, for the purview of sentimental vision is far broader than this. It includes, for example, the varieties of visual and visualizing activity found in surveying land, an activity that is itself divided up into various techniques or technologies depending on the specific functional requirements that motivate the survey. Landscape aesthetics, for example, in which a very carefully demarcated set of responses is outlined and regulated, determines one form of looking at the land, and this should be strenuously distinguished from those forms that motivate, for example, the agricultural survey.[21] In both cases the visual is open to both regimes, the one leaning toward the affective registers of response, the other toward the categorizing impulses of taxonomy. Whichever predominates was to a great extent determined by functional considerations. A survey of the land for tax purposes has little use for the regime of the eye and its affective registers of response.

Furthermore, there is considerably more at stake in the entry into visuality than just different modes of looking, since as I have already remarked practices of viewing also say something about the person who looks. It is precisely because of this that the experiment of sentimental vision holds out such interest, both for the period and for us, since it is based in a leveling and potentially democratic conceptual fold: all who have eyes to see are able to experience an affective response, to "feel" as an eighteenth-century commentator would have it. Throughout the middle decades of the century, say between 1755 and the early 1780s, we find countless rehearsals of the arguments around this point. Thus, John Shebbeare, writing in 1755, makes the case for the eye: "the true taste in gardens is formed on what we feel in ourselves, at the sight of different scenes in nature."[22] The case for the picture, for the educated eye, is here put by Mathew Pilkington:

> As Painting is the representation of nature, every Spectator, whether judicious or otherwise, will derive a certain degree of pleasure, from seeing nature happily and beautifully imitated; but, where taste and judgment are combined in a spectator, who examines a design conceived by the genius of a Raphael, and touched into life by his hand; such a spectator feels a superior, an enthusiastic, a sublime pleasure, whilst he minutely traces the merits of the work; and the eye of such a connoisseur wanders from beauty to beauty, till he feels himself rising gradually from admiration to extasy.[23]

It is important to register here the clear distinctions between activities of slightly different sorts: looking in the garden is not identical to gazing at

painted representations (although the latter may take place within the context of the former), but this distinction is unimportant in relation to the point I want to make. Both activities depend on the education of the eye, and it is this that determines the different modes and modalities of looking.

In relation to the fine arts one argument has it that the arts themselves "educate" the viewer. At a time when increasing numbers of people whose social and economic filiations were to the "middling sort" began to figure more forcibly within the public sphere (and their visibility in that sphere noted with increasing alarm), such arguments were inevitably made on behalf of certain ideological beliefs. These beliefs might have it that everyone is capable of education, or the opposite view might be held, in which only those who already have entry tickets to the domain of visuality will be able to "see." These arguments, which continue into the present, are most especially acute in the period selected for this study since the polite arts are themselves being subjected to contestatory definitions.[24]

Here is the eighteenth-century argument made in a nonelite discursive realm, in a primer on the arts intended for wide circulation:

> This is the Progress of Taste: By little and little the Publick are caught by Examples. By seeing, they (even without taking notice of it) insensibly form themselves upon what they have seen: Great Artists produce in their Works the most elegant strokes of Nature: Those who have had some Education, immediately applaud them; even the common People are struck; *Interdum Vulgus rectum videt.* They apply the Model without thinking of it. Then by degrees retrench what is luxuriant in themselves, and add what is wanting. Their Manners, Discourse, and outward Appearance, all seem to be reforming, and this Reformation passes even into their Souls.[25]

This form of argument concerning the beneficial effects of the "polite arts" is, of course, one of the ways in which the early modern period attempted to justify the expense of investing in nonproductive luxuries and the pursuit of leisure-time activities. The argument runs: much like good household management leads to economic benefits, so the support of the arts leads to a more humane society. Our writer explains: "the Polite Man shall shine forth and shew himself by a lively and graceful Expression, equally remote from Rudeness and Affectation: two Vices as contrary to Taste in Society, as they are in the *Polite Arts*" (5). These and other advertisements for the beneficial effects of artistic production can be found throughout the Enlightenment. Joshua Reynolds made such an argument,

albeit in a rather elitist manner, in his *Discourses*, when he proposed that painting should depict the general rather than the particular, the ideal rather than the specific, since these forms are relatively context insensitive and therefore "educate" the viewer and improve society through time and across social boundaries. Reynolds was all for what John Stedman called "beauties of the understanding" and rather against the more affective, responsive "beauties of the eye": "those beauties which, by the means of vision, strike the sensory with little, perhaps without any reflection of the mind."[26] For Reynolds the moral benefit of the practice of viewing was never in doubt. In his ninth Discourse, delivered on the occasion of the opening of the Royal Academy in Somerset Place, October 16, 1780, he notes, "The mind is continually labouring to advance, step by step, through successive gradations of excellence towards perfection." This trajectory is enhanced by the refinement of taste, "which, if it does not lead directly to purity of manners, obviates at least their greatest deprivation, by disentangling the mind from appetite, and conducting the thoughts through successive stages of excellence, till that contemplation of universal rectitude and harmony which began by Taste, may, as it is exalted and refined, conclude in Virtue."[27]

For similar reasons the high cultural theory of the arts at this time legislated the hierarchy of representations. This hierarchy has traditionally been understood exclusively in terms of academic painting: the ordering of genres that insists on history painting as being the most elevated, precisely a beauty for the understanding. However, arguments concerning the genres constitute only one part of a general cultural eruption in which a range of objects and practices, of looking and production, burst on the scene and jostle for attention in a variety of modes. This high cultural theory is closely linked to certain political and social goals, expressed most succinctly in the term *civic humanism*, and its ambitions were clearly focused on the stratification of the visual domain into a series of hierarchized forms and practices requiring a range of skills and competences one needed to acquire, either by dint of birth or through some kind of educative labor.

This high cultural argument has been well documented and deeply researched so that now we are in a position to begin situating such arguments within a wider sphere.[28] More specifically it is now possible to piece together the contentious context in which these arguments were made, a context in which a professional or bourgeois culture competes with elite culture, sometimes as a parasite on the body of the public and at other times as an alternative to it. In traditional art historical terms this contest is usu-

ally illustrated through the rivalry of Reynolds and Thomas Gainsborough or that between the Royal Academy and earlier schools of art, especially St. Martin's Lane.[29] If Reynolds represents the civic humanist advocate of the regime of the picture and develops a theory to justify it, then Hogarth is his adversary, the advocate of the regime of the eye.

Hogarth's textual intervention into this debate has been poorly understood, partly on account of the very unusual feel to his *Analysis of Beauty*, the treatise he published in 1753.[30] In terms of the discussion I have been presenting, Hogarth's intervention represents the most ambitious counterargument to the academic view concerning the need for "book learning" in the appreciation of the visual arts. His *Analysis* is certainly the first work of phenomenology in English applied to the visual sphere written by a practicing artist: its ambitious aim is nothing less than a complete phenomenology of the eye.

Hogarth's opposition to the academic view is clearly stated in one of the discarded sections of his treatise:

> The profound conoiseur, joind to the man of letters, and deeply read in the works of antiquity, has been urg'd (since this little essay was first in agitation) as the only person, fully qualified in all respects, to undertake the Task; but let it be observ'd a few things well seen, and well understood, are more likely to furnish proper matter, for this purpose, than the cursory view of millions; the knowledge requisite to this end, in my opinion, differs as much from that, studied by the polite conoisieurs, as the art of Simpling, doth from the scientific knowledge of the Botanist.[31]

Hogarth proposes in place of book learning a training of the eye, but not in a routine or commonplace sense. He claims that the eye sees in two distinct ways, and one is to be preferred over the other. The preferred mode is a kind of seeing from within the object, as if the eye were placed inside the object looking out toward the viewer. Consequently, he suggests that one needs to "conceive as accurate an idea as is possible, of the *inside* of those surfaces" (21). He continues:

> In order to my being well understood, let every object under our consideration, be imagined to have its inward contents scoop'd out so nicely, as to have nothing of it left but a thin shell, exactly corresponding both in its inner and outer surface, to the shape of the object itself: and let us likewise suppose this thin shell to be made up of very fine threads, closely connected together, and equally perceptible, whether the eye is supposed to observe them from without, or within; and

we shall find the ideas of the two surfaces of this shell will naturally coincide. The very word, shell, makes us seem to see both surfaces alike. (21)

This way of seeing is opposed to the more usual conceptual schema in which the eye "surveys" what is exterior to it and remains constrained by the surface of things, of what lies "without." Hogarth comments on this inferior form of seeing: "my design is to consider this matter as a performance of nature *without*, or before the eye; I mean, as if the objects with their shades, & were in fact circumstanced as they appear, and as the unskill'd in optics take them to be" (83).

In order to see from within, Hogarth develops an extensive metaphorology of the eye that figures the organ of sight in unusual ways (unusual on account of the pressure to literalize these tropings). Hence we learn that the eye may be "fix'd" to a point that offends it (just as the ear is offended by a continual note) (27); it is "led" (as in the famous "leads the eye a wanton kind of chace") (33); it may be "employed" by the folds in a piece of material that again "fix" its attention (36); it is "entertained" (passim); it may be "in play" (40). This metaphorics, which I wish to stress is not original to Hogarth, nevertheless helps him construct his phenomenology of the eye in terms of the eye's independence of the seeing subject, or the subject-in-sight. Agency in the matter of vision is handed over to the ocular: the eye becomes the emperor of sight.

The ramifications of this are everywhere in *The Analysis*; the eye, for example, derives pleasure or entertainment from certain forms. It may be "ravished" by the sight of intermingling locks of hair (34); it might "rejoice" in seeing an object turned, or "delighted" by the waving serpentine line of a horn (50); and it may be "informed" by the proper disposition of lights and shades (76). There are also negative aspects to its experience, such as "disgust" from the misapplication of the forms of elegance (25), or the sensation of being "glutted" with a succession of variety (27) or "satiated" by the sight of a naked body (40). The eye may also come up against "displeasure" in the regularity of forms (56) or find such uniformity "disagreeable" (88). In these instances the eye may seek out "relief" as in the case when it is glutted with a succession of variety (27); but it may also become "confused" by such a proliferation of variety (45). Most important for the current discussion, the eye has its own agency: it "understands" the relation between parts and whole (44); it has a natural form of "persuasion" (46) and may be "affected" by objects in the visual field (86).

This phenomenology of the eye proposes a radical intervention into both the science of optics and the cultures of visual perception. It argues, two hundred years before Lacan, for a disturbing conception of subjectivity in which the material world is understood to have a kind of quasi agency, a form of interactive reflection that gives back to the subject its corroborations of self. Vision, according to Hogarth, is as much a property of the world viewed, of the object of sight, as it is of a viewing subject. Furthermore, Hogarth is proposing an extreme alternative to the training of the eye, to its acculturation in the hierarchies of culture. This amounts to giving up agency or to an attenuation of subjectivity in order to let the eye do its own work. It is the most disturbing account of the regime of the eye proposed during the period because it leads to the acceptance of a nonagential subjectivity that is beholden to the materiality of outward forms.

The acceptance of this disturbing account of subjectivity prompts the obsession with the body that characterizes Hogarth's treatise and his formulation of vision as radically embodied. Thus we find dozens of examples intended to demonstrate the physicality of sight and its corporeal basis. Here is one concerned with the examination of skin: "The skin . . . is evidently a shell-like surface . . . form'd with the utmost delicacy in nature; and therefore the most proper subject of the study of every one, who desires to imitate the works of nature, *as a master should do*, or to judge of the performances of others *as a real connoisseur ought*" (55).

This is just the beginning of the Hogarthian *anatomy* of beauty; it is supplemented with the examination of bones ("There is scarce a straight bone in the whole body" [52]), muscles, the face, and legs. I will have more to say about how this metaphorics of the eye works out in the specific environments of the landscape garden and the neoclassical house in subsequent chapters. Here I wish to return to the contested space of visuality as it impacts on the practice of painting.

The lines of battle between the academic, Reynoldsian, position and the popularizing Hogarthian can be seen quite clearly in relation to a common thread running through debates about the hierarchy of genres. In these arguments portraiture was understood to have a lower position in the hierarchy than history painting. A large number of strands make up this argument, which is certainly concerned with issues of nationalism and individualism, as well as more technical debates about easel painting. But we do not need to unpack this complex set of positions and posturings in order to note that in spite of the Reynoldsian, high cultural, position vis-à-vis the preeminence

of history, it remained the case that mid-eighteenth-century Britain was overwhelmed with the production and circulation of portraits.[32] Indeed, if one tabulates the number of successful submissions to the Royal Academy exhibitions throughout this period, it becomes clear that even the Academy itself, prime mover in academic art theory and the hierarchy of the genres, depended on the craze for and booming economy in portraits.[33] In fact, Sir Joshua Reynolds, the Academy's first president, exhibited vastly more portraits than any other genre throughout his tenure of office.[34]

The fashion for portraits can be taken as emblematic for my argument since it illustrates the heterogeneity of the social composition of an audience for visual culture; even more pointedly, it raises the question of how much entry to the electorate of taste should cost. The economics of a speculative society are everywhere imprinted on the culture of visuality. How much one can afford to pay, for a portrait or entry to an exhibition room, is an index to one's rights to see and be seen. This economy of the visual and the visible is nowhere more viciously operative than in the production of and market for portraits, which came in a variety of sizes and media, from the simple silhouette through the miniature in enamel right up to the full-length oil painting. Artists were also valued according to their production—miniature, say—as well as the "accuracy" of their depictions and social standing of their sitters. This market had its own logic and forms of promotion: on the one hand, for example, painters who wished to make a living from painting might paint a likeness of a fashionable and important, say wealthy, person without that person having sat for the portrait. If the painter was skillful enough, the likeness would be applauded and custom would follow (indeed, the person represented might even commission a portrait from "the life" and sit for it). Here the value of the image lies precisely in its *vraisemblance*, or "true likeness," and the skill of the artist is measured according to verisimilitude; but, on the other hand, vraisemblance becomes redundant when one does not know the sitter. Thus other criteria must be invoked to distinguish between good and bad productions. For example, over time the portrait's value on account of its likeness is bound to diminish as those who might compare the image to the person die. Consequently, the value of painting, the argument goes, cannot depend solely on vraisemblance; indeed, in relation to a national school of painting it becomes clear that portraiture is unlikely to maintain a high value, in both the sense of its position within the hierarchy of genres and in straight economic terms of the price one might realize for the picture over time. Thus, while the professional and aspiring middling sorts were advocating the com-

missioning and exchange of likenesses, high cultural theory was doing its best to trash what was far and away the predominant pictorial form of the day.

John Stedman's comment is typical: "The demand for portraits hath proved a detriment to the art in general; for painters, when they are able to catch a likeness, finding that they can thus subsist, or perhaps pick up some fortune, devote themselves wholly to that servile occupation, and remain all their lives unqualified for the great branches of their art."[35] William Combe, however, a friend of Joshua Reynolds, recognizes the compromising position in which high art theory places him. Knowing that he ought to take the same view, he is unable to do so since Reynolds himself was the foremost practitioner of portrait painting of the day. He enthuses:

> This seems to be a *Portrait-Painting* Age! . . . It may be Fashion; it may be the increase of Sentiment, which some suppose to have now attained its utmost refinement; it may be that spirit of Luxury which pervades all ranks and professions of men; or it may be an [*sic*] union of them all.
>
> In former times, Families of Distinction and Fortune alone employed the Painter in this line of the Profession. But in these days, the Parlour of the Tradesman is not considered as a furnished room, if the Family-Pictures do not adorn the wainscot: And many a good Woman, whose arms are marked with an eternal red, from the industry of less prosperous days, considers the Bracelet, with the Miniature-Painting, as an ornament necessary to her Station in Life.[36]

This passage gives us a very vivid picture of the content of culture for a certain segment of eighteenth-century society: this is what culture should look like, what this culture imagined to be in the place of "art"; this is its fantasy of the ethical value of taste. The problem faced by Combe and his tribe of connoisseurs, however, was that the marks of value that segregate the social and economic realm—status, prestige, gender, profession, wealth— were bound up with those that stand for cultural education and aesthetic interest. Combe, therefore, is caught in a double bind: although he wants to bestow on his friend Reynolds the highest possible accolades for his production of portraits, he realizes that in so doing he is courting the possibility of allowing any old painter and any old "likeness" a place within the modern pantheon. He strenuously attempts to avoid this possibility:

> Portraits, unless they were produced by the Pencil of a very eminent Master, have, from the insipid and uninteresting style in which they were generally painted, been considered as mere Trash and Lumber by all who were ignorant of the Originals. But, by the Genius of many modern Professors of Eminence, that

Insipidity is vanished; and, by their Hands, a Portrait is now interesting even to the Stranger, and, where its colours are of a lasting nature, will be interesting to future Ages. (introduction)

This longevity can be explained by the concept of "character," which "calls forth new sentiments to the Picture."[37] In valuing this Combe is in effect merely writing an apology for Reynolds's practice of painting his subjects in historical or allegorical poses and costume (in fact, many of these images were painted so on instruction from the sitter and not because of artistic choice); for "character," whether "Historical, Allegorical, Domestic, or Professional," represents the subjects "with an appearance suited to them, or in employments natural to their situation," the effect of which is described in the following manner: "our ideas are multiplied, and branch forth into a pleasing variety, which a representation of a formal Figure, however strong the resemblance may be, can never afford" (introduction).[38]

Combe is here appropriating the affectual aspect of looking—the feeling eye—to the high cultural mode of the beauties of the understanding. There can be no doubt that for him and his like the eye must be educated first in order for the senses to feel subsequently. As Mathew Pilkington asserts: "It is only by a frequent and studious inspection into the excellencies of the artists of the first rank, that a true taste can be established; for, by being attentively conversant with the elevated ideas of others, our own ideas imperceptibly become refined. We gradually feel a disgust at what is mean, or vulgar; and learn to admire, what only is justly intitled to our commendation."[39]

Strictures such as these are frequent in the high cultural arena because they serve to shore up an elitist form of visuality in their promotion of the regime of the picture. The entire project of the Royal Academy can be understood in relation to this argument since it clearly sets out to police what could and should be taken for representations of value. These elitist forms of policing were often expressed in the notion that one required a specific social description in order to "see" works of art. In this case that description was often made by the use of the term *connoisseur*, but, as will become evident, the numbers of individuals circulating within this new cultural sphere of visuality were so large that it took very little time indeed for the term to lose its sense of approbation and to be satirically marshaled against those deemed to be lacking in class for full membership of the club. Consequently, at a certain point in this intricate history the last thing one would want to be called was a "connoisseur."[40]

It is relatively easy to discern the force of this form of argument when one has in mind the elevated genres, such as history painting. In such cases the regime of the picture clearly predominates, so it makes sense to claim that only those who know how to create representations are ultimately capable of judging artworks. Thus, the argument goes, only artists could be the "proper judges of the works of art":

> An Artist therefore is a judge of the whole, an ordinary Spectator only of a Part, and generally a very small one, and Modern Connoisseur, for whom this is chiefly intended, no judge at all.
> Here it will very likely be asked, where then is the Advantage of having the finest Pictures? if none but Painters can see their Beauties and Perfections, none but Painters can be delighted or instructed by them? To which I answer; there are two distinct Pleasures received in the Contemplation of a beautiful Performance; one is from the Picture, the other from its Effects: Every Spectator of good Sense receives, and feels the latter: The Artist only, or those instructed by him, enjoys both: That receives the Impression the Painter intended; This sees the beauteous Combination from whence they proceed: One catches the Ideas the Story would inspire; the other, the glorious Composition, waving Lines, glowing Tints, and animating Touches that excite them: One in short enjoys the Story, the other that and the Picture too.
> And even this, little as it may be thought, is in general allowing an ordinary Spectator, especially a Connoisseur, too much; for though he may be properly affected, 'tis only with the general and obvious Beauties; the Artist alone sees those that are latent and more exquisite: To the former 'tis only Pleasure, to the latter, the highest Luxury.[41]

But in the case of portraiture, the overwhelmingly predominant genre of the period, things are not so clear-cut. Joseph Highmore, an artist himself, takes a different view and helps us to understand what was something of an obsession during the period: the production and exchange of likenesses. Recognizing the power of the regime of the picture, he was also far more comfortable with the seductions of the regime of the eye. In the case of portraiture one need not be a "connoisseur," need not submit to the regime of the picture since "[c]hildren, servants, and the lowest of the people are judges of likeness in a portrait; that is, whoever would know the original from every other person, would know the picture, if it be really like."[42]

When faced with the question of likeness, then, it is less a case of training, of educating the eye, than one of a particular kind of recognition, which Highmore suggests is close to a universal human facility, just as "all mankind are judges of the passions, and readily see what expression the painter

intends."[43] If one sets out to police entry into the culture of visuality, a hierarchy of the genres will serve one well; but, when faced with the proliferation of portrait images and the enormous popularity of their exhibition, one clearly needs something else. It is precisely because of the ease with which the merits of portraits can be ascertained, precisely on account of their being produced and consumed predominantly (although not exclusively) under the aegis of the regime of the eye, that a public for art became so rapidly established. Portraiture, as Highmore notes, is valued primarily on account of its vraisemblance, its truth to the "real," and it is this lifelike quality that creates the seductive illusionism of representation (as I will show in Chapter 2, it is this illusionistic quality of the painted image that so fascinated visitors to Vauxhall Gardens). If, as Highmore suggests, anyone with eyes to see can recognize whether a likeness is a true likeness, then the means for policing entry into the polis of taste are severely diminished. For these and other reasons most contemporary commentators derided portrait artists, and since there was very little other paid work for native painters, such devaluation of the portrait inevitably led to the corresponding derogatory assessment of all contemporary artists. The constant search for a native history painter was motivated in part, therefore, by the need to separate out the social standing of different members of the culture of visuality: one needs a British tradition of "history" painting in order to ascertain those who might only be fit to appreciate the mechanic arts of likeness, and to segregate them from the elite few, those viewers who could aspire to the role of the connoisseur or true critic in their appreciation of the higher genres.

This kind of policing is evident in countless attempts to characterize the art market of the day. Andre Rouquet, for example, writing in *The Present State of the Arts in England* makes the point: "speaking of a modern picture, it still shines with that ignoble freshness which we perceive in nature; time is far from having covered it with its learned smoke, with that sacred mist which some day or other must conceal it from vulgar eyes, when none but the initiated shall perceive the mysterious beauties of its venerable antiquity."[44] The force of this comment suggests the deep extent to which the self-proclaimed guardians of "high" culture were disturbed by the flooding of the market, both in the sense of the number of images being produced and the number of people engaged in the activity of looking at pictures.

London specifically and Britain in general became the focus of an extraordinarily healthy art market during this period, but most of the transactions completed in this market concerned imported images: precisely those dark-

ening images of high genre, the landscapes and historical paintings of the European "master" tradition.[45] Thus, although painting in Britain was most easily identified with portraiture, such images were explicitly devalued in relation to other high genres that began to attract added value as they were traded in the auction market. As has been noted above, in the terms of high art theory portraiture was seen to lean toward the "mechanic" as opposed to the "liberal" arts; therefore, the status of British art could be diminished only as long as the obsession with images of self continued. This led John Shebbeare to complain:

> ENGLAND has not yet produced a good face-painter, much less an historical; of all the productions the present performers who have been born in England, there is not one of them will be ask'd, of whose hand it is forty years hence, and perhaps the whole production of one master, ammass'd together, will not sell at that time for as much money as was given originally for one of them: they have almost reduced face-painting to a mechanick art, and make portraits as they make pins; one forms the head, another the point. I dare say, the time will come, when there will be as many painters to finish a whole length figure, as there are now trades to equip a bean: the face-painter, the wig-painter, the cloaths-painter, the linen-painter, the stocking-painter, and the shoe-painter.[46]

Shebbeare is referring to a common practice in eighteenth-century portraiture in oil: the jobbing out of various parts of the image. Even the most highly regarded and prized artists employed other painters to complete a portrait once the face had been rendered into a true likeness. All this adverse comment on the "trade" of portraiture created considerable pressure on ambitious artists to paint higher-genre pictures. Unfortunately, this too led to difficulties since the contemporary history or landscape was unlikely to have acquired the patina of "learned smoke" that gave to the picture its luster of value (although the practice of varnishing the image with bitumen went some way to correcting this).

Benjamin West, for example, fell foul of precisely this feature of the art market. In 1766 he exhibited *Pylades and Orestes*, a history painting much admired by all who saw it. Indeed, Northcote tells us that "those amongst the highest rank who were not able to come to his house to satisfy their curiosity desired to have his permission to have it [the painting] sent to them." But, Northcote continues,

> the most wonderful part of the story is, that, notwithstanding all this vast bustle and commendation bestowed upon this justly admired picture, by which Mr

West's servant gained upward of thirty pounds by showing it, yet no one mortal ever asked the price of the work, or so much as offered to give him a commission to paint any other subject. Indeed, there was one gentleman so highly delighted with the picture, and who spoke of it with such praise to his father, that he immediately asked him the reason he did not purchase, as he so much admired it, when he answered, "What could I do, if I had it? You surely would not have me hang up a modern English picture in my house unless it was a portrait?"[47]

This ironic comment cuts a swath through the conflicting posturings of the cognoscenti: if one really wanted a native tradition of history painting, why were those artists who produced portraits, such as Reynolds, so favorably honored? It is unlikely that a single explanation will suffice here—in a very intricate web, social, commercial, and aesthetic interests are knitted together to produce this midcentury passion for self-image—but there are aspects of this curious persistence of portraiture that can be explored profitably since they bear upon the shapes, forms, and interests of eighteenth-century visuality in important ways.

The pleasure of portraiture is often thought to lie in the experience of recognition: we are thrilled by the art that renders a likeness.[48] This thrill is clearly muted, if not eradicated, in the case of a representation of someone we have never seen, but it is equally intensified if the subject happens to be ourselves. It is this second case rather than the first that I will dwell on since, as noted above, the period under investigation has an obsessive relationship to self-image.[49] This is so not merely in the literal case of portraits of oneself but also in the philosophical accounts of a well-regulated and mutually profitable society. The culture of visuality places a high premium on visibility; indeed, it tends toward narcissistic specularity. Given this fact, a distinction needs to be explored between "presentation" and "representation," "self-picturing" and "self-presentation."[50] In the latter case portraits can be understood as falling within a general concept of depiction and consequently share the problematic of "re-presentation" with all other images. The representation "stands for" the real; its initial frame of reference is the simulacrum, that which by whatever trick of the illusionist's art fools the viewer into taking the image for the reality it depicts. Of course, this initial frame of reference and the concomitant "naive" position of the viewer it produces (the bumpkin satirized in early exhibition literature who talks to the painted representations of people as if they were actually there in the exhibition room) represents only the starting point for entry into visual culture. From this point on things become significantly more complicated as the art

of illusion ducks and weaves around the development of visual style, painterly skill, pictorial tradition, narrative organization, customs of display and use, and so on. But, as sophisticated as things get (and they very quickly become extremely complex intermeshings of mimesis and diegesis, a hall of mirrors in which representation re-presents itself), the portrait also has another, more overtly psychic, frame of reference, that of self-presentation (and in this it shares the grounding conceptual frame of the photograph, which also plays in and out of presentation and representation).

This attentive frame can be most easily understood in the case of the portrait of oneself in which the relationship the sitter has to the image is mediated not only through the complexities of representation (here the "style" of the image, its pictorial assembly, gives clear signals to its representational force) but also those of presentation. The viewer's relation to the portrait—and here I am thinking of all portraits, not just those depicting oneself—is split between two divergent positions: the one, in which the viewer inhabits the space of the image (presentation) collapsing down the distance between the eye and the image, eye and object, is produced in the scopic technique of identification. This viewing position precisely overlays the image upon the eye; it results in an extremely strong sense of being here in the place of both vision itself and the world that is seen. Presentation, I am here, is sutured precisely and seemingly without remainder, with representation, the seen world over there. The other viewing position, in which the viewer maintains his or her distance from the image, negotiating the various filters through which the world or object is seen, is produced in the scopic technique of recognition. The viewer matches the object with a prior mental image, moving between the "there" of re-presentation and the "here" of vision. As I have argued above, these two scopic techniques align themselves "naturally" with the different regimes of the eye and the picture, but this alignment is potentially fluid—at least it is unfixed. This is to note that the four terms are not ordered as a chiasmus, thereby constructing a static grid of interrelations. What I am thinking of in terms of the plasticity of these relations can be gauged immediately by noting that both of the scopic techniques, identification and recognition, may take place in rapid succession in any encounter with the visual field. This is why I temporalized the description above in which the regime of the picture leans first toward recognition whereas that of the eye leans toward identification. The viewing of portraits, then, oscillates between identification and recognition, but in some instances (over the history of the Western art tradition or in the case of self-image) one of these

scopic techniques, say identification, may predominate over the other. In such instances the image should be understood under the protocols of presentation and self-presentation rather than representation, and as I will argue below in respect to the "conversation piece," one such moment in the history of Western art when images were produced under the protocol of presentation was, roughly, the second quarter of the eighteenth century in Britain, when the republic of taste was being formed and subjected to the competing interests of the regimes of the eye and picture.

I now want to take this conceptual distinction into the specific culture of portrait production and consumption in mid-eighteenth-century Britain. Rouquet's commentary provides some first impressions; he tells us no less than three times: "it is amazing how fond the English are of having their pictures drawn."[51] Such images came, of course, in a variety of forms: the high art social portrait by an academician was only one of the many possibilities. Others included miniature representations, silhouettes, or drawings in media other than oil. Everywhere one turned, portraits were being commissioned, copied, and circulated in a society predicated on specularity and speculation. As Rouquet observes: "Portraiture is the kind of painting the most encouraged, and consequently the most followed in England; it is the polite custom, even for men, to present one another with their pictures" (33). And later he notes "the custom of frequently making a present of one's picture" (45).

The culture that is beginning to come into focus is suffused with the desire to see oneself and to exchange self-images as a form of social practice: self-presentation is the bedrock of polite behavior. In sitting for an easel portrait this fascination with seeing oneself is also evident—and indeed itself represented in those images that depict scenes at the portraitist—and at least one handbook on painting in the early decades of the century suggests that portraits are most effectively accomplished by the artist looking at the image in a mirror. Thomas Page instructs the painter: "you must always have a Looking-Glass behind you, wherein at times you must look to behold your Work, for that will show you your faults; whether the Masses of the Lights and Shadows, and the Bodies of the Colours be well distributed, and are all of one Piece."[52] This, an instruction for the painter, implicates the sitter to only a small degree in the reflective surfaces of the culture of visuality. Reynolds's practice, however, brings the sitter into the catoptric look very forcefully indeed. We learn from Charles Leslie and Tom Taylor's *Life and Times of Sir Joshua Reynolds* that Reynolds commonly set up his studio so that the sitter could see him- or herself coming into representation by the

simple expedient of placing a mirror obliquely to the canvas.[53] Here Leslie is quoting Beattie, who sat for Reynolds on August 16, 1773:

> I sat to him five hours, in which time he finished my head and sketched out the rest of my figure. The likeness is most striking, and the execution most masterly. The figure is as large as life. Though I sat five hours, I was not in the least fatigued, for, by placing a large mirror opposite to my face, Sir Joshua Reynolds put it in my power to see every stroke of his pencil; and I was greatly entertained to observe the progress of the work, and the easy and masterly manner of the artist.[54]

Beattie, who claims this is an unusual practice, is corrected by Leslie, who notes: "In reality, Sir Joshua was painting from the reflection in the glass—his usual practice" (33). I do not want to blow up this comment into anything more than the little anecdote that it is; nevertheless, this culture's fascination with the *process* by which one comes into representation is almost tangible. It would seem that there was no more delightful way to spend one's time than seeing oneself made the object of the look.

Such objectification came along with problematic aspects of being looked at, most obviously those concerned with the erotics of the situation. Self regard is, perhaps, always caught up in an erotics of visualization, but in the case of having one's picture "taken" there are clear indicators of propriety. It was for this reason that women portraitists were strongly discouraged; it was believed that the situation in which a woman painted a man would necessarily tend toward impropriety.[55] It is noteworthy that commentators on the practice of portraiture did not find the opposite situation, in which a man "takes" a likeness of a woman, equally problematic.

Similarly, it is clear from Leslie and Taylor's *Life and Times* that easel portraits could often be realized with an audience of onlookers present, there to witness the sitter's likeness appearing, as if by magic, in front of their eyes. Thus the experience of sitting for a portrait was, perhaps inevitably, one in which spectatorial activities infused the scene of representation, and such spectatorship might be autovoyeuristic as well as simply voyeuristic, narcissistic as well as predatory. It is possible that this invasion of what we would understand as a private space is more troubling to our own notions of propriety than it was to a culture in which spectating was an engrossing practice. Nevertheless, there are clearly problematic issues over the public nature of the space.

A visit to a portrait painter, depending of course on one's particular sta-

tion in life, would most likely be undertaken within the view of others. Studios were equipped with waiting rooms specifically designed to cater to the clientele who would frequently pass the time by inspecting the wares displayed by the artist: those portraits he chose to advertise his skill and promote his being well connected. Thus, not only would one be able to note who had sat for this particular artist, but one would also be seen by others in the "gallery" or waiting room who might themselves be contemplating having their portrait done. As Rouquet notes: "Every portrait painter in England has a room to shew his pictures, separate from that in which he works. People who have nothing to do, make it one of their morning amusements, to go and see these collections."[56]

As fashions came and went, different artists would become more or less in demand, and well-to-do sitters would make it their business to have a likeness taken by the current favorite portraitist. This might lead to problems for the artist, since his business would suddenly expand at such a rate that his pictures would need to be completed at great speed. Rouquet explains the problem:

> A portrait painter in England makes his fortune in a very extraordinary manner. As soon as he has attained a certain degree of reputation, he hires a house fit for a person of distinction; then he assumes an air of importance and superiority over the rest of his profession. . . . His aim then is not so much to paint well, as to paint a great deal; his design is to be in vogue, one of those exclusive vogues which for a while shall throw into his hands all the principal portraits that are to be drawn in England. If he obtains this vogue, to make a proper use of it, he is obliged to work extremely quick, consequently he draws a great deal worse, by having a great deal more business. Fashion, whose empire has long ago subverted that of reason, requires that he should paint every face in the island, as it were, against their will, and that he should be obliged to paint much worse than he would really chuse, even by those who employ him. (38–39)

If this is the unhappy lot of the portraitist, his sitter is not in much better shape because fashion demands that once one artist has slipped from favor, another replaces him, and hence the need to have one's portrait painted a second time, and so on. Furthermore, the public nature of this coming into the visual is compounded by the fact that an ambitious artist would have been likely to submit his canvas for one of the many yearly exhibitions. Hence the prospect arises of being seen not only at the studio or in the process of having one's likeness taken but also on the walls of the exhibition room where the public would be none too reluctant to judge the var-

ious performances (and by implication the sitters depicted).[57] This is equally true of the more intimate and private miniature portrait, which might also be entered for one of the growing number of exhibitions.

In my comments so far concerning this culture's fascination with self-image I have held firmly in view the practice of easel painting: the production of images that are frequently, although not always, life sized and are usually in oil and on canvas (although other media and other supports were of course used). In the case of the miniature a slight twist enters the story since the portability of these images allowed for a further set of uses. Most miniatures were set into frames that allowed them to be worn as jewelry—as a necklace, bracelet, or pendant—and this created the possibility for another dimension to self-display, identification, and recognition.[58]

The most obvious, and to present-day practice most understandable, way of using such images was to signal attachment to another person. The wife/lover wears a pendant image of her husband/lover; the mother wears one of her child; sisters exchange bracelets with settings of their portraits. Contemporary practice is fully attuned to this—the father/husband carries photographs of his children/wife in his wallet, for example. But other ways of using these images were possible: if men exchanged likenesses as frequently as Rouquet suggests, what did they do with them? Did they wear them? If women sat so frequently for the portraitist and had miniatures set in jewelry, what did they do with these images? Did they wear them themselves? Evidence here is limited, but given the near obsession with self-reflection that I have been detailing, it would seem at least possible that miniatures were used in these ways. And, if this is the case, the *presentational* aspect of the portrait subordinates the representational through the social practice of self-display and exchange. The display of the miniature then becomes part of a set of practices and rituals, both social and psychic, that come together in the cultural technique of individualism or what might be called person-ification.

I now want to turn to the early exhibitions at which these self-images were presented and to explore the ways in which the first viewers responded to the public display of "artworks." How did these untrained viewers approach the image, and what was their reaction to the new social space of the exhibition room? There is not a great deal of evidence on these matters since these first viewers rarely wrote down how they responded; there are, however, newspaper accounts of varying kinds—satirical as well as critical—which give us some indication of the initial reaction of a fledgling viewing public.[59]

Early in the century Addison makes the claim that the activity of viewing is class specific:

> A Man of a Polite Imagination is let into a great many Pleasures that the Vulgar are not capable of receiving. He can converse with a Picture, and find an agreeable Companion in a Statue. . . . It gives him, indeed, a kind of Property in everything he sees, and makes the most rude uncultivated Parts of Nature administer to his Pleasures: So that he looks upon the World, as it were, in another Light, and discovers in it a Multitude of Charms, that conceal themselves from the generality of Mankind.[60]

The aesthetic is, from its earliest formulations, engaged in the process of social discrimination: one argument has it that art is only art insofar as it is out of the reach of the vulgar. This kind of argument seeks corroboration in the regime of the picture and has far and away become the dominant rationale in the construction of a public sphere for the appreciation of artworks. In Chapter 2 I will explore another possibility whereby the particular visual environment of Vauxhall Gardens creates a kind of museum of visual deception or illusionism that results in the leveling of all viewers. But if Vauxhall represents a broadening and opening up of the politics of vision, then the exhibitions I am about to discuss attempt predominantly to go in the other direction and push hard to close down the rights of way and to restrict access to the pleasures of visuality. This elitist project is all too clear in Addison's comment, in which the "Vulgar" are excluded from the view of art because only an educated eye is able to see what is concealed from the "generality of Mankind." There is also a rather curious aspect to his fantasy of the scopic, which seems to suggest that the representation is equivalent to and indeed can be addressed as if it were the thing represented. In this way one might begin to converse with a picture as if the person represented were really in front of one's eyes. This permeability between the image and what it is taken to represent very quickly became a topos in the discussion of early exhibitions.[61] Again, as a way of discriminating between educated and vulgar viewers, one's ability to "see" an illusionistic natural representation for what it is, that is, a representation, qualified the spectator in terms of rank, education, or class. The need to make this distinction would seem to have been generated by the incredible popularity of the first exhibitions, but the reasons for this popularity were not, of course, entirely grounded on an appreciation of fine art: the social environment created in the exhibition room certainly had its own attractions, as is made clear below.[62]

I have already mentioned that the first regular public exhibitions of paintings in England began in the 1760s; by 1772 there were at least five exhibitions of art in the capital that could be visited in the spring and summer months. These exhibitions were held at Spring Gardens, the Free Society of Artists at Christie's, the Royal Academy, Mr. Strange's at St. Martin's Lane, and the Great Room over Exeter Exchange in the Strand. Almost as soon as these exhibitions were mounted, issues of competence in the matter of judging the works displayed were publicly debated. An ironic comment on those who presumed themselves to be critics appeared in the *Public Advertiser* in 1767:

An Infallible Receipt to Make an Exhibition Critic:

Take the shilling you will receive by the bearer, go to the exhibition room at Spring Gardens, give it in exchange for a catalogue and sneak into the room, taking great care you are not smoked, for should you be known it will ruin the whole process. When you have shaken off the pleasing sensation that such a number of ingenious performances must necessarily give you, direct your attention to the company, particularly to such of them as you observe use glasses or wear spectacles; lose not a word of what they say, for as the wasp steals the honey he cannot make himself, so you are to avail yourself of everything those gentlemen who are stiled *connoisseurs* utter, by which means you will procure a large quantity of the *Essence of prejudice*; and observe, that of this essence you cannot have too much. You may next direct your attention to the ladies, of whom you will easily obtain two or three ounces of *exhibition salvolatile*, or epithets, such as *horrid! shocking! abominable! a perfect dawb* etc etc. Cork these up immediately least [*sic*] they should evaporate. Then turn your eyes towards such persons as you will observe to wear a kind of *green and yellow melancholy*, who swell and look *askance*, who *knit the brow* and *bite the lip*, who walk in couples, point and utter themselves in half whispers; from these you will with some difficulty gain a most valuable extract of *Envy, Detraction, competition* and *personal pique*. Lastly, attend to the conversation of those persons whom you apprehend have real taste, candour, judgment; and from these in a very short time, you will procure more of these salutary simples, *good manners, admiration, and applause*, than you will have occasion for; keep a *very little of these for use*, and cram the rest into your tobacco-box; a quid of this *trinidado* taken now and then is better than rhubarb for indigestion occasioned by the too frequent use of that intoxicating drug *virtu*.[63]

We are clearly meant to find this barbed commentary funny, but leaving its comic intentions aside we can extract from it some—albeit incidental— information concerning the practice of exhibition going. Most notable, I think, is the sense of overhearing, which pervades the viewing experience.

This conveys the predominating sense of the social aspects of the exhibition room: here one finds oneself in a public space, visible and audible. Not only are the walls full of images for display, but the room is also crammed with people looking at and listening to other people: here, in all its chaotic jostling and posturing, is the society of visuality.

Not surprisingly, therefore, these exhibition rooms quickly became associated with a kind of licentious social practice, precisely places in which the "normal" rules of polite conduct might be relaxed. In another newspaper cutting from 1764 the comic potential of this situation is exploited:

> Being a passionate admirer of the marvellous, the beautiful, or the new, I have for some time reflected with concern, that no plan of amusement has yet been thought of to succeed the exhibitions in Spring-Gardens and the Strand, and supply new matter of speculation to the connoisseurs. It was therefore with infinite satisfaction that I perceived a design lately set on foot to blend utility with pleasure, and to carry our amusements to a point of perfection unknown before. For though some of the danglers in vertu may be possibly so much in love with copies as to disregard originals, I think a man of taste will scruple to give the preference to a design, which, disdaining to exhibit inanimate forms, presents a group of living figures to the view. I need not inform your readers that I mean that admirable institution ycleped the *Marriage Register*, in which I can see no objection, except the name, which, being common to a plan of inferior nature lately established our Exeter -'change, somehow unavoidably suggests the idea of a formal bargain. I would therefore humbly propose the *Grand*, and if you please *Royal Exhibition of Ladies and Gentlemen*, as a title much better adapted to the elegant and delicate nature of this undertaking. And to save many Ladies and gentlemen, who might, for good reasons, dislike to have their names publicly known, I would further propose that such titles should be borrowed from the terms of art in painting, as may at one glance give the enquirers a full idea of the qualifications of any lady or gentleman without the trouble of asking questions.[64]

Aside from the fun being had at the expense of philandering social parvenus the serious point made by the commentator concerns the self-display encouraged by the spacings of the exhibition room.[65] It might be argued that these days things are hardly different and that one goes to an opening as much to be seen as to look at art. In this sense the viewers compete not only with the images displayed but also with one another. Consequently, then, as now, the viewer becomes a kind of exhibitionist as he or she enters into the spacings of the visibility of visuality. Given this development, the precise composition of the crowd became a crucial issue, hence the problem over admittance.[66]

It was decided very early on in the history of these exhibitions to restrict entry, supposedly because of the crowds. The March 17, 1764, *Public Advertiser* informs us: "Last night, at a meeting of the society for the Encouragement of Arts, it was resolved, on account of the prodigious crowd occasioned by the unlimited allowance of tickets, at the exhibition, to confine the number for each Member to sixty-four."[67]

This problem continued right into the 1770s and beyond; the Academy introduced the shilling entrance fee, for example, but other solutions were also tried.[68] An auction house display in 1771 followed this line of action: Mr. Goodhall of Mersham Street advertised his exhibition, to take place on Mondays, Wednesdays, Fridays, and Saturdays, from ten till three—an exhibition of two hundred fine pictures, and "to keep out all disagreeable Company, the Nobility and Gentry who intend me the Honour of their Presence, are hereby desired to send to my House for Tickets, as none will be admitted (former Purchasers excepted) but such as have their Names and Titles inscribed thereon in my own Hand Writing."[69]

As I have suggested, the reasons for restricting admittance seem to be connected to the social status of the viewers and the kind of activity thought proper to the viewing of pictures. If the environment prompted particular forms of social intercourse, it was important to control the kinds of people one might encounter. To justify such social engineering, arguments based on aesthetic criteria were enlisted. These arguments concerning the need for a very specific training of the eye invoked the illusionist topos referred to above. Here is a typical newspaper rendition of that topos:

> The other day I went to see the exhibition in the Strand, when I met a gentleman who is an artist, and having some acquaintance with him, he was so kind as to explain the beauties of several of the pictures. . . . A Lady being deceived by one of the figures, taking it to be alive, stept across the room, that she might have a full view of it, and standing quite still, looked steadfast at the figure; Another lady coming in, being likewise deceived by some of the figures, fixt her eyes upon the first lady, who, after satisfying her curiosity, began to move, to the surprise of the second, who cried out, *Look! Madam, I really thought you had been alive*—Indeed so I am, madam.—*I mean, Madam, I took you to be a figure.* A gentleman, who had made a mistake of the like kind, said, *I will be a figure*, and accordingly put himself in a good position, and fixing his eyes on a particular part of the room, stood as well as [a] man could do for that purpose.[70]

It does not matter in the least that we are not supposed to take this seriously, for what is given away by the joke is precisely the possibility of mis-

taking a representation for the reality it is taken to represent. It is the same topos we found in Addison; only here there is the admission that uncultured viewers may be used by the trope rather than use the trope themselves. And in this newspaper rendition of the topos the two ladies are presented to the reader as emblematic types who are supposed to take the butt of the joke in order for us to recognize that we would never make the same mistake. It must be at least a possibility that some uninstructed viewers might make such a mistake for the parody to work, that some viewers, those with "vulgar" eyes, were unable to distinguish a figure from the reality it figures forth. Such uninstructed viewers were to be scorned as much as the "lower class" of artists. As the *Public Advertiser* put it:

> To the honour of the society of artists be it said, that for these three years past they have obliged the town with noble exhibitions; and for it they deserve our peculiar thanks. But it is to be wished, that to the lower class of artists they would not extend their indulgence so much. The works of Reynolds, Cotes, Zoffani [*sic*], Gainsborough, West, Lambert, Wilson, Barrett . . . need no foils. Hence, therefore, for the future, let no admittance be given to the bushel work, which, like vile weeds crowded about the finer flowers of the garden, will certainly detract from, but add not a jot to their native beauty.[71]

It is clear from this comment and others like it that social standing and class affiliation are important qualifiers not only for the viewing of representations but also for the production of the artwork itself. But what of the social standing of the artist him- or herself? Can a "lower-class" artist, a mere "mechanic," make discriminating judgments about work by other—say, higher-class—artists? If "truth to life" is the criterion for judgment, how can one distinguish between those with taste and those without? Given that the most lifelike image is more likely to fool us into taking the representation for the thing represented, it follows that the "best" pictures are those that encourage the most naive viewing position. Thus the ablest artists are those who deceive the viewer most effectively, turning us all into Ben the Bumpkin. The paradox of this argument is illustrated in the following newspaper cutting, once again from the *Public Advertiser* in 1764:

> You must know, Mr Printer, that I live in the country, and was persuaded by a friend to go to see the pictures. . . . Well I looked about, and saw several pictures that wanted nothing but speech . . . then fixed my eyes upon the Death of Abel, which I heard much talk about; but, being a country-fellow, I thought it above my cut: For, when I came to view it, I found it so very able, that I was quite unable to

make an able judgment of it. And now, Mr Printer, comes the reason of my desiring you to excuse me to the Company.—The variety of objects had tired me a little, and casting my eyes up on a sudden, I saw the sign of the Green Man at Barnet, dogs and all. I am unfortunately apt to be a little absent sometimes, (and so it happened now) for I immediately fancied myself before the inn door, and called, in a loud voice, for Will Hopkins the ostler to take care of my horse.[72]

This knowing, punning commentary points up the difficulty of settling the issue of judgment: if vraisemblance is the only criterion, then we all become duped viewers; we all fall for the illusionist's trick.[73] It is in relation to this difficulty that another way of understanding the activity of looking is investigated, and this alternative signals the fact that the conceptualizations of both the aesthetic and the cultural realm have begun to reach some complexity and maturity. If representation is no longer tied to vraisemblance, that is, if one can begin to see with the image rather than track back and forth between it and the "real" it purports to represent, then the artwork may begin to instruct the eye in how to look. It is the regime of the eye that develops this address to the visual and enables the artwork to explore its grounding in its own materiality. That exploration moves only slowly out of the domain of figurative expression toward abstraction. Certainly at the beginning of the culture of visuality a far more straightforward relationship to the materiality of the image is more common. This is apparent in what I take to be the didactic purpose of many mid-eighteenth-century paintings: they picture to their first audiences certain facets of the culture of visuality. In effect they image that culture to itself, present different self-representations, produced by and consumed within sometimes different scopic regimes, to an emerging public sphere. They are essays in the self-presentation of culture. Given this fact, they are far from indifferent to the social, political, and psychic implications attendant on their promotion of or resistance to particular ways of looking. If the artwork itself instructs the eye, what are the social consequences? This question reverberates through the intervening 250 years and has yet to be finally settled—Turner's late canvases present perhaps the most sustained pictorial attack on the regime of the picture; twentieth-century abstraction presents another later skirmish in the same battle. Its being posed in the second quarter of the eighteenth century, however, signals an awareness of the complexities of the argument even if, as will become apparent below, the *pictorial* argument is still grounded in the elementary moves of representation. It is that pictorial argument on behalf of the regime of the eye that I now turn to.

I have said that these early arguments in paint are relatively elementary; they picture "simplistically" to an as yet visually unsophisticated audience certain facets of visuality. They show people being looked at, having their likeness taken; they *present* person and personality, and in doing so they image to the viewer ways of looking at these images as well as ways of presenting oneself in society, in the demos of taste. This is less simplistic than it might seem, however, and all the more so if the context I have been constructing for the development of the culture of visuality is kept firmly in view. Here I will recall that entry into the cultural domain of visuality for this period was commonly experienced in terms of becoming a portrait, and this troping of self into image, into an exchangeable commodity, was available to the "middling sort," gentlemen, professionals, and increasingly commercial entrepreneurs, as well as to the aristocracy, to men as well as women. Consequently, the franchise within the society of visuality was potentially rather larger than obtained within the voting electorate. This fact and its disturbances will return again and again as we explore the different public spheres of looking.

In looking at these pictorial arguments on behalf of the culture of visuality I will pass over the interrelationships between these and other contemporaneous images; that is, I will ignore the internal history of painting (say, the relationship between portraiture and other genres) and the interconnections between types of portraiture (say, the informal group portrait and the miniature). Portraiture itself has an internal history—the anxiety of influence that structures the filiations of one image or subgenre with another—that is inflected through the vicissitudes of the commercial environment that sustains and promotes it, the evolution of "style," changing taste, and the development of materials and techniques. I am going to leave these considerations aside in order to *look* at some images of looking since the point I am making, that the image itself instructs the eye, needs to be illustrated by some examples.

There is an initial problem in setting out to look at paintings that comment on or even construct the activity of looking since every image that includes depictions of people who have their eyes open might, to greater or lesser extents, be taken as in some sense representations of looking or, at the very least, of seeing. Some images, however, refer explicitly to a practice of looking, even define the contours of such a practice in important ways. It is not coincidental that a particular form of the portrait known as the "conversation" or "family piece" began to be produced in quantity at the moment when the domain of visual culture became publicly visible, nor, indeed, is it

coincidental that its popularity waned at the moment when rights of access to that culture were narrowed. Recent work on this genre has excavated the precision of these images, their attention to detail in the sense of pictorial rendition—the high resolution of the image in its depiction of objects, surfaces, and so forth—as well as the specific meanings conveyed by the assembly of the image that inform us about the persons portrayed.[74] In relation to this semantic content the detail of the image is assumed to present information about the relationships between the individuals we see and about their specific identities in terms of class, rank, and profession. Thus in what is perhaps an exemplum of the genre, Arthur Devis's *The John Bacon Family*, painted around 1742, the image presents a snapshot, a captured moment in time in which the relations between parents and children are frozen in order to convey the good order of this family (fig. 1).

John Bacon, the eldest son of a large landowner in Northumberland, married Catherine Lowther in 1732 in London.[75] We see them in the interior of what is probably a London townhouse with their four children. The rooms are packed with significant objects and images, all clues to the semantic register of the image. We see, for example, a number of scientific instruments: a transit quadrant set up in the window on the right with a reflecting telescope on a table in front of it. In the far room at the back an air pump sits with a bell jar on the table, which has been tipped up in perspective to display the objects to advantage; in front of these instruments there is another, a small compass microscope, and under the table are two globes, one celestial and the other terrestrial.

It has been suggested that the portrait on the wall in the far room is of Edmund Halley, the Astronomer Royal from 1721 to 1742, and the grisaille panels in the front room depict Milton, Pope, Sir Francis Bacon, and Newton. The image pretty much screams, "Man of Science!" which indeed Bacon was—his election to the Royal Society took place in 1750. But it is not these visual clues to the image's semiosis that I want to dwell on; instead, I will attend to the poses struck by the sitters. Conventionally enough, the mother and daughter, along with the two children playing cards, look out of the image at the viewer in the typical pose of the portrait subject. They look at us looking at them, their faces caught in the perpetual oscillation between embarrassment and satisfaction; embarrassment at being caught looking upon themselves and satisfaction at being looked upon. These faces are frozen, masked even, not in the camera's cheesy grin but in the look's uncertain pleasures, the look of becoming a portrait.

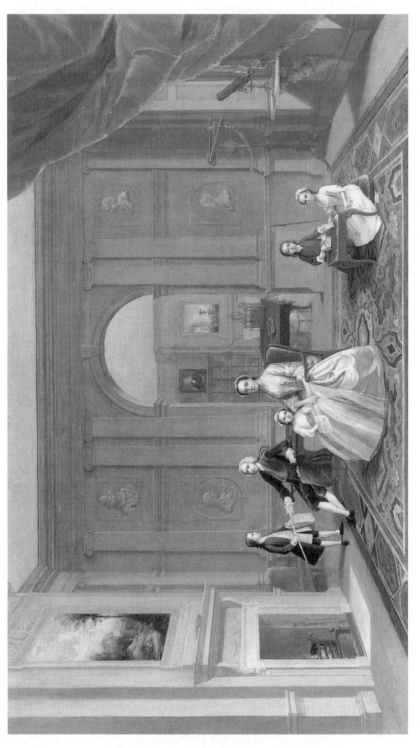

FIGURE 1. Arthur Devis, *The John Bacon Family* (1742–43); oil on canvas, 30 × 51⅝ in. (76.6 × 131.1 cm). Yale Center for British Art, Paul Mellon Collection.

Bacon and his son, however, do not engage the viewer's eye; they do not even engage each other's look since the father's angle of vision appears to glance off the look directed at him from his son. This area of the image slightly diverts the onward rush of the viewer's incorporation in the scopic regime of the picture. There is, in fact, a kind of rotation, both toward and away from the viewer's gaze, as if the attempt at a studious gaze transforms into a rapid glance that skids off the speeding look imaged to us on the picture plane. This results in a stolen glance, a surreptitious peek at the area of the image that is occluded from the view: Bacon's outstretched hand, half open, which seems to await the arrival of some object—perhaps the flute his son holds. On closer inspection—for now once the eye has been drawn to this occlusion, it is hard to look at anything else—the gesture seems one of solicitation, as if Bacon were encouraging an exchange of something—say, an exchange of looks. Here the imprint of the look in the image is most masked, sublimated in the strange configuration of the bottom fingers of Bacon's hand, suggestive perhaps of a secret handshake, a fraternal gesture of mutual association. That gesture, both inviting and repelling, fractures the time of the look, punctuates its drive toward identification. In effect it asks of us our rights of entry should we seek to become spectators in its world.

The period itself used the term *conversation* in a way that is slightly confusing—indeed, I will argue below that not all pictures traditionally grouped together in this genre can be most usefully understood as participating in a common viewing practice. Where it is clear that one criterion for inclusion in the genre is the informality of the setting, and perhaps another the presence of a group, these criteria are too loose to help in the construction of a useful taxonomy. Another way to think about these images has been to cluster them around the notion that they depict in some sense a moment of frozen discourse, as if we have caught the protagonists in the process of a private conversation; in this sense they present to the viewer a sense of *overlooking* or *overhearing*, as in *Arthur Holdsworth Conversing with Thomas Taylor and Captain Stancombe by the River Dart* (fig. 2). Here we seem to stumble on a private party as two of the subjects continue their conversation unaware of our presence, while the third looks out of the picture plane at us in the typical portrait pose.

Images of this kind engage the viewer's look by inviting us into the picture plane through an exchange of sight lines: someone looks out of the image at us, and we look him or her back in the eye. Once in the image, as it were, the eye then follows the various sight lines of exchanged looks in a

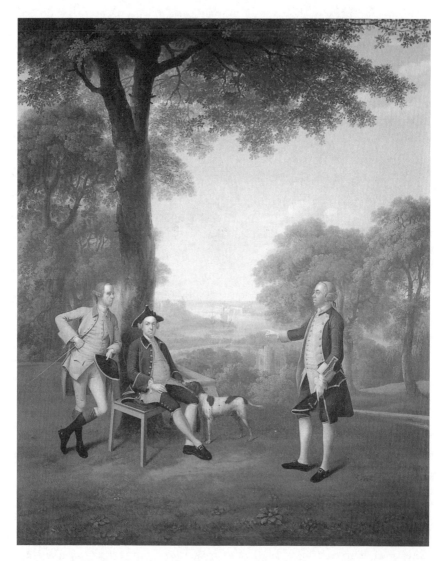

FIGURE 2. Arthur Devis, *Arthur Holdsworth Conversing with Thomas Taylor and Captain Stancombe by the River Dart* (1757); oil on canvas, 57 × 47⅛ × 2½ in. (1.448 × 1.197 × .063 cm). National Gallery of Art, Washington, D.C., Paul Mellon Collection.

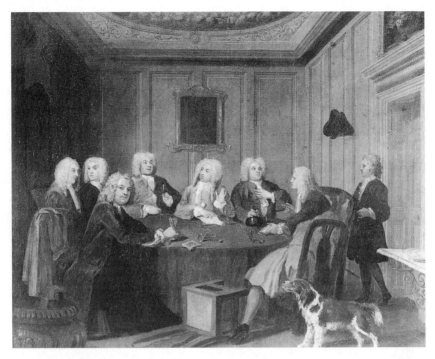

FIGURE 3. William Hogarth, *A Club of Gentlemen* (c. 1730); oil on canvas, 18½ × 23 in. (47.0 × 58.5 cm). Yale Center for British Art, Paul Mellon Collection.

temporalizing and narrativizing movement. A good example of this is the painting by Hogarth entitled *A Club of Gentlemen* (fig. 3), in which the figure closest to us on the left of the image looks at us. We return his gaze and then follow the sequence of exchanged looks around the table. The activity of looking presented by the image gives the viewer the sensation of being included within the plane of representation, within the conversation. *A Club of Gentlemen* is extremely effective in conveying a kind of casual sense to this staging of a scene; Francis Hayman, in a similar conversation (fig. 4), is less effective. Here the figures are considerably stiffer, as if they are aware of having their picture taken. Indeed, the figure seated on the ground sketching is there to remind us of precisely the staginess of coming into representation, visibility, of turning the private self into the public subject, entering the culture of visuality; and it is this which gives us a clue to the scopic drives animating the conversation.

In these and similar images produced in numbers from the mid-1730s up to the early 1760s an interesting transformation of the portrait genre is

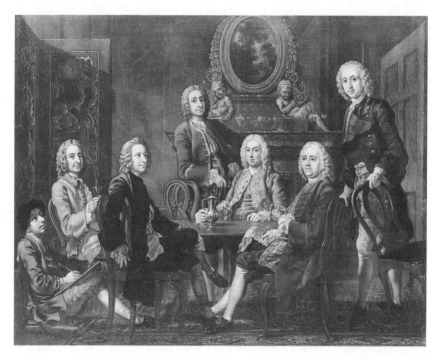

FIGURE 4. Francis Hayman, *Portrait of a Group of Gentlemen, with the Artist* (c. 1740–45); oil on canvas, 44 × 56 in. (111.75 × 142.0 cm). Yale Center for British Art, Paul Mellon Collection.

staged. Such paintings are clearly less formal, often less ambitious in terms of their size or settings, and their subjects are from nonaristocratic backgrounds. These are images of a newly affluent bourgeois and professional class whose members are keen to have themselves recorded as entering into the domain of culture, and as such they submit to the urge for self-presentation. In part they announce, "Look at me; I am here to be seen." But this is only one layer of the image, which also records the awkwardness and strangeness of seeing oneself in the plane of representation, of witnessing oneself being depicted. The images both present the sitter and represent him or her, respond to both the satisfaction of self-promotion and embarrassment of self-recognition. It is because of this complex pulsation of drives that a particular look to the sitters arises—the characterless, immobile, masked look that is the common feature of these images—in effect this look is the solution to the problem facing these newly enfranchised viewers in the

culture of visuality, the problem of *how to appear in public*, how to be imaged and imagine oneself as a subject-in-the-picture. And in solving that problem these images simultaneously present a fantasy, a phantasmic projection of what it feels and looks like to be seen in the culture of visuality. They project an imaginative account of the psychic economy of self-display, and, at least to our modern eyes, that look is far from comfortable with the notion that it might be returned by another, returned in the circuit of the viewer's gaze.

It is important to recognize that this problem is solved through a very taught control of the pose. In pointing to this aspect of these paintings I want to raise some general questions about the nature of the pose and its history in self-presentation and representation. What exactly is a pose; what is going on when one self-consciously strikes a pose? What makes one pose "natural" and another "unnatural"? Why do we habitually, unconsciously, prepare ourselves, make ourselves ready for our likeness to be taken? It cannot, surely, merely be the desire to be seen "in the best light." Given that the pose is, by definition, distinguished from how we look (or imagine ourselves to look) most of the time, why do we seek it out in self-presentation? One way to answer these questions is to begin the work of historicizing the pose, placing it within the larger historical context of the portrait, its modes of production and display, the economics of commission, and the social vectors that link sitter to painter and patron to client. Such a historicization would take into account the status of the sitter, his or her relationship to the artist (patron, client, or subject), and the uses to which such images were put.[76] It is clearly beyond the scope of the present argument to engage in such an extensive account; instead, I want to present a miniaturized history of the pose as it is portrayed in these group portraits produced in the period 1730–60 before returning to the topic of the look.

Hogarth's portrait of *Mr. Woodbridge and Captain Holland* (fig. 5) is a good starting point; both sitters and the servant entering the room from the right are posed quite deliberately as resisting a returned look: they stare off into the unpeopled recesses of the image in two cases, and in the third, that of Captain Holland, the stare constitutes inspection of a glass of wine. Even though Hogarth has composed his sitters to give considerable animation to the image—the acute line created by the angulation of the two bodies in the center of the painting—it remains curiously lifeless. The reason for this concerns the willingness of the sitters to present themselves to the viewer's gaze:

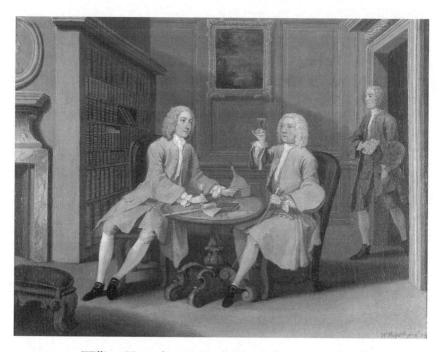

FIGURE 5. William Hogarth, *Mr. Woodbridge and Captain Holland* (c. 1730). Agnew and Sons, London (The Bridgeman Art Library).

in the portrait genre the sitter must accept the viewer's gaze, which is then returned to the viewer in the look presented by the visage of the sitter. In some curious way the group portraits usually referred to as conversations produced between 1730 and 1760 refuse by and large to return the look. Although it would clearly be impossible to make this case for every image painted at this time, it is so predominant a feature that it is all the more remarkable for having been overlooked.

Arthur Devis's *The Crewe Conversation* of 1743–44 (fig. 6) is a good example in which the sitters have an almost doll-like quality. Each sitter studiously avoids another's gaze as if it were awkward or embarrassing to be caught *looking*. Yet, in a strange way, the image is preparing us for precisely the moment at which we feel ourselves to be looked upon, the sympathetic feeling a viewer experiences when he or she is made the object of the gaze: so this is what it feels like to become a picture. The sentimental look—the attitude or pose in which the canvas pictures what it feels like to be a viewer both looking and gazed upon—is, however, not fully achieved by this paint-

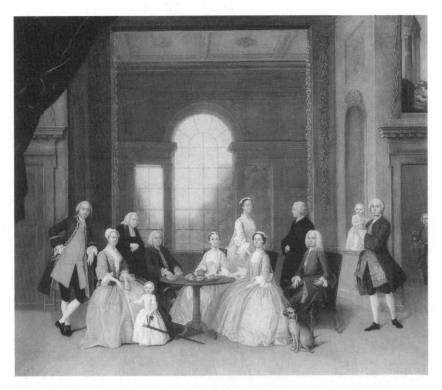

FIGURE 6. Arthur Devis, *The Crewe Conversation* (c. 1743–44); oil on canvas. Leger Galleries, London.

ing. Most of the sitters resolutely strike poses of grim resignation; they *present* themselves to us in the full light of their residual ambivalence about being represented: do, don't take my picture! Examples of this unease in the face of the viewer's gaze abound; Hogarth's *The Strode Family*, circa 1738 (fig. 7), presents its sitters staring obliquely out of the canvas, refusing to meet the viewer's gaze, and even when a sitter does look directly out of the canvas at us, the face is so immobile and featureless as to dull the mutual exchange of looks, as in *Nicol Graham of Gartmore and Two Friends in a Library*, c. 1732 (attributed to Gawen Hamilton) (fig. 8), or Hamilton's *Family Group*, c. 1730 (fig. 9).

When these images are taken as a group (and the list could be augmented by Hamilton's *Mr. and Mrs. Robinson*, c. 1735; *A Family in Their Drawing Room*, c. 1735; *The Porten Family*, 1736; Marcellus Laroon the Younger's *A Musical Tea Party*, 1740; and virtually all of Devis's output, including the

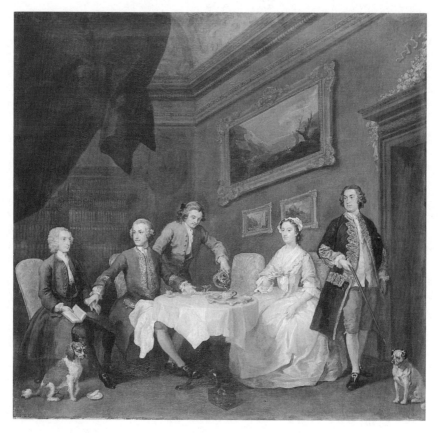

FIGURE 7. William Hogarth, *The Strode Family* (c. 1738); oil on canvas. Tate Gallery, London.

paintings discussed below), what emerges is a different attitude to the *presentation* of self from the "standard" portrait. It is not just that these figures seem at best ambivalent and at worst uncomfortable with the notion of having their pictures taken; it is also, we must suspect, that they chose (or at least were content with) these poses. An image from the period that makes a striking contrast is Francis Hayman's *The Bedford Family*, also known as *The Walpole Family*, c. 1747–48 (fig. 10). Here the sitters comfortably embrace representation; they engage the viewer's gaze without awkwardness, welcome the sense of being looked at, bathe in the satisfactions of a returned look. It is not coincidental that this image and another very like it, *Jonathan Tyers and His Family*, 1740 (fig. 11), were painted by Hayman, the artist

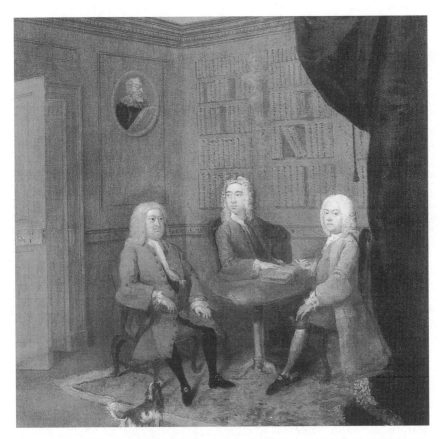

FIGURE 8. [Gawen Hamilton], *Nicol Graham of Gartmore and Two Friends in a Library* (c. 1732); oil on canvas. Sotheby's, London.

mainly responsible for the decorations (including full-scale paintings) at Vauxhall Gardens. As I will argue in Chapter 2, the project of the gardens was intimately tied up with the creation of a public space in which the viewer learned how to look and to be seen, observed, in the activity of looking. Hayman's group portraits present a different way of being in the picture from the so-called conversations presented above, but that different attitude to the public culture of visuality had to be learned, tried on until it became comfortable. It is for this reason that many of the images produced around the time of the first public exhibitions pictorially argue for a particular attitude to visual culture: they picture the look in a variety of ways and didactically present the regime of the eye as a means of gaining access to the devel-

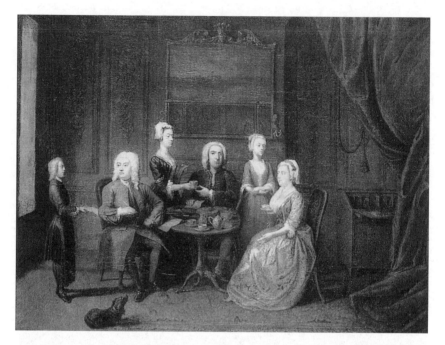

FIGURE 9. Gawen Hamilton, *Family Group* (c. 1730); oil on canvas. Colonial Williamsburg Foundation, Williamsburg, Va.

oping culture of visuality. This is why so many of the paintings I have presented so far picture people engaged in a variety of poses that foreground the countenance, that draw attention to the way the face looks: they present—both make present and represent—looking

This is even playfully commented on by an image such as Devis's *John Orde with His Wife, Anne, and His Eldest Son, William, of Morpeth, Northumberland*, which was painted around 1754 (fig. 12). The immediate look of the image would seem to place it within the orbit of the conversation genre: the sitters refuse an engaged look and have a kind of stiffness to their physiques that gives a certain staginess to the image. When we look closer, we note that the picture plane is almost sealed off from our gaze as the characters, completely oblivious of the viewer, engage one another in some social transaction. This almost sealed scene of regard is attenuated, however, since Devis has included two formal portraits on the wall of the room, and the sitters here look out from their frames in typical, engaged, portrait poses.

There is clearly a semiotic register to these portraits: they articulate the complex ideologies of family, inheritance, and heritage. But I want to stay

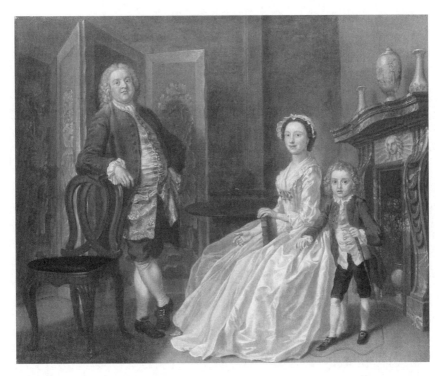

FIGURE 10. Francis Hayman, *The Bedford Family*, also known as *The Walpole Family* (c. 1747–48); oil on canvas. Royal Albert Memorial Museum, Exeter (The Bridgeman Art Library).

with the *look* of the image since at some level it provides a commentary on the genre of portraiture and therefore by implication on the ideologies of family and inheritance. Indeed, it is not fanciful to claim that part of the painting's energy derives from the discomfiting economies surrounding the inheritance of the image: how does one learn to look on the image of a forebear in terms of one's inheritance, of what one looks like (or is supposed to look like), of how one is supposed to look? These are far from simple questions, but they become even more fraught when one considers the relation between the likeness and the sitter: if, as Rouquet suggests, that relation is from image to person, "the original like the portrait," how does one inherit one's own self-representation, self-image?[77] In a sense all of the paintings I have discussed so far address this question through the pose: they explore the disjunction between an internal imagined self-image, the image of our ego ideal, and that presented to us in the plane of representa-

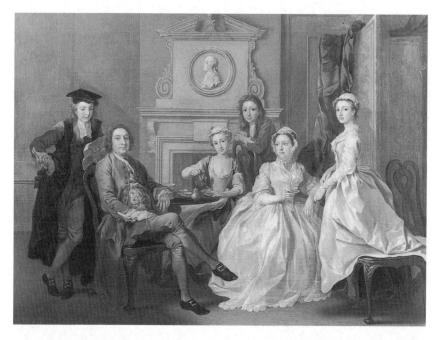

FIGURE 11. Francis Hayman, *Jonathan Tyers and His Family* (1740); oil on canvas. Courtesy of The National Portrait Gallery, London.

tion. Seen in this light the portraits on the back wall of *John Orde with His Wife, Anne, and His Eldest Son, William, of Morpeth, Northumberland* take on a variety of functions: they remind us of how one should take up a particular look at the same time as they disturb the surface of the image, rendering it a problematic space in which inheritance, heritage plays out its psychic games.

Devis experienced a considerable falling off in his popularity in the 1760s; his somewhat static and staged images began to look out of place in a culture that was increasingly comfortable with the notion of being-in-the-picture, in the plane of representation. And they looked particularly out of place in metropolitan culture.[78] In effect that culture had matured, grown to accept the public face of self-image, become comfortable with the seductions of visuality and the pleasures of narcissism. And one of the most important factors in the development of that culture was the context in which such images had public exposure: the exhibition room. As the magnificent re-creation of the exhibition space of the Royal Academy staged at the Courtauld Institute

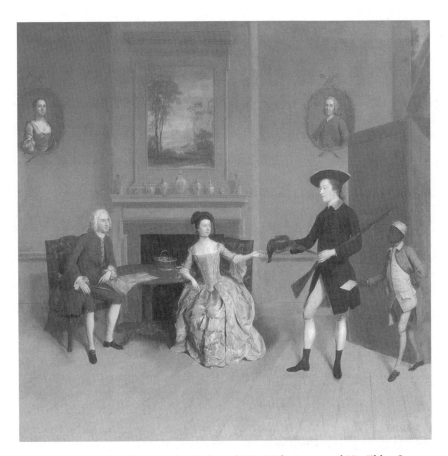

FIGURE 12. Arthur Devis, *John Orde with His Wife, Anne, and His Eldest Son, William, of Morpeth, Northumberland* (c. 1754–56); oil on canvas. Yale Center for British Art, Paul Mellon Collection.

in 2001 clearly demonstrated, to be seen on its walls, the canvas had to conform to very particular specifications. And size, here, very clearly mattered.[79]

This more complex visual culture is proleptically announced in a number of conversations—perhaps most obviously in the first image I presented, Devis's *The John Bacon Family*, where those scientific instruments point toward another register, that of observation, and not just in the scientific sense. This increasingly sophisticated culture of looking was, however, prey to all manner of distractions in the visual sphere that might draw the eye away from the artwork. As I have already remarked, the craze for exhibitions

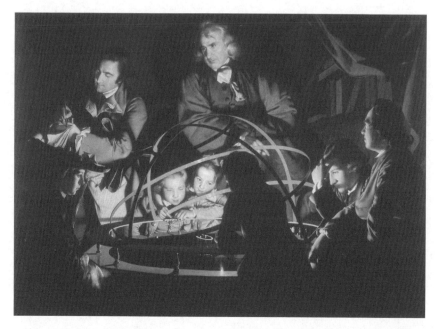

FIGURE 13. Joseph Wright of Derby, *A Philosopher Giving That Lecture on the Orrery, in Which a Lamp Is Put in the Place of the Sun* (1766); oil on canvas, 58 × 80 in. (147.3 × 203.2 cm). Derby Museum and Art Gallery, Derby, U.K.

was not solely created by an interest in painting. Given this fact, the didactic purpose of the paintings that were shown at the first exhibitions should not be ignored; such images competed with one another and for attention, moreover for the right form of attention.[80] In this regard Joseph Wright of Derby's famous "candlelights," those pictures exhibited in the 1760s that elicited excited responses from the viewing public, are exemplary.[81] Art historians have most often discussed canvases such as *A Philosopher Giving That Lecture on the Orrery, in Which a Lamp Is Put in Place of the Sun*, 1766 (fig. 13), or *An Experiment on a Bird in the Air Pump*, 1768 (fig. 14), in relation to issues of provincialism and the rise of scientific demonstration.[82] Both works yield helpful information concerning popular scientific demonstration during the period and, indeed, contribute to our understanding of the history of scientific inquiry.[83] However, they also manifestly depict the activity of looking; indeed, they didactically present an encyclopedia of looks, from the intent peering of the man seated to the left of the image in *Lecture on the Orrery* (fig. 15), through the respectful glance of the man standing on the right (fig. 16).

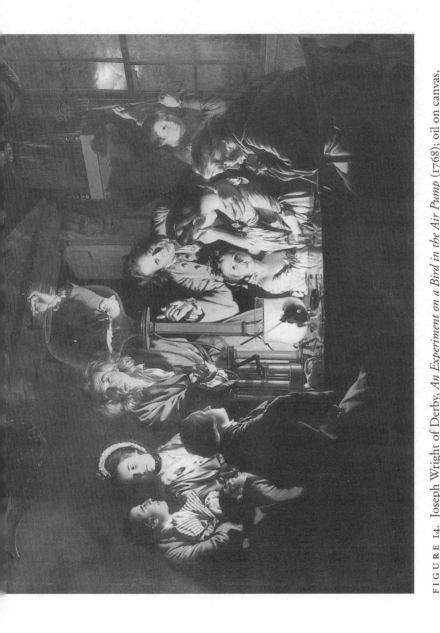

FIGURE 14. Joseph Wright of Derby, *An Experiment on a Bird in the Air Pump* (1768); oil on canvas, 72 × 96 in. (182.9 × 243.9 cm). National Gallery, London.

FIGURES 15 and 16. Joseph Wright of Derby, *A Philosopher Giving That Lecture on the Orrery*, details.

The saturation of the image with the taxonomy of looks performs two slightly divergent functions. In the first place it advertises the activity of looking, thereby presenting the possibility of being included in the look; in the second place it forcefully says to its audience of spectators, "Look, and look in this particular way." This second function carries with it a sense of reproval that can be gauged from the evidence of early exhibition viewing, where many if not most of the people in the room were busy looking at each other rather than at the pictures. Given this kind of situation, Wright's images are plainly designed to be eye-catching, and having caught the eye they then instruct it in how to look. When placed within the original context of display, this feature of his candlelights becomes very apparent. *Lecture on the Orrery*, for example, was first exhibited at the Society of Artists exhibition in 1766. The visitor to this show would have encountered approximately 200 paintings, 125 of which were portraits (59 miniatures, 66 full scale); of the rest, landscapes were the largest category (33), with history, scenes of nature, and animals coming some way behind (8 each). The overwhelming impression of the exhibition space would have been determined by portraiture, and, therefore, the modes of display and the viewing practices it encouraged and even required would have predominated. If, as I have been at pains to point out, those practices positioned the viewer in very specific ways, in relation both to the image and to the sociocultural environment in which viewing took place, then the demands of Wright's canvas are surely unusual. In the case of the portrait the scopic technique of identification tends to operate in the first instance; in the exhibitionary spaces of the room the viewer not only identifies with the genre of portrait, of self-presentation; he or she also identifies with what is seen all around, other viewers looking at one another: the look, then, sutures self-image, binding it up in the faces of the spectators and the pictures hanging around the walls. This identification and the corresponding regime of the eye that prompts it compose the particularly satisfying socioscopics of the exhibition room. But some images, notably West's four histories that were also displayed at the same exhibition (*The Continence of Scipio, Pylades and Orestes, Cymon and Iphigenia,* and *Diana and Endymion*), interrupt this cozy, comforting, and slightly improperly exciting space in their demand for a differently trained eye, another attitude of inspection. In the terms I have been exploring, that difference is produced by the regime of the picture; in the case of Wright's image, however, the seductive comfort of the one is combined with the patient knowingness of the other in a mixing of both genre and regime. The

poses, for example, suggest that we are in the presence of a portrait, yet the narrative thrust of the image draws it toward history. Above all, the canvas functions as an eye-catcher within the spacings of the exhibition room: it draws the eye toward it, interrupts the exchange of glances among viewers in the room, and didactically presents, in a pretty stagy manner, a series of distinctly articulated *looks*.[84]

This is even more apparent in the second of these intensely dramatic images, *Bird in the Air Pump* (exhibited in 1768), in which look after look is displayed and accounted for in a series of folds in pictorial space that lead us from the immediate surface, the picture plane closest to the viewer, to the object of the gaze within the image, the white cockatoo fluttering helplessly in the globe.[85] These looks include the respectful glance of the man in green at the left of the image, a species of looking already encountered in *Lecture on the Orrery*, the contemplative stare of the seated man on the right (fig. 17), and the longing look of the woman on the left (fig. 18), who gazes in admiration or maybe just sexual interest at the young man to her right. He, for his part, does not engage her look, even though he is being encouraged to do so. Indeed, in common with the conversations discussed above, both images seem wary of the engaged look: nearly every actor in both scenes fixes his or her attention on either an inanimate object or a person who looks elsewhere. There is, however, a crucial exception: *Bird in the Air Pump* does present a full frontal portrait pose, the man conducting the experiment who gazes out of the image directly into the viewer's line of sight.[86] Wright, then, combines his intensely dramatic narrative painting with the genre that is all around the walls of the exhibition room, portraiture, and in so doing he takes the viewer through the modes of identification toward recognition, thereby enabling the sensation of being a spectator in the domain of culture. My point here is that the image performs this educative progress. It pictorially educates the viewer, gives a space to the spectator within the canvas in which he or she is enabled to feel comfortable being looked at from the plane of representation. That place is at the extreme right of the canvas where the oblique glance of the young boy lowering the birdcage engages the viewer's look. It is here, in the harmonics of this pictorial presencing, that the didactic purposes of the image are most keenly felt. Thus while the viewer is warned away from the illicit engaged look, the voyeuristic look of desire, the eye is simultaneously caught in the proper mode of attention to visual culture. The eye is, precisely, captivated.

These pictures could be termed scenes of observation, since they take as

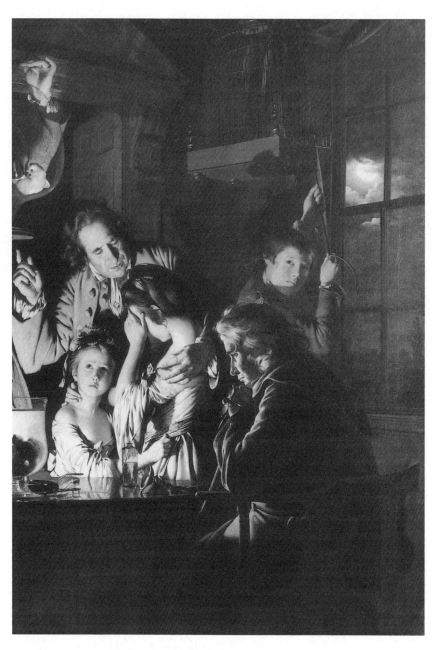

FIGURE 17. Joseph Wright of Derby, *An Experiment on a Bird in the Air Pump*, detail.

FIGURE 18. Joseph Wright of Derby, *An Experiment on a Bird in the Air Pump*, detail.

their subject matter the presentation of scientific learning, which is itself dependent on techniques of observation. Wright, however, exhibited two further candlelights, one in 1765, *Three Persons Viewing the Gladiator by Candlelight*, and the other in 1769, *Academy by Lamplight* (fig. 19). Each presses the context for looking into a more obviously aesthetic domain.[87] Once again the activity of looking is foregrounded, this time in relation to something instantaneously recognizable as within the domain of culture: the aesthetic form of sculpture. In these images the depicted viewer does not seem to be preoccupied with the observation of the material world as in the "scientific" images discussed above. Here the viewers are learning how to look with sculptural form, educating the eye either through the pencil, as in the young man sketching, or in the comparative movement of the gaze between the drawing of the statue and the sculpture itself. When viewed within the context of their first display—that is, the context of the early exhibitions I have been describing—these images must be seen as didactic, as exemplary models for the activity of looking, looking at artworks. They make an argument in respect to the franchise of the culture of visuality at the same time that they present, pictorially, a mode of entry into that culture. In this way they are autodidactic: they teach viewers how to look upon themselves, and in so doing they make visible the domain of visuality.

Wright, then, in common with Francis Hayman, pictorially argues for the combination of scopic techniques, both identification and recognition, the regime of the eye and of the picture. Like Webb and the other writers discussed above who argue against the regime of the picture, Wright promotes the sentimental look by helping the viewer to recognize him- or herself in that look. This sentimental affective insertion into visuality is no less "educated" than the connoisseur's eye; where they differ is over their distinct senses of the social and class filiation required for entry; and, as I will argue in the following chapter, the success of the former, at least in the case of Vauxhall Gardens, was, even if only for a limited time, spectacular.

The central point I want to make in this opening chapter is that the culture of visuality is grounded in the modes and modalities of display and exhibition. Mid-eighteenth-century Britain was obsessed with visibility, spectacle, display. It constructed a culture of visuality in which seeing and being seen were crucial indices to one's social standing, to one's self definition. This obsession with visibility is evidenced in the vast array of diversions presented to the eighteenth-century spectator: public hangings and other

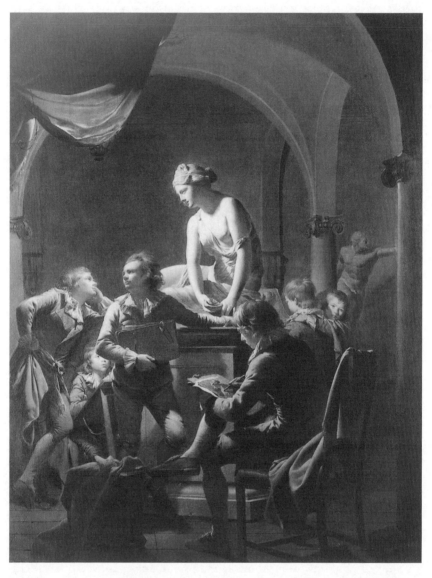

FIGURE 19. Joseph Wright of Derby, *Academy by Lamplight* (c. 1768–69); oil on canvas, 50 × 39¾ in. (127.0 × 101.0 cm). Yale Center for British Art, Paul Mellon Collection.

spectacles of punishment, theatrical performances (in which the distinction between audience and players was rarely maintained), sale room exhibitions, masquerades, ridotti, fireworks, pleasure garden walks, balls, dances, fêtes champêtres, scientific demonstrations, and art exhibitions.[88] All these entertainments, in their different ways, opened up the problematic of the visibility of person and of visuality itself, and it is this problematic I turn to in the following chapter in an exploration of a specific location: Vauxhall Gardens.

Vauxhall Gardens
The Visibility of Visuality

In the previous chapter I sketched out some of the issues informing the mid-eighteenth-century construction of visuality. I suggested that entry into its socioscopics was in part determined by the spacings—both physical and discursive, literal and virtual—of display and exhibition and was regulated by two distinct regimes, that of the eye and that of the picture, which articulate, both singly and in concert, distinct attitudes to the politics of looking. These attitudes can be thought of as an envelope that contains the subject and gives it definition in the sociopolitical realm of culture. Thus a pose, a gesture, an attitude, or posture—somatic embodiments of the viewing position—may independently or in conjunction contribute toward the construction of particular kinds of sociopolitical subjects and constitute a specific address to and insertion within the culture of visuality.

Consequently, in describing a person as a viewer a very precise set of markers is being invoked; such a person is placed or positioned by a specific activity of looking, situated in relation to a social and cultural topography, thereby taking on specific social, economic, and gender descriptions. This activity, looking, is to be distinguished from other possibilities of visual address—such as spectating, observing, watching, staring, gazing, or glancing—and is regulated through what I call the metaphorics of the eye, an

Enlightenment conceptualization of the discursive regimen of seeing. It is this metaphorics of the eye that creates the specific sites to be occupied by the organ of sight—what I termed above the somatic embodiments of the viewing position—and in so doing it locates the body of the viewer in the larger cultural terrain of visuality.

In coining the phrase "metaphorics of the eye" I mean to refer to the collection of figurative, or more precisely metaphorical, expressions generated within eighteenth-century discussions of visual experience, some of which we have already encountered in the discussion of Hogarth's *Analysis of Beauty*.[1] I now want to explore in a little more detail the range of these figurative expressions: in the viewing of landscape, for example, the eye is "thrown" to a particular point, or sometimes it is "drawn" toward an object in the landscape known as an "eye-catcher." This same eye is sometimes "exhausted" or "sated," sometimes "hungry" or "restless." Eighteenth-century viewers were well acquainted with the notion of "fatigue," for example, as the eye quickly becomes tired of too much visual stimulation, but they were equally familiar with the pleasures of the eye.[2] As will become apparent in the fourth chapter, in the case of the country house this metaphorics is angled in slightly different ways; in the enclosed environment of architectural space the eye moves according to two distinct techniques of scopic activity: gazing or glancing.[3] In the gaze the eye fixes on an object, say a painting, and in so doing it organizes the entire visual field: the objectifying gaze structures both the field of vision and the spectators' position within that field. This kind of scopic activity constitutes a specific mode of address to the objects seen and generates what might be termed a readerly or semiotic practice: the gaze penetrates the visual field in order to arrive at "meaning" or coherence. As I have argued above, one of the ways that coherence is arrived at is through a particular form of recognition or "matching," the confirmation of a taxonomy of style or form, of how things look. The glance is quite distinct as a scopic technique, requires a different mode of address, and arrives at a different end point.[4] In this mode the eye moves hurriedly across surfaces, delighting in variety, that cornerstone of mid-eighteenth-century aesthetics, and as it moves around the enclosure of the visual field, it feels itself to be located, positioned by the space within which it moves. Far from imposing its own structure of coherence on the visual field, it is inducted into the architecture of the scopic, and through this induction the viewing eye is itself subjected to the rules of formation governing visuality. Thus where the gaze imposes an orderliness in vision and on the seen, the glance is ordered by and

through its encounter with the visual field. Whereas the former is most adapted to and comfortable with the regime of the picture, the latter dovetails more readily with the regime of the eye. There is, however, a third form of viewing, that I will term the look, whose mode is catoptric. This look can be thought of as an oscillation or pulsation between the gaze and the glance, sensorium and retinal surface, as the eye shuttles back and forth between penetration and reflection, depth and surface, and it is this third way of viewing that will be the common topic for this and the following two chapters.

It is unnecessary to investigate the rigidity or permeability of the distinction between looking and gazing or glancing in order to register the power of the metaphorics of the eye. Such a metaphorics was developed as a response to both an epistemological and a phenomenological impasse: lacking a sufficiently satisfying empirical model of sight the Enlightenment created an extensive figurative account of vision.[5] This tropological system was to determine not only how the visual domain came to be described, analyzed, or conceptualized but also how a particular address to the visual field constructed specific subject positions (viewer, spectator, observer). Thus what the period was to understand as the "facts" of vision were themselves the products or residues of this metaphorics: vision was only knowable, could only itself be held as an object of attention or sight, through the discursive mappings created by the metaphorics of the eye. What I am suggesting here is that the ground of vision, its knowable architectonics, is deeply embedded in the cultural construction of visuality.[6] And this is so even for Hogarth, the foremost proponent of the embodied nature of seeing. What the period came to recognize as "the facts" of vision, then, could not be found simply in the corporeal evidence contained within the viewer, within the organic and electrochemical reality of the optical system. What muddied this simple—and heretofore largely acceptable—model was a newly keen sensitivity to the social, physical, and discursive evidence of the individual's insertion into the place of sight and seeing: visuality. Although this insertion certainly includes the somatic locations of a particular body—its specific posture, distance, and address to the object held in view—and is, therefore, not indifferent to the physical organ of sight, the eye, such a literal physical basis to explanations and explorations of the visual—of optics and representation—ran out of ground. It did so because the basis for the belief in the empire of the ratiocinative subject—the neutral Cartesisn subject of empiricism—began to be challenged by more complex articulations of

subjectivity that were no longer able to separate absolutely and without remainder the observer from the observed.

Thus in order to know the "facts" of vision it became necessary not only to correctly map the anatomy of the eye but also to examine the various ways in which the organ of sight is dispersed throughout the discursive strategies of visuality. In other words within this Enlightenment metaphorology optics only goes so far in explaining the visual field; to understand it more fully, one must redirect attention from the anatomical ground of opticality, the eye, toward the social and cultural manifestation of a viewer, spectator, looker. In relation to this probing of the visual the creation of public spaces for the activity of looking, indeed the self-conscious creation of the public sphere, can be seen as deliberate cultural ploys for the greater understanding of the "facts" of vision: these spaces are experimental laboratories for the investigation of visuality, labs in which the visual field may be brought into the gaze of investigative science, ways of knowing vision. Consequently, by means of that entry into the architecture of visuality an eighteenth-century viewer also, simultaneously, made of him- or herself an object of sight, an experimental subject adopting certain positions within the enclosures of visuality in order to render more visible the ground of seeing and of being seen. And these "poses" or "attitudes" were a feature of the period's self-conscious construction of polite society.[7]

In the following discussion I will clarify how this very literal form of being the object of sight, being-vision-for-others, works out in the eighteenth-century exhibitionary enclosure of the pleasure ground. But before moving on to my material example it is important to note that the physical spaces no less than the discursive mappings I will be investigating inflect a number of equally significant definitional criteria of the subject, how they inflect, for example, rank, gender, social register, or economic status. Such "spacings"—the physical, psychic, and discursive enclosures that give shape and form to the subject—are the topic of all that follows: an inquiry into the subject's formation through visuality, precisely an attempt to open out these spacings to view.

In becoming a viewer, entering into a scopic regime, one takes on some and refuses other descriptions of person, and the extent to which one has a choice in these matters is variously available. In the exhibition room, for example, there is a problematic triangulation of exchanged glances as the viewer enters into a three-way circuit of gaze, glance, and returned look as he or she both seduces and is seduced by the naked eye that appears in the field

of vision.[8] In this space the surface of the canvas and the bodily presentation of others in the trajected positional objectification of sight are both flexible enough to fulfill a variety of roles: the screen on which distinct viewpoints are projected, the opaque transparent surface through which the look of others and of the eye is made out, or the voyeuristic pinhole opening on to another visual enclosure on which viewers can only wantonly gaze as they mark their exclusion from the there of the view. All these roles are inflected through power, status, and gender and, to the extent that one might choose one rather than another of these inflections, give the subject limited abilities of self-definition. Thus for some becoming a viewer might be consciously inflected by the characteristics of the connoisseur; for others it might remain with the pleasures of the naive spectator. Equally the acceptance of the subject position "viewer" may come wrapped up in the psychic energies of the voyeur or the importuned object of the desiring gaze.

In my attempt at a historical recovery of the look, the metaphorics I have been exploring is intended to sensitize the following account of Vauxhall to a set of eighteenth-century formulations of the visual sphere. I have made the point that the science of optics does not figure in this account since my emphasis on visuality directs attention to the social and cultural grounds of vision. There is, however, a philosophical description of spectating in the period that will be extremely helpful in uncovering the full implications of my analysis of the visibility of visuality in what follows. This philosophical excursus, which I call the "theory of spectatorial subjectivity," is found in Adam Smith's *The Theory of Moral Sentiments*, perhaps the most significant work of Scottish philosophy in the second half of the century. Throughout this extensive text of moral philosophy there runs a pretty continuous address to a concept Smith labeled the "impartial spectator" that produces a particular sensitivity to matters concerning spectacle and spectatorship.

As I have already made clear, the period in question was obsessed with questions concerning spectatorial comportment and behavior. This was a culture in which one of the most notable publications was entitled the *Spectator* and in which all manner of public events, from hanging to masked balls, were deeply implicated within the conceptual folds of the spectacle. Smith's text, then, must be read in relation to this culture of the spectacle and should be seen not only as reflective of that culture, produced from within it, but also as providing a model for behavior appropriate to a society fixated on questions of visibility. In other words *The Theory of Moral Sentiments* is both a product of that cultural matrix and productive of it.

Smith is primarily concerned to demonstrate how one might derive an ethics, that is a mode of assessing and policing one's actions, from the simple observation that if all members of society acted solely on the information they derived as individuals from their own experience, then the social would collapse as self-interest overrides all impulses toward benevolent action on behalf of others. Smith comes up with a solution to this problem through his appeal to the imaginative imputation of what another might feel based on the evidence of our own experience. This, the doctrine of sympathy, is the motor that governs a just and ethically correct society.

This sympathetic imagination is not only focused on others who might lead lives more miserable than our own; in an extraordinary conceptual concatenation it is also focused on the subject itself. So it is that the society of the spectacle in which one sees others through the prism of sympathetic imagination is troped into a self-regarding spectator sport in the production of subjectivity itself. It is worthwhile following this argument in some detail, since it will illustrate the complexity of the visual field as it is addressed by Smith's ethics.

On the opening page of the treatise Smith explains the first tenet of the doctrine of sympathy: "By the imagination we place ourselves in his situation, we conceive ourselves enduring all the same torments, we enter as it were into his body, and become in some measure the same person with him, and thence form some idea of his sensations, and even feel something which, though weaker in degree, is not altogether unlike them."[9] This passage describes the imaginative leap we make when confronted with others, and it is this leap that makes us resonate with sympathy for the plight of other individuals. Such sympathetic reactions are, primarily, governed by what we *see*, and their affects are observable at the somatic level. The *techne* of sympathy creates a somatically sensitized visuality. Smith writes:

> When we see a stroke aimed and just ready to fall upon the leg or arm of another person, we naturally shrink and draw back our own leg or our own arm; and when it does fall, we feel it in some measure, and are hurt by it as well as the sufferer. The mob, when they are gazing at a dancer on the slack rope, naturally writhe and twist and balance their own bodies, as they see him do, and as they feel that they themselves must do if in his situation. (10)

For Smith it is precisely this reflective quality of the visual field, the mirrored surface of the social, that enables a just and ethically sanctionable society to function. Thus, step 1 of the argument is to claim that a sympathetic

look is one that translates through reflection those sensations we take to be experienced by another into our own physicality. The body of the spectator is, in effect, a resonating epidermis, stimulated into somatic spasm through the operation of sight (and this is an optical extension and elaboration of Hartleian associationism). Step 2 of the argument is to note that this somatic reflection depends on and is enhanced by imaginative and ratiocinative activity: "the spectator must, first of all, endeavour, as much as he can, to put himself in the situation of the other, and to bring home to himself every little circumstance of distress which can possibly occur to the sufferer" (21).

Smith makes it clear that the spectator will never quite manage to reproduce those feelings of the other at the same intensity since sympathetic sentiment is, in the last analysis, "imaginary" (22). However, this leads spectators to notice a tension within themselves between the feelings they experience in their own right and those they experience through this imaginative projection onto the observed. It is this tension that leads a spectator to ponder not only what it might be like to be the afflicted person but also what it might be like to be spectated upon. In an extremely important sentence Smith writes, "As they are constantly considering what they themselves would feel, if they actually were the sufferers, so he is as constantly led to imagine in what manner he would be affected if he was only one of the spectators of his own situation" (22). Here the catoptric nature of the society of the spectacle begins to be fully and sophisticatedly articulated. Not only does the spectator in Adam Smith's theater of morality look on others with imaginative sympathy, but he also looks on himself in the same manner, thereby becoming what I will call a *spectactor*.[10] In this sense subjectivity is precisely not positioned in the eye of the beholder but, rather, in the exchanges that occur in the phantasmic projection of what it might feel like to be constituted as a subject by looking on the onlookers of our selves. So it is that the moral agent in Smith views himself "in the light in which he is conscious that others will view him" (83); hence, we must "imagine ourselves not the actors, but the spectators of our own character and conduct" (111). This extraordinary note continues:

> [we must] consider how these [our own character and conduct] would affect us when viewed from this new station, in which their excellencies and imperfections can alone be discovered. We must enter, in short, either into what are, or into what ought to be, or into what, if the whole circumstances of our conduct were known, we imagine would be the sentiments of others, before we can either applaud or condemn it. (111)

Agency here takes on a very indirect form, essentially being translated into spectatorial sympathy for ourselves. The full extent of this society of the spectacle is to turn even the subject as agent into the object of the gaze: we locate ourselves, or come to self-description, through the agency of a sympathetic fantasy projection in which we image to ourselves what we would look like were we the spectator looking upon us as we are looked upon—precisely spectactors of our own subjectivity.

Smith, however, does not leave things here since he turns the figure one more time in his attempt to account for this overly voyeuristic scheme. It is in response to this that Smith introduces his concept of the "impartial spectator." This idealized position, the spectator who is never locatable within a specific individual, within a real person, represents the best-case scenario: the spectator as the projection of every individual who aspires to the condition of the ethically sound. This idealized person must be internalized within the breast of every man who would make judgments and be judged according to sound ethical precepts. This is to say the technology of vision now gains a depth as the resonating somatic surface of sympathetic viewing dives into the subcutaneous levels of interiorized sentiment. Smith writes:

> The man of real constancy and firmness . . . has never dared to forget for one moment the judgment which the impartial spectator would pass upon his sentiments and conduct. He has never dared to suffer the man within the breast to be absent one moment from his attention. With the eyes of this great inmate he has always been accustomed to regard whatever relates to himself. This habit has become perfectly familiar to him. He has been in the constant practice, and, indeed, under the constant necessity, of modelling, or of endeavouring to model, not only his outward conduct and behaviour, but, as much as he can, even his inward sentiments and feelings, according to those of this awful and respectable judge. He does not merely affect the sentiments of this impartial spectator. He really adopts them. He almost identifies himself with, he almost becomes himself that impartial spectator, and scarce even feels but as that great arbiter of his conduct directs him to feel. (146–47)

The result of this is a society in which one's sense of self and, indeed, actions are entirely regulated through the triangulation of the gaze: one looks at oneself as if one were a spectator for another. Above all else it is a society predicated on the correct insertion of the subject into visuality: into the visual field constructed according to the phantasmic projection of an imaginary third person. Autovoyeurism might perhaps be what this feels like, and in the account that follows we will see how a contemporary physical and dis-

cursive spacing of the visibility of visuality plays into and upon the threat and seductions of voyeurism.

The central point made by the theory of spectatorial subjectivity is that our construction of self-image is realized through the imaginative and phantasmic projection of a third person, and this triangulation enables us to enter the visual sphere as it is constituted in and by the society of the spectacle. Smith is essentially claiming that within the obsessively spectatorial culture of the Enlightenment the spectator is precisely constructed in and through imaginative work, through fantasy. This means that the position occupied by the real spectator, be that oneself in the activity of looking or another being observed in the activity of looking, must constantly be mapped on the idealized, fantasized, impartial spectator. Consequently, the position of the spectactor is inevitably produced as a site of contest: a contest in regard to one's social definition, as, for example, either masculine or effeminate, ethically sanctioned or reprimanded, a man of retirement or a man of the world. These rather speculative remarks will take on far greater material depth, gain flesh and bones, in the exploration of Vauxhall Gardens, to which I now turn.

There are a number of reasons for taking this London pleasure garden as my example.[11] The first is that the garden was crammed full of paintings.[12] But not only were there paintings all over the garden; the actual experience of visiting this garden was one in which the activity of looking became visible. In fact the decorative work carried out in the garden is exactly coincident with the first "exhibitions" of paintings in England following Hogarth's donation of his portrait of Captain Coram to the foundling hospital in May 1740.[13] Vauxhall, then, was merely one of the most prominent public spaces in which artworks were beginning to be displayed. A pleasure garden had certainly been established at Vauxhall by the early 1660s, when records tell us that the New Spring Gardens opened. It would appear that the Old Spring Gardens existed simultaneously for a short while but were quite quickly supplanted by the new garden. In any event there are no records of this Old Spring Gardens surviving into the last decades of the seventeenth century, by which time Vauxhall had evolved into a popular location for outdoor recreation; by the beginning of the next century Vauxhall Gardens had become, according to Addison, "a kind of Mahometan paradise."[14] It was not until 1728, however, when Jonathan Tyers obtained the lease of the gardens, that Vauxhall began to figure prominently in metropolitan culture. Tyers became proprietor in 1732, and from this time on he was devoted to increasing the popularity of the venue, famously employing the talents of his

friend Hogarth to mount a grand *ridotto al fresco* and to decorate the pavilions. Tyers died in 1767, and the gardens passed on to his sons, one of whom, Jonathan junior, continued to manage them until his death in 1792.

The gardens were situated on the south bank of the Thames, occupied about twelve acres, and comprised a number of gravel walks lined by trees. At the center was a wood of about eight acres, first known by the name Il Penseroso and later more simply as the grove. Many walks intersected with this wood, whose center contained a temple in which inscriptions could be found. The gardens were almost continuously altered in very small ways season by season to continue or refresh their attractions.

By the middle decades of the century the gardens began to contain very large trompe l'oeil paintings at the ends of the gravel walks, and the supper boxes (the enclosed outdoor seating for dining) had been decorated with painted scenes. Painted images, in other words, were an integral feature of the pleasure ground. Parallel to the grand walk, for example, which itself terminated with a painted representation of a gothic obelisk, ran the south walk, which also terminated in a large painting, in this instance the ruins of Palmyra.[15] A third avenue, which intersected the grand walk at right angles, the grand cross walk, also contained a representation of ruins. The walk terminated on the right-hand side with the lovers' (or Druid's) walk, and on the left an area known as the Wildernesses and Rural Downs was located.[16] The social center was a quadrangle containing an orchestra surrounded by a semicircular sweep of supper boxes, decorated with paintings in about 1742, mostly by Francis Hayman. The principal building in the gardens was the rotunda, seventy feet in diameter, containing an orchestra, and running off this grand circular space was a long room known as the saloon or picture room. All in all by midcentury there were about 115 pictures throughout the gardens and its buildings.[17] What I mean to point out here is that a visit to these pleasure gardens was, already by the mid-1740s, one in which paintings were to be viewed; indeed, the first image one encountered on entering the gardens was of "two Mahometans gazing in wonder at the beauties of the place."[18] So, what were such visits like?

THE TOUR OF SPRING GARDEN, VAUXHALL

Before entering the Mahometan paradise we must pause at the entrance and pay one shilling, precisely the same amount as for the Royal Academy

summer exhibition but less than the amount charged by a number of rival auctioneer-sponsored exhibitions of paintings mounted in the early 1760s. *The Ambulator*, a contemporary guidebook to London, describes the entrance in the following manner:

> The first scene that salutes the eye, is a noble gravel-walk, about nine hundred feet in length, planted on each side with a row of stately elm and other trees, which form a fine vista terminated by a landscape of the country, a beautiful lawn of meadow ground, and a grand Gothic obelisk, all which so forcibly strike the imagination, that a mind scarce tinctured with any sensibility of order and grandeur, cannot but feel inexpressible pleasure in viewing it.[19]

At once we are within the discursive territory of the theater—a "scene that salutes the eye"—which is thoroughly appropriate since it is precisely a spacing of the spectacle that we are going to witness. This spacing, in which the viewer is constantly suspended between two distinct positions, actor and spectator, tells us a great deal about the ways in which this particular viewing activity is framed: here vision is imbricated within the witnessing of a theatrical event in which we participate and at which we spectate, thereby making us into spectactors. This comes with its attendant problems, especially in relation to the ability or willingness on the part of the spectactor to cathect the seductions of voyeurism.

The theatrical spacing that greets our entry into the gardens is a common feature of landscape experiences in which various elements of the view are understood unambiguously in theatrical terms as "screens" or "side screens" deployed to direct the viewer's eye. This first scene on entering Vauxhall is, then, "noble," a class indicator one can hardly fail to notice, and this nobility is reinforced by the planting of elms, trees that are usually associated with farming but that here are qualified as "stately."[20] More significant, however, is the sense that one is walking into a picture, into a pictorial rendition of the landscape. This illusionism whereby the "real" is mediated through representation will feature consistently in the tour through the gardens.

Once the eye has registered these first impressions, it is able to continue its trajectory toward the vista that terminates the view, a large painted depiction of nothing other than the landscape. It is clear from contemporary engravings of this garden that its perimeter was far from enclosed by tightly cramped dwellings (fig. 20). In fact, all the views looking out from the garden would have been to open countryside. It is, then, of some importance that in the place of the "real" extension of the garden into a landscape we find a *repre-*

sentation of such a landscape. Here, immediately, the conceptual base of representation is brought to the forefront of attention as the viewer's entry into the scopic field delimited by the enclosure of the garden constitutes a negotiation of the folds and frames of representational spaces and surfaces. At a glance this brings to the foreground the tension between illusion and reality, representation and imagination, surface and depth; between the somatic surfaces presented to the optical realm—retinal surfaces—and the experiential virtual space of depth perception. Surface—retina or canvas—is played out against depth—the three-dimensional projection of perspectival representations—in ways that analogically mirror the exchange of looks between spectator and actor in theatrical space. The result of this, as I hope to show, is a spectacle in which we witness the entrance of visuality into the domain of the visible: that is to say, what the spectator is going to see, and be seen seeing, is visuality itself.[21] As *The Ambulator* has it: we "cannot but feel inexpressible pleasure in viewing" this scene. I will return more than once to the particular modes and resonances of that pleasure. That it is "inexpressible" gives an indication of its aesthetic register, but if everyone finds it similarly "inexpressible," the experience is rendered more obviously democratic and therefore has ramifications for the politics of the look.[22]

What is the stimulus for this pleasure? In the first place delight is aroused in our recognition that the scopic field is potentially eidotropic, deliberately striving to deceive the eye. Most of the pleasure the eye derives from this is occasioned by the suspension of optical veracity, thereby enabling it to delight in the free play of the imagination. In so doing the eye leads us into a social domain in which visual error, where perception is deception, is the basis for collective empathy: we are a part of this socioscopic experience only insofar as we allow our eyes to be deceived.[23] Similarly, in the political terms of republican civic humanism, we are free insofar as we give up a part of our freedom to and on behalf of the state. Thus the primary entrance into visuality—the social terrain on which vision is itself mapped—is effected via our common suspension of the demand for the "truth" of perception, for opticality. The eye is thrown to a flat surface on which a representation of the countryside stands between the viewer and the real countryside, stands in the place of, that is, precisely re-presents, what the representational surface itself bars or blocks from vision. Furthermore, this deception works only if one projects into that surface the virtual space of perspectival depth; in other words it works only if one imagines the surface to dissolve its singular materiality of flatness into the receding depth perspective of the scopic field.[24]

FIGURE 20. Johann Sebastian Muller, after Samuel Wale, *A General Prospect of Vaux Hall Gardens, Shewing at One View the Disposition of the Whole Gardens*; engraving.

The playful necessity of this can be illustrated by the grand walk, which as I have already mentioned terminated with a gothic obelisk. This painted surface, *The Ambulator* tells us, "is to appearance a stately pyramid, with a small ascent by a flight of steps, and its base decorated with festoons of flowers; but it is only a number of boards fastened together, and erected upright, which are covered with canvas painted in so masterly a manner, that it deceives the most discerning eye" (195).

Even being armed with the knowledge that the eye is going to be deceived will not prevent the deception; this is why it makes no difference if the guidebook warns one in advance since the entry into visuality effects the suspension of optical truth. In this way the socioscopic determines the parameters for vision; the "truth" of perception is no longer grounded in an absolute regime of the optical; on the contrary it is constructed by the eye's insertion into a specific scopic regime, and here, at Vauxhall, that regime is characterized by the theatrical spacings of the spectactor outlined above. Indeed our shedding the need for optical precision is the payment extracted from us as we disembark from the south side of the Thames and walk through the peephole into the spacings of the spectacle. If we refuse to enter this scopic regime, it will only give us grief, will in fact destroy what the eye naturally seeks out: its pleasure. This is made abundantly clear by the decoration of the obelisk: the base contained representations of a number of chained slaves, and above them an inscription warned: Spectator fastidiosus sibi molestus [A disdainful spectator is troublesome to himself].

I take this to indicate the full measure of the stakes being played for; it is not merely a matter of entering into the playfully deceptive modalities of representational space, not merely a matter of going along with the pleasures of the eye, for what is at stake in the final analysis is the constitution, fabrication, and enfranchisement of the viewer as a fully formed subject. Here I mean "formed" in every sense: social, economic, psychic, and political. If we resist the enticements of this socioscopic, refuse to play at being spectactors, we make ourselves blind to visuality. In this place such a refusal is tantamount to being blind in the here of vision, that is, blind in the technical sense of being unable to see; but it is also equivalent to being blind to the there of visuality, that is, absent from the projected place of pleasure, the site of representation. Either we remain chained slaves, or we become citizens in the society of specularity.

In Smith's terms a disdainful spectator turns his back on the imaginative and sympathetic visualizing required by the theory of spectatorial subjectiv-

ity. The here of vision, how perception feels to the subject, creates one of the most intense sensations of being a subject: vision takes place inside me; it is I who see. The there of visuality, however, seeing as others see, seeing ourselves as others see us, gives one the impression of being a social subject, of being in the plane of representation, being represented: it is the world that is available for being seen, and I am over there, a part of that world. Being blind either to the here of vision or to the there of visuality necessarily results in some form of dysfunctional subjectivity, just as an excessive indulgence in either may result in narcissism or voyeurism.

The inscription warns us that we will harm ourselves if we refuse the purposiveness of the eye; it warns us that a disdainful eye will inflict pain on the viewer if it resists baptism into the theatrical and illusory spacings of visuality that are here constituted by the gardens and its viewers. To embrace or espouse such a refusal or resistance is to be enchained, disenfranchised, without liberty and in effect without representation in the socioscopics of visuality. We must be both spectator and actor in this drama of vision, must be spectactors if we are to be fully agents within the society of visuality. If we do accept this, then, the liberating and enfranchising politics of looking are activated. This political dimension, in which people from different ranks might see each other in the activity of looking, presents problems at the psychic level even as it seems to embrace a form of democratic looking at the social and political level.[25]

I have not yet done with *The Ambulator*, my exemplary spectator, however, who continues his description of the layout of the grounds, pausing to note the various other marvels of deception, chief among them the cascade, "the effect of which was brilliant, and the contrivance ingenious" (196). This was a large transparency of a cascade of water that was hidden behind a curtain. At the appointed hour a bell was rung to alert the spectators that the curtain was to be drawn back. *The Ambulator* writes: "It is wonderful to observe how the people of both sexes flock in rapid crowds to observe it, on the notice of the bell, about nine o'clock" (196). One of the most compelling attractions of Vauxhall was the possibility of sexual encounter; even the prospect of a relatively free social space in which men and women could interact without the constraints of those polite codes of conduct that everywhere surrounded eighteenth-century social encounters was titillating. Deception ruled everywhere in this garden of pleasure, and the illusionistic registers of the visual sphere were not confined to exciting the eye alone. It was, nevertheless, primarily through the eye that such pleasures were to be

taken. As *The Ambulator* remarks of the cascade, which attracted "people of both sexes": "Perhaps no better eye-trap (as a Templar once called it) is to be found anywhere" (196).

The tour continues into the Prince of Wales's pavilion, where four large paintings by Hayman were hung, their subjects having been taken from the historical plays of Shakespeare. *The Ambulator* describes these paintings— taken from *Lear*, *Hamlet*, *Henry V*, and *The Tempest* (a picture of Miranda reading)—before commenting on the overall impression of the gardens: "The groups of figures varying in age, dress, attitudes, & moving about on this occasion, cannot fail giving great vivacity to the numberless beauties of the place, and a particular pleasure to every contemplative spectator" (197).

So, once again, the socioscopic environment is permeated with figures of self-observation, the mutual *recognition* of being in the domain of looking, within visuality.[26] Such self-reflexivity or identification is even given repre- sentation in the picture that adorns the outside of the central pavilion: a pic- ture that "represents the entrance into Vauxhall, with a gentleman and lady coming to it." There is clearly an indication of rank or class here, as if entry into the gardens confers on the visitor a social status that might, for exam- ple, qualify one for milling around in the company of royalty.[27] This aspect of the gardens, its *civilizing* process, is noted in a newspaper account of 1787. In an explicit articulation of the politics of looking at and in this gar- den the commentator writes:

> Amongst the fashionable circle, were the Duke of Queensberry, with a large group of foreigners; but, speaking of this place, we are not anxious to say, the quantity of the company, which did not exceed a thousand, made up for the want of quality. The manners of the lower orders of the people have, by almost imperceptible degrees, been humanized by often mixing with their betters; and that national spirit of independence which is the admiration and astonishment of Europe, in a great measure takes birth from the equality it occasioned.[28]

At the end of this chapter I will examine the nationalist connotations that lie on the surface of these remarks in relation to Francis Hayman's pictures in the room adjoining the rotunda. I want to continue with the tour a moment longer, however, since the most spectacular spacings of the look to be found at Vauxhall, those encountered in the rotunda, have yet to be described. So far I have suggested that the overall experience of these gardens is one in which the visual sphere is constantly brought before the eye: one goes to Vauxhall to look and to be seen looking. And, as I have argued, this

dual agenda serves to bring into the domain of the visible visuality itself. Furthermore, the particular form of the socioscopic at Vauxhall is one in which the beholder constantly sees self-reflection in the form of others engaged in the activity of looking; the look is, in a way I will make abundantly clear in a moment, entirely catoptric. This is recorded in all the guides and descriptions of the gardens that inform us that the place was so enticing to representation itself that not only were visitors constantly amused by the sight of other visitors but that artists flocked to the gardens to paint these visitors looking on and at other visitors. As the 1762 guidebook to the gardens puts it:

> A curious and contemplative spectator may at this time enjoy a particular pleasure in walking round the grove, and surveying the brilliant guests; the multitude of groups varying in figure, age, dress, attitude and the visible disparity of their humors might form an excellent school of painting, and so many of our lovely countrymen visit these blissful bowers, that were Zeuxis again to attempt the picture of Venus, it is from hence, and not Greece, that he would borrow his image of perfect beauty.[29]

Before approaching the largest building in the gardens, the rotunda, which was described as early as 1752 in the guide to the gardens as a "Temple of Pleasure," I want to underscore a constant feature of this self-reflective viewing experience, the bringing together of the sexes in a common social practice: looking, by which is meant the insertion into the culture of visuality, becoming a spectactor. It is clear that this practice was openly recognized by contemporary visitors to the pleasure ground, as a pamphlet of 1752 notes "in a letter to a noble lord": "In a word, an intelligent Spectator, of a warm Imagination, is so variously delighted here, that he need not envy the Transports felt by the ancient *Greeks* in their . . . Temples of *Venus*, these tasted by him being equal, if not superior; and unsullied by the Guilt of which the Votaries of that Goddess were often conscious."[30] The author continues: "here the Splendor is so great, as well as in the *Temple of Pleasure*, that the juvenile Part of both sexes may enjoy their darling Passion—the seeing others, and being seen by them" (13).

Seeing and being seen are perhaps inevitably infected by the erotics of the scopic field; indeed, as noted above, such an erotics of the look made Vauxhall's reputation, seduced its thousands of patrons into the culture of self-display. Added to this was the heady mix of visual deception and the permeability of social ranking that resulted in a powerful if not unique con-

coction. The term occurring most frequently in descriptions of these pleasures is *satisfaction*. Here Goldsmith gives his gloss to the experience of the gardens:

> The illuminations began before we arrived, and I must confess that upon entering the Gardens I found every sense overpaid with more than expected pleasure: the lights everywhere glimmering through the scarcely moving trees; the full-bodied concert bursting on the stillness of night; the natural concert of birds in the more retired part of the grove, vying with that which was formed by art; the company gaily dressed, looking satisfaction, and the tables spread with various delicacies,—all conspired to fill my imagination with the visionary happiness of the Arabian lawgiver, and lifted me into an ecstasy of admiration. "Head of Confucius" cried I to my friend, "this is fine! this unites rural beauty with courtly magnificence."[31]

I want to note a number of things in regard to "looking satisfaction" with reference to the painterly context of the gardens. These are explored in detail below; for the moment I will dwell on the erotics of the visual field. Contemporary visitors could hardly have failed to notice that the relaxation of social codes of behavior went hand in hand with a certain licentiousness; that such unlicensed behavior might be encountered contributed to the seductions and popularity of the place. One incident became so notorious that a small publication, *The Vauxhall Affray*, was devoted to it, and it is worth dwelling on this publication briefly. This collection of letters and "eyewitness" accounts of a fracas in the gardens was, no doubt, highly ironic; it may even be the product of an overly active imagination, but this does not detract from the fact that the gardens were renowned for either the real or indeed equally palpable fantasized possibility of sexual encounter. Highly charged sexuality throbbed through the pleasure ground, and this extraordinary book gives us good insight into the social environment created there. Most tellingly the text exposes the gardens' flirtation with a potentially disruptive elasticity of social, economic, class, and gender determinations of the viewer. The book was published in 1773 with the full title *The Vauxhall Affray; or, the Macaronies Defeated.*[32]

The volume constitutes a series of reports of an incident that allegedly took place in the gardens in which a clergyman named Bate and an actress named Hartley were supposedly accosted by a group of macaronis, those effeminate strange creatures who were fashionable at the time. The so-called affray is quite explicitly the result of a contest over the gaze: Bate, the cler-

gyman, claimed that he was made to feel so uncomfortable by the young men ogling the actress—"to stare her out of her countenance"—that he challenged one of them, a certain Fitz-Gerall.[33] The ensuing argument is very clearly one over the spectatorial rights of the two men; and this argument, it should be made clear, is foregrounded by its specific location: Vauxhall Gardens, the place in which I have been arguing the siting of the viewer was made so public, in which visuality was made so visible. The dispute between the two men concerns who should have power within the visual: the upstanding clergyman occupying the traditional position of the masculine spectator or the effeminate beau whose gender identity is less certain and viewing position more ambiguous.

It is to be noted that the position of the spectatorial object, Hartley, hardly figures in the affray and that the politics of the gaze are contested by males occupying differing positions within the spectrum of eighteenth-century modes of masculinity.[34] Bate, in his description, marshals cultural disapprobation in calling the macaronis "these pretty beings" who stare "at her with that kind of petit maitre audacity, which no language, but the modern French, can possibly describe."[35] Here Bate is attempting to disempower his rivals in the spectatorial contest: the beaux, although laying claim to the position of the spectator, are in fact a spectacle, objectified by Bate's gaze on them as "pretty beings." This objectification is intensified through the use of the term of abuse, *French*, which for a certain part of this culture represents not only all that is other but also all that is objectionable.

The question over the triangulation of the spectatorial position is explicitly raised by Bate in his comment that "to be a silent spectator of such insolence, would be tacitly to countenance it" (11); that is, to occupy the position of the impartial spectator would leave the question of male gender undecided and the vectorial direction of the gaze ambiguous. Consequently, Bate enters into the exchange of looks and thereby the contestatory enclosure of visuality: "I became now the subject of their loud horse-laughs and wise remarks. Thus unpleasantly circumstanced, I thought it better to face these desperadoes, and therefore turned about and looked them, in my turn, full in the face; in consequence of which, some distortions of features, I believe, passed on both sides" (11).

What is happening here is a face-off in which each party attempts to master and control the site of spectatorial authority. In so doing each makes of the opponent not, as in Adam Smith, the catoptric other who gives back self-image but the object of the look, the spectacle we witness. In this case

the question of gender becomes extremely fraught since what these two differently inflected gendered men are fighting over is both the right to look at another object, the woman who occupies the picture plane on which the spectator wishes to gaze, and the right to make of oneself a spectacle. This is explicitly stated by Fitz-Gerall, who asks Bate "Whether any man had not a right to look at a fine woman" (13). Of course, for Bate the problem lies in precisely "any man," since for him some men do occupy the powerful masculine position of the gaze, whereas others do not and should not. Bate says in reply that "he despised the man who did not look at a fine woman" but asserted that Fitz-Gerall and his macaronis looked at Hartley in the wrong way (13). The "affray" is, therefore, staged around a homosocial contest over the rights to spectatorial authority.

This contest exposes Bate's latent homophobia even as it finally asserts the "normalizing" gaze of the heterosexual male. At one point Bate remarks that Fitz-Gerall's presence "of aerial divinity courted my thoughts from manhood, to a silent contemplation of the progressive beauties of the pigmy system" (35). We can read this a number of ways; it may be ironic in regard to the "progressive beauties" or alternatively might convey the threat posed by Fitz-Gerall and his macaroni friends to the homophobic Bate. This sense of threat is intensified by the inclusion of a poem in the text, called "The Macaroniad," which explicitly states that the macaroni occupies an ambiguous and disturbing if not disturbed mixed gender position:

But Macaronis are a Sex
Which do philosophers perplex;
Tho' all the priests of VENUS' rites
Agree they are *Hermaphrodites*. (59)[36]

Although this corroboration of Bate's "normalizing" masculinity and the objectification of the female by the gaze is clear enough, an even more forceful policing of masculinity is performed by a so-called impartial spectator. The assembly of texts that make up *The Vauxhall Affray* include various items claiming to be newspaper cuttings. One of these, in the guise of a letter to the paper that first printed the story of the "affray," is from the self-proclaimed "impartial spectator," who advises Fitz-Gerall "to appear *only* in petticoats at Vauxhall for the remainder of the season, as the most likely method of escaping the chastisement due for his late unmanly and senseless conduct" (71–72).

In this contest over spectatorial authority two competing forms of masculinity lay claim to the gaze; at the end of the day the text settles the contest on the side of the heterosexually normalizing male who seeks to make the abnormal macaroni over into an object for the gaze. In this way the macaroni no longer functions as an "other" to the "normalized" gaze, cannot be the phantasmic projection of oneself as an onlooker, since he becomes objectified as an abnormal, effeminate male. The twist, however, is that the macaroni himself also strives to occupy the empowered position of the "male gaze," which objectifies the objects it looks on. The point here is that the gaze, far from being monolithic, in one stable position, clearly defined and operating without causing disturbance within the visual field, is shown to be mobile, a site of contest in which competing versions of masculinity attempt to render each other a spectacle to themselves. Each attempts to occupy the position of the spectactor, and each tries to render the other a spectacle.

Just how explicitly this is understood can be judged from another letter to the editor, in which an observer of the affray sends in a report as follows:

Vauxhall Intelligence Extraordinary

Some part of the conversation between the rioters of this place being omitted in other papers, we insert it here for the entertainment of our readers.

MR BATE: Why do you, Sir, thrust yourself into this quarrel?

MR FITZ-GERALL: I would always be forward to assist my injured friend.

MR BATE: Forward enough—but would you defend him right or wrong? Has he not insulted a fine woman?

MR FITZ-GERALL: Insulted, Sir! I always thought a fine woman was only made to be looked at.

MR BATE: Just sentiments of a macaroni. You judge of the fair sex as you do of your own doubtful gender, which aims only to be looked at and admired.

MR FITZ-GERALL: I have as great a love for a fine woman as any man.

MR BATE: Psha! Lepus tute es et pulpamentum quaeris?

MR FITZ-GERALL: What do you say, Parson?

MR BATE: I cry you mercy, Sir, I am talking heathen Greek to you. In plain English I say, A macaroni you, and love a woman?

MR FITZ-GERALL: I love the ladies, for the ladies love me.

MR BATE: Yes, as their panteen, their play-thing, their harmless bauble, to treat as you do them, merely to look at: but pray, Sir, what have you to do in the present dispute?

MR FITZ-GERALL: To support my friend, and prove myself a man.

MR BATE: God help the friend who stands in need of such sup-
 port; and as to your manhood, Sir, you had better
 secure yourself under your acknowledged *neutrality*, or
 you may feel the weight of my resentment.
MR FITZ-GERALL: I see you are a bruiser, I shall answer you by my servant.
MR BATE: You speak like yourself, Sir; macaroni-like, you do
 everything by proxy; whether you quarrel, or make love,
 you answer by proxy. (100)

What is going on here, and it does not matter if this is merely a fantasy or
a "real" incident, is a staging of the rights to the society of visuality, the rights
to see and be seen, to be seen either without becoming a spectacle or, on the
other hand, to turn oneself into a spectacle on one's own terms. Throughout
the montage of reports and eyewitness accounts the category of maleness, of
male gender, is inflected in a variety of ways according to the degree of elas-
ticity allotted to it. Bate stands for a "normalizing" masculinity, whereas his
opponent, Fitz-Gerall, is most often painted as a self-regarding deviant, pre-
cisely the "pretty creature" whose "snow white bosom [is] decorated with the
miniature resemblance of his own sweet person" (72). Perhaps Grosley's
remark about "uniting both sexes" now takes on a slightly different reso-
nance; be that as it may, it is important to recall that the "affray" is located
within the confines of a garden whose pleasures come in many guises.

I now turn to the building that contains within it the greatest scopic
pleasures of all. Slightly to the right of the entrance to the gardens stood the
large covered building known as the rotunda, or "Temple of Pleasure." It was
constructed around 1750 and was extended by the long room known as the
picture room by 1760. The rotunda contained a large domed roof, known as
the "umbrella," under which could be seen a large glass chandelier. The 1762
guide to the gardens describes the rotunda:

In the middle of this chandelier is represented in plaister of Paris, the rape of
Semele by Jupiter, and round the bottom of it is a number of small looking
glasses curiously set: round the rotundo is a convenient seat. Above are sixteen
white busts of eminent persons, ancient and modern, standing on carved brack-
ets each between two white vases: a little higher are sixteen oval looking glasses,
ornamented with pensile candlesticks, or a two-armed sconce; if the spectator
stands in the centre which is under the great chandelier, he may see himself
reflected in all these glasses. (21–22)[37]

Here is the eidotrope made visible: it would be difficult to imagine a
more overt description of the experience of coming into representation, of

the entrance into the visual, the enfranchisement of the viewer within the society of visuality.[38] Everything from the self-reflection in the looking glasses, wherever the gaze falls, to the eminent figures that form a retinal afterimage, on which our self-reflected image is superimposed, contributes toward the viewer's induction into the visibility of visuality. To be a viewer in the gardens of visual pleasure is to be in the here and there of representation, to be both imaged on the representational plane and the viewer of the image, to be both sitter and artist, both subject reflected to itself in the mirror surface of the socioscopic and object on the picture plane.[39] This eidetic register is, of course, not necessarily a fully comfortable place to be, a sense given most obviously by the presence of the plaster of Paris representation of the "rape of Semele by Jupiter." Does this situate us as the Dionysian offspring of that act or as the perpetrator of it? At precisely this point the singularity of the entire scopic experience of the gardens, the oscillation between penetrative gaze and recumbent glance, is all too uncomfortable as the threat of recognition in voyeurism becomes almost too pressing, and the embarrassment of self-regard is made all too visible. Here the politics and erotics of the look become most unwilling bedfellows, and this contentious alliance will force various displacements of the look in the subsequent viewing of the pictures in the adjoining room.

Francis Hayman was commissioned by Tyers to paint four very large canvases in 1760 that in the words of the 1762 guide were meant to "celebrate with his masterly pencil some of the most glorious transactions of the present war."[40] In 1761 the first of these pictures was hung in the picture room depicting the surrender of Montreal "to the victorious arms of Great Britain, commanded by General Amherst" (24). Hayman represents the moment of Amherst's magnanimous gesture of feeding his captives who had endured weeks of siege. This painting, like the others a massive twelve feet by fifteen, was clearly meant to invoke the great generals of antiquity, and, as if *The Continence of Scipio* was not already so firmly a model for this painting, the message to be conveyed was actually printed in the painting in one corner, where a stone has the following words chiseled into it: "Power exerted, conquest obtained, mercy shown." The second picture, *The Triumph of Britannia*, was hung in 1762. This was an allegorical painting, with Neptune in his chariot driving Britannia, who bears a medallion portrait of George III, across the waves. Below her Hayman painted portraits of the victorious admirals (Hawke, Pocock, Boscawen, Anson, Saunders, and Keppel).

Later in 1762 the third canvas, *Lord Clive Receiving the Homage of the*

Nabob, was hung directly opposite the first painting.[41] The last picture, *Britannia Distributing Laurels to the Victorious Generals*, completed the set and was hung opposite *The Triumph of Britannia* sometime before June 1764. These paintings give clear indications as to their nationalist intent: Tyers was, of course, exploiting the situation of the war, but we should pause to note that they were in fact commissioned before the war had ended and therefore before it had been won. All four paintings have been lost; the first three are known to us mainly through engravings or earlier sketches for the finished paintings; the last, *Britannia Distributing Laurels*, has failed to come down to us in any form and can only be reconstructed from newspaper accounts. It is this last image that I initially want to concentrate on and will begin by reconstructing it from the first of two contemporaneous newspaper accounts. It opens: "BRITANNIA, with her usual attributes, is seen distributing to her Heroes wreaths of laurel, which are supplied to her from the lap of Peace, who appears under the form of a most beautiful woman, with satisfaction and plenty so strongly depicted in her countenance, that she can be taken for no being but what she represents."[42]

I am going to press hard on the resonances of *satisfaction*, a term already encountered in Goldsmith's description of the spectators in the gardens. Here Hayman has chosen to render the look of satisfaction—that half-bemused grin, half-erotic glance—into which the spectator is lured and coerced by the socioscopics of the gardens in the countenance of the "most beautiful woman." This woman, in the allegorical register of the painting, is taken to represent peace. But, as the newspaper tells us, the representation is so true to itself that it effectively erases or collapses the virtual depth of representational space. As in the case of the most "lifelike" portraits, where the sitter has come to resemble the image, the distance between the "real" and the picture plane has become negligible. This, it should be more than clear by now, is fully in line with the illusionistic topos of the gardens and, in terms of the viewing position constructed by this topos, enfranchises all who have eyes to see. The representation effectively inhabits the same space as the things represented. Such a viewing position is most often associated with a naive viewer; but, by the time we encounter this image, we have been inducted into the socioscopics of the gardens; we are spectactors, fully here, in the interior of vision, and there, in the plane of reflection-representation. The picture room, after the catoptric delights of the rotunda, is merely going to reinforce our sense of *being in the picture*. In the face of these canvases the viewer no longer needs a truly reflective surface—mirrors have become dis-

pensable—since the spectactor is fully within the spacings of both the sub-
ject who looks and the object gazed upon—is a fully saturated visual field in
and for itself. This is why I want to dwell on the image of satisfaction, since
as I noted above, visitors to the gardens took on a particular outward appear-
ance; their countenance had a specific "look" that Goldsmith called "look-
ing satisfaction." But, we may well ask, What is it to "look satisfaction"?
How does one look at or with or in satisfaction?

An answer can be approached by returning to the (imaginary) image
itself, an image that from the ekphrasis is recognizable in terms of its domi-
nant and subordinate genres—history and portrait. These two genres ask the
viewer to adopt slightly different "poses," attitudes in the face of the paint-
ing; consequently, the spectactor continually alternates between the attitude
of recognition, in which he or she is positioned in front of the picture
plane—the viewer "sees" the there of representation—and the attitude of
identification, in which he or she is positioned within the picture plane—the
viewer feels him- or herself to be "here" in the same continuum as the rep-
resentation. This form of looking—a continual flip-flop between sensing
oneself here and there in vision and representation—is what I am claiming
to be the particular project of the midcentury in its coming to terms with an
enormously expanded franchise for visual culture. It is the *technique* that
opens up visuality to a potentially democratic public sphere.

This project and Hayman's participation within it can be understood in
more technical art-historical terms. Seen from this perspective, Hayman's
canvases use the portrait genre to trope the history genre in order to weld
together the different viewing positions demanded by each into a singular
moment of self-recognition and belonging. Consequently, not only do we
feel ourselves a part of a widely disseminated social practice of viewing, but
we also recognize ourselves on the picture plane, see ourselves in the other
that is representation. The viewer both identifies with the image and recog-
nizes him- or herself in the look of satisfaction. In this way the larger more
political interests of Hayman and his patron are realized since there can be
no more effective means of promoting identification with the ideology of
nationalism. I want to dwell a little longer on this image that we can only
imagine because I believe the scopic techniques of identification and recog-
nition bear on the viewing of this painting in interesting ways.

To recapitulate: the newspaper account claims that the image depicts
someone who is no more or less than what she *represents*, and what she *looks*

like is satisfaction. In the first place, then, this is an image of satisfaction, per-haps *the* image of satisfaction, and in terms of the larger scopic environment of the garden such an image represents what the spectator sees all around, that is, the image of looking satisfaction on the faces surrounding him or her. Consequently, in the face of *Britannia Distributing the Laurels* the real is sud-denly seen in the plane of representation, there on the canvas, so that being here, taking the correct distance to the image, being the subject in sight, sud-denly transforms into being there, being the object of the gaze. It is as if I cannot look without seeing myself being seen; that is, in order to feel myself in vision, a seeing being, I must experience myself as the object looked on. So it is that the viewer recognizes what appears on the faces all around, the look of satisfaction, looking satisfaction, and as one recognizes the look that corresponds to one's own countenance in the picture, one is, as if by uncon-scious consent, taken up into the swelling pride of national identity that is the overt ideological register of the painting.

It is significant that it is a "beautiful woman" who images this look of sat-isfaction for the viewer, since, as the argument above makes clear, the address to visuality at Vauxhall is fraught with questions bearing on gender. The viewer, then, enters the image through an identification with what is pre-sented as a female-gendered look, the look of satisfaction that is the facial sign of having entered the socioscopics of Vauxhall's seductive pleasures. This feminized satisfied countenance is the result of the oscillation between regard, or penetrative gaze, the hereness in the eye of opticality, and the recumbent glance, the thereness in the surfaces of representation-reflection. This duality echoes the visual encounter with the chandelier in the rotunda, where the viewer seems to perform the rape of Semele as one sees self-reflection superimposed on the image of the rape; the spectator's entry into the planar surfaces of *Britannia Distributing the Laurels*—what can now be seen as an oscillation between the desiring gaze and identificatory look—pre-cisely echoes the dual positionality constructed by the chandelier in the rotunda. The entire scopic experience of the gardens promotes this dual position: spectator and actor; a penetrative God and submissive woman; objectified quarry of sexual attention and predatory voyeur; upstanding man and effeminate fop; patron of the arts and paying consumer; naive viewer and knowing connoisseur. The garden creates this series of roles, and the spectator willingly submits to their pleasures. Thus, in an important sense the viewer in the rotunda performs the *representation* of "the rape of Semele."

That is, he or she occupies both positions in the narrative, since to be enfranchised in this socioscopics is to be a player on its stages. This, in another sense, is what is involved in looking satisfaction in the face.

There is a psychic dimension to this playful entry into visuality; one might understand what I have called the attitude of recognition as a necessary refuge from the threat of self-observation produced by the attitude of identification: being "there," in the picture, is a more comfortable place than "here," in the returned look of the object. I do not like recognizing myself as a voyeur but I find it even more painful to be caught out by the other identifying with the sightedness of the object that returns my look, caught being a voyeur of myself. Consequently, the lure of recognition, that is, the onward rush toward identification with the picture plane, has its attractions; by this means the viewer seeks to avoid the embarrassment of catoptric voyeurism.

In terms of this psychic dimension to the visual experience there is a clear preference for the regime of the picture, the lure of recognition, over the regime of the eye and its attendant embarrassments of self-discovery in the act of self-identification, but this preference is not always so simply available in the encounters that construct an experience of the gardens. This is particularly evident in the large canvases Hayman painted for the picture room, these present-day "histories"—a compound genre he pretty much invented—that activate both the pleasures of the eye and the comfort of the studious gaze. Indeed, the ways in which these paintings both submit to and are produced by the two regimes—of the picture and the eye—are emblematic for my argument about the socioscopics of the gardens. For what Hayman brilliantly realizes in pictorial terms is the overlay of one regime on the other, an analogue of the collapse of the educated patrician elite into the upwardly aspiring bourgeois public sphere. Hayman takes the most popular and easily accessible genre, the portrait genre, and through its modes and modalities of presentation leads the aspiring viewer into another, more inaccessible, genre, the history genre. The painting itself elicits and produces a mode of education; *it* educates the eye.

This progress can be followed from the contemporary account of the painting that alerts us to this mixing of genres. The critic notes: "Liberty, with her proper emblems, is placed near the figure of peace, and Victory is seen flying towards them with a medallion, which we instantly perceive to be that of General Wolfe in her Hand."[43]

It is almost as if the image transforms before our eyes; it begins as one

kind of painting (allegorical history) and ends up as another (portrait); furthermore, this shift is "instantaneous." This is important since it points to the fact that the viewer has no choice in the matter: having entered the attitude of identification, we are led inexorably toward recognition, and in that recognition we come to see ourselves as part of this society of visuality, promoting the nationalist sentiments there in front of us in the form of the semantic content of the image. The account continues: "it is certain that his [Hayman's] aim is moral, and that of the Proprietor of the Gardens public-spirited, by them paying a well judged compliment to that military merit, which has so eminently contributed to the present glory and happiness of this country."[44]

In the previous chapter I outlined the development of the culture of visuality and its emphasis on the portrait as its preferred form of pictorial representation. This genre, as I noted above, most readily submits to the regime of the eye. As Highmore noted, everyone who has eyes can recognize a likeness, hence the potentially "democratic" embrace of this scopic regime. I also argued that the form of recognition attendant on the address to the portrait is not identical to the "matching" that characterizes the operation of the gaze—the kind of recognition that aligns what the viewer already knows with what he or she sees—and that the technique of identification that first interposes itself in the viewing of portraits leads eventually to self-recognition.

Vauxhall Gardens exploits these modes of address and scopic techniques; the visual entertainments were designed to appeal to as wide an audience as possible, but they were also aimed at the development of a particular socio-scopics, precisely at an enfranchised public sphere in which all who had eyes to see (and the shilling entrance fee) were equal participants in the demos of taste. Early in the century, for example, soon after Hayman's first paintings were placed at the back of the supper boxes (arranged on some kind of pulley system so that they were initially hidden from view), the effect of this educative project was noted. These early paintings took as their subject matter everyday activities—dancing round a Maypole, playing skittles, and so forth—which would have encouraged the paying customers in their identification with the social environment they found themselves in. This identification was quite literally encouraged by the supper box pictures that allowed viewers to superimpose the real faces of diners on the images behind them. As *Scot's Magazine* noted: "the paintings at the back of every arbour afford a very entertaining view; especially when the Ladies, as ought ever to be contrived, sit with their heads against them. And, what adds not a little

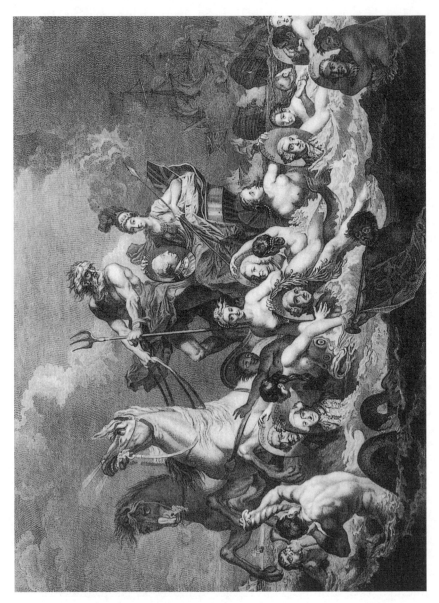

FIGURE 21. Simon Ravenet, after Francis Hayman, *The Triumph of Britannia*, engraving.

to the pleasure of these pictures, they give an unexceptionable opportunity of gazing on any pleasing fair-one, without any other pretence than the credit of a fine taste for the piece behind her."[45] These so-called genre paintings enabled an audience as yet uninstructed in the "polite" forms of viewing to experiment with the different attitudes of identification and recognition, play with the grammars of depiction and illusion utilized by the distinct regimes of the picture and the eye. In the four large canvases of the picture room Hayman takes this educative model and brilliantly exploits it on behalf of a particular politics that was to inform the emerging public culture of visuality. He works the regime of the eye into that of the picture and harnesses each regime's individual interests on behalf of a common goal: the socioscopics of the gardens.

I turn now to the second of the *Britannia* pictures, *The Triumph of Britannia*, which has come down to us in the form of an engraving (fig. 21). It is immediately apparent that this image, in common with *Britannia Distributing the Laurels*, mixes two genres, portrait and allegorical history. In terms of the argument I have been making it embraces both the regime of the eye and the regime of the picture, weaving them together into some form of hybrid scopic drive. On first sight the image, although it has precedents in terms of its mixing of genre, strikes the viewer as intensely unstable. Something about it disturbs our entry into its picture space, and this disturbance is far from contained by the absurdity of the content: the mythic Nereids holding medallion portraits are no more or less improbable than Neptune conveying Britannia in his chariot. It is not its semantic register that seems strange; in fact, this was spelled out in a rather labored fashion underneath the canvas in the form of a printed account of the painting. That this ekphrasis appeared directly under the image alerts us to the expectations of both the proprietor and artist in regard to the sophistication of the audience.[46] As is more than clear, all four paintings both participate in and construct a specific nationalist ideology: the triumphant but also humane British people. All this is well and good in the context of the war then current (we need to remember that it had not been successfully concluded at the time when the first three paintings were hung); what is less easily accounted for is the *feel* of the image. Those medallion portraits, for example, are worked into the design in the most bizarre fashion; they are displayed to the viewer by naked Nereids who either look at or embrace ("fondle" would be a more accurate term for the gesture in the center of the picture) the portraits in a most unseemly, improper manner.

The image pulsates with a barely containable energy: the power of the turbulent sea, the rearing of the horses that draw the chariot across the waves, the distant battle depicted in the background, and the all-too-visible sexual desire that throbs through the naked female figures, whose modesty has thoughtfully been salvaged by the judicious positioning of the medallion heads (which look like miniatures, thereby increasing the register of familiarity). And in all this excess of energy, the pounding of power, there emerges a look, a way of being with the image, of great stillness: a look of satisfaction.[47] It is there on the faces of the victorious admirals who appear outrageously smug, but, even more important, it is figured in the lips and smile of the Nereid bang in the center of the picture. It is this look, explicitly commented on in the second *Britannia* painting, that reflects back to the viewer the image he or she presents to the surrounding audience. This is the look that signals one's membership in a particular social club: the culture of visuality. It is formed in the calculating educative progress of the gardens that weave together the scopic techniques of identification and recognition, embracing the viewer in a socioscopics, a generally accessible public visual culture that opens out the pleasures of the visual to all who have eyes to see. And, in seeing this way, a look—somewhere between a smile, seductive gaze, and smug self-recognition—comes across the countenance of the viewer. This look, developed through the regime of the eye and the technique of recognition attendant on the portrait, is unwilled, unconsciously adopted; above all, it is "instantaneous."[48] And this is the sheer brilliance and bravado of the Vauxhall project since the viewer, once exposed to the pleasures of visual culture, effortlessly performs the identification with "satisfaction," sees him- or herself everywhere in the plane of representation, *feels* a part of the society grounded in the theory of spectatorial subjectivity.

It is clear that something is given up by the subject who accedes to this sociocultural practice: on entering the gardens one gives oneself over to its peculiar powers of seduction. As I pointed out above, this surrender was signaled explicitly by the inscription on the obelisk. But any and every entry into a social practice entails giving up some description of the subject if only to take on others. Vauxhall's politics of looking set out to embrace as large an audience as possible for its time (of course it too restricted access—to the footmen who escorted the *beau monde* across the Thames and who were herded into what *Scot's Magazine* called a "coop" at the entrance to the gardens proper) and to argue for a socioscopics built on the regime of the eye that was not antagonistic to the regime of the picture. This project of course

had its commercial ends, which were well served by the illusionistic topos that depended on a naive viewing position; but, as I have been at pains to point out, that position may also be understood in a more complex fashion, as part of a project to construct a sentimental look, an aesthetics responsive to the drives and pleasures of the eye. This "sentimental" register to visual culture is all too easily parodied, too easily dismissed as uneducated, and indeed such attacks were far from slow in coming. By the time Charles Philipp Moritz visited the gardens, his reaction would have seemed embarrassingly crude; he famously gushed in the face of *The Surrender of Montreal to General Amherst*:

> If you look at the painting with attention for any length of time, it affects you so much that you even shed tears. The expression of the greatest distress, even bordering on despair on the part of the besieged, the fearful expectation of the uncertain issue, and what the visitor will determine concerning those unfortunate people may all be read so plainly and naturally in the countenance of the inhabitants who are imploring for money, from the hoary head to the suckling whom his mother holds up, that you quite forget yourself, and in the end scarcely believe it to be a painting before you.[49]

The knowingness of the culture of expertise was quick to assert itself and ridicule exactly this kind of response to art. Although Moritz's wide-eyed reaction to Hayman's painting was clearly over the top, we should be careful not to dismiss the seriousness with which a general sociopolitical project to construct a public for visual culture was mounted in the second quarter of the century. The foundation of the Royal Academy represents an attack on that project, and it was substantially successful. Nevertheless, throughout the 1760s a number of distinct spaces and viewing practices continued to construct and exploit the regime of the eye, and one such practice was developed within the context of the landscape garden, to which I now turn.

The Leasowes and Hagley Park

A School for Taste

In the previous chapter I examined the ways in which specific modes of address to the visual sphere—forms of looking, spectating—were constitutive in relation to the subject who looks. My larger purpose, that of writing the *history of an activity*, was served by paying close attention to a particular social and geographic environment, the pleasure gardens at Vauxhall. It is important to keep in view the contextual specificity of my analysis and to resist, as far as possible, an unremarked transference of one set of spacings (social, political, physical) into or onto another. Thus, in moving to another example I will take care to avoid the simplistic alignment of those markers that define the subject who looks in one context (Vauxhall) with those of another (the landscape garden). There are, of course, points of contact, since both examples participate in what I have called the general project of a public visual culture mounted in the second quarter of the eighteenth century and developed with some gusto in the 1760s. That culture embraced the regime of the eye, worked with it, worked it up into a sociopolitical technique that had the potential to increase the franchise for art. This chapter will explore this general project and its associated politics of looking as they are played out in the construction and viewing of two midcentury landscape gardens, William Shenstone's Leasowes and Lord Lyttleton's Hagley Park.

By the mid-eighteenth century the landscape arts and the aesthetic theory that grounded them were well developed. The first histories of this landscape tradition were being written, and competing schools of the practice of viewing and designing landscapes were beginning to establish themselves. In order to situate my chosen examples, I will begin by sketching out this wider context.

THE STANDARD ACCOUNT

Both eighteenth-century landscape gardening in general and the two gardens that I will look at in particular have extensive secondary literatures. It is possible to extract from this literature what I will call the "standard account," and in order to move rapidly toward the core of my argument I will use the heuristic device of caricaturing a lengthy and complex scholarly tradition in a few sentences.[1] Of course, this caricature will inevitably distort that tradition, but I hope that this will prove to be only minimally distracting. In very brief and schematic outline the "standard account" can be reduced to the following statements: landscape, in the uninflected sense of "nature," became an object of substantial aesthetic interest in eighteenth-century Britain. The definition of *nature* and things *natural* is always contestatory on account of the normative implication of the terms, so a certain politics is wrapped up in this preoccupation, but a shorthand will suffice to situate the discussion. In speaking of "landscape" I will refer to representations and constructions of "nature" that fall under the general rubric of the term *landscape garden*. The period did not, of course, understand "nature" in such a restricted sense, but the full scope of the term does not need to be rehearsed at this point. The standard account continues by noting that the "taste" regarding the style of landscape gardens underwent a series of changes in the period, and these changes are most commonly conveyed by a narrative in which the formal garden, usually taken as an Italian mode but also clearly associated with Le Notre's geometric designs featured in the gardens at Versailles, is supplanted by a more "natural"-looking landscape, most often taken to be a specifically English form and predominantly associated with the work of Capability Brown.[2]

Such an account, even in this bowdlerized and schematic form, raises the question of whether the "history" of landscape, of how it looked and was represented in eighteenth-century Britain, can be intelligibly understood in

terms of changes in taste. It also points to the difficulties arising from the concatenation of the various terms used in the period: *landscape, nature, garden, parkland,* and *ferme ornee.* Be this as it may, the central point remains that arguments from "taste," whatever the object in view, occlude a number of important considerations regarding the construction of taste itself. This is because the concept of taste during the period in question is implicated within the networks of exchange of cultural capital: taste has its own look, which is also subject to contestatory maneuvers surrounding its definition. Consequently, we cannot reason that a certain taste determined a certain look for the land because the appearance of the land may itself determine the development of a particular taste. But even more important, how the land looks is connected in subtle and interactive ways to how the viewer looks. Furthermore, a history of taste, as such, is as problematic a concept as a history of style.[3] Thus, an examination of how landscape looked in and for the eighteenth century cannot be undertaken without an analysis of how the activity of viewing itself determined to varying extents both the person who looks and the object looked upon.[4] The point here is that "landscape" only looks the way it does on account of an interactive relation among viewer, physical land, and a cultural imaginary: we only ever see what we have learned to see. Of course, this begs the question of how we learn precisely that.

The standard account notes that in concert with this dramatic change in taste there occurred an adjustment to the ways in which the landscape was viewed, the ways in which a spectator took up a position in regard to the "natural" world. This change in position might be glossed in a variety of ways, from the very specific physical attitudes of the body to the more ideological indices surrounding questions concerning land use.[5] It is, of course, of signal importance that changing positionalities in the activity of viewing landscape occur at precisely the same moment as changes in the organization of land and property ownership, and this has certainly not been lost in the "standard account." However, the precise connections between social and political dimensions to land use and the more overtly "aesthetic" *experience* of viewing landscape have yet to be fully drawn.[6] Part of the purpose in insisting on the activity of viewing as a cultural form, susceptible of a fully historicocultural analysis, is to indicate the density of the structured relations among aesthetics, the phenomenology of visuality, and politics in the most general sense—and between each of these discourses and the body. If looking tells the subject how to be, the body inflects and interprets what looking

tells it as it is presented to visuality, positioned in a landscape, and in general terms registers experience.

Allied to these adjustments in the ways in which a spectator takes up a position in order to view the landscape are a number of viewing protocols developed in response to *representations* of the land, the most commonly invoked examples of which were high art renditions in the genre that the period called "landskip." Because of this proximity of a set of practices designed for viewing "real" landscape to another set designed for looking at paintings the standard account has developed an analysis of the one in terms of the other.[7] It claims that the protocols of looking at images were analogically related to ways of "viewing" the land.

Thus, it is most commonly stated that the viewing of real landscapes in eighteenth-century Britain was determined by the protocols surrounding both the production and consumption of images of rural scenes by artists such as Claude Lorrain, Gaspar Poussin, and Salvator Rosa.[8] Although these artists are not supposed to have represented identical features of the natural world, their canvases are severally and individually taken to have determined not only how a spectator ought to decode a real landscape from the habituated modes of looking learned from such canvases but also how a proprietor of an estate should strive to make his landscape look. Some fine-tuning to this standard account is required here, since the high art of seventeenth-century Italian landscape painting was not the only example of visual representations of the landscape available to eighteenth-century landowners. There was, notably, a particularly English vogue for estate portraits that did not borrow its visual language from Italian Renaissance depictions of the Tuscan *campagna*; these images also articulated a complex set of relations to both the "real" of how the land looked and the "imaginary" of how owners wanted it to look *on the canvas*.[9]

This qualification notwithstanding I will assume that the standard account's invocation of paintings by Poussin, Lorrain, and Rosa as exempla for how landscapes should look and be looked at is so well known as to require no further comment. I do not want to suggest that this perspective is awry, since as I noted above eighteenth-century accounts of looking at landscape invoke the names of these painters.[10] However, there is more than one way to take a view, and in the case of the scholarly tradition I have been caricaturing the major alternative, what I will call the antipictorialist account, is notably absent. In what follows I aim to restore this alternative strand to the argument and to bring into focus not only the ideological

ramifications of the "painterly look," that determined by the regime of the picture, but also those associated with an alternative way of being in and with the landscape developed under the regime of the picture. In the next section I explore the origin of that history and the arguments made on behalf of the painterly look as a mode of address to the landscape.

THE PICTORIALIST ARGUMENT

Manuals and treatises giving advice and rules on how to construct a garden, parkland, or riding began to be published in Britain during the second decade of the eighteenth century. Although there had been earlier books on gardening, it is customary to take Stephen Switzer's *Ichnographia Rustica*, first published in 1718, as signaling the beginning of the tradition.[11] It is not until the 1770s, however, that something like a tradition became fully identifiable, given its shape and contours by the first two historians of the landscape arts, Horace Walpole and Thomas Whately.[12]

Walpole's observations are set out in his *The History of Modern Gardening* and have been the source of countless histories of the English landscape ever since. They are, then, too well known to require a full exposition.[13] I want to begin, therefore, with what I take to be a symptomatic feature of his account that has important consequences in relation to this subsequent tradition of commentary. This feature is the insistence with which the landscape is seen through the lens of national identity. Walpole's history is very much a history of how the garden developed in England, in contrast to how it might have or even actually developed elsewhere in Europe; and the development of the landscape arts is understood in terms of a specifically ideological commitment to "Englishness." Of course, this begs the question of whose England or Englishness is being promoted, but I will leave this aside for the moment. In the service of this explicitly nationalist argument Walpole's developmental narrative of the history of gardens is insensitive to the "real" of how the landscape looked: his history is as much about how the landscape ought to have been as about how it necessarily was. In noting this I mean to highlight the extent to which Walpole was a "Whig" historian.[14] It is significant, in relation to this, that Walpole's story ends at the point at which Brown enters the narrative.[15] This is convenient insofar as it allows his account to end on the rising note of the achievement of Kent and the prospect of greater achievements to come from his pupil Brown.[16] The struc-

ture of the narrative, moreover, is closely linked to a prospective experience, of looking out over a scene, taking a view, temporalized into the expectation that arouses and stimulates our hopes for the future. And this narrative structure is at one with its Whig historiography: Walpole surveys the past in order to write the future.

For similar reasons Walpole declines to comment on the present, hence his introduction of "living artists" in a kind of prolepsis. This is, perhaps, intelligible in terms of a certain kind of history—that which is unable to make judgments without the distance of time—but makes less sense when we consider that Walpole's readers would have had the opportunity of viewing Brown's landscaped parklands for more than forty years by the time the *History* was published.[17] In a curious sense, then, the real objective of Walpole's "history" is precisely to arrest history. It is as if the narrative structure of the modern—it is, remember, a history of the *modern* taste in gardening—demands this arresting of time, a suspension in which we are held up, overlooking a terrain we have in fact already traversed but that we look back over in prospect. It is a kind of back formation for the currently held ideology that inscribes the history of taste, of gardening, of "modernity."

Consequently, the modern is where we have gotten to but have yet to get to, where we are now in prospect. This strange temporalization, what might be called the temporal grammar of the modern, occurs not only in the larger contours of Walpole's *History* but also in specific details. Indeed, the temporal aspect of the viewing experience was a topic of repeated concern to eighteenth-century landscape theorists: what is the time of the look? How can the modern see with the hindsight of the past? How can the viewer inherit his or her scopic heritage? These questions of temporal accident keep resurfacing in Walpole's argument; at one point they seem to bear on the narrative structure of his history; at another they infect his description of the viewing activity. For example, in commenting further on Kent, who had, in the now habitual quotation, "lept the fence, and saw that all nature was a garden" (26), Walpole writes:

> Thus the pencil of his imagination bestowed all the arts of landscape on the scenes he handled. The great principles on which he worked were perspective, and light and shade. Groupes of trees broke too uniform or too extensive a lawn: evergreens and woods were opposed to the glare of the champain, and where the view was less fortunate, or so much exposed as to be beheld at once, he blotted out some parts by thick shades, to divide it into variety, or to make the richest scene more enchanting by removing it to a farther advance of the spectator's step. (26)

It is hardly surprising that Horace Walpole, the second son of Sir Robert, who had been brought up around the largest and most spectacular collection of paintings assembled in England during the period, should be attentive to painterly features of the natural. It is still less surprising that he should be overtly active in promoting a painterly framework for the appreciation of landscape, developed within the regime of the picture, since his own formation was fully within a cultural elite that had yet to become properly sensitive and sensitized to the potentiality of the sentimental look and was indifferent if not openly hostile to the regime of the eye.[18]

I am going to leave these issues aside, however, in order to concentrate on the temporal aspects of Walpole's description itself. I want to direct attention to the notion of speed or duration of viewing before returning to the dominant metaphoric register, that of painting, because the time of the look becomes one of the most important markers of a counterview, developed in reaction to the Walpolian painterly gaze. The point here is that at this crucial moment in the history of narrativization of the viewing experience that is *The History of Modern Gardening* we find the seeds for a countertradition, one in which the spacings of visuality are going to be opened up to a heterosomatics—the body in its manifest diversity—and hence to a much wider public. And as the view is forced out of its elite and semiprivate enclave, out of the sequestered vale, and pulled into a newly conceptualized public space, into the realm of culture, a crisis develops over the definition and discipline of the public realm.[19]

This tension is identifiable at the descriptive level in the passage above, where Walpole approvingly conveys Kent's reaction to and dislike of wide-open countryside that might be "beheld at once." Kent, we learn, skillfully "blotted out" such views. Why was the experience of viewing everything "at once" to be avoided? What created the requirement for a linear temporal structure of the view, exactly a narrative in the look, and what upheld this view to such a height of aesthetic approval? These questions clearly bear on the painterly framework for viewing and should not be understood without reference to that larger discursive context. But before returning to that frame I want to press this concern with the time of the look a little further.

If one views everything "all at once" the complexities of the sequential look, more specifically the narrative of looking that is structured according to a temporal grammar, is collapsed into a single gestalt. It is almost as if the eye only knows two modes: open or shut. The rapidity of the single take might be understood to result from a resistance to the return of the look,

almost as if the threat of embarrassment that is attendant on being discovered as a voyeur might be averted by collapsing a temporally elongated scopic drive into an instantaneous "take." The phenomenology of seeing in this case is grounded in the same mechanics as the camera shutter. In contrast, the narrative or sequential look depends on as long an exposure as possible; it sustains the open eye, thereby allowing the world in, flooding the interior of vision with the objects in view; and, in so doing, it holds the demons of imagination and fantasy at bay. It is the speed of the single click of the shutter and the prospect of an inner, imaginative looking, of fantasy that disturbs Walpole since both pose the threat of an unassimilable modernity to him. For the same reason he is also uneasy with the loss of narrative focus, of what a narratologist might term focalization, since, as I remarked above, he requires the complex narrative structure of Whig historiography in order to recognize what he knows he has already seen, the present in the permanent suspension of the future anterior. Consequently, his "history" is grounded in a form of narrativization that sets out to defend as well as expose the present state of things, and that defense is coincident with a legitimation of being present. In other words his history serves the purpose of enabling a particular form of the subject, not to say particular subjects, to come into their own history. Thus the circuit walk in which we patiently discover the hand of the artist, patiently experience the unfolding narrative of the look of the land, is to be understood in the final analysis as an analogical framework for structuring the subject's coming into self-awareness, becoming a citizen within the public sphere. The problem with this, however, is that the viewing experience itself may constitute a training of the eye. And if this is so, the requirement may be relaxed that one already have a certain standing, an educated eye, in order to enter into this description of the subject, inhabit a particular somatic disposition and come into "self-awareness." Walpole recognizes this, recognizes the fact that, on the one hand, the single gestalt, the view that can be taken in at once, eradicates the need for the temporally structured narrative of self-fashioning and hence for an informed eye; whereas, on the other hand, the narrativized experience of the circuit walk itself instructs the viewer, leads the eye toward its destination in the "I," the sociopolitical subject who acts in the demos of taste. Walpole, then, both wants the painterly view and realizes that if it becomes subjected to these temporalized modes of narrativization, the subject in and of the look could not remain unproblematically within the realm of elite culture. He recognizes that the viewer is a construct of the aesthetic experience of land-

scape he promotes but also that the consequence of that experience is an ero-
sion of the need for an already instructed painterly eye. This is why he writes
a history of the present with his back turned to it, why he views the current
state of gardening through the convex mirror of his Claude glass. This is why
the history of modern gardening ends in 1740, not in 1770.

Thus, although the hand of Kent was instrumental in beginning the
movement toward the democratization of the viewing experience and the
foundation of a republic of visuality, Walpole needs to stress the painterly
aspects of Kent's craft in order to maintain a certain elite distance and to
return the activity of viewing to the disciplining of the regime of the picture,
thereby keeping visuality firmly within the domain of oligarchy. Put simply,
Walpole is reluctant to relinquish the social, class, and gender inflections sur-
rounding his version of the viewer: in order to see the landscape properly,
according to him, one needs to be instructed in the modes of appreciation
of high art—that is, oil painting. So, if the temporal structure of the view
educates the eye into the look, there must be, accordingly, an admission
price for entry into the gallery. In other words one needs to be someone
before one can become someone—perhaps the ground rule for any elitist
definition of culture.

This insistence of the regime of the picture surfaces in the text following
the previous quotation. Walpole writes: "Thus selecting favourite objects,
and veiling deformities by screens of plantation; sometimes allowing the
rudest waste to add its foil to the richest theatre, he realised the compositions
of the greatest masters in painting" (26).

I take this to be the pictorialist account at its baldest: the landscape
designer works the natural environment as the greatest masters work oil
paint.[20] It would seem only logical, therefore, that taking a view of and in the
landscape is a complementary activity to the viewing of painting. As I have
already pointed out, this would be relatively unproblematic were it the case
that the viewing of "the greatest masters" could be undertaken without a cer-
tain social standing, a certain social training—the grand tour—and a certain
gender affiliation (male).

In the light of this pictorial ideology I want to return to the opening com-
ments I made about the inflection of national identity. The English garden,
Walpole maintains, developed in tandem with a set of political objectives
concerning Englishness. Thus, the "freedom" Kent gave to nature is to be
explicitly read in terms of the freedom of the natural-born Englishman, the

freedom upheld by the unwritten constitution. Such a political reading of the landscape can be seen emerging in the following:

> Thus dealing in none but the colours of nature, and catching its most favourable features, men saw a new creation opening before their eyes. The living landscape was chastened or polished, not transformed. Freedom was given to the forms of trees; they extended their branches unrestricted, and where any eminent oak, or master beech had escaped maiming and survived the forest, bush and bramble were removed, and all its honours were restored to distinguish and shade the plain. (27)

Here man gives freedom to the natural world; mankind liberates nature from herself so that she might more fully represent "nature." In doing so man is himself liberated from the need to view the land as productive, as producing food, liberated from the need to work the land, granted the freedom to view the land as itself set free. Enclosure and engrossment are the political means by which this visual aesthetic is realized.

The vocabulary we find here has its foundations in a particular view of the social and cultural order, one in which the claim for freedom is made on behalf of those who already have it. This freedom is proclaimed with a certain civic pride for nature, in the specific guise of the eminent oak and master beech, and merely replicates what the observer knows he should see all around him, namely the finely tuned and perfectly functioning hierarchy of the social domain in which those who can become "eminent" (attain high social rank) and "masters" (skilled artisans) will also have the opportunity to be "liberated," given access to the demos of taste. Throughout the text these political views and the status quo they defend underpin Walpole's visual aesthetics; indeed, in a very deep sense an assumption about the perfectibility of English society *as already having been achieved*, as that which cannot be seen, cannot be narrativized in the time of the Whig look underpins this account. The *History of Modern Gardening* cannot be written in the present tense because from time immemorial the present has been, has always been, *nachträglich*. This is why the modern has to confront its own self-image as heritage, as what it always is about to inherit from the past; this is why it constructs a fetishistic relation to the present, thereby distancing itself from itself. This is why the modern is never realizable, always prospective.

This temporal ideology gives great rein to Walpole's visualizing narrative of Englishness and the garden. In effect all the world becomes a vast canvas on which one might paint one's own estate: "An open country is but a canvas

on which a landscape might be designed" (37). Seen in this way, the productive use of the land is subordinated to the strictures of a developing aesthetic appropriate for the newly emergent leisured classes; the countryside becomes one vast appropriable canvas subject to the prevailing aesthetics of landscape capitalism and to the protocols governing the viewing of painted representations. The freedom given to nature, therefore, is merely the reflection of the freedom appropriated by a class that is deeply embedded in both the political elitism and nationalistic pride that legitimates such a vast appropriation in the first place.[21] Thus, immediately following these figurative invocations of cultural and national elitism it is hardly surprising to find the far bolder statement that freedom can be granted to nature only in a country already free—furthermore, such freedom is coterminous with wealth. For this reason the English taste in gardens will have little success in being exported: "Truth, which after the opposition given to most revolutions, preponderates at last, will probably not carry our style of garden into general use on the continent. The expense is only suited to the opulence of a free country, where emulation reigns among many independent particulars" (37–38).

Walpole' s idea of a free country is inextricably bound up with his desire to promote the perfection of the English constitution and the beneficial effects of a society made up of "many independent particulars." These political and ideological commitments are never far from the surface of his *History*.[22] But what I mean to highlight in this account is the sense of threat or unease that causes these jingoistic formulations. Walpole is speaking for, on behalf of, and located within a culture under siege, under fire from another cultural formation that was all too steadily making inroads into the private estates of elite society and that constructed for itself and was constructed by another story about the land, landscape, and the political subject. My point is that Walpole's *History* is published at the moment when the practice of viewing the landscape begins to open up to a heteroptics of the socioscopic, and it was the Brownian park in all its softened contours and disdain for the strict allegoresis of its predecessors that played a significant part in this retraining of the eye. And Brown, of course, represents both the projected and unacknowledgable future and the unknowable past in Walpole's narrative. His strategy, then, in claiming the freedom of the view, is to propose the liberation of the one (nature) in order to maintain the disenfranchisement of the many (untutored spectators).

I have stressed the ideological commitments of Walpole's account and have suggested that his history of gardening is inextricable from his history

of Englishness, a story that is, of course, far from unique to Walpole's account of gardening taste. Although so open an assertion of a political and ideological commitment cannot be found in Whately's *Observations*, there is a similar reliance on the elitist framing of the view encountered in Walpole's text. I will consider Whately's arguments at the close of this section, but before doing so I want to make the contrast between the "painterly look" and a revisionary and potentially democratizing sentimental look as sharp as possible. I am going to move along another fifteen years to explore the counterposition to Walpole's *History*, to the moment when both Walpole's text was published independently for the first time and William Marshall's *Planting and Ornamental Gardening* made its first appearance: 1785.

THE ANTIPICTORIALIST ARGUMENT

I have claimed that in practice the experience of viewing landscape was already, at the time of Walpole's writing, beginning to open up to more varied and less elitist cultural forms. Although it does not seem likely that Walpole noticed changes to his own viewing practice, he did recognize that a new class of viewer was populating the enclosed spaces of the landscape park: tourists. The changes I am referring to are usually associated with what the standard account narrativizes as the development of the expressive garden from the emblematic.[23] And as the form of the garden changed, so the practices of viewing changed, and alongside these changes we find alterations in the social filiation of viewers, garden designers, and commentators on landscape aesthetics. In relation to the designers of landscapes the hegemony of an elite class of designers and theoreticians began to be fragmented by the growing number of "lay" practitioners, those outside the nascent professional circles of architecture and garden design in which the high cultural argument about aesthetics took place.[24] In the texts produced by these "amateur" designers we begin to find evidence of an antipictorial tradition that is based on a different insertion into the culture of visuality, sometimes determined by a very different relation to the landscape, as in the case of those people who worked the land, and sometimes by an alternative politics of visual culture.

William Marshall was by training an agriculturalist who had become interested in "improvement." His ideas came to the attention of a Staffordshire landowner, Samuel Pipe-Wolferstan, who invited him to help manage

Statfold, the estate Pipe-Wolferstan had inherited in 1776. Their collabora-
tion led to the publication of Marshall's *Planting and Ornamental Gardening*
in 1785, which was then reissued in a slightly different format as *Planting and
Rural Ornament* in 1795. Marshall outlined his views on landscape design in
the last part of *Planting and Rural Ornament* (over half of which was dedi-
cated to horticultural description), and these were subsequently augmented
in a later review of Richard Payne Knight's poem "The Landscape." Taken
together these three texts represent an impressive critique of the pictorialist
position. I introduce that critique with a passage from Marshall's 1785 text:

> In a picture bounded by its frame, a perfect landscape is looked for: it is of itself
> a *whole*, and *the frame must be filled*. But it is not so in ornamented Nature: for,
> if a side-screen be wanting, the eye is not offended with the frame, or the wain-
> scot, but has always some natural and pleasing object to receive it. Suppose a
> room to be hung with one continued rural representation,—would *pretty pictures*
> be expected? Would correct landscapes be looked for? Nature scarcely knows the
> thing mankind call a *landscape*. The landscape painter seldom, if ever, finds it
> perfected to his hands;—some addition or alteration is almost always wanted.
> Every man, who has made his observations upon natural scenery, knows that the
> Mistletoe of the Oak occurs almost as often as a perfect natural landscape; and
> to attempt to make up artificial landscape, upon every occasion, is unnatural and
> absurd.[25]

This direct counter to the pictorial look is no less than an alternative lib-
eration of nature, only in this case it is a liberation from the painterly con-
straints placed on viewing by the regime of the picture. It is certainly possi-
ble that this reaction to the painterly stems from the fact that Marshall's
relation to the landscape was grounded in a sense of its productive uses
rather than its aesthetic affect. Marshall's invective against the false standard
of landscape painting when applied to a real landscape is, however, most
clearly stated in his review of Payne Knight's poem "The Landscape." In
his review, entitled *A Review of "The Landscape," Also of an Essay on the
Picturesque* (London, 1795), Marshall writes:

> Enquiring about a STANDARD of "improvement," as the author equivocally names
> the art of RURAL ORNAMENT, he finds it in "the authorities of those great artists
> who have most diligently studied the beauties of Nature,"—for the purpose,
> shall we add, of ornamenting a few square feet of canvas, in order to produce the
> greatest possible effects, by a framefull of objects: not to be viewed among a vari-
> ety of surrounding objects in the open air and sunshine, but to be hung up,
> singly, in a given light, and viewed from a fixed and given point. What analogy

is there between this toy, this petty thing to please grown children, and the boundless display of ornamented Nature, which ought to surround a magnificent residence; where the eye must generally receive, at one glance, a whole hemicircle of objects; objects which must bear to be seen in lights, as various as those of morning, noon, and eve, under colours varying with the seasons, and changing their very *substance* with the falling leaf; and with lights and shadows varying with the returning year; objects, which must please in every light, at all seasons, and in various points of view.[26] (37–38)

Marshall's comments not only take into account the time of looking, the temporal aspect to the activity of viewing the landscape, but they also raise questions about the status, gender, and experience of the viewer. If the regime of the picture requires an educated eye and the high social standing that usually accompanies it, the regime of the eye allows all kinds of people, especially women, access to the viewing experience. Thus, Marshall alludes to the time when walled gardens were popular and deliberately constructs an analogy between an older garden style, and what it says about "freedom," and the more modern style, and its corresponding inflections of the politics of viewing:

In those days of caution, females were kept, as birds, in cages, or at least in aviaries, inclosed within walls, if not netted over, on the *Spanish* principle. But times are changed, and manners, too. In these more liberal days, the sex are permitted to ramble at large. No sooner do they set foot without doors, than they are (if not so within) at full liberty. Dry, comfortable walks receive them at the door, and convey them, on the varied bosom of the earth, to scenes and scenery of every description the given country affords; from the most polished grounds, to the wildest, most savage scenes; if such the neighbourhood possess; walks adapted to all weathers, and suitable to every season. (30)

It would be stretching the point too far to claim that Marshall proposes a thorough revision to the elitist activity of looking at landscape—he was after all in the business of improving gentleman's estates—nevertheless, there is a commitment here to widening the franchise. His challenge to the pictorial gaze comes mainly in the form of a critique of the temporal structure of looking at paintings as a model for viewing "real" landscapes. Part of this critique is based on the observation that looking "in the real," at and in a landscape, involves more than one sense. It is, to its very core, an *embodied* activity. Thus, he notes that looking at a landscape painting requires merely the use of one's eyes, whereas the experience of landscape proper requires a more complex sensory attention:

On the contrary, in viewing natural scenery, where almost every sense is more or less engaged; where the eye, beside the objects before it, is acted upon by a varied light; the intervention of a building, a tree, or a cloud, cutting off the rays; it is also irritated by the motion of animals, especially birds, crossing the view; of trees, waving their branches, or sending off a shower of leaves; and of the shadows of clouds, sweeping across the field of view, one of the most delightful objects in natural scenery. The ear, too, is engaged in living pictures; the lowing of kine, the neighing of the horse, the bleating of the flock, the coarse *barking* of the deer; the roaring or murmurings of waters, . . . all add variety and intricacy to the general effect. (81–82)

This has clear connections to what in romanticism would be termed the synesthesia of the experience of the natural. It locates the body in the natural environment, and the viewing practices it imagines are based in the difference of *soma:* looking is a somatic technique. And visuality for Marshall constitutes an energized network of phenomena registered through a variety of organs and includes many viewers, who all, according to their particular social, class, and cultural formations, interact within this network. Looking is also a *social* activity.

It would diminish the force of Marshall's critique were one to understand the differences with Walpole's study merely in terms of the history of taste. Of course, to some extent the term *taste* serves as a shorthand for the more complex changes being suggested here, but there is another dimension that should also be addressed. This concerns the look of taste, namely the look one adopts in order to be sighted within the republic of taste and sited within its politicoscopics. A connection can be made to the points given above in relation to Marshall's widening franchise, since for Marshall the look of taste is quite clearly a look accessible to numbers of different people from a variety of social backgrounds.

I want to stress that the history I am constructing is both a record of the practice of viewing landscape and an account of its legislating theory. As I have already suggested, practical experiences of viewing landscape were by 1770 more varied and open to a wider range of viewers than Walpole wished to acknowledge. As I have argued, the decade of the 1760s witnessed consistent attempts to legislate rights of access to the public realm of visual culture as the number of individuals who were able to enjoy the various activities of looking, spectating, or viewing, which were foremost routes of entry into visual pleasure, significantly increased. In the decade following the foundation of the Royal Academy questions concerning rights of access needed to

be settled, and it is within this context that the countertradition I am examining began to surface in prescriptive and analytic texts on the landscape. But these textual skirmishes lagged some way behind the *practice* of viewing, which already by the late 1760s was adapting to different imperatives and contexts. Easily the most important and identifiable change in practice was that associated with the aesthetics of the picturesque.

Something of this delay between the practice and the textual account can be seen in the case of Gilpin's *Observations on the River Wye*, which remained unpublished for twelve years after Gilpin had made his tour to the valley in 1770.[27] Although a number of reasons might be given for this delay, such as Gilpin's awaiting a satisfactory method of reproducing his illustrations, at least among such reasons is the changing context in which discussion of viewing practice took place. The Walpolian hegemony of the regime of the picture was under attack from a number of quarters, and perhaps prime among them was the burgeoning group of picturesque theorists. The intricacies of this contest are worth pausing over since they illustrate the stakes being played for in the antipictorialist tradition.

It is often assumed that the picturesque promoted the viewing of landscape *as if it were a picture*. Given this, one would expect it to conform to and indeed corroborate the regime of the picture, but in fact the kind of picture and viewing practice envisaged by the picturesque does not chime with the pictorialist account as I have given it. The picturesque, as it develops in tandem with the phenomenology of viewing landscapes, constructs a phantasmic relation to the real and develops an alternative visual aesthetics to the elite cultural mappings of Walpole and his followers. This distinct way of seeing the *activity* of looking at landscapes is based in a direct refutation of the modes of address to the canvas proposed by high art theory. This can best be illustrated by turning to a manuscript of Gilpin's entitled "Instructions for Examining Landscape," where there is an explicit attempt to wrest the viewing of landscape from the clutches of the regime of the picture. Gilpin begins by asserting that there is a "great difficulty of painting any view as a portrait," which he characterizes as the prevailing orthodoxy.[28] Given this, the usual provision for the correct distance to the image no longer holds: "But perhaps no exact point of view is required. The object only is wanted; & you may take it from what stand you please. You are then at liberty to go round it; & may hit upon some tolerable view" (5). In the first instance, then, the picturesque departs from the regime of the picture by noting that viewing landscape does not depend on the viewer's occupying the true point of sight. In

this sense the relationship between picture and landscape is reversed: whereas the pictorialist argument moved from canvas to the real in its promotion of a high-art look to the landscape, the picturesque moves in the opposite direction, from the real to the picture. Gilpin therefore has no problem at all with the notion of vraisemblance, since once representations of the landscape become released from the protocols governing portraiture, they are enabled to become imaginative projections. Gilpin states, "It ought always to be in the painter's view to endeavour to please the eye. He should aim to make a country he carries us through, such, as we should wish to inhabit, or at least examine. . . . There is one thing more, which should contribute to give pleasure in landscape, when it can be obtained; and that is to interest the *imagination* of the spectator, as well as his *eye*" (13–14).

It is this imaginative activity that gives license to the eye, opens up the view to a phantasmic experience: the regime of the eye follows its own logic and dispenses with the need for accuracy in representation. This is why many commentators, both contemporary with Gilpin and later, have been confused by the term *picturesque*. They have assumed that the theory must be advocating a reflective account of the relationship between the landscape and its representation: the one mirrors the other. If this were so, an experience in and of the landscape would be identical to an experience of a representation of the landscape. But this is never likely to be possible and certainly is not what Gilpin proposed in his theory of the picturesque. This error can be found in the many contemporary observations that the sketches and aquatints in Gilpin's published tours were inaccurate, that the "real" view did not in fact look like its representation.[29] Such complaints completely miss the point in their repetitions of the strictures of the regime of the picture. Gilpin was after something more strange, more disturbing: an imaginative relation to the phenomenology of viewing, exactly a fantasized encounter with the real. As he puts it: "If therefore we can interest the imagination of the spectator, so as to create in him an idea of some beautiful scenery beyond such a hill, or such a promontory, which intercepts the view, we give a scope to a very pleasing deception. It is like the landscape of a dream" (15).

The picturesque has been taken to be a bourgeois reaction to a high cultural aesthetics of the sublime and beautiful, and to some extent this is correct.[30] There is certainly a political undertow to this new aesthetics, conveyed succinctly by Gilpin in the following disparaging remarks about the standard images promoted by the pictorialist account:

Figures are also useful in *characterizing* a scene if we introduce *adorned nature* (which the picturing eye always resists, when it can). . . . But when we open scenes of *wild*, or even of *unadorned* nature, we dismiss all these courtly gentry. No *ladies with their parasols*—no *white robed misses ambling two by two*—no *children* drawn about in *their little coaches*, have admittance here. They would *vulgarize* our scenes. Milk maids also, ploughmen, reapers, and all peasants *engaged in their several professions* we disallow. There are modes of landscape to which they are adapted: but in the scenes we here characterize they are valued, for what in real life they are despised—loitering idly about, without employment. (17)

This passage gives some sense of the antagonism between the elite regime of the picture and the more populist regime of the eye. Certainly Walpole and his followers responded to the picturesque in ways that bear witness to their outrage given that, from their perspective, the entire project of the picturesque looked like a bourgeois attempt to mimic elitist cultural forms, that is, to wrest the picture from its gallery context and place it within the orbit of an upwardly mobile bourgeois tourist industry. In so doing the protocols of vraisemblance, of the true likeness, were dispensed with in favor of imaginative doodling, fantasy projections. It was not so much the pictorial impropriety that vexed the Walpolians but the political ramifications of this intervention.

The extent of this reaction to the picturesque can be gauged by comparing the first and second editions of George Mason's *An Essay on Design in Gardening* (1768 and 1795). Mason was a friend and allay of Walpole and had published a pretty standard pictorialist account of garden design in 1768. By the time of the second edition the picturesque debate was in full swing, and Mason entered the fray in a pretty unusual manner.[31] Essentially he recanted his earlier pictorialist leanings in order to wrest the regime of the picture (as it was seen to be operative in the picturesque) away from the parvenus. The following comments, taken from the revised second edition, can be found in Mason's "revisal"—that is, review—of Price's *Essay on the Picturesque*:

One insufficiency of pictures, as models for gardeners, is (in my idea) their limitation of extent on either hand. There is often a certain portion of a scene, which, if viewed between a pair of blinkers, may form an agreeable landscape. But take the blinkers away, and the landscape altogether shall be no longer pleasing. Every landscape-painter puts blinkers on the spectator. But a gardener must look *on either hand*, before he ventures to apply what the painter has set immediately before him. I have seen strong instances of the necessity of this discrimination in *real* landscapes. I remember a beautiful vista-scene in a certain park, where the view was as much confined on each side, as it is by the edges of a piece

of canvas. This vista was imitated at a neighbouring seat; and the imitation (as far as its own extent was concerned) might have had the advantage; yet, for want of *lateral boundaries* to the eye-sight, it had lost the appearance of a reach of retirement; and the whole was inconsiderable and unmeaning. If this observation is just, how shall a gardener learn from pictures "unity of character"?[32]

And in an even more shocking admission to a confirmed pictorialist he claims that as far as he is concerned, the Claudian image itself never succeeded in its supposed aesthetic effect, that of transporting the viewer to a real scene: "I freely declare, that very few of Claude's pictures (even of his best-chosen subjects) ever excited in myself an ardent desire of being transported to the spots, from which they were taken. They always seemed to me rather wonderful combinations of objects by an effort of genius, than what were likely to have existed together anywhere in reality" (199–200).

We can glimpse in this contracted account of the picturesque and the reaction it provoked a strenuous contest over the rights to visuality. Once again the question comes down to this: how educated must one's eyes be to see? What kind of person do I need to be in order to become a viewer? What kind of person do I become by accepting the protocols of viewing, looking, spectating? These questions permeate the midcentury in both the pictorialist and antipictorialist traditions. But I do not want to give the impression that a single contestatory narrative explains the emergence of the antipictorialist account. The pictorialist and antipictorialist views coexisted, sometimes causing a great deal of heat and light, at others hardly a spark. It depends on the context—high or low culture, an aesthetic treatise or a painter's manual—and the politics of a specific debate.[33] The point I wish to emphasize is that the painterly look represents only *one* possibility for the spectator. I have been arguing for the existence of a more heterogeneous discursive environment in which a dialogue emerged about the nature of the "frame" one might use, and be used by, in the activity of viewing landscape. At least two possibilities were taken seriously; the one, what I have called the elitist high cultural model, insists on the analogical relation of the real landscape to high art renditions of the land—the Claudian ideal; the other, no less motivated around a politics and ideology of viewing practice, insists on an affective—bodily—experience in the real of looking. In this second model of affective vision the eye is inserted into the landscape in its full somatic envelope. Furthermore, the viewing activity is stretched out in a series of views, stretched out in time and space, and sensitized to a fuller range of sensory perception. It is a fully somatic experience.[34]

This challenge to the Walpolian view is far from silent in relation to the forms and functions of aesthetic experience itself. Marshall, for example, is clearly pointing the way toward something more universally available, toward what one would now call popular culture. Consequently, modes of looking that require an eye educated in the high art renditions of landscape in order to take a view were exposed for what they were: ways of policing entry into the public sphere of visual culture.

It is for this reason that questions about how the eye is educated become so fraught. For if the eye itself may educate the viewer, then those social and cultural forms of education practiced and policed by the polite classes no longer exert so much power. It is noteworthy, then, that theoretical discussions of landscape generate an entire metaphorics of the eye that has the potential to trouble, and perhaps even destabilize, those givens of elite cultural education. This is as true for Walpole as it is for his adversaries, since the cultural construct of visuality is based on a grammar of the eye that might be marshaled toward enlarging the franchise as much as policing it. Once the distinct domain of the aesthetic is in place, the public sphere of visual culture constantly runs up against the autonomy of aesthetic experience. Culture, if it is to be based in the aesthetic, has varying needs for prior education since the artwork itself interacts with the protocols of its reception; this is to say that the artwork may itself instruct the viewer in how to look. Thus, even within the elite context of the painterly look the strength of the need for an already educated eye is a matter for debate. But, aside from the difference that the autonomous aesthetic realm makes, the generation of the practice of viewing I call the painterly look in and through the articulation of a grammar of the eye itself poses a challenge to the self-sufficiency or self-sealing of the domain of culture. I turn now to that grammar.

Thomas Whately's *Observations on Modern Gardening* was published in 1770, the year before Walpole's history, and the work presents a suitably representative account of the metaphorics of the eye. Here, for example, Whately is talking about how the eye needs variety in the visual field since a "large dead flat, indeed, raises no other idea than of satiety: the eye finds no amusement, no repose, on such a level: it is fatigued, unless timely relieved by an adequate termination; and the strength of that termination will compensate for its distance" (4).

The descriptive registers here—fatigue, amusement, repose, satiety—are all related to leisure activity and hence to an overt politics of the look, but

they also articulate the pleasures and displeasures of the eye; they track the desire of the eye. Visual experience, according to Whately, constitutes an economy in which the eye balances one pleasure or displeasure against another. Satiety, for example, is important because the eye needs to find a resting point, a place where it might find repose; amusement, on the other hand, carries with it the sense that the eye can be endlessly occupied, insatiable, never at home. This sense of balancing something positive against something negative pervades Whately's landscape aesthetics and is based in the psychic economies of desire. For this reason when viewing the landscape the eye is most concerned with composition; it seeks out, just as it seeks to order, the visual field:

> A hillock which only intercepts the sight, if it does not contribute to the principal effect, is, at the best, an unnecessary excrescence; and even an interruption in the general tendency, though it hide nothing, is a blemish. On a descent, any hollow, any fall, which has not an outlet to lower ground, is a hole: the eye skips over it, instead of being continued along it; it is a gap in the composition. (12)[35]

The harmony being sought here is not simply an aspect of the visual field, not a demand being made solely on how things should look, since there is a bodily demand as well in which the eye itself requires repose or harmony among the somatic imperatives of viewing, the physical restlessness of the gaze, and the objects in view.[36] Such "harmony" has its political ramifications, which are rarely far from the surface of these texts. The landscape, therefore, meets two slightly different needs: the first, as has been previously noted, is that it provides the material that will enable the temporal structure of the look; the second requires that the look of things be in harmony with the needs of the eye and by implication the demands of the socioscopic. Taking the temporal structure first, Whately continues: "Though ground all falling the same way requires every attention to its general tendency, yet the eye must not dart down the whole length immediately in one direction, but should be insensibly conducted towards the principal point with some circuity and delay" (18).

Linear characterizations of the visual field articulate the spatial with the temporal through distance, the lens that stains the viewing subject as a voyeur. The eye that is given various prescriptive pointers is clearly a metonym for the spectator, and its movement or travel should, ideally, be circuitous. What might it be for the subject to delay reaching its end point, its full coalescence? I want to explore some of the stranger aspects of this

thought by pressing on with this notion of the metonymy of the eye. When Whately cautions that the eye/I "must not dart down the whole length immediately in one direction," he is articulating both temporal and spatial registers to the phenomenology of looking. One of the forms of the experience of looking that is identifiable or recognizable to the viewing subject is made accessible through a *structure*—here the structure of delay or suspension—already known or familiar to the viewer. This structure may be no more than a *theoretical* rebus; nevertheless, it constructs an analogy for experience. And if this experience is, at base, a feeling for the self, then one of the ways the subject has of recognizing itself as a subject is through this structural analogy.

The form of the experience Whately describes above is recognizable in terms of the strategies of the sublime by which the temporal axis of the experiential encounter is elongated. According to the structuration of the sublime, delay, detour, and indirection withhold the moment of revelation— the point of arrival—so that our attention gradually shifts from anything end-trajected toward a fascination for, precisely, the circuitous workings of delay, detour, and indirection. When this process is translated into temporal terms, it results in a weird backward-facing mode of the temporal, figured in the Walpolian trope of the modern, which seems to suggest that one only recognizes where one is by means of forgetting where one is going and where one has been. Forgetting—or being in a mode of suspension—enables this kind of temporalized experience, since the eye/I is both given over to the immediate experience and at the same time constructed in and by it. Thus, when Whately prescribes that the eye must not dart down the whole length immediately, he is attempting to legislate for the fact that the eye/I has its own intentionality: the eye, according to optics, is merely open or closed, and if open it takes in the entire visual field, whether one likes it or not. Although the intellect may restrain the eye and attempt to impose a certain look, indeed although it sets out to effect the conjunction of the eye with the look, the real of looking—optics—constantly interferes with what one sees. This is all to say that one must forget the evidence of sight in order to look properly, unlearn how to see in order to come into the view: this is the education of the eye.

Whately suggests that, paradoxically, the eye is most easily restrained when it registers and obeys the structuration of the sublime: "The eye, which hurries to the extremity of whatever is uniform, delights to trace a varied line through all its intricacies, to pause from stage to stage, and to lengthen the

progress" (44–45). Again it is the recognition of the analogical structure that enables this; the structure of expectation, delay, and arousal theorized in the discourse on the sublime guides the viewer as an analogy for the particular form of temporalization activated by this mode of landscape experience. What I called above the grammar of the eye comprises the rules of analogy I have been teasing out. The viewer can look (where looking is to be understood as a cultural technique) only according to a grammar—or at least the practice of looking makes sense only when seen in terms of the rules of such a grammar—and this determines both what is seen and the form of the envelope containing the subject who looks. To recognize myself as a viewer—someone enfranchised within the socioscopics of landscape appreciation—I must find a surface capable of reflecting back to me some kind of self-image, and I must interpret that reflection as precisely a simulacrum of myself: my eye/I. This is partly why water is held out to be very beneficial to the landscape; it "captivates the eye at a distance," "invites approach," and is "delightful when near" (64), a sequence of movement for the eye that very clearly structures the temporalization of the viewing scene. The presence of water in a landscape also helps to entice the eye from its all-encompassing spatial overview—the blink of opticality—into a sequential temporalizing look. This sequential form is developed from very early in the eighteenth century through the construction of landscapes based on the form of the "circuit walk."[37] This spatial organization, however, is but the crudest means for prompting a temporalizing look, whereby planting and the utilization or fabrication of varied geographical contours play with the restriction and liberation of views. A far more complex method of articulating the temporalities of the look involves the temporal dimension of reflection itself. In respect to this I want to investigate some of the ramifications of what I will call "mirror time," since the temporalization specific to reflection lies at the heart of the eighteenth-century metaphorology of the look.

A good deal of the argument in this chapter has circled around the notion of reflection-representation that I first introduced in the discussion of Vauxhall. In the pictorial gaze, the form of looking I am associating with Walpole's promotion of the regime of the picture, the spectator is presumed to recognize the structure of the experience of seeing a representation of a landscape as precisely identical to the experience of "real" landscape. The representation is a "true" reflection of the real. It was noted above that the Claudian image failed in this respect for George Mason. It does not matter to the confirmed pictorialist, however, whether either experience—looking

at real landscape or looking at its pictorial representation—presents visual information that *actually* corresponds to how the real looks, since the regime of the picture determines both what one sees (the representation) and how one looks (the form of the viewer). Accordingly the extent to which a canvas is taken to mimic or reflect the look of things—real landscape—is a coefficient of the effectivity of the regime of the picture and its corresponding articulation of a socioscopics, a particular take on the sociability of visuality. In the previous chapter I argued that this socioscopics has particular energies and interests in the case of the representation of the subject itself. Although such a social articulation of the scopic can be identified most clearly in the case of portrait painting, it is no less crucial an issue for the experience of looking in the landscape, a point made by attending to Gilpin's reaction against the values of portraiture, which he assumes to be the prevailing norm in the representation of nature. The point I want to take away from Whately, and more generally from the elaboration of the metaphorics of the eye, is that the subject's insertion within the look constitutes a reflective surface for self-identification; in this way looking is always caught up in the psychic economies of narcissism. The stakes, then, are high; it is not merely a matter of vraisemblance, not simply an argument over taste for one kind of painting over another. At base the debate concerns who is allowed to recognize him- or herself as a subject and how that recognition-reflection is articulated, and it is the temporal accidence of this that I shall explore under the rubric of "mirror time."

In the case of "pure" or optical reflection, that constructed by a real mirror, the seeing subject is thrown into crisis since it has two options, neither of which give it much comfort or support.[38] These two options are quite simply that of recognition of self and misrecognition. The temporal structure of looking at a mirror image—the articulation of that crisis—is foundational for the subject's sense of time itself. I will call this temporal structure hesitory time, the hesitation that is the history of the subject's coming into its own sense of subjectivity—that is, self-recognition. This "hesitation-history" informs the continuous instability of the look of recognition and the recognition of the look. This is what we see in Devis's pictures of startled sitters. When the subject is faced with a mirror image, the spatial dimension of the visual field is suddenly shafted into a temporal axis that seems to be determined by the architecture of the echo. The viewer is caught up in the hesitory moment, the optical blink of recognition in which the image of the self is seen now there in the surface of the mirror now here in the eye that

sees. As such it is trapped in the hesitory moment of recognition/misrecognition, being here in the look/being there in the plane of reflection. Time for the subject-in-the-look of recognition is therefore a continual flip-flop, fort-da of being-hereness/being-thereness. The subject-in-the-look of recognition wants to be in the time of that hesitory moment yet constantly desires to arrest its oscillation, and it is because of this dual yearning that strategies for extending that moment of echo are developed. This is why the look is structured as a sequential experience so that the subject might begin to stretch out hesitory time. Here I am suggesting that reflection-representation provides for the subject a route or means of access to the temporalities of mirror time: the arrested moment of recognition/misrecognition gives a window onto what it might be to be in the time of the eye.

The problem Whately faces, alongside Walpole and other writers within the elitist cultural tradition, is that the birth of the aesthetic subject is predicated on the autonomy of affective experience. Once this is granted, the means of policing access to the aesthetic realm become severely restricted: the aesthetic subject inhabits a democratic egalitarian polis. In the experience of hesitory time, the temporal aspect of becoming a viewer according to the metaphorics of the eye, the subject glimpses itself in the plane of representation at the same time that it feels the impression of the world on its retinal surface, which here is extended to include the entire somatic carapace. It is as if, in hesitory time, the seeing eye becomes the seeing I, as the mechanics of opticality are elongated and transmuted into the full sensorium. This experience may lead to dysfunctional states of narcissism or voyeurism, but while it remains in balance, moving between the here of vision and the there of the world, the viewer takes up his or her position within the culture of visuality, and the regime of the picture gives way to the regime of the eye. In the second half of this chapter I will explore this move into the regime of the eye through an examination of specific encounters with landscape.

DIRECTIONS FROM SHENSTONE:
HOW TO LOOK IN THE LEASOWES

In this section I want to take one site, William Shenstone's the Leasowes, and explore the ways in which contemporary eighteenth-century visitors to the garden went about the business of looking in and at it.[39] In 1747 the poet

William Shenstone took over control of a modest family farm of three hundred acres near Hales-Owen in Shropshire and spent the rest of his life creating one of the most important gardens in eighteenth-century England.[40] In the now standard distinction between the emblematic and the expressionistic garden Shenstone's "ferme ornee" occupies a midposition, in terms of both the chronology of styles and type of landscape.[41] One way to understand the Leasowes is to plot its aesthetic according to the axes of the two regimes of visuality and, to put this schematic rendition into three dimensions, to historicize this mapping. Taken this way Shenstone's efforts at landscaping lie on the cusp between the change from the emblematic style that falls under the regime of the picture to the expressionistic, that colored by the regime of the eye. It is partly happenstance that this should be so since had Shenstone been considerably more wealthy than he was, it is at least possible and probably likely that he would have created a far more classically allusive and monumental garden than he did. This rather weakens the developmental narrative of stylistic change. Be this as it may, the Leasowes of mid-century combined elements of the emblematic in the form of classical inscriptions, urns, and statues with the looser expressionistic and sentimental form that was in greater evidence after midcentury. The garden was organized according to the "circuit" principle, ordering a set of views and experiences as one moved in and through the garden, but it lacked a specific allegorical meaning, as can be found for example at Stourhead.[42]

During Shenstone's lifetime the garden was one of the most visited in the country. After his death in 1763 it changed hands very frequently—as often as ten times in as many years according to Goldsmith—and was altered considerably.[43] Today the post-Shenstone house serves as a clubhouse for a golf course, which has incorporated part of the garden into its fairways and greens.

Shenstone wrote up some of his ideas concerning the layout of landscapes in his "Unconnected Thoughts on Gardening," and I will take these as a convenient means of entry into the garden he created.[44] Perhaps unsurprisingly parts of Shenstone's essay feel as if they had been written earlier in the century since they share some common aesthetic precepts with writers such as Shaftesbury and Addison. His insistence on "variety," for example, would be at home in a *Spectator* essay or Shaftesburian rhapsody. He departs from these earlier writers, however, in noting that variety along with novelty can be carried too far: "Variety however, in some instances, may be carried to

such excess as to lose it's [*sic*] whole effect. I have observed ceilings so crammed with stucco-ornaments; that, although of the most different kinds, they have produced an uniformity" (Shenstone, 2:127).

Although the terms operative here—*variety, novelty, uniformity*—had become a commonplace of early-eighteenth-century aesthetic debate and were given canonical form in Burke's *Philosophical Inquiry* of 1757, Shenstone begins to depart from the mainstream of debate in his investigations of the metaphorics of the eye. We learn, for example, that "objects should indeed be less calculated to strike the immediate eye, than the judgment" (2:126) and that the "eye requires a sort of balance" in experiencing variety (2:129). The purpose of these investigations is to ascertain reasons for an increasing dissatisfaction with an older, more formal style of garden layout. Shenstone writes:

> It is not easy to account for the fondness of former times for strait-lined avenues to their houses; strait-lined walks through their woods; and, in short, every kind of strait-line; where the foot is to travel over, what the eye has done before. . . . To stand still and survey such avenues, may afford some slender satisfaction, through the change derived from perspective; but to move on continually and find no change of scene in the least attendant on our change of place, must give actual pain to a person of taste. (2:130)

Governing these precepts is a central preoccupation with the well-being of the eye, which "must be easy, before it can be pleased" (2:133). This concern with a bodily response to the visual field aligns Shenstone with sentimental theorists of visuality within the Hogarthian tradition of aesthetic speculation. In this tradition the eye/I is always embodied, and vision is a fully somatic affair. I want to provide a context for my comments on the actual activity of looking at and in the Leasowes by briefly turning to another set of comments on landscape gardening that were certainly known to Shenstone.

Sir John Dalrymple composed an "Essay on Landscape Gardening" during the 1750s, and we know that Robert Dodsley attempted to obtain this essay for his friend Shenstone in December 1759. By March 1760 Shenstone had certainly received a copy of this work, so its observations form a backdrop for his own "Unconnected Thoughts." Dalrymple is useful for my argument since his approach is firmly focused on the sentiments he understands to be aroused by different visual experiences. In relation to the laying out of gardens, for example, he writes, "There seem in nature to be four

different dispositions of grounds, distinct from each other, and which create distinct and separate sentiments."[45]

These distinct sentiments give rise to a set of varying responses to the landscape. The "first situation," Dalrymple writes, "is that of a highland country, consisting of great and steep mountains, rocks, lakes, impetuous rivers" (147). This kind of countryside arouses a sentiment "in the breast of the beholder" that, he claims, everyone feels. That sentiment is "grandeur." The essay continues in this manner, outlining three more "dispositions" of grounds, all of which are said to raise distinct sentiments in the viewer. This very programmatic form of response is somewhat loosened in Shenstone's commentary, but notwithstanding the looser schematic it is clear that in constructing his own garden he attempted to create a landscape that would prompt certain kinds of fantasy or "sentimental response." And such affective experience required the spectator to see with the inner eye as much as with the outer.[46]

There is evidence for this form of sentimental looking in many descriptions of visits to the Leasowes, some of which I discuss below. I wish to begin, however, with what might be called the ur-text: Robert Dodsley's account of the garden, which he appended to Shenstone's posthumously published *Works* and which went on to form the basis for a number of subsequent published accounts of the garden.[47]

One of the most renowned aspects of the Leasowes, commented on by Dodsley, was its "natural" feel. The viewer felt him- or herself to be in a landscape devoid of artifice.[48] One needs to be cautious here since the term *natural* inevitably wanders between normative and descriptive registers; this drift tends to create a tension around the concept of nature as different interests compete for the right to delimit the reach of the term. As far as Dodsley was concerned, for example, Shenstone had respected the hand of nature: "Far from violating it's [*sic*] natural beauties, Mr Shenstone's only study was to give them their full effect" (Shenstone, 2:334). But he also notes that this illusion was created by much "thought and labour," which made it fundamental to the entire experience of the garden. Here, Dodsley explains, one *feels* oneself in a landscape unadorned or uncontaminated by human artifice, and that feeling allows one to experience the well-being of the eye.

This well-being results from the designer's continual attention to the eye's needs and desires. So we learn that at one point "the back ground of this scene is very beautiful, and exhibits a picture of villages and varied ground, finely held up to the eye" (2:338), and a little further we are led "by a pleas-

ing serpentine walk" to a narrow glade, where we find a common bench "which affords a retiring place secluded from every eye, and a short respite, during which the eye reposes on a fine amphitheatre of wood and thicket" (2:339). It is important to remark the various needs of the eye here—that it be both active and at rest, both seeing and unseen—since the grammar that determines how one looks prescribes various modalities for the eye. And these modalities bear on the subject-in-the-look, give shape and form to the viewer in the republic of visuality. Consequently, at some moments of the tour through the garden the viewer is made to feel comfortable being observed while engaged in the activity of looking, and on these occasions he or she takes delight in the pleasures of reflected voyeurism. But at other moments the viewer is made uncomfortable by the voyeur's gaze as the eye seeks out seclusion and an occluded plane of reflection. In this case reflection-representation takes the landscape itself as its mirrored surface, whereas in the former case the plane of reflection is provided by the other, the viewer-as-voyeur.

Dodsley continues his description of the circuit with an account of the Priory, a fake ruinated structure, which he notes is "more advantageous, and at a better distance, to which the eye is led down a green slope, through a scenery of tall oaks, in a most agreeable manner" (2:344). The eye is then conducted to a narrow opening and on toward a path that "winds on betwixt two small benches, each of which exhibits a pleasing landskip, which cannot escape the eye of a connoisseur" (2:349). And it continues to "travel" and to be "drawn" to various objects in the visual field until the spectator reaches the cascade when the eye rambles to the left, "where one of the most beautiful cascades imaginable is seen by way of incident, through a kind of vista, or glade, falling down a precipice over-arched with trees, and strikes us with surprize" (2:365).

In all these descriptions the viewer is educated into the visual experience via the movement and motion of the eye; and what tells the eye how to move is the visual field itself, that is, Shenstone's creation of the physical disposition of the garden. This is made clear in Dodsley's account of his friend's garden since he emphasizes that entry into its spaces and looks is structured as an educative progress designed to instruct the visitor in the grammar of its forms.

At this point in the circuit the spectator has reached the most splendid artifice, the cascade that Dodsley remarks on in the following rather breathless manner: "It is impossible to express the pleasure which one feels on this

occasion, for though surprize alone is not excellence, it may serve to quicken the effect of what is beautiful. I believe none ever beheld this grove, without a thorough sense of satisfaction; and were one to chuse any one particular spot of this perfectly Arcadian farm, it should, perhaps, be this" (2:365).

As I remarked in the previous chapter, *satisfaction* is a key term in the aesthetics of the sentimental look; here it refers to the culmination of a fantasy experience in which one's feelings or sentiments overrun ratiocination: satisfaction arises when the imagination is stimulated into excessive activity and the spectator feels transported to another world.[49]

I noted above that Dodsley's description formed the basis for a number of subsequent accounts of the Leasowes, many of which plundered the text without acknowledgment. These borrowings, however, are not always precise, and in two cases the editorial interventions warrant comment since the silent omissions from Dodsley's original account can be shown to obey an intended design.

The first of these "reprints" appeared in 1767 in *The English Connoisseur*, the collection of descriptions of "palaces and seats of the nobility and principal gentry of England" put together by Thomas Martyn.[50] A careful comparison of Martyn's text with Dodsley's original yields up a very clear logic to the principles governing editorial intervention. Martyn, and one must assume tourists of his persuasion, seems to have been embarrassed by or at least uncomfortable with those sections of Dodsley's description that move closest to the kind of fantasy experience I outlined above.

Thus, for example, the first omission gives a good indication of the type of cuts made throughout. After the first poem, "Here in a Cool Grot," appearing in both texts Dodsley writes, "These sentiments correspond as well as possible with the ideas we form of the abode of fairies; and appearing deep in this romantic valley, serve to keep alive such enthusiastic images while this sort of scene continues" (Shenstone 2:336). This passage has been excised from Martyn's chrestomathy, as has the following, which we find four pages later in Dodsley's description: "the eye is presented with a fairy vision, consisting of an irregular and romantic fall of water, very unusual, one hundred and fifty yards in continuity, and a very striking scene it affords" (2:341).

It is possible that Martyn was responding to a different landscape—it did change after Shenstone's death in 1763, and Dodsley's account, although published in 1764, was based on long-standing familiarity with the garden—but the omissions are so much of a kind I think it sensible to discount this

possibility. They all, for example, contribute toward the sense of a fairyland evoked in Dodsley's description and stress the sentimental aspects of the response.[51] I will suggest some reasons for this below in the context of a discussion of masculinity, fantasy, and the look.

Dodsley's text was effectively reprinted a second time, again unattributed, in *A New Display of the Beauties of England* in 1787. The text here has clearly been taken from Martyn's *English Connoisseur*; it follows all the cuts made there. The central difference to this later version is the addition of English translations to the Latin inscriptions, which suggests that the market for this book was rather different from that for Dodsley's essay as it had been published in Shenstone's *Works*; this attests to the changing composition of the social background of tourists as the century moved into its last decades.[52]

There is a further curious aspect to these later repackagings of Dodsley's description. If we take as reliable evidence Goldsmith's "The History of a Poet's Garden," published in 1773, it would appear that by that date Shenstone's garden had altered considerably. Goldsmith writes:

> I was led into this train of thinking upon lately visiting the beautiful gardens of the late Mr Shenstone, who was himself a Poet, and possessed of that warm imagination which made him ever foremost in the pursuit of flying happiness. Could he but have foreseen the end of all his schemes, for whom he was improving, and what changes his designs were to undergo, he would have scarcely amused his innocent life with what, for several years, employed him in a most harmless manner, and abridged his scanty fortune. As the progress of this Improvement is a true picture of sublunary vicissitude, I could not help calling up my imagination, which, while I walked pensively along, suggested the following Reverie.[53]

So how accurate would Dodsley's account have been in 1787? If there had been considerable changes, it seems unlikely that his description would have then corresponded with the "real" landscape. Given this probability, the force of the textual account becomes somewhat attenuated and takes on a slightly different role in the practice of viewing. In effect it began to function as the real of looking, standing in the place of the evidence of the eyes.[54] So by 1787 Shenstone's instructions had become rather more than guides for looking; they stood in the place of the visual itself. Whereas before one had required the text in order to direct the look, in this later instance the text has become the eyes of the beholder. This later deformation requires comment since it suggests a counterreading of the educative purpose of the garden. If Shenstone's text as it was disseminated through Dodsley's account of the gar-

den later functioned as the law of sight, as that which determined what should be seen, then the embodied look came to be subsumed in a textual practice. Shenstone's purpose was to educate the viewer in and through the activity of looking; it would appear that after his death, in the context of another set of arguments about the culture of visuality, his text began to stand in the place of the eye. Visitors to the garden, armed with their guide-books, no longer had the opportunity to look on Shenstone's artful con-struction of nature; instead, they looked through the veil of a text that had come to operate as the letter of the law of sight: they came encrusted in text reverence, in heritage consciousness. Where Shenstone and Dodsley had delighted in the imaginative, phantasmic encounter with the visual field, later tourists brought their distaste for and embarrassment with the "fairy" world of homosocial friendship. One tourist, Joseph Heely, did not; his encounter with both the Leasowes and Hagley Park forms the basis of my concluding section.

MASCULINITY, FANTASY, THE LOOK

There are dozens of published tours of country houses and gardens under-taken by a variety of eighteenth-century gentlemen.[55] These accounts some-times take the form of primitive guidebooks to a region, county, or specific house; or they may be presented in the form of correspondence, such as Heely's *Letters on the Beauties of Hagley, Envil, and the Leasowes*, or even rhapsodic dialogue, as in Gilpin's *Dialogue upon Stow*. I concentrate on one example, Heely's *Letters*, since the issues that have been raised so far come home to roost in interesting ways in this text.[56]

The middle decades of the eighteenth century saw a considerable increase in domestic tourism.[57] The reasons for this can be explained partly by restric-tions on travel abroad—European war made the traditional grand tour difficult—and partly on account of a new kind of tourist, whose social affiliation was not to the elite classes, beginning to make his or her presence felt. Undoubtedly, improvements in roads and transport contributed to the increase in domestic travel, as did the growing numbers of people who had the opportunity, mainly financial, to indulge in some kind of leisure-time activity. Many of these tours were undertaken by people interested in a specific locality, be they amateur local historians, agriculturalists, or indus-

trial spies.[58] These tours need to be seen in the context of the earlier paradigm for travel.

From the 1740s on it had become relatively common for the elite classes to visit country seats. During the midcentury when many of the most spectacular country houses were being constructed Horace Walpole, for example, began his inventory of the contents of many of them, written up as "Visits to Country Seats"; such documentary endeavor is also evidenced in the continuation of Colen Campbell's catalogue of native English architecture, *Vitruvius Britannicus*, which Campbell had begun in 1717 and revised and augmented during midcentury. Many of the proprietors of these country houses and estates began to formally organize and facilitate visits; they arranged opening hours, charged for admission, instructed housekeepers or other servants to show visitors around, and privately published guidebooks. In short, the heritage industry began in earnest during the middle decades of the eighteenth century.[59]

An informal list of the "required" visits began to develop, so anyone with pretensions to polite culture would have made it their business to see Chatsworth, Blenheim, Holkam, Houghton, and a dozen or so more. Similarly a list of must-see gardens began to form that included Stowe, Painshill, Studley Royal, the Leasowes, Kew, Rousham, Blenheim, Chatsworth, and Hagley. Extant accounts of visits to these country seats do not conform to any particular mold, although most describe the extent of the estate and often list the paintings and artworks displayed in the house. In relation to the garden or park many draw on the kind of prescriptive account found in Marshall or other treatises on the ornamentation, disposition, and arrangement of landscape; and, following their prescriptive accounts, they often state that the land either does or should look in such and such a manner, that water and buildings either are or should be arranged in such and such a fashion, and so on.[60]

Most of these descriptions give the impression that the visitor is alone, although evidence suggests that a solitary visit to a garden would have been relatively uncommon. Although the gardener, owner, or housekeeper might have accompanied one on an inspection tour, there was an even greater likelihood that one went in company and that indeed a visit would overlap with other parties making their tour.[61]

Heely was far from keen on the presence of other tourists in the garden; of course, a long-standing topos characterizes the countryside in terms of retirement from society, so Heely is merely repeating a centuries-old desire

to remove oneself from the noise of society, the noise of others, by moving from the city to the country. Some gardens, such as the Leasowes, were constructed with this topos expressly in mind. But even so it was still unlikely that a visit to Shenstone's rural idyll would have taken place in complete solitude. Heely visited the garden after Shenstone's death, but even during the poet's lifetime a visit during the fine weather months was likely to result in encounters with other tourists. One summer, for example, Shenstone writes that he had been "exhibiting himself" to 150 people in his walks, and likens this situation to that of a "Turk in a seraglio."[62] Similarly, contemporary engravings of Stowe, for example, make it clear that visits to country estates were popular pastimes. It is important to note this because by the time Heely makes his tour the ideological resonances to depopulated landscape are stacked high; this was, after all, the period in which Goldsmith's *Deserted Village* began to speak for a particular constituency with specific political objectives.[63] When Heely expounds on the pleasures of solitary rural experience, he is, self-consciously or not, intervening in a politics of the look—of how to look at the land and how the landscape itself looks. But I am going to pass over this in order to focus on that aspect of his visit that can be understood most clearly in terms of a fantasy encounter with the landscape. Heely, I suggest, no more or less than Goldsmith, pays scant heed to the "real" of the landscape itself: he is not interested in the truth of opticality, of what the eye sees. Rather, he goes to the landscape in order to experience the eye/I of the look, to feel himself become a part of the republic of visuality.

Heely first published his account of Shenstone's garden in *Letters on the Beauties of Hagley, Envil, and the Leasowes*; this was subsequently split into individual descriptions of the gardens, thereby making them in effect dedicated guidebooks.[64] In the first letter Heely refers to the contrast between the country and the city as a way of setting the scene for the subsequent pastoral experiences. Although this oppositional pairing might be taken as conventional—the motif can be found in classical literature and continues to be productively used to the present day—it is an exceptionally fraught pairing in mid-eighteenth-century England.[65] In a context in which very significant areas of landmass were, by private bill, removed from public access, the "country" could not fail to arouse political interests. But I want to attend to another, no less political, set of resonances in Heely's text, that concerned with gender. He begins by stating that gardening "fills the mind with every flattering sensation" and "charms the eye" (1:5), thereby locating his account immediately within the orbit of seduction: we are about to encounter a

series of strategic seductions in the field of vision. Yet this is slightly curious since Heely's account is uncertain in regard to the binary division of gender. Put simply, it is difficult to ascertain precisely whether the distinction between male and female functions oppositionally. Hence in contrast to some late-twentieth-century accounts of the masculine gaze—figured as an appropriating or objectifying power that subordinates everything within the field of vision—Heely seems to operate a more supple, perhaps confused but certainly less monothematic and monolithic, category of gender.[66] It would be appropriate to describe this model in the plural, as genders. We can begin to pick up on this in his contrast between the pleasures of the country and the city:

> The mind when surrounded by the pageantry of courts, the noise and bustle of cities, and the idle dissipation of a vicious misguided multitude, is bewildered and confined; sinks into a contemptible effeminacy; is lost to every manly reflection; and dead to the tender feelings both of humanity and friendship: but in the calm undisturbed hours of retirement it is free, and open to every great and generous reflection worthy [of] its dignity. (1:6–7)

The category of gender here has an uncommon density, and it articulates a range of relationships between terms that are usually understood as oppositional. Here these relations are appositional, nested, or complementary. This results in a greater flexibility of descriptive terms, which in turn implies a permeable filament between what are commonly understood to be opposing poles of gender differentiation. Some of these terms, such as *effeminate* and *manly*, give clear indications as to their position vis-à-vis these oppositional poles, but others are more problematic. What of *pageantry*, for example, or *noise* and *bustle*? Are these troped as masculine? In general, given the history of our language and its figurative ascription of gender labels, one might expect these things to lean toward the manly, but Heely's process of thought is all in the opposite direction since these aspects of city dwelling result in an emasculation of the mind. In the case of tender feelings and friendship one might expect these to be conventionally figured as feminine, but once again Heely, at least superficially, defeats our expectations in his claim that they are coincident with manly reflection.

What emerges from this is that the gender category of "male" includes aspects of what might more conventionally be understood as female characteristics. The masculine is stretched on the one hand into an effeminacy caused by an overplus of maleness—the noise and bustle of the city—and on

the other into a softer and more caring "female" reflection or retirement. I take this to indicate a flexibility of gender typing in which the category of male is not opposed by a simple antagonistic category of female but is, rather, one point along a continuous arc that distributes gender categorization. In Heely's socioscopic the man has the potential for being, let us say, stereotypically male—hard, powerful, aggressive—or, at another more distant remove, feminized in the caring, feeling modes of reflection, friendship, and retirement. What this account leaves out is a corresponding distribution of gender ascription for women.[67]

This mobility of gender filiation in the case of the male viewer is complexly interwoven with the figurings of the country/city distinction. The city, which for this period would have been associated with a kind of hardness and brutality, is distinguished by Heely from the softer and more welcoming shades of rural retirement. It is, however, the city in the extract that turns what we must take to be a previously hardened masculine mind into a "contemptible effeminacy." Of course this fall into effeminacy is not identical to gender typing as feminine—as the term indicates, it is a mutation of masculinity. The most helpful way to understand this mutation is in terms of an expanded field for male gender whereby the terrain more conventionally occupied by the feminine is available to men. This view opens up the possibility of a polyvalent gender, of genders, at least in respect to masculinity.[68] Be this as it may, Heely does suggest that a male viewer of landscape will encounter his own gender in an expanded field. Heely assumes, for example, that the designer of a garden is male: "When I walk in the gardens of pleasure, I don't think myself a journeying—I walk there to enjoy, and to admire their variety—to linger at every scene, and trace the pencil in all its touches: if I do not do this, and follow the designer in every of his steps, how am I to judge whether he hath merit or not?" (1:67–68).

This experience of standing in the place of the designer is fully accounted for in the theoretical materials discussed above, where precise locations of seats, views, and so forth regulate and regiment the viewing activity. Standing in the exact place of the designer also has clear connections to the theoretical exhortations governing the viewing of pictures, dictated by the mathematical rules of perspective. Heely is following those precepts that bear on the position of the body in the practice of looking. Space tells the body where to be, and the body tells the viewer how to look. But it is not only position, locality, and embodiment I want to draw out of this; there are also a set of registers bearing on the gender of the look. Standing at the true point

of sight, in the shoes of the designer, arouses a homoerotic charge, an identification produced through the polite forms of male bonding that are wrapped up in the attitude we call friendship. For Heely the activity of looking in the garden creates a homosocial experience in which one feels oneself to be looking through the eyes of the designer.

In the previous chapter I outlined a similar address to the visibility of visuality and its associated erotics of expanded masculinity in the socioscopics of Vauxhall Gardens. Heely represses his full recognition of that erotics and simultaneously flirts with it in his use of the term *pleasure*, the term that also articulates the division pertaining between the country and the city. Gardens of pleasure, which usually demand a certain degree of leisure time and necessitate the expense of travel to get to them, are places of contemplative retirement, private enclaves in which one might be pleasured in less orthodox ways; on the other hand pleasure gardens are those public spaces— Ranelagh or Vauxhall spring to mind—where licentious social activity could almost be guaranteed to take place. Both may provide the opportunity for experiencing an expansion in "manliness," but the public spaces of a Vauxhall, for example, were more likely to be policed in ways already encountered in the previous chapter. The private-public spaces of the landscape garden, however, provided far greater possibilities for the identificatory drives of fantasizing one's standing in the shoes of Shenstone and hence for a practice of looking embedded in the plasticity of male gender.

I am going to press a little further on Heely's account of pleasure since this will open up the phantasmic encounter of male friendship that determines this particular entry into the culture of visuality. Heely suggests, for example, that pleasure is not to be derived from intersecting walks in a landscape garden. Such walks could be found not only in the older more formal garden but also in the "pleasure gardens" of London. In contrast, "[a] single path only, ought to conduct the spectator to every scene" (1:66), which allows the construction of a properly sequenced experience—allows the time of the look to enter into the viewing activity—but it also enables the circuit walk to be experienced in a solitary fashion. Furthermore, the rejection of intersecting walks implies a different conception of the political relations between social subjects: the grand interlocking schematic description of society that was instantaneously intelligible from one, central, viewpoint—the panoptic model deeply embedded in the political structures of monarchy—is rejected in favor of the discovery of each indi-

vidual's relations to another through the temporal unfolding of a carefully routed progress.

But the requirement that only a single path conduct the viewer through the landscape also sets up a context for the discovery of self. The proclaimed solitary nature of the walk impacts on self-revelation or self-description, as do a number of other discursive markers in Heely's text. Primary among these is the notion of male friendship—this was already part of the iconography at Stowe in the late 1740s—which is strengthened precisely by the *lack* of companionship.[69] In the solitary walk one appreciates more keenly the companionship of the place and, via this, the sense of belonging resulting from recognizing that one is a part of a select company that correctly responds to the endeavors of the owner and designer. Emblems to friendship are cues to a solitary form of companionship, one that for Heely is not feminized through the noise of others. So it comes about that the experience of self in the sequestered garden is one in which person and personality are welded in some curious manner to the spirit of the place and, hence, to the individual who designed and the person who owns its rural shades. This companionable environment, generated through the absence of real companions, is "manly" and, we must assume, does not welcome the presence of women, at least insofar as they are to be encountered as "women." Most significant, the sense of companionship is created through the fantasy figure of the poet-gardener himself: the dead William Shenstone, who is the eidetic afterimage of a culture now threatened with extinction. Heely writes in the course of his description of the Leasowes:

> One cannot help feeling for a man of genius, who has the will, and who actually does, with much study, labour, and expence, make his domain so exceedingly beautiful, as to fill every eye that looks upon it with wonder and delight; and at the same time, who is so amiably disposed, as to be highly gratified in seeing the undistinguished, as well as others, indiscriminately walk, and enjoy it with the utmost freedom. (2:186)

Heely's political agenda is clearly visible in these remarks—he sounds snobbish in his put-down of the "undistinguished"—but the dominant register to his viewing practice is determined more by the socioscopics of male friendship than by the politics of class and rank. And this is true in the case of his visits to all three gardens. The account of his visit to Hagley Park, for example, is set up in the following manner:[70]

I did not arrive there till the dusk of the evening; and in the sweetest morning that ever ushered in the meridian of spring, walked up an easy winding avenue of limes, and elms, among a thousand mellow throated birds, till the house burst upon me in all its glory.

I paused—

I saw grandeur supported by simplicity—I saw a proof in this modern pile, that true elegance spurns the aid of superfluous ornament. (1:98–99)

The narrative mode is clear enough: the first encounter with the garden is enveloped in frustrated expectation—it was too late to see properly. This only heightens Heely's sensitivity to the successfully realized entrance to the garden the following morning, which he describes in terms familiar from the discourse of the sublime, whereby suspension and the subsequent release of intense feeling occurs. The trajected end point of that experience—the sublime of wonder—is fully prepared for by the line of beauty, which leads Heely toward his destination and by the aural dimension to his progress. When the expectation and suspension are finally relieved, it is through the agency of an inanimate object, the house, which "bursts" upon the viewer "in all its glory." This also chimes with a standard form for the structure of the natural sublime in which the subject is deprived of agency in order to enhance the agential will: first the subject loses its capacity for action, then, in the rush of intense experience—the moment of the sublime—the subject is overwhelmed only to find in the immediate and almost simultaneous aftermath a vacuum into which the power of the will, of agency, suddenly bursts. This structure whereby the self recognizes its autonomy in the aftermath of the sublime is very closely observed in Heely's description. Having lost the organizing capacities of the eye, the visitor—"I"—pauses, and then in rushes the intentional directiveness of the optical: I saw. And what is seen is a "proof," a corroboration of the authenticity and excellence of modernity. But this is more than a purely optical phenomenon: Heely is charting the narrative structure by which the viewing subject comes to recognize itself as present to the view, in the here and now of the modern. I take it that this is signaled in the repetition of the "I saw," underlining the fact that not only is the visual field, opticality, seen by the spectator—the visible evidence of "grandeur supported by simplicity"—but also the nonoptical material, the "proof" that "true elegance spurns the aid of superfluous ornament." This is a complex articulation of the act of looking: what is "seen" includes the material objects revealed to the eye through optics, and those nonmaterial forms constructed through visuality that shape or contour the viewing sub-

ject. What Heely witnesses is himself coming into the spacings of the viewer, a location saturated with the odor of authenticity, the smell of the modern, and, like the viewer smelling of roses, Heely recognizes himself as a man of taste, a fully paid-up member of the public-private sphere of culture.

Of course a politics of culture interferes with this experience of the self—signaled by Heely's comments about the expense of luxury and the superiority of the modern over the ancient—but such thoughts are soon overpowered by the overwhelming experience of self-reflection and production, of bathing in the reflected image of self that comes back from the pleasure of being here in the domain of the visible. We might call this Heely's self-portrait in landscape. This, without needing to stress a pun, is continually signaled in the reflective aspects of Heely's description. Thus, in moving from Lord Lyttleton's house to the garden Heely informs us, "Before I descended the noble flight of steps (which I thought wanted the addition of a portico) an endless prospect, enriched with every variety, held me for some time in much pleasure: and when I took my way round the house to the centre of the North front I again paused in admiration" (1:120).

What I want to emphasize in this narrative mode is a structure of reflection; the terms *pleasure* and *admiration*, for example, have temporal aspects that are reinforced in the description—"held in pleasure," "pause in admiration"—so that a coherent structure of the contemplative in temporal and spatial terms (precisely reflection in its fullest sense) begins to emerge. In the terms I developed earlier, Heely is responding to and describing hesitory time. But what is it to be held *in pleasure*? This is a question about both the temporal and spatial locations of pleasure, as well as about the larger social and cultural implications of being suspended, suspended being. Pleasure, according to Heely, is generated by an "endless prospect." This runs directly counter to the prescriptive accounts examined in the first part of this chapter, whereby the eye was said to need or require a boundary to the visual field. According to those strictures an unbounded prospect precisely fatigues the eye, destroys its pleasure.

Heely does not quite reject the earlier view since in his account the "endless prospect" is also "enriched with every variety," suggesting that the eye is able to fasten onto specific features of the visual field. Where is this pleasure located, in the eye itself or the ratiocinative subject, in the "I"? What is it to "pause in admiration"; where is the viewing subject while in this moment of suspension, in the here of opticality or the there of visuality? In preparing an answer to these questions I want to recall my earlier comments about mir-

ror time. I argued that this temporal mode constantly oscillates between the here-now and there-then, thereby locating the phenomenology of the look between being-here-ness and being-there-ness. I am going to suggest that Heely is describing that in-between state in the above passage and that he translates the temporal moment into a spatial form so that being held in pleasure can be understood as the arresting of the eye, its being-here-ness in the subject-who-looks, whereas pausing in admiration reflects the being-there-ness of the objects looked upon. In this pause the subject is located over there, in the domain of the visible, and the eye/I becomes an object in and of admiration.

Heely elaborates on this a little further into the narrative account of his visit to Hagley when he arrives at the Palladian bridge, which "operates like beauty on the senses, and charms the spectator into silent admiration" (1:133). Once again we find an active object in the visual field determining an affective response in the viewer; the object presents a reflecting surface in which the viewer discovers a self-description, the charmed eye, and this leads to a moment of "silent admiration," a form of self-arousal produced by the reflection of the self to itself. Admiration is, in effect, the by-product of the subject's witnessing itself coming into subjecthood: I am here, in the process of visualization, but I am also there, in the plane of reflection; and my self has the same consistency and coherence as any other object in the field of vision. The mirrored surface in which self-image is discovered may come in a variety of forms; the social act of viewing, for example, may present one such surface in the context of the exhibition space. A different, but no less efficient, mirror surface is presented by the exhumation and invocation of classical culture. In this case the spectator sees self-image in the fantasized past that is collectively constructed through heritage consciousness (this continues to be a feature of our own contemporary address to the past, which is embalmed in various ideologies of heritage). The common trope used in descriptions of the kind of experience I am attending to is "transport," the figure that sets in motion a structure of removal—from here to there, from there back to here—in both spatial and temporal dimensions. Here is Heely characterizing this experience:

> No vista surely was ever held to the eye with such advantages to please!—With what attention, and even transport does not almost every stranger look upon the clear lake before him!—on the majestic spreading trees that paint its steep and bold swelling sides, nature dropped, bending their horizontal arms, and dipping

down to the curling wave! what does he not even *feel*, when he makes the play-ing cascade, gush from the shrub-green rocky banks, in foaming plunge, down the close embosomed vale! (1:134–35)

The use of the passive construction—"was held to the eye"—suggests a disinvestment from the intentionality of opticality—the viewing subject has a diminished agency—which is followed by the transport from here, where sight occurs, to there, where the viewer is identified with the plane of reflection ("the clear lake before him"). In this oscillation between here and there the viewing subject maps its contours—at one moment the agent of sight within the feeling I and at another the seen object, the eye in the mir-rored plane of reflection. And on this occasion the objects of nature that are over there, in the world-to-be-seen, have a definite bloom of the erotic about them. The very syntax of the account conforms to the enticements and excitements of seduction, while the objects seen—the gushing cascade—sound out in overtly sexual terms the harmonics of desire. In placing his emphasis on the natural forms seen in the field of vision Heely is turning away from the social practice of viewing: for him the mirror of the other is rebarbative. As I have noted above, his desire for a solitary experience over-writes the "real" of looking in which a populated landscape presents itself to the viewer.

Heely goes on to describe the culmination of this transporting experience as a moment of suspension—what I called above a sensation of hesitory time—which nevertheless has an identifiable structure. In turning away from the cascade toward the larger view Heely writes:

when he casts his eyes on those variegated shrubby crossings, and slants of lawn above—on the green rising knole at the extremity of view, covered sometimes with the browsing deer, and crowned into a rotundo, in perfect character, and in perfect beauty! while round him the melody of the thrush, the blackbird, and other different warbles, give their wild, and cheerful notes, to make it still more delightful!—He stands in rapture—he gazes—contemplates—and with reluc-tance leaves the elysian bower! (1:135)

Rapture is the name given by Heely to the hesitory moment, the sudden inward rush of a temporalized structure of being that is translated into an intense sensation of location, of being here in this place. This is prompted through a technique of visuality whereby the here of opticality, recognizing both objects and the self in the field of vision, suddenly transforms into an

inward gaze wherein the viewing subject contemplates its own being. Rapture leads to a visualizing technique that in turn leads to an interiorizing inspection. It is important to stress here that the eye has agency in this activity—it is the eye that seeks out pleasure, the eye that determines the shape or contours of the subject-who-looks. It should not surprise one, then, that Heely articulates as elaborate a metaphorics of the eye as we found in Whately's *Observations*.

This metaphorics energizes a complex set of attitudes to and insertions within visuality. The eye might still movement, for example, as in the following: "the eye commonly fixes first on the object that is the greatest novelty" (2:29). Alternatively, it may become very animated, as when it is described as rambling excursively over "an open, variegated, and extensive prospect" (2:46). At its furthest extreme of independence from the conscious viewing subject it seems to have its own needs and wants, requiring both sustenance and relief: "There is nothing more desirable, or eases the eye so much as a break, now and then, to a lawn, or to some fanciful object in the midst of a gloomy and extensive wood" (2:54).

On other occasions the eye does not know how to look or in which direction; at times it is suffused with too much detail, too much information, and hence needs to be "fastened" on just one aspect of the visual field. At other times it is greedy to catch everything, this time remarking of the Leasowes: "The whole of the grove opens in all its glory;—your eye, greedy to catch every object at a glance, knows not where to rest; for to fix its predominant beauty is impossible—it is all beauty, and that, productive of every thing to fire the imagination, and fasten the eye in delight" (2:201).

The eye is often in a curious relationship to the domain of visual pleasure, at one moment subordinate to the larger needs of an emotive feeling subject, at the next independently pursuing its own desires and gratifications. Thus, Heely notes of a particular effect in the landscape that "the transition does not surprize, but it fills the eye as it reposes on the slanting hill covered with numerous groups of sheep, with ineffable pleasure" (2:56), and what one expects is a failure of surprise on the part of the viewer. Yet it is the eye in distinction to the subject of the look, the disembodied organ of sight that experiences "ineffable pleasure." What I mean to highlight here is the slight indeterminacy for the location of the effects of visual stimuli: does the eye feel metonymically—as proxy for the subject who looks—or independently? Heely wavers; he is not sure, or if he is he notes an oscillation between the two possibilities. At Hagley Park Heely, for example, the exemplary viewer,

"sat down inquisitively curious, and looked upon the gay assemblage of objects with a greedy eye" (1:144). It is the eye, as it were, that directs vision but an eye that is constantly looking over its shoulder, taking account of a different set of needs and desires that feed into the sense or feeling of the self's own mastery. This is why the moment of rapture is held up as the end trajectory, the location where the viewing subject may dwell in self-satisfaction without the need for any external corroboration, the need for any mirrored surface. And the viewer knows he or she has arrived at this point when the feeling rises to the surface of one's conscious attention.

Remarking on a particular view at Hagley, Heely writes: "it is impossible for any one that has feelings, to sit, and look on the graceful combination before him, without rapture" (1:152). This feeling of rapture is simultaneously subjective—only knowable to the subject-in-rapture—and recognizably a part of the repertoire of shared experience; consequently, at the most intense moment of self-determination or discovery there is the complementary sensation of belonging to a common humanity. The most private experience one can have—of one's own self-fashioning—is also at the same time a component of the public sphere.

This section began by exploring the ramifications of Heely's desire to be alone in the landscape. He is only able to satisfy that desire by invoking a fantasy: the imaginative projection of himself into a scopic regime that can get by without corroboration from others, other viewers. Heely creates a pastoral idyll in which the viewing subject is self-sufficient, self-reflective. This enables him to note that "[o]ne cannot leave this sweet habitation of the sylvan deities, without extreme regret: the mind imbibes such a pleasing serenity in the contemplation it affords, that one is ready to wish to remain fixed within its happy bounds, never to mingle again in the follies of a busy and licentious world" (1:155).

I do not want to give the impression that Heely was unique in his responses to the gardens he visited. A number of tour accounts are sufficiently close to this to allow the identification of a common terrain.[71] In fact Heely can be understood as buying into a preexisting cultural form, a communal projection of a fantasy in which the man of taste removes himself from the "follies of a busy and licentious world" in order to gain an authentic experience of the making of the viewer, in order to feel the subject's entry into the spacings of the socioscopics of landscape. It is here, in this sylvan shade, that one experiences oneself as "authentic," fully a member of the republic of visuality. And, as I have suggested above, there is a

homosocial gloss to this experience of authenticity and an erotic charge to the public-private spaces of the garden.

Seen in this light the entire project of the English landscape garden is counternaturalistic; the point, indeed, is to construct an alternative vision of the real, to legislate and control the look of things in order to maximize the efficiency with which landscape reflects and represents what we desire most to see: ourselves as citizens in the demos of culture. This is a group fantasy constructed in and through a specific politics of visuality that polices both the means of access to the garden-as-fantasy and what is seen in the plane of representation, what appears as the "natural." Consequently, the viewing experience in its construction of the subject position "viewer" represents a site of struggle in relation to who is allowed into the garden and, once in, who and what might be seen. I think it is clear that Heely's political filiations are deeply embedded in the desires of an upwardly mobile bourgeoisie wishing to distinguish itself from its perceived lower-class compatriots. His problem, however, is remarkably similar to Walpole's: if one holds to the hypothesis that the eye—through its elaborate metaphorics—may itself instruct or induct the viewer into visuality, then all manner of people may end up in one's shared domain of culture. There may well be a republic of visuality, open to all who have eyes to see. As Heely remarks of all three gardens:

> Each may be called a school for taste—together, an accomplished one—where you are taught, whatever be the genius of your grounds, how the pencil should be guided—where the cascade should gush—where the tower, the obelisk, the temple, or the grot, best become the situation—it will teach you where woods, groves, and lawns should intermingle to grace each other—where water should be secluded, and where visible—where light and shade have the best, and most agreeable effect, and where the solemn and the gloomy more happily contrast the sprightly and the gay. (2:232)

I have argued that Walpole's history of gardening takes one side in a politicized debate as it writes a history of the present with its back to the here and now. It tells the present as a reflection of how the past ought to have been. It does this on behalf of an elite class whose cohesion is in part produced through its enfranchisement in the public realm of culture. Walpole pursues this strategy as a means of combating or ignoring what was happening all around him during the middle decades of the century, namely the fracturing of a cohesive elite culture brought about through the violent insertion of commercial interests into those social spaces hitherto regarded as the

exclusive domain of the aristocracy. Heely tells a slightly different story and from a slightly different perspective: for him the key to his entry into visuality, as for those like him from a similar bourgeois background, is the mastery of the modalities of viewing by means of imitation. And this takes place through both identification and phantasmic projection: access to the society of visuality is gained in the psychic spacings of standing in the shoes of another. As I noted above that other is, of course, merely the fantastical doppelganger of oneself. Adam Smith put it tellingly: "He does not merely affect the sentiments of this impartial spectator. He really adopts them. He almost identifies with, he almost becomes himself that impartial spectator.[72]

Fantasy had been a part of the landscape experience from the early decades of the century—Addison, for example, presents a fantasy in one of his *Spectator* essays that became a kind of prompt for the construction of Stowe's Elysian Fields. Here in Heely's description of Hagley Park the fantasy seems almost involuntary, as if the place itself had power over the mind:

> This elegant scene pertains to a garden, equally with the preceding; and though totally its opposite in every respect, you will be convinced that its intention is to fill the mind with the most romantic ideas; and you cannot help fancying yourself, as you recline upon a screen, under a bush of laurels, near the old oak, to be within those happy regions of the rural deities, which the classic muse so sweetly sings. (1:160–61)

It might be argued that Heely has been co-opted by the ruling ideology he mimics even as he remains ambivalent about adopting its poses. The problem for him lies with the drive toward identification, the recognition of self within the plane of reflection that is the culture of visuality, the sense that looking with the garden is, in effect, to see with the eye of another. This fantasy in which the viewer feels the male bonding of homosociality may begin to run away with the subject-in-the-look, either toward the sublime introspection of self-regard, into narcissistic specularity, or toward the ultimate identification with the maker himself. In the moment of recognition that some things are beyond words, out of bounds of the intellect, there arises the seductive possibility of going yet one stage further, of mastering not only self but also the world: "In short, Nature from this delicious brow, appears so great, that she spurns description—she affords those glories which not only fascinate the eye, but fill the mind with the most awful impressions of the majesty, and inconceivable greatness of that Power from whence she herself proceeds" (1:200–201).

Perhaps the ultimate fantasy, then, is that one glimpses the hand of the creator in the works of nature; this, to put it mildly, is a hubris we may only dream of.

Looking in the garden is surrounded by a host of discourses that legislate and control entry into the public domain of the culture of visuality. As I have argued the eighteenth century developed two distinct ways of understanding that activity, and within this broad division further qualifications need to be made. Heely, for example, was not a part of the Walpolian elite, even though he trained himself to look according to the precepts of the metaphorics of the eye. He wants to enter the public domain of culture, and his way of doing so is to disparage those whom he considers to lack the taste required; but even as he does so, he recognizes the power of the regime of the eye, its liberating and enfranchising work. In the following chapter I will explore the site-specific look created by one house, Kedleston Hall in Derbyshire.

Kedleston Hall

A Palace of Art

For nearly 850 years a house has stood at Kedleston, during which time this place has been the uninterrupted residence of the Curzon family (fig. 22). The house standing in this place today, however, dates from the mid-eighteenth century. Indeed, in the course of its construction it significantly altered the *look* of the previous 600 years' occupancy, destroying one house, removing a village some considerable distance away, in fact only retaining the predominantly late-thirteenth-century church as part of the dwelling. This monument to modernity was built by Nathaniel Curzon, the first Lord Scarsdale, and is, without doubt, one of the finest examples of the eighteenth-century country house extant in England today.

What are we to understand by this forceful act of origination, the marking of time, of history in the monumentality of this building that writes, etched into its stone fabric, the frozen moment of the present? In writing this present a story is being told and a prior story, a history in and of this place, is thereby attenuated, even in part erased. This chapter will explore something of that story in an effort to gain access not only to the building and its stone secrets but also to a cultural imaginary, an edifice of the collective imagination held, suspended in the volume and surface of the building itself, as if in the shadowy recesses of a daguerreotype made of marble or alabaster. That cultural imagi-

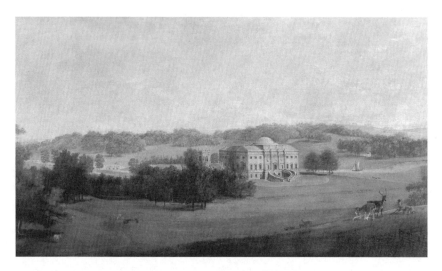

FIGURE 22. Kedleston Hall from the north, attributed to George Cuitt. National Trust Photographic Library/John Hammond.

nary, what I will term *the look* of this place, is an aggressively assembled montage, an eclectic borrowing from the sourcebook of history so as to fabricate the seamless fantasy that is the surface of culture. It does not respect tradition or heritage, does not strive for the accuracy of the copy or slavishly follow so-called academic reconstructions of the past as it was—merely, of course, another fantasy—but aggressively makes its own image in its fantasized version of the antique. In so doing it stakes a claim for the utmost sophistication, proclaims itself as standing at the summit of cultured progress; it embodies absolute good taste. As the inscription on the south front unambiguously asserts: AD MDCCLXV N. BARO. DE SCARSDALE AMICIS ET SIBI.

In attempting to enter that cultural imaginary I will essay a number of "approaches" to the building, a series of varying methods and overlapping narratives that will foreground the entry proper into the spacings of this physicophantasmic spacing of a past culture. In doing so I will be reconstructing and constructing a series of histories, of the building and its architect, as well as the recorded views that have been left by contemporaneous visitors to the house. All this will be marshaled in order to excavate the history of taste so that one might better respond to the look of this building, not only look *at* and *in* it but also look *with* it. This last activity, looking with this cultural imaginary, is a form of being in and with the house and will mark out the end point of my discussion: the attempt to present a form of

looking with history, with time; a look sensitized to the specific articulation of time and history embodied in this monument to culture.

APPROACHES

First Approach: Building History

The extent of our stone-awareness has varied through time. The invention of archaeology represents one of the most important moments in our attentiveness to the materiality of culture, but the study of ancient and past buildings is often pursued with a set of ideological and sometimes theological beliefs that may on occasion blind us to the technical impossibility of knowing in the past tense. It was Ruskin, perhaps, who most systematically and profoundly alerted us to the necessity of being stone-aware, but the level and extent of his attentiveness could hardly be the standard one might expect to be generally emulated. Perhaps the most depressing feature of our early-twenty-first-century culture is its singular lack of attention to stone-awareness, which it ignores in favor of something marketed as "heritage culture," which also has its own "industry" and a government department to promote, protect, and regulate it. The clumsy swagger of heritage culture is so far away from the stone-awareness that Ruskin and Robert Adam before him both taught and learned, that it increasingly comes to resemble stone-blindness. The ramifications of this for our present guardians of culture are explored below; I want to begin, however, with a more simple if not simplistic observation: buildings have an exemplary relation to the etching of time. They register temporality, the passing of time, in very legible ways. And they also have histories, of design, construction, habitation, and social articulation. They may accrete histories as they are adapted and altered over time, or, alternatively, they may attempt to resist such change; and the history of such resistance may be either etched into the surface of the building, which speaks of the ravages of time, or erased in the polished surfaces that look like new. But buildings are not only material objects, subject in varying ways to the passing of time; they are also conceptual spaces that determine both how and what we experience while we are within their enclosure. The "moment" of a building, the tense of its coming into being, is therefore a complicated and complex form: its temporality is often the anterior future. And, in common with the landscape garden, building or designing in the present rarely overlaps with building for the present. Although on its surface

a building may appear to us as a frozen moment in time, the temporal accidence of its conceptual form militates against such a possibility.

In order to break in on the moment that is monumentalized in a building as traditionally conceived, we must first inquire into the drive or desire that fuels the intention to build a monument in stone that will outlive patron, architect, and the craftsmen who physically construct it. What does it mean to build for posterity? To build in the tense of the anterior future? This is to ask something about the temporal aspect of architecture as well as the temporality of building as such. My approach to these questions will consist of a set of hypotheses about the ways in which modes of temporality are etched into the spaces constructed conceptually by architecture and materially by building and decoration. I will, therefore, be attempting to historicize the look in order to look both with history, that is, inhabit the fantasy that I might look in the past, and against it by strenuously accepting the impossibility of inhabiting any time except the present of looking. In this way I hope to pay due respect to the notion that building for posterity articulates the desire to stop time while acknowledging that the present of such building is always yet to come.

It seems important to disentangle two quite distinct attitudes to history that are often conflated when we begin to play with the fantasy that we might know the past. On the one hand there is what I understand to be a sensitivity to the historical *as such*, to the ways in which history is embedded or figured in the look of and in the spaces we will encounter, whereas on the other hand there is abroad ever more vocally an attitude that seeks to make these spaces over in the cosmetic surgery of heritage: precisely that which seeks to "preserve" a past culture in how we imagine it to have looked. The second attitude of mock deference stakes a claim for authenticity; it presumes to speak for history when in fact it is deaf to the past and seeks only to preserve its own pious self-image as the guardian of culture, of "historical accuracy." In contrast to this the first attitude recognizes the impossibility of being in history only so that it might more skeptically and rigorously explore the imperative that we look historically.

These matters are both philosophical and political inasmuch as they are grounded in historiographical debates, and I will return to them in the conclusion to the present volume. In order to gauge what is at stake here, I am going to approach as patiently as I dare the building that is to be my example, and I will begin by rehearsing some of the details that make up a "history" of this place. This will constitute the first approach of Kedleston Hall.

In the opening sentence of this chapter I remarked that the Curzon family has, in all likelihood, been at Kedleston since 1150, but it has certainly been there since 1198.[1] The present house was built for Nathaniel Curzon, the first Lord Scarsdale, who had inherited a red brick Queen Anne house, built around 1700, in November 1758. This house was quite substantial, containing three stories with a dormer-windowed roof. It was constructed in red brick and would, already by the 1750s, have started to appear slightly dated in the prevailing neo-Palladian times. This Queen Anne house, we must assume, replaced the older medieval hall, which has entirely disappeared from the present site.

Nathaniel was thirty-two when he inherited his estate. By that time he had developed a great interest in both architecture and the fine arts and had already begun collecting pictures on a serious scale. As soon as he came into his inheritance he put in motion plans to build a more capacious country house for this growing art collection, sending the architect Mathew Brettingham to Kedleston to measure up and produce outline plans for a new building. The old brick and timber outbuildings were immediately razed, and the family and kitchen pavilions of the new palace were begun.

Brettingham did not last long and was superseded by his fellow architect James Paine. The plans for the house suggest that Nathaniel had very specific ideas, which we must assume he expressed to whoever was the current architect. Proprietors of large country houses were, at this period, far from shy about making their demands known; indeed, many were accomplished amateur architects themselves.[2] Paine did not last much more than a year, although his overall plan for the house was largely maintained by Robert Adam, who took over complete control of the design of the building and its execution in 1760.[3] Adam, who had only recently returned from his grand tour, had first been engaged by Curzon in December 1758 to plan the gardens and a few buildings in it. On assuming responsibility for the house he proposed an extension to Paine's plan to include four pavilions (fig. 23) in place of Paine's two, in a scheme reminiscent of three extant houses: Houghton and Holkham (both in Norfolk) and Nostell Priory (in Yorkshire). The north front of the house (fig. 24) is usually attributed to Paine, although it had not been built at the time Adam took over complete control of the building, thereby having made it at least possible to alter the design had he or his patron wanted to do so; the south front (fig. 25) is entirely Adam's work and is based on the Arch of Constantine with a Pantheon-like rotunda behind. These Roman allusions are considerably amplified in Adam's interior decora-

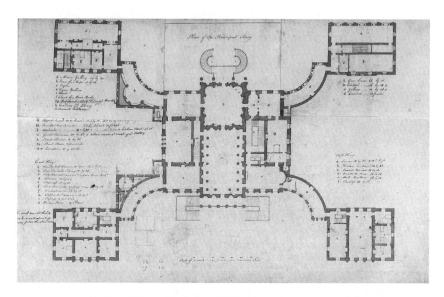

FIGURE 23. Robert Adam, Kedleston Hall, plan of the principal floor (c. 1764–65, with a flap added c. 1768); pen, ink, and wash. National Trust Photographic Library/John Hammond.

tion and, as will become clear in my second approach, construct a look that results in an experience of the fantasy that is culture for this place.

It is important to register at this point that this building cannot be understood as the product of one creative mind, as the realization of either the architect or the patron's vision. Although it is today very closely associated with the Adam style, even the Adam corpus, the important qualification should be made that it was designed and built in a cooperative venture engaged in by both Adam and Curzon in harness, as well as by a host of expert craftsmen who interpreted to varying degrees the wishes and ideas of both the owner and architect.[4] This is not unusual since most ambitious buildings of similar scale and pretension are realized in this fashion; what needs to be emphasized here is that Kedleston is not simply a magnificent example of the Adam style but that it is also, and for current purposes more important, a collective cultural production, a summation, concatenation, conglomeration of views, tastes, skills, and techniques present to mid-eighteenth-century Britain. It is a trace etched into the stone of history, still legible across the distances of the intervening 240-odd years.

This complex cultural product, then, was worked on by at least two major architects, an informed and determined patron, and over one hundred

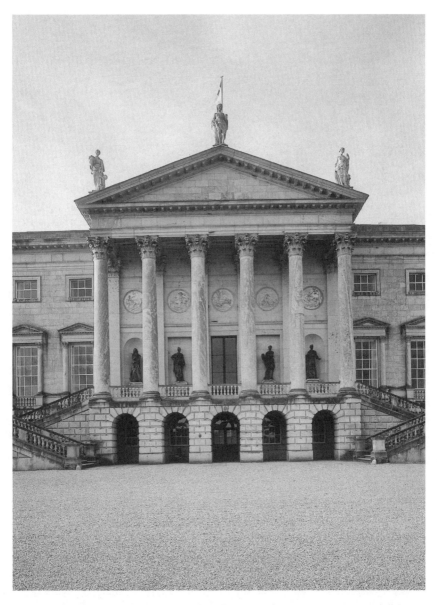

FIGURE 24. North front portico of Kedleston Hall, showing stone medallions by William Collins; statues of Venus, Bacchus, and Ceres on the pediment; lead figures in niches by John Cheere. National Trust Photographic Library/Matthew Antrobus.

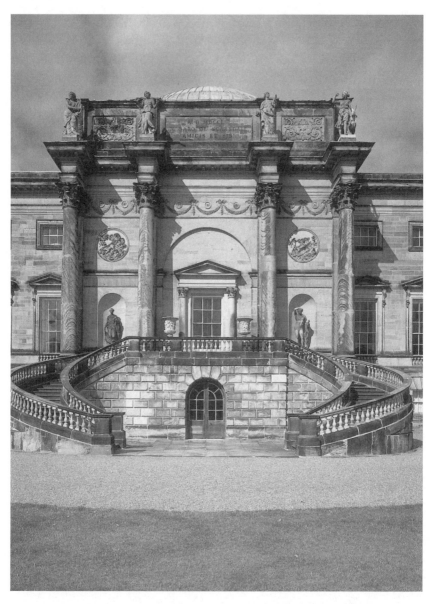

FIGURE 25. South front (entrance) of Kedleston Hall. National Trust Photographic Library/Matthew Antrobus.

craftsmen of varying reputations and skills.[5] Although two figures dominate the creation of this cultural expression—Lord Scarsdale himself and Adam—the final result is an expression of a publicly available commodity, a "taste" that could be both purchased and imitated. Consequently, what we now term the "Adam style" depended on craftsmen, of considerable skill and invention, who were not only valued and employed for that skill, not only educated into those skills, but were also able to reproduce the "look" that was identified by such taste. In this respect one must be careful to note that the name *Adam* stands for a complex mesh of interlocking signifiers, constituting a family architectural practice; a studio of draftsmen; an aggressive developers' and builders' empire; a group of subsidiary companies; and a vast and pretty stable cohort of subcontracted artisans, laborers, artists, and craftsmen. It was the product of all this that came to be known as the culturally disseminated style called "the Adam style." Such a capitalist enterprise could only operate effectively, only survive, to the extent that it successfully marketed its name and its style, and it was Adam's great genius to recognize that this cornering of the market could take place only under conditions in which both those who produced and those who consumed the style were educated so as to value its look. This educative mission was, of course, not restricted to craftsmen, since no building could take place without patrons and no patron would commission a building without plans and drawings. Consequently, it was necessary to educate in effect an entire culture, not only the culture of wealthy landowning Britain but also the technical support that would imaginatively present this new taste and then realize it. And in order to stimulate demand for this new look, the eye would need to be educated so that patrons might buy into the public collective fantasy that is the "antique style."

It is in relation to this style that Kedleston Hall provides us with an extremely helpful document, since it has preserved in a significant number of details the expression of this taste, commonly referred to as neoclassicism, which swept through mid-eighteenth-century British elite culture. It is the purpose of my varied approaches to the house to get the measure of that taste so that in the second part of the chapter, when an entrance is made into the building itself, the specific spaces articulated by the design and construction of the house can be seen in terms of a cultural imaginary that determined not only how things should look but also how the viewing subject should be. The point of articulation between the two parts of the chapter, therefore, is the reciprocal relation among a publicly available "taste," a cultural form proper, and the specific physical disposition of built architectural space. Moreover, it

is not merely a question of "taste," not merely an issue of decor and decorum, that will occupy the discussion, since the surface of how things look is imbricated within the deep fabric of the political and ideological productions of the cultural domain. The document I will be attempting to read, then, lies deep in the interior of the physicophantasmic cultural monument that is Kedleston Hall. For this reason I will insist on the necessity of gaining access to both the physical spacings of the house and its cultural imaginary.

It is, therefore, appropriate to begin with the actual look of the house, since the public rooms that may be inspected in situ today are in many important respects *exactly* as they were created in the 1760s.[6] Consequently, the initial emphasis on the "physical" spacings of the house should be understood as a point of departure for a material account of looking. My contention here is that architectural space and decorative surface instruct the eye in how to look, and this instruction is part of an educative process that the house itself puts in motion.

One of the distinguishing features of the spaces we are going to encounter is the disposition of the paintings in the public rooms. As has already been remarked, a motivating reason for the construction of this massive and grand building was to house more comfortably (and fashionably) Nathaniel's art collection. In pursuit of this aim he gave precise instructions to Adam as to the location of many of his pictures.[7] These, in many instances, were set into plaster frames in the walls, thereby rendering them immovable and, perhaps as important, therefore effectively unsaleable.[8] The marking of time is everywhere in this monument to the present of culture.

In relation to this collection of paintings it will be helpful to rehearse a few salient details about the developing interest in art collecting for this period, as well as the implicit rules and fashions for the public and semi-public display of artworks. As Iain Pears notes, the period between 1680 and 1760 witnessed the virtual invention of the English art market.[9] Before this time there was no institutional structure for the distribution or sale of artworks; therefore, unsurprisingly, the number of significant collections of paintings in pre-1680 England was small. If this is so, it is also the case that the first half of the eighteenth century saw the creation of substantial collections of art, a list of which would certainly include those displayed at Houghton, Blenheim, Chatsworth, Holkham, Chiswick House, Kedleston, and Burlington House. Many of these collections were put together as the result of and even during the grand tour, but they were also supplemented by purchases from the ever-expanding auction market. In addition to this

burgeoning home market wealthy collectors also enhanced their collections by employing agents in Europe, most commonly in Italy, which kept the flow of imports at a steady rate. As to the hanging and disposition of paintings in country houses there was no fixed rule.[10] It does seem to be the case, however, that particular collectors put much thought into the arrangement of their canvases. Whereas some adopted the scheme of frame-to-frame hanging, others, like Scarsdale, arranged their collections symmetrically around the walls and gave considerable amounts of space to each canvas.[11]

It is difficult to assess how hanging practice developed in the first place and what principles governed its evolution. To what extent does the function of the space determine the hang? Is a public room organized on different principles than a private one is (which is to beg the question over the distinction between "private" and "public" spaces)? At what height should a canvas be hung? How close together and how many in a single room? Which canvases complement each other, and which do not? Where do ideas about hanging practice get discussed, and to whom might one turn for advice about this matter? These questions remain somewhat inert since the archive does not yield up a great deal of information concerning them. We know that a wealthy patron like Curzon discussed such matters with his architects, but what guided his eye in this matter, and how was he educated into desiring or promoting a particular look?[12] One source of information for the wealthy collector was the small number of European galleries, such as the Borghese in Rome, where paintings were symmetrically arranged. Another example, and closer to home, might be found in the hanging practice of auction rooms and the yearly exhibitions; in this case the collector would have seen the crowded hang in which paintings were crammed on walls from floor to ceiling. It is also clear that wealthy collectors took great interest in other rival collections and their disposition; the landscape room at Holkham, for example, was much admired even if less successfully imitated.

As to the thematic aspects of a hang, again a varied practice seems to have been followed. Whereas some rooms might have "naturally" demanded particular images, others had less specific themes to present. The dining room, for instance, was a fairly natural space in which to hang still life renditions of game, food, and so on—this is indeed the case at Kedleston—whereas entrance halls might be the most obvious location for formal portraits of the owner and family.[13] In some houses it is clear that a very precise semiotic space was created by the collection itself so that the viewer is invited to read or decode the hang. The display of the owner's social and familial connec-

tions—either real or boasted—was a common feature of earlier displays of portraiture that were supposed to indicate both a set of political allegiances and a sense of dynastic continuity. The hang in most mid-eighteenth-century houses, however, eschewed this precise semiotics, either by design or because the collection itself was not susceptible of so formal and precise an arrangement. Of course, even in such looser semantically charged environments we can never be sure whether semiprivate systematic meanings are being articulated by a particular combination of images and other decorative motifs.

The problematic status of this uncertainty will become much clearer in the entrance into Kedleston Hall. For the moment it is enough to register that the extent to which a particular hang might be understood in readerly ways is problematic and contentious. This is reinforced when one recalls that the most precise set of rules and instructions governing the disposition of paintings, those found in perspective theory, are by and large ignored in the practice of hanging. These theories uniformly dictate that there is one and only one position from which the image can be viewed correctly, the position termed the true point of sight, which was precisely identical to the position occupied by the artist when he painted the image.[14] Although this form of the rule can most obviously be found in technical treatises on the science of perspective drawing, it was by no means restricted to this specialized domain. Similar instructions are rehearsed, for example, in a primer on the polite arts written for the ladies and published in 1767:

> A proper attention should likewise be paid, in the disposition of a picture, to the posture and attitude the painter and his eye were in when he painted it, as that position must always be most natural. . . .
> Paintings should also be disposed as well according to their quality, as to their beauty. Those pictures whose subjects are comic and humorous should be placed in a dining-room; those of a serious turn, in the salon, hall, or stair case; and landscapes, in a parlour or ground floor.[15]

As noted above, Curzon took great care over the positioning of his paintings and seems to have had something like these strictures in mind. His collection was fairly large; he had inherited around one hundred paintings and bought fifty or so more at London auctions in 1753 and 1759. In addition he instructed an agent, William Kent, to purchase thirty more for him in Italy during 1758, and at the same time he also commissioned a number of pictures from contemporary artists.

Although the collection did not rival the greatest of the day—such as

Walpole's at Houghton—it was substantial enough to warrant a catalogue, printed in an edition of two hundred copies in 1769, which Scarsdale updated as necessary.[16] Such catalogues were increasingly common in the expanding environment of domestic tourism and could be purchased when visiting Wilton, Blenheim, Strawberry Hill, and Holkham, to list a random few.[17] When Mrs. Lybbe Powys visited Wilton in August 1776 she signed the visitor's book and noted that 2,324 people had already been to see the house that year.[18]

Returning to the design of the interiors at Kedleston, it was not only the paintings that were specifically sited; almost every artifact in the public rooms was carefully thought about, designed, and located.[19] In the circular saloon, for example, curved chairs were designed specifically for its curved walls.[20] In fact, as will become increasingly apparent, when the eye roams about the interiors, it registers design everywhere in the field of vision; every surface has its embellishment, every object its space; everything is positioned, in place.

Two small qualifications are required at this point: first, I do not want to suggest that this decorative spacing is unique to either Kedleston Hall or to Robert Adam. Interior design, decoration, has its own part to play in the history of taste, and it intersects with larger movements in the changing fashions for architectural style. Thus, although the Adam style punctuates this grander narrative of the history of styles, and although it may be taken as an identifiably distinct form of interior arrangement and composition from the classical or the rococo, it is also a part of the larger continuum of the history of taste.[21] This is to note that the "Adam style," although distinct from the styles that preceded it, also bears strong resemblances to later forms and, equally, that the neoclassical elegance with which the name of Adam is synonymous is also a feature of the ensemble decorative styles of architects working after Adam. Second, I do not want to imply that the physical arrangement of space at Kedleston remains to this day absolutely unchanged from its appearance in Curzon's lifetime—how could it? We should recall that buildings have histories, and as I have already remarked, the surfaces on which those histories are etched are curiously both resistant and responsive to the passage of time.

Some small points can be made in relation to the "history" that is the building as it has come down to us. In the first place, as I have already had occasion to remark, Curzon changed his mind over a number of significant and not so significant decorative features. Adam, for example, had specified smooth polished columns for the entrance hall, whereas the owner had them fluted in 1775. Adam's original design for the completion of the south side of

the house was, in any case, never constructed owing to a lack of funds.[22] Other changes, such as the removal of the statues from the saloon to the staircase and hall, were effected by Curzon himself from 1787 to 1789, when the decoration in the hall was finally carried out to George Richardson's designs, which amended Adam's originals; and a change of heart seems to have motivated the alteration of the ceiling painting in the dining room from the Zucchi scheme, in place in 1769, to what is there today, which comprises a central panel by Henry Robert Morland of *Love Embracing Fortune* and four oblongs depicting the seasons, executed by William Hamilton in 1776 or 1777.[23]

Whatever the force of these changes Kedleston nevertheless remains a space that is substantially a document bearing witness to mid-eighteenth-century decorative taste and architectural design.[24] A visit to the house today creates an experience as close as one gets to standing with one foot in the second half of the eighteenth century; the eye moves around the highly ornamented spaces of these rooms, alighting on furniture, carpets, chimney-pieces, fire grates, ceilings, mirrors, decorative motifs on the doors, walls, door handles, almost all of which were designed and made specifically for their precise locations by skilled craftsmen, skilled in the dissemination of the "Adam style." One can see the pictures still in place, the arrangement of silver on the sideboard as Horace Walpole would have seen it, the books in the library cases as Arthur Young would have noted, the gilt on the coffered domed interior as glittering as it appeared to Boswell. Here, if anywhere, the fantasy of history winks to us in the field of vision. In such surroundings it is difficult to resist the lure of heritage consciousness.

All of this would seem to point to the arresting of time; the intention of the building, as it were, is to mark a point in time (not of course a single point at all) at which this cultural artifact came into being. That point is etched into the south front: 1765. This tablet, so clearly and pointedly present, should not be mistaken for a foundation stone; it is as distant as one can get from the convention of marking the point at which a building symbolically commences. On the contrary it is a label to a monument, a declaration of intent, an exhortation that the visitor join the amicable company for whom the building was constructed. In its arresting of time it marks history, not in a naive way, imagining that it can stop the progress of time, but by signaling its here, its now as one moment memorialized in and through this monument. Furthermore, it sets out to instruct viewers so that they might look with the building, look in its time, not as spectators on an idealized and fantasized past, as consumers of a prepackaged heritage culture, but as actors, spectactors who participate in

the visual environment, the visual culture created by this house. Building for posterity, then, turns out to be building for the present.

Second Approach: The Adam Style

Style stages a continual contest with time. A style that we might recognize in our own time as, precisely, style, that is contentless embellishment, usually has a very limited half-life. It falls into the debris-strewn backyard of consumer culture and, once there, decays into insignificance, rapidly becoming incomprehensible. Our contemporary fascination for, indeed obsession with, style is a mark of our fear that such insignificance is the postmodern state of things. The postmodern has become, in fact, a history of the present-presence of style, and its seductions are grounded in the fear that the present is only style, contentless history. This explains in part the rapidity with which styles come and go, as if the satisfactions of our current images and imaginings of the present are no longer accessible or available in the now of lived experience, as if they are only present to us as history, in the immediate past of yesterday's fashion. But style has not always been held in such uncertain regard; indeed, one of the ways an era makes its identity known and felt is through the deliberate and systematic cultivation of a style.

Eighteenth-century Britain was the location for the most extensive and rigorous examination of taste and the ideologies of the aesthetic that Western tradition knows. This complex tradition articulates a set of debates touching on issues such as the nature of aesthetic experience, the relationship between aesthetic affect and ethical principles, and the form of aesthetic objects. Sewn into this dense fabric is a weave concerned with taste, which is taken to be indicative of the internalization of aesthetic judgment, and this "taste" has an object, something at which it is directed. Taste is a taste *for* something. One such thing is style, and this object is both made in the address taken to it, that is constructed by taste itself, and a commodity susceptible of exchange and marketing. Style, in what has become a cliché, not only makes the man but also makes money. This will become very apparent in my second approach, a narrative of the creation of the Adam style.[25]

Robert Adam was born into an architectural family on July 3, 1728. His father, William Adam, was the best-known and most widely employed architect in the Scotland of his day; and the family, being from lowland gentry stock, was well connected to the fashionable intellectual circles of early-eighteenth-century Edinburgh. Robert began his career by working with his

father, but his desire to rise to the top of his profession necessitated that he move away from Scotland in order to practice almost exclusively south of the border. He was successful and established himself by 1770 as the most influential architect and interior designer working in Britain during the second half of the eighteenth century.

Robert's early work, carried out in Scotland under the aegis of his father's practice, conformed largely to the prevailing taste of the day, although the interior decoration at Hopetoun that Robert took over after the death of his father shows some signs of the "revolution in taste" that was to come. To understand that revolution and the Adam style more carefully, we need to look at Adam's real training, the internalization of antique style he deliberately set out to accomplish on his grand tour.[26] Adam was on tour between 1754 and 1758, during which time he visited Nimes, in France; Portofino, near Genoa, in Italy; Florence; and Rome.[27] The story of this tour has been told a number of times, so there is no need to repeat what is by now a well rehearsed narrative in the secondary literature. Instead, I will extract from that story a genetic narrative of the Adam style in order to track the education of Adam's eye and pencil.

It is clear from Adam's grand tour correspondence that he himself understood his sojourn in Italy in terms of the education of the eye, a training that required him to learn not only the skills of draftsmanship but also those that would help him construct a wealthy client base on his return home. This courting of potential patrons also determined that he should pick up some "paper" qualifications along the way to impress and reassure future clients. Accordingly, by 1757 he had become a member of the Academy of St. Luke in Rome, the School of Design in Florence, and the Institute of Bologna.

For similar reasons on his journey through France he had developed his social skills—although he never became very good at nor did he learn to like gambling, the popular pastime of the young milords. He writes home that he purchased the requisite fashionable dress and began to adopt behavior fitting for a young man of culture—although he was hardly so young, nearing thirty at the time. His incidental exposure to French architecture may have been more influential than is often claimed, especially in relation to the variation in style and decor of the public rooms of large houses. His training proper, however, began when he met the French draftsman and painter, Charles-Louis Clerisseau, in Florence. This man was to be the most significant influence on his education.

Adam promptly engaged Clerisseau as his tutor and left Florence for

Rome, where for the next two years he was to undergo the most thorough education in taste, in how to look and how to draw, and, more important, in stone-awareness, how to read culture from the stones it left behind. It is this attention to the remains of a past culture, to the stones that prompt fanciful and fantastic reconstructions of the buildings they once constituted, that was to prove the key to success. In this regard it was equally important that Adam received instruction not only from Clerisseau but also from Giovanni Battista Piranesi, the great virtuoso of the capriccio, the imaginative, fantastic "re-creation" of antiquity.[28] It was Clerisseau, however, whose guiding eye and hand Adam first encountered, writing that even after just one week in Clerisseau's company he believed his taste improving every day—it was becoming "more free, more grand, and more masterly."[29] He hoped to "have my ideas greatly enlarged and my taste formed upon the solid foundation of genuine antiquity. I already feel a passion for sculpture and painting which I before was ignorant of, and I am convinced that my whole conception of architecture will become much more noble than I could ever have attained by staying in Britain."[30] Clerisseau, for his part, commented that Adam was "very ignorant of architecture when he came to me, except the gothic: But I put him off that and gave him some taste for the antique."[31]

Up until this point Adam's tour had been a mixture of socializing with the right people—an extremely important factor in the winning of commissions on his return home—and light tourism to the famous sights. But on entering Rome all this was to change; Adam was overwhelmed; there was so much to see, so much to take in. An early letter, for example, has Adam waxing lyrical about the Pantheon, where "the greatness and simplicity of parts fills the mind with extensive thoughts, stamps upon you the solemn, the grave and the majestic and seems to prevent all those ideas of gaiety or frolic which our modern buildings admit of and inspire."[32]

But wherever he went in Rome, there seemed to be something more to record, something to educate his eye. It was, therefore, extremely sensible to set up a surveying enterprise in his lodgings, which were shared with Clerisseau and any number of other painters and draftsmen. This venture would be instrumental in the transformation of his own style into the Adam style, since what it amounted to was a process of cornering the market in images, imitations of antiquity. To begin this enterprise he engaged "painters, drawers &ca., to do the fountains, the buildings, the statues and the things that are of use for drawing after and for giving hints to the imaginations of we modern devils."[33]

At the same time he was "buying up all the books of architecture, of altars, chapels, churches, views of Piranesi and of all gates, windows, doors and ornaments that can be of service to us. In short, I intend to send home a collection of drawings of Clerisseau's, my own and our myrmidons' which never was seen or heard of either in England or Scotland" (152). This vein continues in much of the correspondence from Rome, making it evident that Adam perceived his route to commercial and aesthetic success back in England as lying in his cornering of the market in representations of classical buildings, statues, and decoration. In one letter, for example, he lets on that many of the English artists and other students in Rome "feared him as the populace do the Pope" for the vast number of purchases in pictures, drawings, and other virtuosi he was making" (187). He quite simply set out to buy up and copy what would prove to be the source for the Adam style. But it was not only the purchase of these styles that would enable him to become the greatest architect in mid-eighteenth-century Britain; there was another crucial element: the internalization of these forms from antiquity so that his own style, his own identity as an architect, was essentially constructed in and through his identification with the remains of classical antiquity, an identification effected through his pencil and in his fantasy constructions based on his copying the remains of ancient culture. In another letter he claims that some of the cognoscenti he had met on his travels had assured him that he would be "the remover of taste from Italy to England" (190), a comment that precisely captures the appropriative sense in which Adam apprehended his task.

The purchase of all these books, statues, busts, casts, and antique ornaments—by the autumn of 1755 they filled an entire room of his lodgings (they were later displayed at the brothers' London premises)—would also serve as helpful props for his future career in London. For Adam was not only creating a style that could be marketed to meet the demands of taste; he was also cataloguing the history of this taste, providing an archaeology for it. It was not only Robert Adam, of course, who was engaged in this activity; it was a newly created preoccupation for the culture he was to present to itself. Not only were societies such as the Society of Dilettanti formed for the excavation and promotion of antique culture, but individuals like James Stuart and Nicholas Revett were similarly engaged on the recovery and presentation of antiquity.

Adam was acutely aware of the fact that he was not the only person onto this—Rome was full of aspiring Englishmen finishing their education in similar ways. He marked out William Chambers, who had already been in Rome for six years at the time of Adam's arrival, as his greatest potential

rival, as indeed he proved to be. Consequently, Adam determined to out-Chambers Chambers, to do in a matter of months what had taken his rival six years; and what this consisted in was drawing, in extenso, the remains of Roman culture (fig. 26). Writing to his brother James he comments:

> When I came here and had had my views confined to Scotland alone I imagined that it would be sufficient for me to enlarge my ideas, to pick up a set of new thoughts which, with some little instruction in drawing I imagined would be sufficient to make one who had seen so much carry all before him in a narrow country where the very name of a traveller acquires respect and veneration to no great geniuses. There you have rivals, and these not unformidable: you have people of real taste, and not few of them. The first will do all they can to destroy real merit and the others will judge and from that condemn or approve. For this reason it is evident that unless one can appear equal if not superior to these antagonists, so as to acquire the preference from the connoisseurs, all attempts to succeed, even with good interest, won't continue for any tract of time, so that after a little blaze you are sent home with little honour and less profit.

The careful and searching self-assessment continues:

> These considerations made me determine to go to the bottom of things—to outdo Chambers in figures, bas-reliefs and in ornaments, which, with any tolerable degree of taste so as to apply them properly, make a building appear as different as night from day. You'll own the attempt was bold, but nevertheless I have attempted it. I am drawing hands and feet, from which I make the proper advances to full figures and from that to composing and putting any story or fancy together. My progress is as yet very trivial, though Pecheux, my instructor, gives me great encouragement and assures me in three or four months I shall do infinitely better than Chambers ever did or will do. Thus you see, my dear Jamie, *that* obstacle is not unsurmountable. (169)

But before he could do this, he needed to improve his skills of draftsmanship, hence the employment of Laurent Pecheux, a young French painter who put him through a swift course in French academic training. This training was extremely important in the following respect: as we have seen, Clerisseau refused to allow Adam to draw any buildings until he had first learned to draw human figures and landscapes. It was only after this that Clerisseau thought it appropriate to begin drawing buildings. In the same letter Adam writes:

> Clerisseau preaches to me every day to forbear invention or composing either plans or elevations till I have a greater fund, that is, till I have made more progress in seeing things and my head more filled with proper ornaments and my hand more able to draw to purpose what I would incline, as he very justly says that

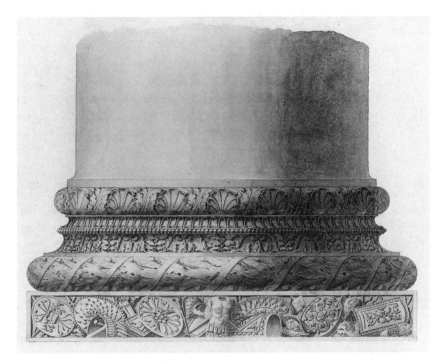

FIGURE 26. Robert Adam, drawing of neoantique column base. Board of the Trustees of the Victoria and Albert Museum, London.

inventing indifferently and drawing so-so ornaments is to fix these in your head and to prevent your getting into the taste of better ones. (169)

This training in draftsmanship, and more specifically in renditions of human figures and landscapes, was immensely important since it gave Adam the ability to sketch for his clients fantasy projections that imaged to this culture its inheritance of the past, coupled with its desire to be modern. Adam pictured the cultural fantasy of an antique heritage mediated through the utmost refinement of the present of style; in this way he gave a face to taste itself. And he did this in ways that were instantly recognizable to the young milords of the grand tour. Whereas academic architectural drawings—both of antique buildings and of projected modern constructions—presented buildings without the patina of accumulated history, without the soft focus of the picturesque, Adam learned from both Clerisseau and Piranesi how to present images of a past culture that were not only more accurate representations of how ancient Rome looked to eighteenth-century tourists but were

also how these tourists fantasized the look of their own culture.[34] In a sense what Adam was learning to do was to make antique Roman culture come alive in the fantasy life of mid-eighteenth-century British gentlemen—enabling the identification of the present through the phantasmic construction of the past—and to make it come alive in rural Derbyshire moreover. He learned how to transcribe the aesthetic affect of his own experience of Roman architecture and the plastic arts in order to conjure up and animate the past so that it might provide the materials for his "invention" of a distinctively modern look. In one letter from Rome we can glimpse something of that affective experience; he writes, "I am returned to my studies to feast on marble ladies, to dance attendance in the chamber of Venus and to trip a minuet with Old Otho, old Cicero and those other Roman worthies whose very busts seem to grin contempt at my legerity" (205).

Antique Rome not only existed in the statues and monuments Adam was daily sketching; it was also becoming a part of his "real" lived experience, as if he were learning to project himself into a fantasized space midway between the historical period of antiquity and the contemporary moment of the invention of a new style. It was not for nothing that while in Rome he called himself "Bob the Roman." For Adam there was a lived continuity between the stark classicism of ancient architecture and the natural forms that intrude more insistently into the picturesque. This is why what is sometimes taken to be the later "picturesque" Adam style should more properly be understood as one element in this educational training; indeed, the connection between buildings and natural forms, perhaps the great hallmark of neoclassicism, was everywhere around Adam in the ruins he drew. For example, figure 27 is a fantasy, not an accurate copy—in fact, it provides the source for one of the sketches Adam made for the dining room at Osterley (fig. 28), and these imaginary constructions were an extremely important feature of the Adam style: they represent one of the ways that style looked to clients, what they saw as the look of modernity, in contrast to how that style now looks to us from the evidence of those buildings and decorative schemes that were realized and have survived. Another example is provided by figure 29, a sketch of a ruined castle executed once again for Osterley; in this case the pictured ruin was supposed to be an imaginary fortified precursor for the current house.[35] The ruin was never built, but it demonstrates the allure of Adam's promotion of the look of a modern adoption and adaptation of antiquity. The culture in which he was working and which he partly helped to create was suffused with an awareness of the past, with the need to recognize and

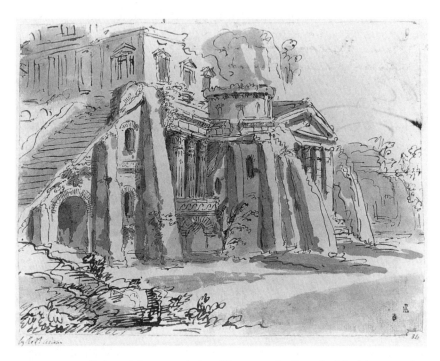

FIGURE 27. Robert Adam, capriccio of Roman ruin. Board of the Trustees of the Victoria and Albert Museum, London.

negotiate either a real or an imagined past in order to feel comfortable with the achievements of the present. It was a culture both supremely self-confident and reliant on its proclaimed genealogy, both self-assertive and retiring. In this climate Adam's skills as a draftsman were to prove invaluable, since they enabled him to present designs to his client that came with the pedigree of history, the patina of antiquity, and at the same time presented the look of the now. Adam, as an architect, was selling something more than a set of designs or the promise to construct a building; he was picturing a collective fantasy to a culture that was making itself over in its image of the modern. The now. 1765. So it was that Adam's style became the style of Adam, a style that proclaimed its firstness by its name and embodied the cultural imaginary in its look: The Adam Style.

Adam returned to England during January 1758 and almost immediately busied himself with beginning his professional career. He was elected a member of the Society of Arts on the first of February and commenced practice as an architect based in London, where he was to remain domiciled

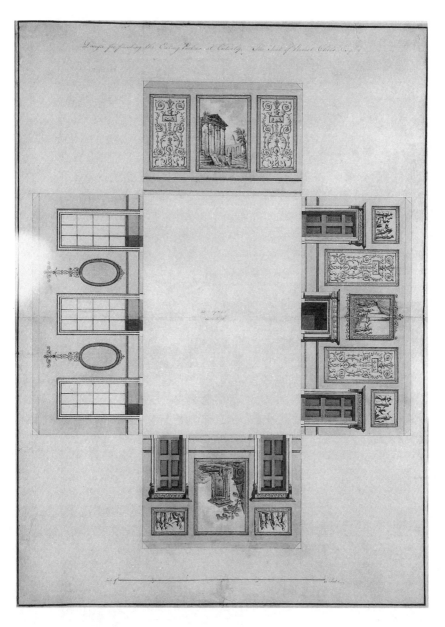

FIGURE 28. Robert Adam, Osterley Park, design for dining room. Board of the Trustees of the Victoria and Albert Museum, London.

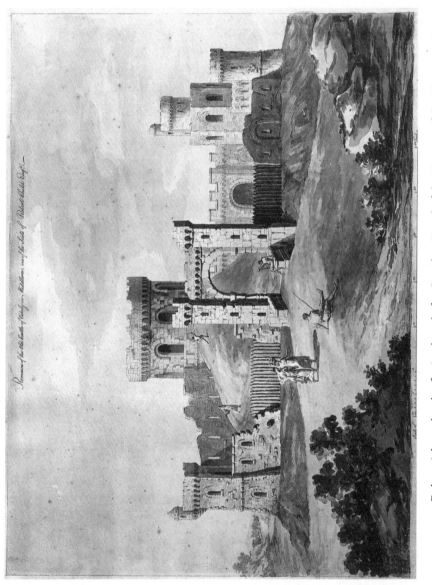

FIGURE 29. Robert Adam, sketch of ruined castle for Osterley. Board of the Trustees of the Victoria and Albert Museum, London.

for the following thirty-four years. His younger brother James joined him after his own tour of Europe, and together with his three brothers he was to build the business empire that set its stamp on the architectural and decorative style of Britain for the next fifty and more years.

Perhaps the most important feature of this immensely active capitalist enterprise was its employment in depth of the master craftsmen of the age—among them the cabinetmaker John Linnell, the sculptor Michael Spang, and painters Angelica Kauffman and Antonio Zucchi—many of whom worked on a number of Adam projects.[36] It was above all a collective enterprise that operated with considerable success and growing commercial power in an expanding market. It was not afraid, for example, to take on lengthy litigation over its exclusive right to manufacture moldings for ceilings in the so-called Adam style or to self-finance vast speculative building projects such as the Adelphi.[37]

If this was the business practice, what was the commodity they were selling? What is the "Adam style"? I will begin with some indicators of its *look*. It is, as figure 30, illustrating one of Adam's interior designs, shows, primarily an ensemble that compounds motifs from neoclassical and Renaissance design—the griffins, sphinxes, altars, caryatids, urns, and putti one finds throughout the Adam interior. Adam was not the first to create such interior spaces—James Athenian Stuart's rooms at Spencer House are usually credited with originating this total design—but he developed the look so systematically that the overwhelmingly distinctive feature of his interior work is the ensemble.[38] As I noted above, at Kedleston Hall Adam worked his decorative schemes around the precise placing of specific pictures, but such detailed design did not stop here. It might include the ceiling and matching carpet, skirting board and dado rail, door frames and handles, chimneypieces and fire grates, and furniture and a host of other objects that were all supplied to clients, as shown by figure 31, a chimneypiece designed by George Richardson for Kedleston.[39] It does not take much to observe that all this could never have been accomplished by one man. Herein lies one of the keys to understanding the dissemination of this taste: its deeply rooted foundation in an awesomely complete capitalist enterprise that included a developer's and builder's company, William Adam and Co., a brickworks, a timber business and stock of wood, a drawing office in Edinburgh and London, a stone and paving business, interests in granite quarries, and shares in a firm of builder's suppliers. This vast design conglomerate not only employed some of the finest craftsmen of the age, but it also mobilized an enormous workforce of some three thousand men according to David Hume.[40] The business, in

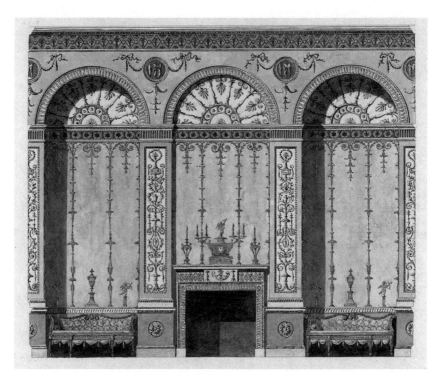

FIGURE 30. Robert Adam, design for one of the walls in the book room (1768); pen, ink, and watercolor. National Trust Photographic Library/John Hammond.

short, aimed to market a style, a look—the Adam style—and to provide an efficient business empire that could deliver this style to its clients.

It would perhaps be misleading to suggest that there is one "look" that adequately conveys the Adam brothers' "revolution" in domestic design. Although the so-called Etruscan decorative scheme is, for example, often linked with the Adam style, the period in which the Adam brothers realized fully Etruscan decoration is very brief.[41] It would also be misleading to suggest that the Adam brothers single-handedly revolutionized mid-eighteenth-century interior design. In many respects the work of Kent prepared the way for the ensemble design that is the hallmark of English neoclassical interiors, whereas at the other end of the chronological sweep of the century it is the work of James Wyatt, which has so often been taken as the exemplar of the "Adam style" (and in many cases Wyatt's work has in the past been misattributed to the Adam brothers).[42]

This is to recall the difficulty of assigning a point of origin to any one style;

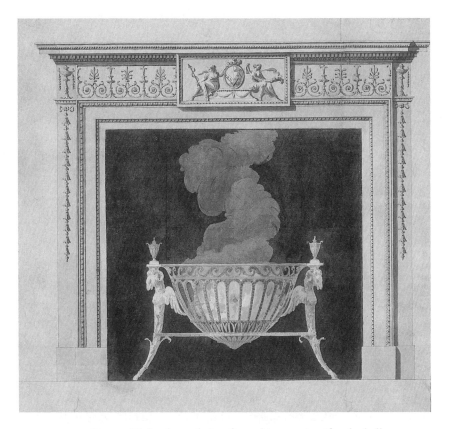

FIGURE 31. George Richardson, design for a chimneypiece for the hall at Kedleston (1775); pen, ink, and wash. National Trust Photographic Library/ John Hammond.

indeed, the history of taste confounds any attempt at grounding a decisive moment when one style ends and another begins. I have already remarked on early-eighteenth-century Britain's growing interest in both Roman and Greek architecture and interior design. Such interest was stimulated by the discovery of the paintings and frescoes at Pompei and Herculaneum that began to be published in the form of designs from 1757 onward.[43] Architects and amateur enthusiasts such as Kent and Burlington had already initiated the taste for Palladian architecture in the early decades of the century, and indeed many of Kent's interiors are closer to what is called the "Adam style" than is often supposed.[44] Not surprisingly, then, the Adam brothers were working within an already defined context of design and taste; they had learned their first principles under their father in Scotland, and even if Robert's sojourn in

Rome was, in effect, a complete retraining, the continuities of style as a general cultural form nevertheless exerted their pressure on the Adam look.

It is, then, significant that the brothers' *Works in Architecture*, published in 1773, claimed to have brought about "a kind of revolution in the whole system of this useful and elegant art." As the introduction to the *Works* states, their style is to be understood as entirely new:

> The novelty and variety of the following designs will, we flatter ourselves, not only excuse, but justify our conduct in communicating them to the world. We have not trod in the path of others, nor derived aid from their labours. In the works which we have had the honour to execute, we have not only met with the approbation of our employers, but even with the imitation of other artists, to such a degree as in some measure to have brought about in this country a kind of revolution in the whole system of this useful and elegant art.[45]

There is clearly something of the promotional about this, a certain *chutzpah* that was perhaps necessitated by the financial difficulties the brothers faced at the time of publication.[46] But there is also a claim being staked out over the ownership of a style, a decorative look, that had become, exceptionally rapidly in fact, the dominant form of interior design and decoration for a specific section of English society.[47] The rapidity of this change in style needs addressing before we return to its actual look. Part of the explanation for the speed of adoption lies in Adam's outstanding business acumen. From early on, while in Europe in fact, he recognized that if his reputation were to be made, he would need to construct a client base from the highest echelons of society; indeed, part of the raison d'être for the grand tour (which was extremely costly to his family) was to meet young milords who would engage his services on their return to Britain. This client base was necessary because the architecture he wished to build and the revolution in taste he proposed to effect could be realized only with the backing of great wealth. Thus, on his return to London he was constantly looking for introductions to the wealthy landowning elite who would buy into the "antique style." It is typical, for example, that on first meeting Nathaniel Curzon in 1758 he wrote to his brother:

> I revised all his [Curzon's] plans and got the entire management of his grounds put into my hands, with full powers as to temples, bridges, seats and cascades, so that as it is seven miles round you may guess the play of genius and scope for invention—a noble piece of water, a man resolved to spare no expence, with £10,000 a year, good tempered and having taste himself for the arts and little for game.[48]

In a similar vein the dedication to the king in the *Spalatro* volume reads:

> All the Arts flourish under Princes who are endowed with Genius, as well as possessed of Power. Architecture in a particular Manner depends upon the Patronage of the Great, as they alone are able to execute the Artist's plans. Your Majesty's early Application to the Study of this Art, the extensive Knowledge you have acquired of its Principles, encourages every Lover of his Profession to hope that he shall find in George the third, not only a powerful Patron, but a skillful Judge.
>
> At this happy Period, when Great Britain enjoys in Peace the Reputation and Power she has acquired by Arms, Your Majesty's singular Attention to the Arts of Elegance, promises an Age of Perfection that will compleat the Glories of your Reign, and fix an Aera no less remarkable than that of Pericles, Augustus, or the Medicis.[49]

The headlong rush into this new "antique" style was, therefore, partly incited by Adam and partly a result of his shrewd tapping of a set of interests—a taste—that had been developing within midcentury polite culture.[50] The "Adam style" was, in effect, a montage and imaginative recreation of various antique styles—Roman, Greek, Etruscan—that were becoming increasingly familiar either through the medium of printed designs—Stuart and Revett's *The Antiquities of Athens*, for example—or through firsthand experience of the ruins of antiquity on the grand tour. Consequently, the taste for the antique did not originate with Adam, but it was, manifestly, exploited by him.[51]

Although this style comprised many distinct aspects—stucco, grotesques, highly patterned decor, small-scale wall and ceiling painting—it nevertheless came to be very strongly associated with the name of Adam. In this respect it matters little whether the Adam brothers were in any sense original; what matters is whether they brought about the revolution in taste they claimed to have initiated.[52] What is not disputed is that the brothers set out to market a style, to create a look that spoke for and presented a socioscopics founded in a culturally disseminated set of values that were associated with "good taste," the taste for the antique. Indeed, one could only claim that good taste and espouse those values through the look that so eloquently spoke for them.

Certain technological developments aided them in this endeavor, such as the advances made in the molding of stucco ornament, which led, as has been noted already, to a court case over the copyright of specific stucco patterns. Other improvements, such as the fabrication of ormolu, were adopted seamlessly into the total design ambitions of the look.

The most notable experiential feature of this style is the sense of ventila-

tion created by an Adam interior. When one stands in the state dining room at Syon or the library at Kenwood, the senses are constantly stimulated by the delicacy of the decorative motifs. The feeling is one of lightness, of an airiness to the enclosed space allied to an intense sensation of motion, movement, as if decorative surface might at any moment change its look, transmute into another, different arabesque, almost as if a play of light sequentially illuminated different features of the design that appear to alter in front of one's eyes. In this way the interiors *are* completely distinct from their immediate predecessors; indeed, they are precisely the opposite of the heavy-handed Palladianism of Kent's decorative work at Houghton, for example. This was, of course, the effect Adam intended. He writes in the preface to the first volume of *The Works*:

> But on the inside of their edifices the ancients were extremely careful to proportion both the size and depth of their compartments and panels, to the distance from the eye and the objects with which they were to be compared; and, with regard to the decoration of their private and bathing apartments, they were all delicacy, gaiety, grace, and beauty.
> . . . But at this same time the rage of painting became so prevalent in Italy, that instead of following these great examples, they covered every ceiling with large fresco compositions, which, though extremely fine and well painted, were very much misplaced, and must necessarily, from the attitude in which they are beheld, tire the patience of every spectator. Great compositions should be placed so as to be viewed with ease. Grotesque ornaments and figures, in any situation, are perceived with the glance of an eye, and require little examination.[53]

If Adam had a theory of design, a philosophy of architecture, it is to be found here in his sensitivity to the eye, to its needs, desires. Indeed his training in Rome was little more than a thorough examination and stimulation of the appetites of the eye; it was, in a profound sense, Hogarthian. It was his unique talent that prompted him to recognize the distinctive feature of what he took to be antique decorative traditions. This feature was its promotion of the glance over the gaze, and it was this that Adam exploited in his architectural designs and decorative schemes.

Thus, the first thing to note in the above quotation is the distance of the eye, that which determines *how* one might address a specific space. Adam states that if one crowds the ceilings with fresco compositions, the viewer must strain to make out what is going on; the distance is too great; the eye becomes exhausted, fractious, the look fragmented. This is why grotesques, which Adam defines as "that beautiful light style of ornament used by

ancient Romans, in the decoration of their baths and villas," are favorable. They can be viewed "at a glance."[54] In this case the tension of the look is relaxed, the distances uncritical, and the eye flits from surface to surface, delighting in the variety of decoration, the sheen and glitter of the reflective surfaces. In the concluding section of this chapter I will argue that these distinct modes of looking are not only connected to the appetites of the eye; they also participate in the construction of particular forms of subjectivity: when the eye is distracted, worn out, the subject loses patience with itself, becomes fractured, fragmentary.

This will become clearer once entry into the spacings of Kedleston has been effected; certainly Adam's strictures on the distance of the eye will reverberate, since everywhere in Kedleston's interiors surface demands that it be seen at a glance, that the eye remain unquiet, restless, on the move. Surface and depth, nearness and distance, frame and image: these boundaries are constantly invoked, constantly traversed as the viewer is placed in a very precise set of architectural, cultural spacings of the look. The overall effect of this experience is the recognition that everything is composed, that one's own viewing position is the result of careful design: the position occupied by the viewer is itself composed in and by the look. I will argue that this results in the viewer's catching him- or herself in the activity of viewing; as if one looks on oneself being made into a viewer in the adoption of the look demanded by this space. Here space tells the viewer how to look, and looking tells the subject how to be.

My approach to that space is nearing its conclusion, but before the entrance proper I want to explore in a little more detail what I called Adam's theory of design. As I have already argued, the Adam style self-consciously advertised itself as "antique," but in so doing it was certainly not claiming to be in any sense reconstructive; Adam was not by a long shot an antiquarian and was not proposing to re-create Roman domestic interiors in mid-eighteenth-century houses, nor was he trading on a form of heritage consciousness in which nostalgia is encouraged for a past that is naively taken to represent a golden age.[55] He was creating a taste, a thoroughly modern taste, out of a fantasized projection both backward, into the past, and forward, into the present of style, the present of polite culture, the present of the publicly available private ethos of civic virtue. Consequently, these interiors are supposed to *look* a certain way, to look part Roman, part Grecian, part Etruscan—indeed whatever materials were deemed appropriate—but were not supposed to *be* Roman, Greek, or whatever. Adam was, in effect, delivering upon his

friend Piranesi's dictate about the modern artist, who to "do himself honour, and acquire a name, must not content himself with copying faithfully the ancients, but studying his works he ought to shew himself of an inventive, and, I had almost said, of a creating Genius; and by prudently combining the Grecian, the Tuscan, and the Egyptian together, he ought to open himself a road to the finding out of new ornaments and new manners."[56]

The attitude to history here is appropriative, not respectful; it promotes a kind of confident raiding of the past to create what Adam called a "fund," a library of past and present styles that could serve a specifically modern invention. But, equally, this moment of invention itself stands in a relation to posterity, and it is that future that must also be appropriated if the look being promoted is to stand the test of time, to remain the apogee of taste. For this to happen the architectural space itself must instruct and inform the viewer how to look, to look with its contemporaneity, and it is precisely this that Adam set out to realize.

If this is the sense of history, of time in his architectural and decorative theory, the articulation of space is also understood in relation to modes of temporalization. In *The Works* Adam, ventriloquizing through his cousin Robertson, comments on the principle he held above all others in the matter of harmonious design: movement. The famous passage reads:

> *Movement* is meant to express, the rise and fall, the advance and recess, with other diversity of form, in the different parts of a building, so as to add greatly to the picturesque of the composition. For the rising and falling, advancing and receding, with the convexity and concavity, and other forms of the great part, have the same effect in architecture, that hill and dale, fore-ground and distance, swelling and sinking have in landscape: that is, they serve, to produce an agreeable and diversified contour, that groups and contrasts like a picture, and creates a variety of light and shade, which gives great spirit, beauty and effect to the composition. (46)

Adam is clearly thinking pictorially here—indeed, his fairly constant use of the word *picturesque* as a term of approval points to the same conceptual frame—as if architectural form, that is the spaces articulated by these forms, might be viewed under the same conditions and with the same aesthetic affect as pictures. The pictures he has in mind are sentimental, affecting picturesque landscapes that direct the eye in very precise ways.[57] This movement of the eye, in and around the image, is an analogue of the eye's traversing architectural space as it picks up detail here and there, restlessly skidding over the play of surfaces presented to it for its delight. But as I

argued in the previous chapter, the taking of a view in the visual experience of landscape positions the viewer in very specific ways, siting the viewer, presenting a subject position to be adopted, inhabited. In relation to the arguments I have made in the previous chapters, Adam's "movement," the experience of time in the viewing activity, is closely related to the temporalizing modes of aesthetic experience generated by the regime of the eye. As such it is antipictorial in the sense of its antipathy to high art images—history painting, for example—dispensing with the pre-educated academic eye demanded by the regime of the picture in favor of an educative process initiated and guided by the viewing experience itself. With movement you must let your eye go, let it be led, let space tell you where to be. To look at the Adam style, one needs to be open to its temporalities, allow oneself to be flooded by the time of the look. That is Adam Style.

In my third and final approach to Kedleston, Adam's fantasy projection of the present-past, his version of historical consciousness, will be translated from the pictorial to the discursive in a verbal analogue of his picturesque compositions.

Third Approach: A Tour to Derbyshire, 1779

The splendours of the county of Derbyshire have no rivals.[58] Pre-eminent among these is the Duke of Devonshire's glorious sylvan seat. Alas many of the entertaining waterworks for which this parkland is eminently renowned have been removed, but the house itself is magnificent. The extent and weight of a building is always of capital importance. The planting here is very fine, though not such pleasing variety as at Rousham. The most disagreeable park encountered so far was Lord Huntingdon's. The house is tawdry and placed in a hole, with two absurd assemblie rooms containing a few forgettable family pictures. The want of luxury is often at the expense of taste. Nothing can prepare one for the first impression of Lord Scarsdale's, which is quite the most palatial house we have yet seen.

The approach to this palace, for palace it certainly is, if there is such a thing in England, is through an avenue of old lofty oaks, which, leading to a bridge, over which you cross, brings you immediately in front of the mansion. Here you first pause. The exact dimensions of the building are given in Lord Scarsdale's guide; it is certainly sufficiently large to admit of every idea of grandeur and of magnificence. The house is situated on a gently declining hill, with woods and lawns diversified, and a widening rivulet running in

front. The main body of the building is very noble with a fine portico supported by pillars, and a flight of steps up to it. The wings are at some little distance and join'd to the main body by corridors.

The effect of the front is not as heavy as one might expect; the niches containing statues give the building an air of somber grandeur; the wings are almost separate houses, but they sit uncommonly well in the complete design. The back front is all elegance and feminine beauty, not at all the monstrous weight we were led to expect from the massy portico.

We knocked at the visitor's entrance and were admitted into the servant's hall under the portico. Our first task was to sign the book kept to record the names of visitors, and, having done so we were shewn up into the Grand Hall where the housekeeper joined us. Of all the Housekeepers I ever met with at a nobleman's House, this was the most obliging and intelligent I ever saw. There was a pleasing civility to her manner which was very ingratiating, she seem'd to take a delight in her business, was willing to answer any questions which were asked of her and took care to refer us to Lord Scarsdale's catalogue which accompanied us on our tour. She was also studious to show the best lights for viewing the pictures and setting off the furniture.

The room we now stood in is called by Lord Scarsdale "the Greek Hall." It is, indeed, a most superb hall, the sides and ceilings of which are most beautifully ornamented, and the whole supported by four and twenty massive pillars of variegated alabaster finely fluted. The stone has been cut from Ld Scarsdale's estate, and the room measures a magnificent 60 feet by 30. Here indeed the senses become astonished. The alabaster pillars have a wonderful appearance; the other ornaments, likewise, carry their intrinsic proportion of elegance. The walls are painted in chiaro obscuro, the subjects taken from Homer. There are two beautiful oval paintings over the chimney pieces, the one Ceres and Arethusa; the other Apollo and Hyancinthus. The panels of the doors are of Clay's paper manufactory.

There are five statues in the Hall, the best of which are an Apollo Belvedere, a Medicean Venus, Meleager, dancing fauns etc. There are 12 stands for lights each containing 3 candles, and the effect of the whole when lighted up must appear like the palace of an enchanter. In a word, the whole strikes as if it were designed for a more than mortal residence; nor are the other rooms of the mansion inferior.

Behind the Hall is a domed saloon, the grandeur and magnificence of which is unsurpassed in England. Here one enters a temple consecrated to the finest taste and pinnacle of elegance. Johnson's comment—"useless and

therefore ill contrived"—strikes me as unwarranted, and his distaste for the pillars in the hall as containing a distinct dose of envy. Taken together the grandeur and magnificence of these two rooms is unsurpassed in England. Here one stands in a temple consecrated to the finest taste and pinnacle of elegance. An exemplum of the modern form of building which, as Dr Baillie remarks, conveys the most sublime ideas of great riches, power and grandeur.

The evidence of great riches is everywhere present; before we entered upon the estate we had heard that the village had been removed to its present site, and that hills have been levell'd and canals dug for the splendid cascades in the park. No expence has been spared in the decoration of the house which has, like Chatsworth, gilt sash frames without. A most splendid effect. In the Music room there is a pretty organ by Adam, and throughout ceilings by him which convey a great lightness. There are fine pieces of furniture, including some settees supported by gilt fishes & Sea Gods which look like the King's coach. These latter appear slightly absurd.

There are many pictures throughout by Wooton, Pieters and Wilson. A Death of the Virgin, fine small picture and said to be by Raphael. A small holy family by Alex. Veronese. A fine Claud, fine old Man, Salvator, but a very bad large History. The library contains the most capital picture, Daniel interpreting Nebuchadnezzar's dream by Rembrandt. The drapery of this is exquisite, and the rich gloss of the velvet out works nature. The saloon, one of the most elegant rooms I ever saw, gives an immediate impression of space and light. It is predominantly white with gilt lozenges in the dome which recede in size up to the sky-light. There are pictures on the walls of ruins and executed by William Hamilton.

In sum the house is the most splendid temple to modern taste, not at all vulgar or over emphatic, even if the ensemble of palace and park is too expensive for Ld Scarsdale's estate. In point of architecture and ornament it exceeds any I have yet seen. It bears the foremost rank amongst English country seats.

ENTRANCES

First Entrance: Spacing the House

In the first part of this chapter I presented three ways of approaching Kedleston Hall, three distinct but overlapping narratives that set out to prepare one for the physical spaces of the house. It is time now to enter those spaces and to attempt to inhabit the look. The first entrance will be relatively

unreflective; essentially I will be attempting to present the physical enclo-
sures of the house via the photograph. The second will be more sensitive to
the issues surrounding the activity of looking. The house is approached
through the park, affording a view of the north front and the full mass of the
central block (figs. 32 and 33). From this distance the house seems to be in
its "natural" setting, the rhythms and repetitions of the architecture blend-
ing into the parkland that rises behind it. The scale is grand but certainly not
overpowering—as one might say of Castle Howard or Blenheim, for exam-
ple.[59] As one nears the building, features of the facade become more appar-
ent, most notably the three statues that surmount the portico (figs. 34 and
35). Approaching still closer, one sees four niches in the wall; these contain
another four statues. Higher on the facade five medallions add to the build-
ing's decorative surface. The columns are in the Corinthian order, a feature
repeated in the massive, overwhelming entrance hall.

When one enters this room, without windows, twenty columns and
pilasters twenty-five feet high immediately strike the eye and create the open
space of the hall (fig. 36). They are carved from local veined alabaster and
fluted. The ceiling contains arabesque stucco patterns executed by Joseph
Rose to the designs of George Richardson. The room measures sixty-seven
feet by forty-two feet. It is without doubt one of the grandest interiors con-
structed in a domestic setting in eighteenth-century England. The over-
whelming experience is one of scale and grandeur—of wealth. The decora-
tive registers are not obviously *English*, except insofar as English style has
appropriated classical forms and made them its own. The most insistent fea-
ture of the room, however, is its *scale*, which produces a slightly daunting
visual environment, as if the eye is unable to settle, remain still, attentive.
This sense of volume both embraces the viewer on entry to the room and
produces a resistance to our attempts at gaining entry into it, being within
its spacings. This dichotomy is partly the result of the slightly forbidding
decorative ensemble that seems to be exacting a price for entry: one needs to
be immersed in classical culture in order to register the significance of the
decorative motifs, statues, and pictures that adorn the room. And this, one
senses, says something about the expectations governing who the viewer
might be, what she or he knows, what values he or she holds dear.

This, at first sight anyway, is a good attempt at an accurate narrative of
the entry into the physical space of Kedleston Hall. This entrance is certainly
far less welcoming or seductive than the comparable architectural example of
Holkham Hall, where Kent's brilliant solution to the potentially unwelcom-

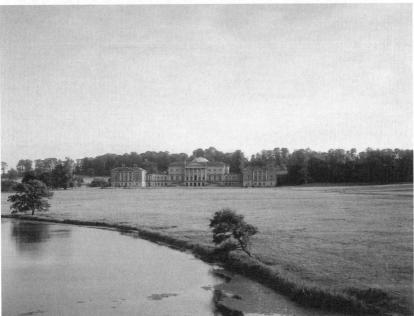

FIGURE 32. (top) Kedleston Hall, approach from the park. Photograph by the author.

FIGURE 33. (bottom) North front of Kedleston Hall viewed across lake and park from bridge. National Trust Photographic Library/Matthew Antrobus.

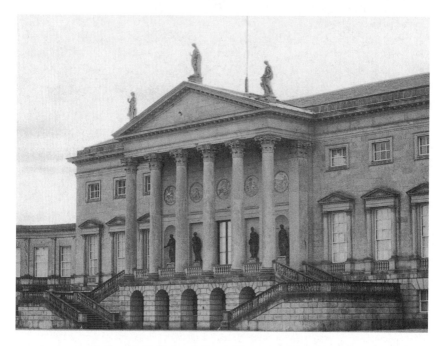

FIGURE 34. Kedleston Hall, north front. Photograph by the author.

ing or unreadable space produced by the monumental scale and classical feel of the entrance hall was to place an extremely simple main doorway, reduced in size to a modest human scale, on the court front of the house at ground level. Consequently, we enter the building by moving from the ground floor to the piano nobile, ascending the stairs in a clearly seductive embrace that welcomes us into the classical spacings of the otherwise monumental and forbiddingly awe-inspiring hall.[60] Thus, by the time we reach the first floor, the height of the room has significantly diminished, and we have, as it were, miraculously become enlarged. By dint of this brilliant architectural device the overwhelming scale has been humanized, and we are co-opted into a visual field that will henceforth reflect back to us our membership of a culture fully immersed in the values of classical antiquity.[61] Adam very seldom had the opportunity to realize his own attempts at surmounting the problems of entry into such grandiose architectural volumes because he designed and built very few buildings from the foundations up—most of the great Adam centerpieces are remodelings of extant spaces. At Syon, for example, where there is a similarly classical entrance hall, Adam had to work within the constraints of the existing Elizabethan building. In this case there is

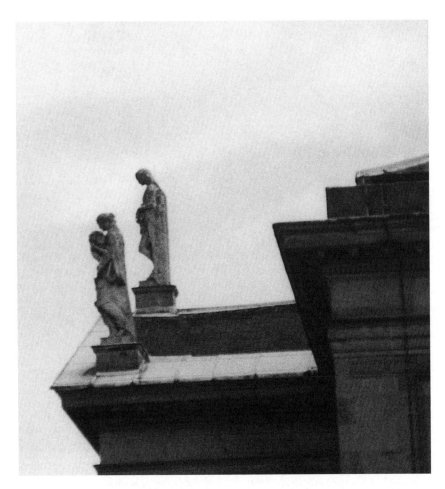

FIGURE 35. Kedleston Hall, north front, detail of two statues. Photograph by the author.

almost a sense of shock as one moves from the exterior to the interior: it is as if one has stepped out of one culture and vernacular—high Elizabethan English—into another—republican Rome.[62]

At Kedleston, Adam had more leeway since the house was undergoing planning and construction when he joined the project. Nevertheless, what I have called the seduction into an informed look to be found at Holkham is not imitated at Kedleston. This is partly because of the repetition of the architectural forms of the facade in the hall itself. This, far from humanizing the scale of the building, in fact amplifies the sense of scale as the viewer

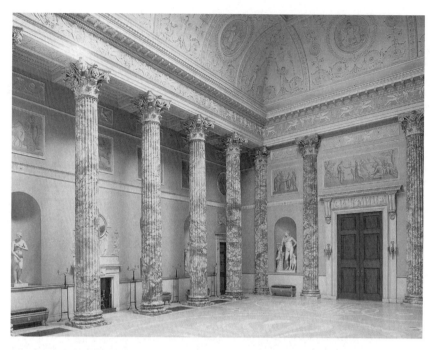

FIGURE 36. Kedleston Hall, Marble Hall. National Trust Photographic
Library/Nadia MacKenzie.

moves from the portico into one of the grandest rooms in England, lined
with alcoves containing statuary and sectioned by vast fluted alabaster
columns with Corinthian capitals: all features that have already been pre-
sented in the approach to the house. This link between inside and outside is
intensified by the lack of strong color anywhere in the room, as if the palette
has been deliberately restricted to this tonal range of monumentality, of
stone. In this aspect the entry into the decorative ensemble of Kedleston
Hall feels very different from the entry to Syon. At Syon the scale is smaller
yet, more surprising, the feel of the entry hall more civic, perhaps more
public since the room has a quality of the functional about it: it seems set up
for the business of some kinds of social or economic transaction—perhaps
deliberately gesturing toward the origin of the medieval hall house. It could
be a public exchange, a forum for public debate. But at Kedleston the setting
is domestic, albeit grandiose; its public function is contained within a set of
private idioms. Thus once in the room, and once the eye has recovered from
the shock of monumentality, one begins to note that, as with all the public

rooms, decorative surfaces abound. The fireplaces are highly ornamented, the overmantels of the interior doors contain stucco, and the stone floor displays an inlaid pattern of radiating Italian marble. The eye, then, at first is overwhelmed; the visual field strikes the eye dumb with its scale, as a single glance fills up the eye. The viewer momentarily becomes stoned-blind. But this single gestalt of monumentality soon gives way to the hunger of the eye. The second pulsation of the view takes the eye toward the surface, where, once again, the visual field is also full. Consequently, there is a doubled structure to the view: the eye is first compacted by the gawp of awe, but when it recovers its balance, it initiates a restless inquisitive movement from surface to surface in a series of skidding glances. This structure of looking that establishes the viewer's entry into the visual field constructed in and through these interior spaces is going to be played on time and time again as one progresses through the circuit of the house, and by now it should be clear that it operates under the constraints of the regime of the eye.

Some of this surface embellishment of the entrance hall can be gleaned from the following illustrations, which, in the decontextualized form of the photograph, give an even greater sense of the obsession with *detail*. Thus figure 37 shows the painted panels above the chimneypiece—Hyacinthus and Apollo—and figure 38 Diana and Arethusa; and around the walls there are monochrome panels depicting scenes from Homer (fig. 39).

What kind of space is this, and what is it saying? What is it stating as its *look*? At first glance the room would seem to be a public space full of publicly available signs that take their cue from Roman architectural and decorative traditions. It cries out to be read: here, if anywhere in this house, textuality seems to beckon from the field of vision. But is the play of surface decoration and embellished material so dependent on an informed look, on the regime of the picture? Do these volumes and articulations of a saturated visual field require that the viewer already be educated, at ease with its *look* before encountering this monument to the owner's taste? Given that Curzon produced a catalogue to the house that in great measure supplied the information needed, may we conclude that he did not expect every visitor to arrive already in the know?

What about the function of this room rather misleadingly designated the "entrance hall"? Are its spaces heroic and ceremonial or private and social? If it is a civic, public space, how publicly available is its semiosis? Indeed does this space have a precise semiotics at all?[63] If one compares it with Northcote's decorative scheme for Vanbrugh's entrance hall at Blenheim, the difference is immediately apparent. Blenheim was the first nationally endowed public

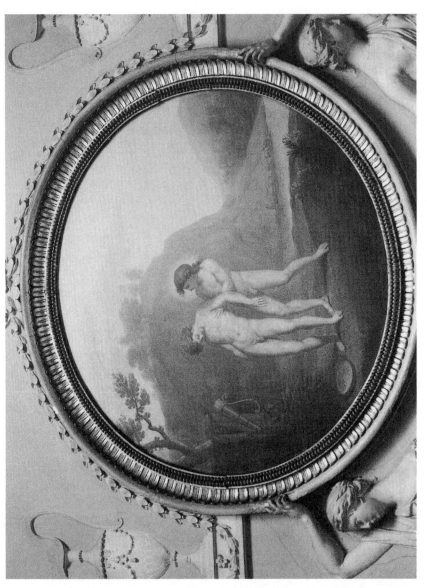

FIGURE 37. Kedleston Hall, Marble Hall. Painted roundel above chimneypiece depicting Hyacinthus and Apollo. Photograph by the author.

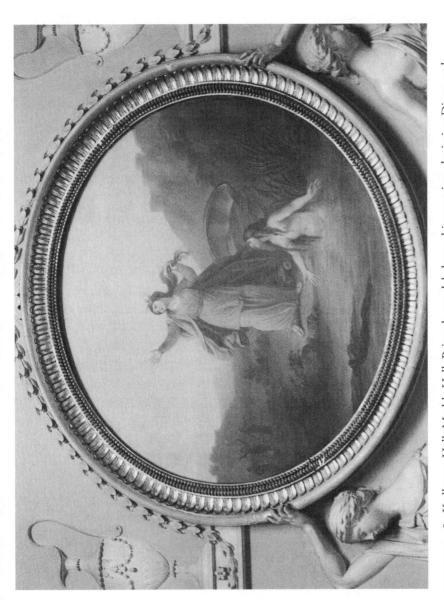

FIGURE 38. Kedleston Hall, Marble Hall. Painted roundel above chimneypiece depicting Diana and Arethusa. Photograph by the author.

FIGURE 39. Kedleston Hall, Marble Hall. Monochrome panel depicting a scene from Homer. Photograph by the author.

monument in Britain, and as such its spacings are clearly, indeed imposingly, semiotic. It is difficult to look here without recognizing that the building, its interior spaces and decorative surfaces, convey a message; the building is a text, and as such it requires reading, its articulations of volume and space, decor and design require decoding. If the architectural and decorative ensemble of Kedleston can also be understood as a text, its meaning is certainly less public; moreover, I will argue that as the circuit of the house progresses, it will emerge that the aim of the spaces created by Curzon, his architects, and craftsmen was to engender a set of affective responses to the lure of visuality. These responses guide the viewer in the movement away from the semiotic gaze via the superficial glance toward the sentimental look.[64]

This is not to say that a narrative sequence is completely absent: there is in fact an easily identifiable narrative to the tour of the rooms. This narrative is, substantially, a conventional presentation of the content or material of culture itself. Thus, moving through the rooms to the east of the central axis takes one through the well-worn steps of the sister arts. First in sequence is music (music room) (fig. 40), followed by painting (drawing room) (fig. 41) and literature (library) (fig. 42).

The most notable effect of the egress from the hall into the music room is the explosion of color. The largely monochrome facade and restricted spectrum of the entrance hall, its lapideous registers, gives way to the vivid pinks of the music room. This entrance into color creates significantly different distances of the eye, something Adam was acutely conscious of and regularly exploited in his interior decorative schemes. But it is not only the entrance into color that should be remarked; the transition from the hall to music room also marks a movement from a perplexing unreadable space, the entrance hall, which almost insists on raising the question of its function, meanings, place in the culture that surrounds and sustains it, to a space far more comfortable and comforting. In this way there is a kind of visual relaxation, an eye-bath of color and incident, accompanied by an inhalation of the oxygen of fashionable style. In this room the present of style speaks far less ambiguously, presenting its values of craftsmanship and respect for expensive materials. Skill, invention, and good taste are valued over the possible distractions of a publicly available historical narrative; dwelling with the surface glitter is here preferred to systematic semiosis. Consequently, the eye does not feel compelled to *read* these spaces; on the contrary it delights in the profusion of decorative surface.

This relaxation of the visual enclosure is apparent in all three rooms on the eastern axis. They present both a familiar and a comfortable feel; the signs of culture itself, of music, painting, and literature are easily recognized, thereby allowing free rein to the darting playful delight of the glance. It is overwhelmingly clear that here no expense has been spared and no ingenuity either: the present of style, the now of taste, proclaims the infinite perfectibility of this culture's modernity. This is an age in which material is ingeniously turned and shaped, woven and molded, carved and gilded in the overmastering service of *design* (fig. 43). And design here says that nothing but nothing is beyond its powers, beyond the reach of style. So it is that the viewer is inducted into a socioscopics in which the eye almost forgets to notice the monumental effort, the sheer willpower, that has gone into the

FIGURE 40. Kedleston Hall, view of the music room, looking toward the organ. National Trust Photographic Library/Nadia MacKenzie.

FIGURE 41. Kedleston Hall, drawing room. Photograph by the author.

meticulous attention to detail that everywhere threatens to engulf the visual field. The grain of wood, gilt of frame, weave of carpet, filigree of stucco, stitching of fabric—all these and more saturate the visual field. The eye is charmed, the senses delighted everywhere by the sheen and shimmer of the object, the sparkle of designed space.

If this is the immediate appearance of these rooms, there is nevertheless a secondary pulsation to the viewing activity that follows on the heels of this restless glance. And in this secondary view the gaze returns in the attitude of inspection fostered by the regime of the picture. These rooms on the eastern axis sit on the cusp between the public and private; indeed, they might be said to investigate the permeability between the two. Thus, the move into the rooms dedicated to the arts not only announces the material of the cultural domain itself, proclaims something about the public realm and needs and desires; it also states something more private, whispers something about the owner of the house. Whereas the "public" references of the circuit concern the content of culture, the "private" explore and display the many ways

FIGURE 42. Kedleston Hall, library. National Trust Photographic
Library/Nadia MacKenzie.

FIGURE 43. Kedleston Hall, gilt chair. Photograph by the author.

in which one man, the owner of the house, is cultured, a citizen of the polis of taste. Furthermore, he is also, manifestly, a guardian of that public culture by dint of his tasteful collection and provision of an appropriate space in which to display it. *Public* and *private* here are terms that designate distinct aspects to virtue, distinct approaches to an ethics and politics of behavior, and both are, as it were, publicly available. The political and ethical spin this gives to the spacings of these rooms is, I will insist, embedded in the *visual*; it structures the *look* both of these rooms and in them; it determines how we are led into a socioscopics that is being promoted by this house. Curzon, like Tyers at Vauxhall, recognized the benefit of the harmonious combination of the regime of the picture with the regime of the eye. Thus, as the eye moves from its primary activity of glancing, it adopts the pose of the gaze in order to look more studiously on the objects presented to view, submits first to one regime and then to another. Prime among these objects are the paintings that adorn the rooms and that, as I have already suggested, provided one of the main reasons for the construction of the house. The gaze, then, alights on images that in and of themselves are understood to have merit, therefore repaying the investment of long and studious attention; but they also have a decorative function, whereby the content of culture itself is signaled.

Thus, in the music room most, but not all, of the pictures have a musical connection, like Rosselli's *Triumph of David*, which hangs over the organ, or the orizzonte landscapes on either side of the chimneypiece, which depict peasants dancing and playing bagpipes. Although this musical theme is one of the motivations behind the hang, another, that of the display of "great works," prevails in other rooms. The drawing room, for example, was intended to contain the most capital pictures in the collection, which is of course appropriate for the room dedicated to painting. Here the gaze is in the ascendant as we look on works the contemporary catalogue attributed to Raphael, Carraci, Andrea del Sarto, Claude, Tintoretto, Parmegiano, and Guido Reni. But even here the gaze is constantly interrupted as one moves around the room in order to set the image in its best light.

This introduces a distinct temporal register to the viewing activity. In the hall there is relatively little to distract the eye, although the different perspectives that open and close as we move around the columns create a temporalizing aspect, almost as if one were moving through a composed landscape. But this aside, the view is, by and large, taken in at a glance, hesitating only here and there in order to register a grisaille panel or a tablet on the chimneypiece. In the three rooms that follow, the movement of the eye is

more varied, halting at some moments, rushing on at others; and this movement of the eye is transposed into a set of gestures, of precise somatic attitudes, physical positionings within the rooms. At one moment the eye moves close to inspect a tabletop; at another it retreats to assume the correct distance to a specific canvas. This pulsation in the viewing activity and its correlative adoption of distinct attitudes—physical spacings of the body and eye—creates a perceptual experience in which the viewer becomes increasingly familiar with the traversing of the boundary between gaze and glance, public and private spaces. The eye is being inducted into another way of looking as the educative progress through these rooms continues.

From the library we enter the saloon, a rotunda forty-two feet in diameter and sixty-two feet from floor to top of the coffered dome (fig. 44). It is almost impossible to convey the extraordinary sense of expansion one feels on entering this room. Walpole, who visited the house before it had been completed, called this room and the hall "temples," which adequately conveys the closest analogy for these spaces.[65] I will return to these two crucial rooms, which take up the entire central axis of the main body of the house, after completing the remaining part of the circuit lying along the west axis. The domed saloon opens on to those rooms devoted to hospitality—the so-called principal apartment, containing the anteroom, dressing room, state bedchamber, and wardrobe—and the circuit concludes with the dining room (fig. 45).[66] This room restates the principal theme of the educative progress in its ceiling decoration, where originally in the four corner roundels Adam had placed representations of sculpture, painting, music, and architecture.[67]

Of course, photographs can only very schematically convey the actual visual experience of standing in these remarkable rooms. Nevertheless, something of the surface of these interiors can be conveyed by the illustrations following. For example, it is relatively clear from them the extent to which everything has been designed, from the mirrors (fig. 46) to the heating system (fig. 47) disguised by Adam's cast-iron altars; everything seems to fit its precise space—this goes for furniture as well as for paintings (fig. 48). Images of femininity abound, especially around the focal point of many of the rooms, the fireplace, where in the state drawing room or in the dining room carved full-length female figures in the form of caryatids or terms uphold the mantels (fig. 49).

What I want to concentrate on, however, are the two most spectacular rooms, the hall and the saloon. These were described by Lord Scarsdale in his 1769 catalogue to the house as "the greek hall and Dome of the Ancients, proportioned chiefly from the Pantheon at Rome and from Spalatra."[68] In

FIGURE 44. Kedleston Hall, view of the saloon. National Trust Photographic Library/Nadia MacKenzie.

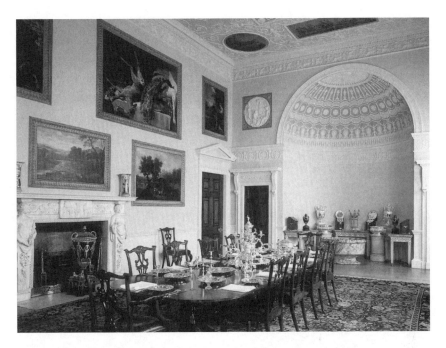

FIGURE 45. Kedleston Hall, view of the dining room. National Trust
Photographic Library/Nadia MacKenzie.

the first part of this chapter I gave an account of Adam's training in Rome
and of the development of the Adam style; here the Roman domestic archi-
tecture he had studied for two years surfaces in the grand statement of these
two rooms. In the volume on the ruins at Spalatro, Adam, through the
mouthpiece of Robertson, presented his views on the architectural disposi-
tion of Roman interiors:

> From the Porticus we enter the Vestibulum which was commonly of a circular
> form; and in the Palace it seems to have been lighted from the roof. It was a
> sacred place, consecrated to the Gods, particularly to Vesta (from whom it
> derived its name) to the Penates and Lares, and was adorned with niches and
> statues. Next to the Vestibulum is the Atrium, a spacious apartment, which the
> Ancients considered as essential to every great house. As the Vestibulum was
> sacred to the Gods, the Atrium was consecrated to their Ancestors, and adorned
> with their images, their arms, their trophies, and other ensigns of their military
> and civil honours. By this manner of distributing the apartments, the Ancients
> seem to have had it in view to express, first of all reverence for the Gods, who had
> the inspection of domestic life; and in the next place, to testify their respect for
> those Ancestors to whose virtues they were indebted for their grandeur.[69]

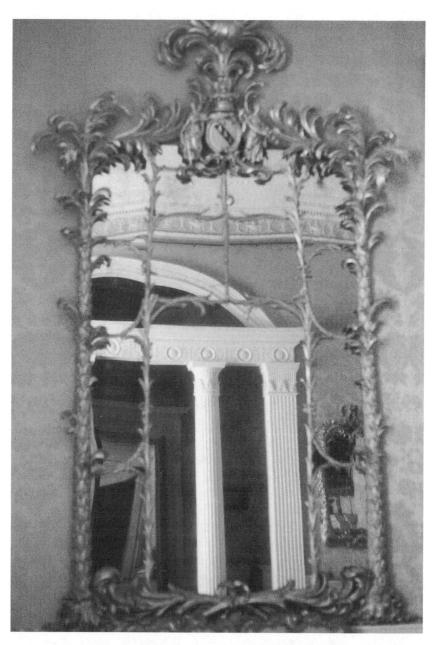

FIGURE 46. Kedleston Hall, mirror. Photograph by the author.

FIGURE 47. Kedleston Hall, heating system in saloon. Photograph by the author.

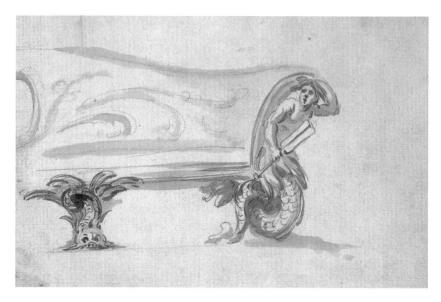

FIGURE 48. Sketch design for a sofa, attributed to John Linnell (c. 1762). National Trust Photographic Library/John Hammond.

When this description is linked to Lord Scarsdale's own comment about the house—"proportioned chiefly from the Pantheon at Rome and from Spalatra"—it becomes very appealing to imagine that the intention behind the creation of these spaces was to allude to those classical models.[70] However, it is useful to recall that these classical forms were transported in both time and space to mid-eighteenth-century Derbyshire. When they got there, the working of the scheme was subjected to the historicization of the look itself. The hall, according to the strict scheme outlined by Adam, is to be taken as the atrium and should, therefore, contain images of ancestors. If one were to interpret the scheme precisely and literally, the two statues that were originally placed in this room, the copies of Apollo and Meleager, ought to be understood as representations of ancestors—certainly a rather hubristic gesture on the part of an eighteenth-century British aristocrat. The saloon, again going along with the Roman model, is to be taken as the vestibulum and should be dedicated to the gods; here the original scheme, which grouped the statues of the Venus de Medici, Capitoline Urania, Belvedere Antinous, and Mercury and the dancing faun, in this room is closer in spirit than the reworkings Curzon executed in the 1780s. The strict working of this scheme is, however, at odds with the educative purpose of the house; it sug-

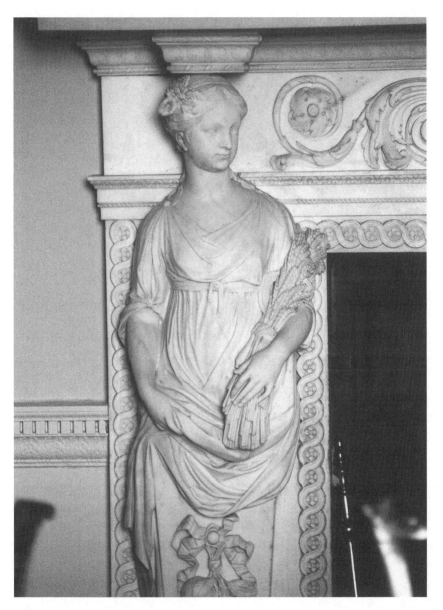

FIGURE 49. Kedleston Hall, caryatid in dining room. Photograph by the author.

FIGURE 50. Robert Adam, one of five designs for the library at Kedleston Hall (1760); pen, ink, and wash. National Trust Photographic Library/John Hammond.

gests a restricted and precise semiosis to these spaces that is "publicly" available; moreover, it demands a form of looking that depends on an already educated eye, a culturally centered viewer who recognizes the signposts presented. Not only do the alterations in these rooms suggest a slackening of this rigid semiotic spacing, but the progress of the rooms themselves and their handling of volume and surface suggest that something else is going on, something complementary but also more open.

Thus, if there is *a* message in these public rooms it is more general; indeed, I have already remarked its overarching theme: the content of culture. And, in harness with this, it proclaims the owner of this house as a cultured man, infused with civic virtue, good taste. The genealogy of that taste has been explored in the first part of this chapter; here its look is presented to the viewer, who is invited to inhabit the cultural imaginary of one section of eighteenth-century British elite culture. It is important to remember that this taste is an invention, a fantasy, a cultural imaginary that reflects self-image back to this elite class. Here we should recall that Nathaniel Curzon never made the grand tour; he made it to the continent for one month during 1749, when he visited France, Belgium, and Holland; therefore, he could

FIGURE 51. Design for a grotto, attributed to Robert Adam (c. 1760s). National Trust Photographic Library/John Hammond.

only have known such Roman classical buildings and interiors from drawings or paintings he had seen. It seems likely, for example, that during the first meetings between patron and architect, Adam, who set great store by his training as a draftsman, outlined his ideas on design by showing his client drawings conveying the sense of "classical" interiors and architecture. Certainly some of the executed designs for the interiors convey the antique style very clearly (fig. 50), whereas the exteriors are reminiscent of the "capriccio" he learned to draw while in Rome (fig. 51).

Curzon could only have imagined what these monumental Roman build-

ings looked like, only fantasized what it might have been to stand in the spaces created by them.[71] Accordingly the use made of an imagined tradition of decorative and architectural style was not in the service of antiquarian authenticity. Adam was not creating the spacings of pastiche, and still less was he interested in the pieties of heritage. What the viewer is supposed to recognize and adopt for him- or herself is precisely the fantasy here presented in these workings of design and decoration; that is to say, the viewer is coerced into recognizing that this *is* a fantasy. He or she is won over by the look, co-opted into these confident assertions of the modern, of style as the ultimate technology. And this fantasy is not a private cliquish property available only to those already in the know, for the purpose of the house is to induct each viewer into this public-private space, and it is space itself that coerces us into this cultural imaginary. This, for a brief moment in the mid-eighteenth century in Britain, is the fantasy of culture itself.

Second Entrance: Being in the Look

Architecture creates and opens up spaces for being (and not simply "living," as recent characterizations of architecture's conceptual manifold have it). But, more than this, it also opens into being, which is to note its enabling functionality as regards our ability to know and understand what it is to be. At one moment architecture distills our sense of location, intensifies the sense that space, place bounds being, thereby giving access to the exclusive attention to being here, in this place at this time; at other moments it works in the opposite direction, taking us far from the physical space we currently occupy, shattering the sense of being here as we come to recognize our estrangement from the now, the here in a kind of etiolated temporal annexation of presence; as if being here has been stretched into being there. Architecture bounds space but that space is only sometimes measurable, literally a physical space. Architecture lives in the continual oscillation between measured volume and the immeasurable enclosure of culture. Its space is both in time and out of time, both fixed in a set of volumes, a bounded space, and subject to the vagaries of culture and history, an open-ended potentially infinite plastic space-time, stone-time.

Such brazenly speculative remarks doubtless seem uncomfortable in the context of the highly specific argument I have been presenting so far. But they are offered in response to the actual experience of standing in the spaces of Kedleston; how they might be warranted will be explored in this final section.

I will commence by outlining some of the distinctions I have drawn over the course of this book between different kinds of address to and insertion in the visual field, that is, to the phenomenology of viewing. I have argued that the educative progress of the rooms at Kedleston maps out an itinerary through a distinct set of visual and visualizing spaces: it constructs an enclosure in which visuality becomes visible. This begins with the overwhelming presentation of the antique in the hall, which immediately fills the eye with its monumentality, and moves through more intimate spaces introducing temporal vistas of viewing where the eye cannot register everything at a glance. In the first instance the look is superficial: it responds to the surface look of things. The eye in this case is restless, easily made replete. This is to be distinguished from another kind of looking activity that is steady, directed at particular objects or specific images.

This second kind of look, that which in modern art theory is usually termed the gaze, is static, studious, attentive, penetrative. It involves a mastering of the image, impels the eye to see behind the representational plane. The gaze decodes the image sign. The first kind of look, what Adam called the glance, skids and slides off surfaces in a restless tracking, back and forth, ever moving on to the next surface. It does not demand that the image sign give up its meaning, merely that the visual field is full. Whereas the gaze sets out to read the image, the glance registers the volumes, depths, and surfaces of the visual field. These two kinds of looking also articulate slightly different epistemological assumptions about the nature of the subject who looks. In the case of the gaze the viewer engages in a process of self-ratification, of matching what it knows with what it sees, a kind of reality testing through the penetration of representational surfaces. This form of looking posits the object as having *depth*, that is, as having an outer surface, its representational epidermis, and an inner meaning, the authenticity of its presentation. Such a model of the object corresponds to the form of the subject, which similarly presents a surface to the world while containing an inner reality of self or subjecthood. The gaze, in its penetrative address to the object viewed, sees below the skin of the real self in a process of recognition. The glance has no need of this surface-depth model; the objects it registers in the visual field only have surfaces, and these surfaces, if they are to give back something to the subject, must be taken to be reflective. Consequently, the analogue of this form of viewing for a model of subjectivity supposes that objects in the visual field present reflective surfaces in which the seeing eye glimpses itself; it is grounded in the technique of identification.

With the gaze one must take a proper distance to the object in order to see it, but in the glance distances between the viewer and the object are uncritical since all objects have the potential to reflect back self-image. In contrast to these, by now, conventional positions within visuality I have argued throughout this book that a third scopic technique was developed in mid-eighteenth-century Britain, what I have called the sentimental look, which utilizes both the gaze and the glance but is not constrained by either. It is created through a kind of pulsation between the regimes of the eye and the picture—attentive to both the affect of a visual encounter and the knowingness of the already seen—and we have already encountered it in the discussion of Hayman's large allegorical canvases at Vauxhall and Wright of Derby's candlelights. In the concluding passages of this chapter I wish to lay out, one last time, an extended account of its operation. The most efficient way of doing this is to rehearse the asymmetry between looking and being in the activity of viewing. I will introduce these final remarks by recalling a proposition introduced at the beginning of this study: if space tells the viewer how to look, looking tells the viewer how to be. What I mean by this can be most profitably explored by returning one last time to the "real" space of the public rooms at Kedleston Hall.

It is in the two central rooms of the house, those strangely public rooms, where this proposition can be most extensively explored. In the saloon, especially, I hope to demonstrate how architectural space and decorative surface direct the viewer in adopting a particular gesture that defines his or her identity as a looker. And, as will become clear, the look adopted is a catoptric form in which the subject looks as it imagines itself to be looked at, as if the activity of looking involves an overlooking of the visual field so that one can recognize one's self as a looker. We have come across this spectatorial activity already in Vauxhall Gardens and in the theory of spectatorial subjectivity; now in this monument to culture we encounter it again. This time, however, it is directed at a specific sociocultural identity summed up in the term *connoisseur*.

The spacings of Kedleston are designed to educate the viewer into this cultural type, to seduce us into the gestures of the look. Furthermore, our experience of looking like the connoisseur is reflected back to us in the visual field as we witness others looking, looking like connoisseurs, looking satisfaction. Thus, as we take up the look, inhabit the look of the connoisseur in our adoption of the physical attitude of *inspection*, we catch ourselves in that attitude in the reflective surfaces that surround us. At that moment our pri-

FIGURE 52. Robert Adam, cross-section design for the Marble Hall at Kedleston (1774). National Trust Photographic Library/Angelo Hornak.

vate sense of self, internalized self-image, becomes public, seen by everyone because seen by ourselves, and we enter the collective fantasy that is culture for this house.

This sense of both being here, in the viewing subject, and being there, the object looked upon, has an architectural analogue in Adam's use of the screen found at Kedleston in the state boudoir. The effect of this screen is to create two spaces in the room, an "inside" and an "outside." From the latter one can gain a vantage point on the interior of the room, as if the frame around the picture we gaze on occupies the same continuum we currently inhabit.[72]

This idea of "picturing" space, of constructing a frame around the space to be seen, is a pretty common feature of Adam's architectural and decorative language. The common eighteenth-century use of pedimented doorways inside the house, for example, creates a continuity between exterior and interior. In fact at Kedleston there is a pretty constant invocation of the exterior look of the house in the interior design. Perhaps the most obvious example of this is the repetition of the facade in the marble entrance hall. Figure 52 conveys the relations between inside and outside very dramatically; architectural forms that we more commonly encounter as external structural elements are here transposed into decorative motifs in the interior.

This play around the inside and outside of a bounded space is also a feature of the saloon—a room that, like the hall, seems to lack an obvious function—the enormous empty space in the middle of the room being only appropriate for large meetings or perhaps dances.[73] The dimensions of the room, again in common with the hall, are hardly on a human scale, and its shape reminds one very strongly of a temple or church interior. This sense of suprahuman scale is intensified by the coffered dome (fig. 53) and its skylight, which provides the major source of light for the room. As the eye glances skyward, the receding perspective created by the diminishing size of the rosettes takes the look on up and out of the room into whatever lies beyond, once again articulating the boundary between inner and outer, here and there. The sense of space one gets on entering this room is of course an effect of the contrast between the saloon and the previous rooms in the circuit, which have all been very busy spaces, full of paintings, gilt furniture, objects calling to us from the visual field. But, be that as it may, the overwhelming drive to look up as the viewer enters this room is irresistible. In recognizing this the eye instantaneously falls upon itself, and the viewer comes into its self-description as a viewer. Wherever one stands in the room, this holds true since every position, every somatic spacing of the subject, allows the eye the same panoptic view: onward and upward through the expanding space of the interior out into exterior light that shines through the lantern.

I have said that scale is all important here; it is manifestly so in the case of the pictorial elements of the room, the paintings of ruins by William Hamilton and the chiaroscuro scenes from British history. These are some twenty feet above floor level, far too distant to be seen from the "proper place," the true point of sight, the position occupied by the artist when they were painted. But it is the attitude taken by the body as it registers the distance of awe that I want to focus on. It is this distance, the space between the body of the viewer and the seemingly infinite enclosure that opens up around him or her, that keeps the eye moving between the gaze and the glance. At one moment the eye alights on a painting, adopting the protocol of the gaze, at the next it returns to the speed of the glance as the viewer registers the distance of awe. It is this glance-gaze that I have termed the sentimental look, a third position in which the body and the eye conspire to fragment the postures of both the gaze and the glance. This attitude of the body, more the pose of the gaze than the glance, is struck as the eye looks up toward the images in the walls some twenty feet above. This physical disposition in space requires

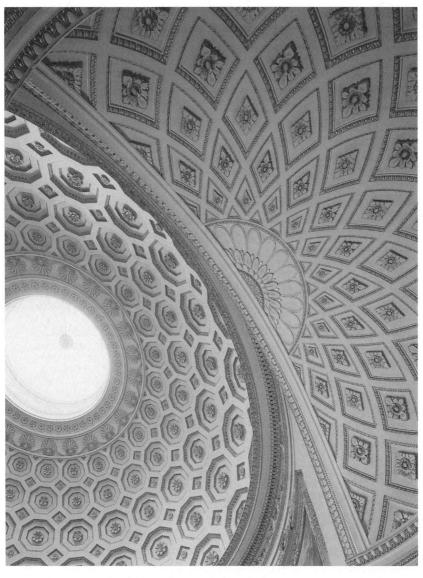

FIGURE 53. Kedleston Hall, saloon, detail of coffered dome. National Trust
Photographic Library/Nadia MacKenzie.

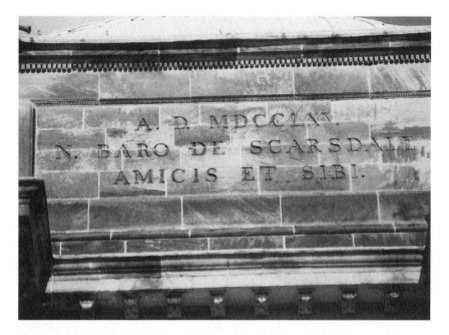

FIGURE 54. Kedleston Hall, south front, detail of inscription. Photograph by the author.

an additional somatic response that is involuntary: the eye demands that it be shielded from the light that, wherever we stand in the room, streams in from above. Thus a pose is struck, an exaggerated attitude of the body in which the arm is raised and the hand cupped, in order to gaze on the distant image; and in striking this pose the viewer is fully immersed in the gestural space of the connoisseur. This physical disposition is described in a primer on the arts:

> When you view a painting, take particular care not to go, like ignorant people, excessively near; but rather, beginning far off, approach gradually, till it appears rough; then recede a little, till it looks sweeter: it is what connoisseurs call finding the proper light of a painting.
>
> An object is best seen when the eye lies in the dark, and the object in the light: for this reason you see some connoisseurs, who make an arch with their hand over the eye, when they look at a piece of painting, as the mind perceives better when the eye is confined, and free from the surrounding atmosphere.[74]

In the private-public rooms at Kedleston the viewer is constantly sited in look of the connoisseur, constantly seeking to adopt the correct distance and

to sustain the correct attitude of the body. In the saloon this spacing itself becomes visible, and we see ourselves reflected in the physical attitudes of others looking like connoisseurs. And, in the recognition that sees self in the other, we finally gain entrance to the socioscopics of Kedleston's spacing. This spacing certainly holds out an ideal, a sociopolitical program that seeks to educate the eye into the fraternity of culture, just as it implies an ethics of compassion, identification with the other. As Curzon and Adam's extraordinary monument reminds us, culture need not be the preserve of the few; it may also be opened up to those with eyes to look and looks to learn. This culture may have been buried under the ideologies of individualism that are in part the legacy of the project this book has been describing; it may have been taken hostage by the sham of heritage consciousness, but in its stone-time this palace of the arts continues to make its claim for something different, something more openly and therefore more deeply committed to the notion that culture might make a difference. Its time, if only we would let it speak, is now and in posterity: 1765 AMICIS ET SIBI (fig. 54).

CHAPTER FIVE

The Sentimental Look

Over the course of this study I have made a case for the emergence during the 1760s in Britain of a cultural form: the regime governing viewing I call the sentimental look. A number of things—institutions, practices, discourses, markets, interests, and, last but not least, individuals—needed to be present at the same time and in a particular alignment or set of relations to enable this cultural form to come into being. And I have also argued that by the end of that decade a number of things conspire against this scopic regime and its associated technique of the subject. This, in effect, decreases rights of access to visual culture: the regime of the picture reasserts its primacy and works in ways to exclude individuals from the polis of taste. But, like all cultural forms, the sentimental look, once formed, does not entirely vanish: it remains *in potentia*, awaiting the moment when an alignment once again allows it to resurface and for it to be enlisted in other arguments about the cultural domain and on behalf of other constituents within the republic of taste. Furthermore, its presence in the culture of visuality after the 1760s is more varied and marked than I may have implied: it depends, of course, on where and how one looks. In this concluding chapter I wish to return to the image and to one of the most significant legacies of the history of looking I have been tracing. As a prelude to those concluding remarks I wish to remain

a little longer with the apparent demise of the sentimental look. Why did it fall from grace so rapidly?

There are two very different ways to answer this question: one takes a miniaturized time frame and attempts to account for the precise factors at work around the end of the 1760s that feed into the construction of a public visual culture. In my first chapter I made some comments along these lines. The second way of thinking about this issue takes a much longer view and places greater emphasis on slowly evolving institutions, practices, and discourses bearing on the formation of cultural forms. Seen from this angle the very same interests that helped in the formation of the sentimental look can also be said to contribute to its disappearance underground. The elaboration of aesthetics from the early decades of the eighteenth century and on into the nineteenth, for example, both provided a conceptual basis for the somatic affectual response I outlined in the previous chapter and, at the same time, pointed the way toward another way of being with the artwork, fully dependent on expertise or ideology, that would end up making strong claims for the contingency of any aesthetic encounter. Under this description our responses to artworks are "subjective" in the weak sense; that is, they are entirely determined by the interests of the beholder. According to this way of seeing things artworks and aesthetic experience are both merely the product of ideology: what I find to be beautiful or moving is simply determined by my own whims, desires, interests, expertise. But arguments on behalf of the sentimental look and an affective experience of artworks that is common, shareable, may be mounted once again, and the peculiar constellation that gives hospitality to that cultural form may once again occur.[1] I have argued that Nathaniel Curzon had hoped to set that constellation in plaster, as it were, all over the walls of his palace of art. We know that such attempts at arresting the onward march of history are doomed to failure, but we can continue to learn from our past even if we cannot inhabit it.

The preceding chapters have set out a number of attempts to recover from the past a cultural form—an activity engaged in by agents in the past: the sentimental look—which is as much the product of my analysis and description as the historical object uncovered by it (the same can be said of the two regimes, of the picture and the eye I derive from eighteenth-century discussions of picture making and viewing). One of my aims has therefore been to push the boundaries of cultural history by testing a hypothesis about a human activity that, to all intents and purposes, leaves no trace. The new cultural history (no longer so new, perhaps) learned much from what is

referred to as the "linguistic turn," and in opening up the terrain of histori-
cal inquiry to many things previously excluded from its domain it has taught
us to see our past with new eyes.[2] Much of that work has been more or less
explicitly concerned with the content of culture and, therefore, with the
meanings of cultural artifacts. More recent work has begun to think hard
about how a *material* history might be written—a history of things or objects
rather than of their meanings.[3] I have also been preoccupied by the materi-
ality of certain cultural artifacts but in ways that depart from much recent
work that takes a "new" materialist approach. My focus has been on the for-
mal properties of a material cultural practice (looking) that has no sub-
stance, no matter. This is what I mean to suggest by stating that the senti-
mental look is a *fully* cultural form: it exists only in the ether of the process
of culture. Given this there is no one place to look for it, yet, as I have
argued, the lineaments of that practice can be discovered in the interstices of
extant accounts of visits to particular sites and in the interconnections I
have constructed between dispersed texts and images.

I now want to say something about the specificity of the historical claims
I have been making since they are, in Janus-like fashion, both extremely
focused and quite general and without tight chronological limits. Thus one
aspect of my historical argument has claimed that the sentimental look and
the culture of visuality arose out of a set of conjunctions coalescing around
the decade of the 1760s. Yet, as I made clear in the first chapter, Hogarth was
already, in the 1740s, developing a strenuous account of the regime of the eye
as a counter to what he saw as the academic view being promoted by rival
artists and commentators on the polite arts. And I have proposed that his
phenomenology of the eye is one of the most significant conceptual supports
for the affective form of vision that I claim results from an encounter with
Hayman's large canvases at Vauxhall or Wright of Derby's candlelights. How
does the fact of Hogarth's intervention in the 1740s (and earlier in his artis-
tic practice) fit with the precise dating I give to the emergence of the culture
of visuality—the decade of the 1760s, when Hayman's and Wright's images
were produced and exhibited for the first time?

Similarly, if one were to situate the garden constructed by Shenstone
within a longer history of garden design, those elements of the landscape I
draw particular attention to were already a feature of some gardens by the
1740s—as at Stowe—and, in any case, Shenstone began the creation of the
Leasowes in the late 1740s. Furthermore, the account I draw on so heavily in
the last third of that chapter—Joseph Heely's *Letters*—was published in 1777.

These (and other) objections can be legitimately raised in respect to the absurdly restricted time frame I claim for the emergence of the culture of visuality. But I return to the difficulties I announced in the introduction regarding the history of a cultural form. There is nothing to look at, no object to be tracked, no archive to be mined, that would yield precise information about *the activity* of looking and the technique of the subject it helps formulate and promote. These are conjectural historical objects. And in the process of *their* formation I have pulled together strands from a number of places and moments that, when seen together in one weave, make those objects visible. I insist, then, that the study of fully cultural entities can work only by this and other means of indirection. What I take to be observable and fully present as a cultural form by the 1760s appears so only when seen from a particular vantage point or according to a specific light. Thus, to return to the above observation about Hogarth, although his *Analysis of Beauty* is certainly an important—indeed a major—contribution to the theoretical articulation of the culture of visuality, it was not taken to be so at the time of its publication. And here I am not making a claim about its insertion within the mainstream of debate and discussion (the influence it had in the period) but about the nature of the historical object I call "the culture of visuality." No one at the time of Hogarth's intervention—or at any other time during the period—would have recognized that culture in the precise terms I have been using to characterize it. It is my invention. Yet, of course, the power and strength of the fantasy that is history leads me to also claim that I have discovered or merely given voice to something that lay deep within the period here studied.

There is another reason for discounting the counterevidence of Hogarth's *Analysis* as proof of an earlier date for the emergence of the culture of visuality, and this takes me back to the comments I extracted from John Brewer's essay on eighteenth-century cultural production. What I understand to be a cultural form could never be the product of any one person's imaginative or intellectual endeavor. In this sense the actors in my narrative—Heely, Hogarth, Hayman, and others—are merely contributors to this generally disseminated process or procedure. In the same way I do not want to suggest that the viewing protocols I have investigated in the previous chapter on Kedleston Hall were either the unique result of the arrangement of architectural space and decorative detail to be found in that house or the intentional creation of Robert Adam, Lord Scarsdale, or any of the other hundred or so people who had a hand in making the building and its contents as they

are. Once again I wish to stress that the sentimental look is a cultural form produced by and within culture. Thus, for example, the design manifold that is Kedleston Hall can and should be compared to similar structures built around the same time. Holkham Hall, for example, would be a very strong contender for a companion since it also was purpose-designed and built to house an art collection, and it also marked time in ways similar to the building of Kedleston.[4] Lord Leicester, the owner, had the following inscribed on a tablet above his front door: "This seat, on an open barren estate, was planned, planted, built, decorated, and inhabited in the middle of the xviiith century by Thos Coke, Earl of Leicester." Noticing this in fact strengthens my contention that the sentimental look is a cultural form—it was dispersed over a wide terrain, disseminated through channels of communication, influence, and emulation that were the bedrock of the cultural domain. But we must also bear in mind that Scarsdale, Adam, and company were, in a very important way, conduits through which certain cultural ideas and energies flowed and that they themselves had some impact on those flows: their own interests, aims, and ambitions colored to varying extents these cultural forms and their transmission. I am not, therefore, claiming that these actors had no part to play in the formation of the culture of visuality and its associated regimes of looking, as should be clear from the previous chapter.

But to qualify the comparison between these two great houses, the design and build of Holkham began in the 1730s (the digging of the foundations took place in 1734), even if it was completed in the 1760s.[5] And although many of the strands of my complex weave were already present to the culture of the 1730s and 1740s, they were not in an identical constellation to that prevailing in the 1760s; furthermore, not all of the elements necessary for the production of the culture of visuality had yet come into being. The formation of the visual culture I have been describing throughout was slow and its progress, as it were, lumpy. Furthermore, any one agent in this story of long and uneven duration could have had only a variable if also interactive impact on the eventual formation of the sentimental look.

Brewer isolates three conditions that, he claims, were necessary for the creation of a public culture, and I want to take them in turn and sketch out how, adapted to my more specific argument about the regime of the sentimental look and the technique of the subject it helped produce, they were present to the 1760s. The first is the growth of an audience for culture. In the first chapter I outlined the concerns eighteenth-century writers raised in

connection with the incredible popularity of the first exhibitions of paintings, and there I remarked that the public space of the exhibition room held a number of attractions, only one of which was the perusal of art. I also made the point that these spaces foregrounded visibility: not only were the sizes and locations of the various canvases of signal importance in respect to their visibility, but everywhere within the confines of the room activities of spectating, looking, gazing, and being observed were performed (fig. 55). In order to be someone in polite society, one must be visible, in the public domain, hence the impulse to have one's portrait painted and to present oneself in the social spaces of polite culture. Similar imperatives fed into the desire to be seen at entertainments like Vauxhall Gardens.

This audience was, of course, primarily made up of the increasingly affluent bourgeoisie, and part of the attraction of these new spaces for display was created by the prospect of encountering one's social superiors: then, as now, the hoi polloi became excited and received pleasure from mixing in company above their station. Culture generally, and visual culture more specifically, provided a terrain within which one might be and become someone else, a space in which one's fantasies might be realized, albeit in the illusory enclosures of representation and self-presentation. Once these delights had been tasted, there was no turning back.

Although public spaces like Vauxhall were being created long before the 1760s and, as I have remarked, in fact the first exhibition of contemporary paintings had been organized by Hogarth in 1747, it was not until the rash of first exhibitions in the early 1760s that the vogue for self-display and observed participation in visual culture became so prominent. Nothing like the crowds queuing up to see these shows had been witnessed before—we might recall from my opening page that the figure of twenty thousand has been suggested for the number of visitors to the 1760 show at the Society for the Encouragement of Arts, Manufactures, and Commerce.

The second of Brewer's conditions is the provision of spaces or places for cultural activity. In relation to visual culture these spaces were legion: rooms could be rented for the display of almost anything; purpose-built exhibition spaces were constructed, pleasure gardens designed, and show houses built. Although auction and commercial displays clearly participated in this visual culture taken in the most general sense, and although many of the objects displayed, such as Wedgwood's porcelain and china, were subjected to aesthetic contemplation (as well as to sentimental forms of appreciation and social intercourse), these commercial exhibitions are tangential to the pro-

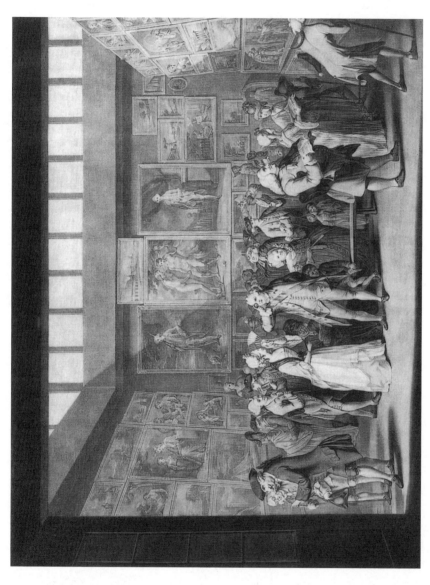

FIGURE 55. Richard Earlom, after Charles Brandoin, *The Exhibition of the Royal Academy of Painting in the Year 1771*; engraving.

motion and creation of the regime of looking with which I have been pri-
marily concerned: the sentimental look.[6] As I have argued, this is developed
within the context of viewing paintings and melds or fuses together the
regimes of the picture and the eye, borrowing a little from each and adapt-
ing where necessary. For this reason the sites of particular importance are
those in which artworks were displayed, hence my interest in the summer
exhibitions in the metropolis and the construction of what were, in effect,
the first public galleries or museums: country houses built by elite collectors.
Although a house like Houghton, built during the 1720s, was explicitly
designed to show off an art collection, and other estates, like Chatsworth,
were adapted over generations to the varying dictates of taste, it was not until
the practice of visiting houses became a relatively feasible pastime for large
numbers of people—enabled by improvements in transport and road travel
and by the financial security enjoyed by a newly affluent class of potential
visitors able to afford the luxury of leisure-time pursuits—that such spaces
began to participate in the construction of a publicly available visual cul-
ture.[7] Throughout the 1740s and 1750s domestic tourism gathered pace and
the enfranchisement of the tourist class continued to expand. By the 1760s
there was an identifiable itinerary for most counties, a collection of estates
that were required viewing, and a burgeoning market in guidebooks hoping
to instruct and entice new tourists. It is symptomatic for my argument that
one such guidebook, Thomas Martyn's aptly titled *The English Connoisseur*,
was published in 1768.[8]

When Nathaniel Curzon began building his monument to posterity, he
knew that it would be visited, and not only by those either connected to him
or within his acquaintance (and the same could not be said of Sir Robert
Walpole's Houghton). He wrote a guidebook to show off his taste and even
built an inn close by "for the accommodation of such strangers as curiosity
may lead to view his residence."[9] And I want to make the strong claim that
the immediate historical context—the 1760s—for building houses like
Kedleston did produce something quite distinct that distinguishes those
houses from both earlier and later building projects. I wish to hold on to this
claim even while recognizing that the room at Kedleston to which I have
paid so much attention, the saloon, was altered from its original design as a
sculpture gallery (which would have made it very similar to the Pantheon at
Stourhead) and only took on its present form between 1787 and 1789. For
what I mean to point to as a *cultural* form has both a distinct outline and
shape and, at the same time, a blotchy or indistinct aspect. It is at one and

the same time like a lens, focusing the many rays of light that hit its surface, and a stain, spreading slowly and unevenly through its surrounding supporting networks. What I claim to be present and visible *as a cultural form* by the late 1760s may, in fact, have a long history of slowly diminishing distinctness; or it may, equally, have such force and power as to have altered the paradigms of visual culture for good (or at least the foreseeable future). I believe this to be a good, if partial, account of the effects of the culture of visuality since I think we continue to live in significant ways in the time of the eye produced by that culture.

Thus I *am* claiming that the specific social, political, and, above all, *cultural* conditions necessary for the emergence of the sentimental look were sufficiently saturated during the decade of the 1760s to allow me to propose this viewing technique as realizable at that moment even if certain of these conditions were, at other times, more forcefully present or more fully developed. And again I wish to make it clear that I am not proposing that particular agents produced this coalescence: they were both actors and spectators, spectactors in this process. I wish to maintain the difference, then, between the culture that sustained and produced, say, Stowe in the 1740s and the show houses and gardens coming into prominence (some literally built, others substantially remodeled) during the 1770s.[10] This study has been concerned with the protocols governing looking articulated by and constructed in the architectural volumes and spaces of my examples, and I have been at pains to show how these forms of looking were attuned (and attempted to attune themselves) to the objects of high culture. The sentimental look is therefore, in the final analysis, proposed as a *way of being* with art.

Stowe was built under different conditions and was used for different purposes, even if, as should be more than clear, the cultural form of looking I claim to have become fully realized during the 1760s may well have been present to visits made to Stowe in the 1770s or even after. Whereas Stowe was built as a bulwark against the then prevailing political hegemony, as a private enclave within which its jokes and jibes could be enjoyed, Kedleston was made for the public culture of visuality.[11] Its owner and principal architect, Robert Adam, understood its spaces as an educative progress, its decor and design accessible to both a relatively untutored eye, its collection of paintings enriched through prior knowledge but not dependent on the form of studious looking, the informed gaze, that would have prevented the realization of its social, political, and cultural project. It was not afraid or scornful of the connoisseurial gaze and equally at one with the rapidity of the excited glance.

It sought, above all, to welcome all its visitors into its cultural enclave, to make anyone with eyes to see a part of the fraternity of culture.

It is important to bear in mind here that the emergence of this cultural form may have occurred in spite of or against the interests of some of the protagonists in my story. Why, for example, should a Tory aristocrat be in any way interested in a cultural program that has democratic, even leveling, implications? Surely Curzon was building for himself and his mates, fully a part of the elitist branch of society harboring those collectors and patrons who were set against the entry of commercial interests into the rarefied atmosphere of the cultural domain? My point here is that a number of things come together—a set of interlocking forces—to produce the sentimental look and its social, political, and educative program. And here I turn to the third of Brewer's conditions: the subversion of the classical in the face of commercialism. Culture, under this condition, is to be understood as capable of being captured by commerce, reduced to the vulgarities of the market: it becomes a product.

Kedleston, as I hope is now more than clear, was built both against and within this development of a commercial culture and culture-as-commerce. It takes a heroic effort to harness the explosive energies of the domain of visual culture and turn them toward a particular inflection of the old values, those built on the exercise of patiently acquired taste and knowledge (exploited by the regime of the picture), coupled with the radical and potentially ennobling invention of the aesthetic (in which the regime of the eye plots its different course). It was this, the notion that the artwork could itself direct attention and produce experiences of value, that so excited and disturbed the elitist patrons of this new culture like Curzon. But for the brief moment I have been describing, another possibility came into view that could take from the old and the new, defeating the worst excesses of commerce while utilizing its preternatural power.

Kedleston, of all the palaces built in eighteenth-century Britain, sets its face firmly against the defeat of classicism: it has the sheen of the classical emanating from its every surface. But it does so in a modern dress and in a way that ingeniously sets out to preserve what is good in that past by arresting the present, the onward march of society, politics, and economy. It presents a vision of culture, a phantasmic projection, that not only is inhabitable but also stakes a claim to being permanent. In effect it proclaims culture, its version of culture, as the antidote to commerce. As I have argued, albeit sometimes via indirection, the attitude taken to a past culture—that of

ancient Rome—exemplified and fostered by this house produces a very particular kind of relation to the classical. It asks us to fantasize that classical past in the image of the modern. Curzon, as we have seen, had many of the pictures he had collected set into plaster in the walls of his new palace, commissioned new paintings for specific locations in his house, and had furniture purpose-designed and made for particular spaces in designated rooms. And one of the results of these design decisions was the (variably) permanent construction of a set of spaces in which these images can be seen and in which they participate (what I have called the spacings of the rooms), thereby fostering the kind of viewing activity described at the end of the previous chapter. But we cannot be sure if Curzon (or Adam) deliberately set out to accomplish this. He may, for example, have been deliberately setting himself, his family, and future descendants against what was happening all around him: the incredibly rapid reorganization of the social, political, and economic bases of British life caused by the seemingly inexorable rise of commerce. In other words he may have been, in his mind, primarily making a *political* gesture, acting within a set of concerns and constraints that were of singular importance to an aristocratic elite experiencing the onset of its dilution within the social and political fabric of the nation.

But, and here again we cannot extract a singular intention, by setting these paintings in the walls Curzon was also, effectively, rendering them commercially valueless. They could not be traded. Nor could furniture designed for specific locations be traded or sold unless, by extraordinary chance, the curvature of a wall, say, precisely matched another building's internal layout and design. And given this he was, therefore, also participating in a set of arguments about the nature of aesthetic forms and the value of artworks. I want to stress that it is not the fact that he rendered a substantial part of his collection immobile that is important to my argument—it could be justly pointed out that this practice was not unique to him or his architects. It is not this that of its own accord prompts the formation of the sentimental look. Neither is the design of the saloon, with its exaggerated disposition of the sources of light and the coffered dome that draws the eye into its vortex, unique to this house. None of these aspects of Kedleston on their own account can be said to divert from the prevailing practices, taste, and interests promoted, presented, and upheld by aristocrats of similar standing to Curzon. And although the claim that what I argue takes place at Kedleston happened *only* there would be too exaggerated, it is nevertheless

the case that the very specific conjunction of all the strands to that argument are completely tied to my description and analysis of this place. I am claiming that Curzon's attempt to arrest history, to mark time in the performative of the tablet on the south front, is unique to *that* moment. This is the optic that allows us to witness the functioning of the regime of the sentimental look, the informed and informing eye, in all its glory.

Curzon and Kedleston function as emblems for my historical argument: they provide a lens with which to see the cultural form I have taken for the primary object of study. But they are only emblematic. The sentimental look can be found in embryo in the spacings of Holkham, for example, and persists as a scopic regime articulating the recesses of visual culture long after the decade I have made so prominent in my discussion. But its demise is already foreshadowed in its inception, partly on account of the success of the version of the aesthetic that needs no prop other than the subjectivity both produced and sustained by affective experience. The institutions of visual culture—prime among them the Royal Academy—were to quickly close off the potentialities of the regime of the eye for fear of an ungovernable polis of taste. So connoisseurship and expertise were tied once again to the singular regime of the picture, the requirement that one (already) know what one sees.

Commerce had its own part to play in the demise of the sentimental look since the possibility of an endlessly proliferating number of cultural artifacts threatened to dilute the value of individual items. It was, therefore, in the interests of culture-as-commodity to return protocols of viewing to those that were not so open or accessible to everyone with eyes to see. And once a differently inflected space and institution appeared in the guise of a national gallery of art, the context for viewing paintings changed enormously. Between the foundation of the Royal Academy in 1768 and that of the National Gallery in 1837 the forces and filaments that coalesced in the 1760s that had helped bring the sentimental look into view gradually dissipated and altered under the pressure of new conditions. Some remained undercurrents for a long time to come, whereas others faded away more quickly. So by 1837 the stakes had become rather higher: now the public display of artworks participated in a set of national ideologies and interests (something that had, of course, been present to debates about the foundation of the Royal Academy nearly a century before). It is, perhaps, ironic that the foundations for a public culture of visuality had been built by an aristocratic elite

and that these foundations would only be dismantled, or at the very least inflected in very different ways, by a society now opening up its political franchise to the male population at large.

One of those forces, which has been an intermittent object of discussion throughout—one of the harmonics sounded out by my main argument—is the developing discourse of aesthetics in the general sense and, more specifically, the interaction of this discourse with the production of visual works of art. Here, in conclusion, I would like to follow a line that stretches from Hogarth to our own contemporaneity and passes through one signal moment that continues to send shock waves into the habitations of all visual artists. In turning to the evidence of art itself I wish to pose my initial questions one last time: what lures us to looking at works of art, at paintings more specifically? And, in that activity of looking, what is said about or done to the person who looks? What am I in the spacings of *this* look?

I have said that the sentimental look runs, as a current underground, through many of the continuing arguments, practices, and institutions after the decade of the 1760s. Its resurfacing, nearly a century later, in the works produced by J. M. W. Turner during the last decade of his life, is as forceful an expression of its grammar and interests as there has ever been. Although manifestly in a different idiom and utilizing a very different pictorial language from the paintings I discussed in the first and second chapters there are continuities between Turner's late canvases and those works by Hayman and Wright of Derby we have already encountered. In the first chapter I claimed that Wright of Derby's candlelights educate the viewer into adopting particular attitudes or strategies of looking, and in the second I proposed that Hayman's large canvases at Vauxhall ingeniously combined the scopic techniques of recognition and identification in their melding of genres. Both are produced and consumed under the regime of looking I call the sentimental look. Indeed, as I have argued, they make pictorial arguments on its behalf. But neither Hayman nor Wright of Derby could have foreseen the sudden eruption of the protocols governing the sentimental look that would take place in a very changed artistic and completely altered social and cultural environment. Neither could have predicted that Britain's most respected and appreciated artist would, late in his life, abandon the language of re-presentation only to open up the Pandora's box of representation to its full, daemonic, imaginings.

So it was that the sentimental look burst in on the picture making of Turner and changed the course of painting. In a series of experiments and

outrageously daring forays into the boundaries of pictorial representation Turner emblazoned the regime of the sentimental look. And these images still stand as moments of arrested aesthetic contemplation whose reach and power as aesthetic forms remain almost unbearable. I am going to take just one of these late canvases, the image that has almost become the icon for late Turner, and close by looking at and with it. Its subject had been painted before by the artist, but now, in the early 1840s, he had become so fully enveloped in the sentimental look that it hardly mattered what he took for his subjects. Its title is *Norham Castle, Sunrise* (fig. 56).

It is a commonplace in the scholarly and critical literature on Turner to note that he painted for the eye. It is, I hope, clear how this image invokes the regime of the eye, but it also utilizes the more patient rhythms of the regime of the picture. It is not an exercise in early abstraction—although these late Turner images have an enormous impact on the development of the language of pictorial representation, through impressionism, postimpressionism, and on into abstraction. In one way of looking at this history those art movements and the pictorial languages they invent and adapt can be understood as imperfect attempts at coming to terms with what Turner did to representation in the last decade of his life.

Turner did not paint "abstractly." His eye was too mired in the physical activity of looking, and he was too much *in* sight, being in vision, to feel the cool regard of abstraction. What he did paint was, as it were, pure materiality: the felt presence of light and the affective registers of being in the process of sight. He painted what it feels like to be within the regime of the sentimental look. Close inspection of how this canvas has been painted helps us to understand more fully what it might be to be in that regime. Turner began his painting career working with watercolor, and he continued, of course, to use a variety of media throughout his long life. There is, therefore, considerable contamination between the various painterly techniques deployed in different media.[12] The blue paint in the center of the image, for example, has been thinned to a consistency that allowed the paint to run—right in the center of the area of blue pigment are three long dribbles of running paint. In other places the paint has been applied with either a palette knife or some kind of blunt point, perhaps the nonbrush end of the paintbrush. This is most evident in the passages of chrome yellow at the extreme left of the canvas. Here the paint falls, almost like blobs or squirts, onto smooth backgrounds and has been left unworked. It remains just color, the material of the pigment and its support. No attempt has been made to brush

FIGURE 56. J. M. W. Turner, *Norham Castle, Sunrise*. Tate Gallery, London.

it out or even to work it with another implement. Here the hand gives way entirely to the eye: in making the surface this way Turner has pushed the visual address we must take to the image away from the purely optical toward the purely haptic, to the feeling eye.

It is important to see this image at very close quarters, not in order to inspect its facture, as I have just done, but to feel the disturbance it produces in the visual field. Up close the passage of blue pigment—what we take to be the representation of the castle from a distance—takes on a very different role. It is almost like an opening in the center of the canvas, an entryway into the recesses of vision. Indeed, it feels as if this section of the canvas inhabits a different stratum than the passages of chrome yellow that frame the opening. It lies deep within the subsoil of the image. Where the regime of the picture asserts its proclivities toward interpretation—decoding the washes and bleeding of pigment so that, for example, the brown dribbles from a distance come into focus as a representation of a cow—when we move in close, the regime of the eye skittles across the undulating and lumpy surface, directed here by a passage of smoothed paint, worked almost entirely with horizontal brushstrokes (the violet passages), and there by the smudged chrome yellow toward the top of the canvas. And this makes one look in a particular way, makes one into a particular kind of looker. Above all, it sets up a sensation of looking almost without direction or the pressure of intention and interpretation. This is what I mean by stating that Turner has painted what it feels like to be within the regime of the sentimental look.

In my final remarks I want to explore this sensation as a technique of the subject. In an essay on some of these paintings produced by Turner in the final decade of his life Jonathan Crary notes the overarching importance of the sun:

> The direct interface of sun and eye is what overturns a stable separation between subject and object, between interior sensation and exterior stimulus. To distinguish between the radiance emanating from the sun and the subjective luminous effects in the eye of the observer becomes meaningless for Turner: they are inherent in each other. The literal body of the spectator and the exterior world of physical events are one indivisible field. Observation as involving a relation of distance between subject and world becomes meaningless.[13]

This I take to be a description of the aesthetic subject, the subject produced in the affective encounter with the artwork. A subject in and of the look that inhabits both the plane of representation and the place of vision, a subject

without the capacity for distantiation since the interior and exterior worlds have been superimposed on each other. In order to *see* this picture, one has to give up the sovereign subjectivity of optics, give up the agential aspects of vision, renounce the intentionality and directiveness of the subject-who-sees. And in doing so the subject is reconstituted in the republic of aesthetic forms, itself one of those forms, a participant in the *sensus communis* of art. In order to be with this painting, one has to be with others—this is the ethical and political sheath enclosing the aesthetic subject—and being there, with the joyful explosions of color, involves being less with oneself.

The experiment that comes to fruition in the 1760s to ground what I have called the sentimental look plays out its variations in the years and decades following. And the technique of the subject that arises within its enclosures and is structured through its grammar holds out the possibility of presenting a different subject, the aesthetic subject, to being. It makes our being within the aesthetic state an imaginable project. That project has had advocates and apologists, practitioners and theorists, over the intervening two and a half centuries, but perhaps none *saw* the implications of its imaginings as clearly as Turner.

Throughout this book I have argued for a particular form of historical consciousness, an attitude for addressing the past that has been set against what I have called "heritage consciousness," a form of fantasy that erases the materiality of history. And I have also been concerned to investigate the indirect ways in which a different story about the material of culture might begin to be told. More than ever, it seems to me, we need such efforts as the guardians of culture close the entryways to our being with art. And, perhaps as dangerous or damaging, where the doorways are so indistinct as to be nonexistent, we seem to have given up on the thought that some cultural products are better than others. The products of culture do matter to us; they do have value, and not only in and for themselves. As this book has repeatedly stated: looking tells the subject how to be, and how one looks is determined by (among other things) what one looks at. Nathaniel Curzon and his architect Robert Adam recognized the power of that sentiment and bequeathed to us, to the indefinite future, an exhortation that we continue to educate the eye. I hope this comes to pass.

Notes

Introduction: The Education of the Eye

1. This was the first purpose-designed exhibition; works had been presented to the public at the Foundling Hospital from the late 1740s. See below chap. 1.

2. These figures are taken from D. Hudson and K. Ludhurst, *The Royal Society of Arts, 1754–1954* (London, 1954), 38.

3. The most extensive examination of this is in Martin Jay, *Downcast Eyes: The Denigration of Vision in Twentieth-Century French Thought* (Berkeley, 1993); see also Jonathan Crary, *Suspensions of Perception: Attention, Spectacle, and Modern Culture* (Cambridge, Mass., 1999); and for a vigorous and deeply original take on the same issue through the lens of modernist painting see T. J. Clark, *Farewell to an Idea: Episodes from a History of Modernism* (New Haven, 1999).

4. The most helpful account of the impact of the science of optics on the making of art is in Martin Kemp, *The Science of Art: Optical Themes in Western Art from Brunelleschi to Seurat* (New Haven, 1990); but see also M. Podro, *The Manifold in Perception* (Oxford, 1972); D. Summers, *The Judgment of Sense* (Cambridge, 1987); J. Hammond, *The Camera Obscura: A Chronicle* (Bristol, 1981); J. Hammond and J. Austin, *The Camera Lucida in Art and Science* (Bristol, 1987); Jonathan Crary, *Techniques of the Observer: On Vision and Modernity in the Nineteenth Century* (Cambridge, Mass., 1990).

5. See Peter de Bolla, *The Discourse of the Sublime: Readings in History, Aesthetics, and the Subject* (Oxford, 1989).

6. Although identifiable it has no certain or fixed disciplinary location. The work I have in mind developed out of a congeries of interests and projects that began in the wake of structuralism in the early 1970s. The cultural analysis of

Barthes's work of this period would be one touchstone, as would film studies—especially articles published by the journal *Screen* at that time—and psychoanalysis (especially work within and in reaction to the Lacanian strain). A little later cross-disciplinary work began to use literary tools and techniques for the discussion and analysis of visual materials—here the work of Norman Bryson has been particularly influential—so that the nascent field of "visual theory" had its initial home in a variety of disciplines: literary studies, anthropology, and, perhaps belatedly, art history. This area of enquiry still has no fixed abode: although many of the scholars working on the topics I have in mind find themselves in departments of art history, many others are dispersed in cultural studies programs, art and architecture schools, literature and history departments. There is, however, now a large enough number of collections of articles and textbooks making a claim to the field for it to be relatively easily identified. These include Norman Bryson, Michael Ann Holly, and Keith Moxey, eds., *Visual Theory* (Cambridge, 1991); Nicholas Mirzoeff, ed., *The Visual Culture Reader* (London, 1998); Jessica Evans and Stuart Hall, eds., *Visual Culture: The Reader* (London, 1999).

7. The secondary and theoretical literature on this concept is now very large. For a good introduction to the Lacanian emphases see Jacqueline Rose, *Sexuality in the Field of Vision* (London, 1986); and for film theory the classic Laura Mulvey, "Visual Pleasure and Narrative Cinema," *Screen* 16, no. 3 (1975). Mulvey has subsequently attenuated her theory in the light of much commentary; see Laura Mulvey, "Afterthoughts on 'Visual Pleasure and Narrative Cinema' inspired by *Duel in the Sun*," *Framework* 6, nos. 15–17 (1981). For further explorations see Lorraine Gamman and Margaret Marshment, eds., *The Female Gaze* (London, 1988). Perhaps the most fruitful recent approach for my own argument is Kaja Silverman, *Male Subjectivity at the Margins* (London, 1992).

8. I have written on the Lacanian model and what I take to be the difficulties of using it in historical work in "The Visibility of Visuality," in *Vision in Context: Historical and Contemporary Perspectives on Sight*, ed. Teresa Brennan and Martin Jay (London, 1996), 63–81.

9. John Brewer, "Cultural Production, Consumption, and the Place of the Artist in Eighteenth-Century England," in *Towards a Modern Art World*, ed. Brian Allen (New Haven, 1995), 7–25.

10. And perhaps for good reason: within the dominant form of visual culture that stretches from the eighteenth century down to the present these two modes of address have seen off most of the competition. I will say more about this in my concluding remarks.

Chapter One: The Culture of Visuality

1. For details of the background to this first exhibition see Ronald Paulson, *Hogarth*, 3 vols. (Cambridge, 1992), 2:323–41.

2. The volumes of press cuttings in the Victoria and Albert Museum contain

valuable evidence of the reactions to these early exhibitions. A newspaper cutting from 1771, for example, notes that "at present the whole town is running helter-skelter after EXHIBITIONS; and as they are staring all day at PAINTINGS, SCULPTURES, and DRAWINGS; it is not surprising that they should dream of them all night" (Press cuttings, 1:28). Horace Walpole noted in 1770 that "the rage to see exhibitions is so great, that sometimes one cannot pass through the streets where they are" (quoted in Charles Leslie and Tom Taylor, *Life and Times of Sir Joshua Reynolds*, 2 vols. [London, 1865], 1:356).

3. These first exhibitions displayed a variety of objects, including formal easel painting, architectural designs and models, sculpture, and less formal "images" in materials other than paint. See below, p. 36.

4. A letter to the Society of Artists following its first exhibition complains that the rooms had been "crouded and incommoded by the intrusion of great numbers whose station and education made them no proper judge of painting and sculpture, and who were made idle and tumultuous by the apportunity of a shew" (cited in *Walpole Society* 6 [1917–18]: 119–21).

5. I have elaborated on this condensed statement at some length in my *The Discourse of the Sublime* (Oxford, 1989). See also Howard Caygill, *Art of Judgment* (Oxford, 1989); Terry Eagleton, *The Ideology of the Aesthetic* (Oxford, 1990).

6. For these debates see John Gwyn, *An Essay on Design* (London, 1755); *An Essay in Two Parts, on the Necessity and Form of a Royal Academy for Painting, Sculpture, and Architecture* (London, 1764); John Newberry, *Essay on the Perfection of the Fine Arts in Great Britain and Ireland* (London, 1767); Robert Strange, *Inquiry into the Rise and Establishment of the Royal Academy of Arts* (London, 1775); Algernon Graves, *The Society of Artists and Free Society* (London, 1917); Sidney C. Hutchinson, *The History of the Royal Academy* (London, 1968); David Solkin, ed., *Art on the Line* (New Haven, 2001); and for information on rival groups see "Papers of the Society of Artists of Great Britain," *Walpole Society* 6 (1917–18).

7. The various plots and intrigues surrounding the foundation of the Academy were a matter of contemporary interest. See, e.g., Robert Strange, *The Conduct of the Royal Academicians While Members of the Incorporated Society of Artists* [London, 1771].

8. The early Academy exhibitions were far from immune to the "raree show." One critic commented in 1785 that "there are two descriptions of persons who visit the Royal Academy:—some perambulate the rooms to view the *heads*—others remain at the bottom of the stairs to contemplate the *legs*" (*Morning Post* [London], May 3, 1785).

9. For a discussion of Webb see James S. Malek, *The Arts Compared: An Aspect of Eighteenth Century British Aesthetics* (Detroit, 1974).

10. See James Barry, "Some Errors in the Present State of Connoisseurship," in *Works* (London, 1809), 257: "Our dilettanti and picture collectors (for the most part) misemploy the little time they bestow upon the arts, in the pursuit of a long list of names and trifling anecdotes of Flemish, Dutch, or obscure Italian artists; they value themselves upon their discernment in distinguishing the different styles, manners, touches and tints of the *masters* as they call them."

11. The ramifications of this observation will reverberate throughout this book;

the popularity of portraiture as the means of entry into the aesthetic is discussed below. See pp. 28–39.

12. The practical difficulty of European travel also contributed to the rise in domestic tourism. See Esther Moir, *The Discovery of Britain: The English Tourists, 1540–1840* (London, 1964); and Ian Ousby, *The Englishman's England* (Cambridge, 1990).

13. For an account of this market see Gerald Reitlinger, *The Economics of Taste: The Rise and Fall of Picture Prices, 1760–1960* (London, 1961); and George Algernon Graves, *Art Sales from Early in the Eighteenth Century to Early in the Twentieth Century* (London, 1918–21).

14. For the earlier network of support see M. Foss, *The Age of Patronage: The Arts in Society, 1660–1750* (London, 1971); Francis Haskell, *Patrons and Painters: A Study in the Relations between Italian Art and Society in the Age of Baroque* (London, 1963); James Lee Milne, *Earls of Creation: Five Great Patrons of Eighteenth-Century Art* (London, 1962).

15. In slightly different terminology this can be understood as a question concerning the proper "public" context for the production and display of art. Indeed the creation of the category of the "public" itself is tied up with this new activity of display. On this see David Solkin, "Edward Penny's Marquis of Grandby and the Creation of a Public for British Art," *Huntington Library Quarterly* 49 (1986).

16. Even if one did pay at the door, however, the physical disposition of the gallery and access to it, up the famous stair, continued to exert its force on the social practice of viewing. On this see John Murdoch, "Architecture and Experience: The Visitor and the Spaces of Somerset House, 1780–1796," in *Art on the Line*, ed. David Solkin (New Haven, 2001), 20.

17. The success of this policy was qualified. The yearly exhibition continued to attract hordes of viewers, not all of whom came for the "right" reasons. In 1787, for example, a newspaper account stated, "Exhibitions are now the rage—and though some may have more merit, yet certainly none has so much attraction as that at Somerset House; for, besides the exhibition of pictures living and inanimate, there is the *raree-show* of neat ancles up the stair-case—which is not less inviting" (*World, Fashionable Advertiser*, May 8, 1787).

18. This was the standard format for the advertisement each year. See the May issue of the *Public Advertiser* for any of the early years of the Academy exhibition.

19. See William T. Whitley, *Artists and Their Friends in England, 1700–1789*, 2 vols. (New York, 1968), 1:229. It is worth noting here that women contributed to the Society for the Encouragement of Arts, Manufactures, and Commerce in rather larger numbers than to the Academy exhibitions.

20. See John Brewer, "Cultural Production, Consumption, and the Place of the Artist in Eighteenth-Century England," in *Towards a Modern Art World*, ed. Brian Allen (New Haven, 1995).

21. For an outstanding account of the interrelations between landscape aesthetics and scientific inquiry in the period see Richard Hamblyn, "Landscape and the Contours of Knowledge: The Literature of Travel and the Sciences of the Earth in Eighteenth-Century Britain" (Ph.D. diss., University of Cambridge, 1994).

22. John Shebbeare, *Letters on the English Nation* (London, 1755), 270.

23. Mathew Pilkington, *The Gentleman's and Connoisseur's Dictionary of Painters* (London, 1770), viii. Pilkington goes on to list the "requisites" for a well-founded taste in painting; they are "to be familiarly conversant with history, particularly the sacred"; "the study of profane history"; "a competent skill in Drawing, and a knowledge of Anatomy"; "to have studied nature"; and "the study of the Works of the most famous Artists" (vii–x).

24. The same argument might be mounted for our own period, but there is a major difference: we have inherited a strong version of the distinctiveness of the aesthetic so that the question of what might count as art is already situated within a prior understanding that there is an aesthetic realm. The period under study is only just beginning to explore the ramifications of a potentially distinctive aesthetic realm. On this see David Summers, *The Judgment of Sense* (Cambridge, 1987).

25. *The Polite Arts; or, A Dissertation on Poetry, Painting, Musick, Architecture, and Eloquence* (London, 1749), 4.

26. [John Stedman], *Laelius and Hortensia; or, Thoughts on the Nature and Objects of Taste and Genius* (London, 1782), 32.

27. Sir Joshua Reynolds, *Discourses on Art*, ed. Robert R. Wark (New Haven, 1975), 170, 171.

28. The most important account of the civic humanist theory of the fine arts is in John Barrell, *The Political Theory of Painting* (New Haven, 1986). Since its publication a number of books have contributed to the debate initiated by Barrell; see in particular David Solkin, *Painting for Money* (New Haven, 1993); Marcia Pointon, *Hanging the Head* (New Haven, 1994); and John Barrell, ed., *Painting and the Politics of Culture* (Oxford, 1992). For a revision to the hegemony of the civic humanist account see Shelley Burtt, *Virtue Transformed: Political Argument in England 1688–1740* (Cambridge, 1992).

29. See Edgar Wind, *Hume and the Heroic Portrait* (Oxford, 1986), esp. 16–52.

30. This is so in spite of the fact that the preeminent modern scholar of Hogarth's life and work, Ronald Paulson, has tirelessly championed the importance of *The Analysis* and of Hogarth's contribution to the philosophical origins of the aesthetic. See in particular his *Hogarth*, 3 vols. (Cambridge, 1992); *Breaking and Remaking: Aesthetic Practice in England, 1700–1820* (New Brunswick, 1989), esp. 149–202; and *The Beautiful, the Novel, and the Strange: Aesthetics and Heterodoxy* (Baltimore, 1996).

31. William Hogarth, *The Analysis of Beauty*, ed. Ronald Paulson (New Haven, 1997), 116.

32. The most useful recent discussion of eighteenth-century portraiture to which the present account is indebted is Marcia Pointon, *Hanging the Head* (New Haven, 1993); see also Desmond Shawe-Taylor, *The Georgians* (London, 1990).

33. Marcia Pointon has calculated that portraits constituted 44 percent of all genres displayed at Royal Academy exhibitions in 1780. See her "Portrait! Portrait! Portrait!" in *Art on the Line*, ed. David Solkin (New Haven, 2001), 93–109.

34. Reynolds, of course, was aware of this and claimed that portraiture was particularly susceptible to being "raised" by the mixing of genre. Hence his espousal of

the "heroic portrait"; see Sir Joshua Reynolds, *Discourses on Art*, ed. Robert Wark (New Haven, 1975), esp. 72.

35. John Stedman, *Laelius and Hortensia; or, Thoughts on the Nature and Objects of Taste and Genius* (London, 1782), 247.

36. William Combe, introduction to *A Poetical Epistle to Sir Joshua Reynolds* (London, 1777), no pagination.

37. See Allan Ramsay, *The Investigator* (London, 1762), 57: "The same country girl, who applauds the exact representation of a man and a house which she has seen, will, for the same reason, be charmed with Hogarth's *March to Finchley*, as that is a representation, though not of persons, yet of general manners and characters, with which we may suppose her to be acquainted."

38. Northcote comments on Reynolds's mixing of genres: "Portrait often runs into history, and history into portrait, without our knowing it" (*The Conversations of James Northcote, Esq., R.A.* [London, 1949], 12).

39. Mathew Pilkington, *The Gentleman's and Connoisseur's Dictionary of Painters* (London, 1770), x.

40. See *The Connoisseur: A Satire on the Modern Men of Taste* (London, 1735); Francis Grose, "Sketch of a Modern Connoisseur," in *The Olio* (London, 1792), 54–57; "A Connoisseur to Mr Urban," *Gentleman's Magazine* 34 (May 1764): 223; Jonathan Richardson, the elder, *Two Discourses* (London, 1719).

41. *A Call to the Connoisseurs, or Decisions of Sense* (London, 1761), 9–11. It is worth dwelling on the date of this pamphlet, 1761, since it represents a very early and forceful intervention into the development of a public for art. Already, before public exhibitions had become the rage, there was a strong antagonism to those who would profess expertise in respect of paintings, the connoisseur. Furthermore the less sophisticated appreciation of painted representations is bounded by an interest in narrative. This will have ramifications in the following chapter on Vauxhall.

42. Joseph Highmore, *Essays, Moral, Religious, and Miscellaneous*, 2 vols. (London, 1766), 2:88.

43. Ibid., 89. Also cf. Allan Ramsay's comment, in his essay "On Taste," that recognition "is so quick and instantaneous, that it often passes for a simple feeling or sentiment" (*The Investigator* [London, 1762], 58).

44. Andre Rouquet, *The Present State of the Arts in England* (London, 1755), 23.

45. See Iain Pears, *The Discovery of Painting* (New Haven, 1988), esp. appendix to chap. 3.

46. John Shebbeare, *Letters on the English Nation* (London, 1755), 51.

47. Northcote, quoted in Charles Leslie and Tom Taylor, *Life and Times of Sir Joshua Reynolds*, 2 vols. (London, 1865), 1:263.

48. See E. H. Gombrich, "The Mask and the Face: The Perception of Physiognomic Likeness in Life and Art," in *Art, Perception, and Reality*, ed. Maurice Mandelbaum (Baltimore, 1972), 1–46; and for a different but fascinating emphasis see Jurgis Baltrusaitis, *Aberrations* (Cambridge, Mass., 1989), 1–56. Many of the issues discussed below are explored in Joanna Woodall, ed., *Portraiture: Facing the Subject* (Manchester, 1997).

49. As Marcia Pointon remarks: "Portraits permitted the convivial activity of identification, recognition, self-recognition, emulation and self-projection. And this engagement resulted in a technology of portrait production, supported by a commercial press, designed to ensure that audiences would be held in thrall" ("Portrait! Portrait! Portrait!" in *Art on the Line*, ed. David Solkin [New Haven, 2001], 95).

50. For an extensive discussion of these terms in relation to portraiture see Harry Berger Jr., *Fictions of the Pose: Rembrandt against the Italian Renaissance* (Stanford, 2000).

51. Andre Rouquet, *The Present State of the Arts in England* (London, 1755), 45; "and yet the English continued to have their pictures drawn; for this nation, especially the ladies, make it one of their chief amusements" (36); "For it is customary with them [the English] to have their pictures drawn at every turn" (27).

52. Thomas Page Jr., *The Art of Painting* (Norwich, 1720), 81.

53. For a general discussion of eighteenth-century practice see David Mannings, "At the Portrait Painters'—How the Painters of the Eighteenth Century Conducted Their Studios and Sittings," *History Today* 27 (1977): 279–87.

54. Charles Leslie and Tom Taylor, *Life and Times of Sir Joshua Reynolds*, 2 vols. (London, 1865), 2:32.

55. For a discussion of female portraitists during the period see Angela Rosenthal, "She's Got the Look! Eighteenth-Century Female Portrait Painters and the Psychology of a Potentially 'Dangerous Employment,'" in *Portraiture: Facing the Subject*, ed. Joanna Woodall (Manchester, 1997), 147–66.

56. Rouquet, *The Present State of the Arts in England* (London, 1755), 42–43.

57. Although most catalogues to the yearly exhibitions declined to name the sitters, many were known well enough to be recognizable to the vast majority of exhibition goers.

58. The production of portrait miniatures from the early decades of the eighteenth century up to 1760 or so has received little scholarly attention. Indeed, Graham Reynolds, in what is the standard account of the miniature from its beginnings with Hilliard, called the period 1740–60 the "modest school." Most interest, such as it is, centers on Cosway and his contemporaries for, perhaps, obvious reasons: the high resolution of the image and skill of the artist. This, it seems to me, is unfortunate because there are a number of questions concerning the production of miniatures during the 1740–60 period that need to be addressed if one is to understand why the images produced during that period look the way they do. We need to assess the skills of artists working then and take into account the development of techniques and materials, but even these considerations do not provide a sufficient analysis of why sitters were both prepared to be represented in a lifeless way and, seemingly, enjoyed being so represented.

59. A number of pamphlets describe and evaluate the submissions at these early exhibitions; see, e.g., *A Letter to the Members of the Society for the Encouragement of Arts, Manufactures, and Commerce, Containing Some Remarks on the Pictures to Which Premiums Were Adjudged* (London, 1761); *A Critical Examination of the Pictures, Sculptures, Designs in Architecture, Models, Drawings, Prints, etc. Exhibited at*

the Great Room in Spring Gardens (London, 1767); *Critical Observations on the Pictures Which Are Now Exhibiting at the Great Room, Spring Garden* (London, 1768); [Robert Baker], *Observations on the Pictures Now in Exhibition at the Royal Academy, Spring Garden, and Mr Christie's* (London, 1771); *Candid Observations on the Principal Performances Now Exhibiting at the New Room of the Society of Artists* (London, 1772); *The Ear-Wig; or, An Old Woman's Remarks on the Present Exhibition of Pictures of the Royal Academy* (London, 1781); *The Bee; or, The Exhibition Exhibited in a New Light* (London, 1788).

60. Joseph Addison, *The Spectator*, ed. Gregory Smith, 4 vols. (London, 1907), 3:278.

61. It is, of course, a classical topos and returns repeatedly in discussions of representation from the competition between Parrhasius and Zeuxis up to the present day. For a good introduction to these issues see Harold Osborne, *Aesthetics and Art Theory: An Historical Introduction* (New York, 1968).

62. For an account of the social dynamics of the early Academy exhibitions see K. Dian Kriz, "'Stare Cases': Engendering the Public's Two Bodies at the Royal Academy of Arts," in *Art on the Line*, ed. David Solkin (New Haven, 2001), 55–63.

63. Press cuttings in the Victoria and Albert Museum, volume marked 1723–1900, 73.

64. *Public Advertiser*, August 4, 1764, in ibid., 31.

65. Robert Baker comments in 1771: "Such observations as these may not perhaps interest the generality of spectators, of whom the greatest part never descend into minutiae in looking at a picture, and not a few go to these exhibitions only for the sake of saying they have been there" (*Observations on the Pictures Now in Exhibition at the Royal Academy, Spring Garden, and Mr. Christie's* [London, 1771], 21).

66. For a discussion of the contemporary awareness of these issues see C. S. Matheson, "'A Shilling Well Laid Out': The Royal Academy's Early Public," in *Art on the Line*, ed. David Solkin (New Haven, 2001), 39–53.

67. Press cuttings in the Victoria and Albert Museum, volume marked 1723–1900, 11.

68. A German visitor to England in 1785 remarked that the Somerset House exhibition was "often so crowded with gentlemen and ladies, with pretended connoisseurs and supercilious critics, who all come to stare at the pictures that in the middle of the day some ladies are ready to faint, on account of the heat of the rooms, and the powerful perfumes of the odiferous company [with] which they are filled" (Frederick A. Wendeborn, *A View of England Towards the Close of the Eighteenth Century*, 2 vols. [London, 1791], 2:197–98).

69. Press cuttings in the Victoria and Albert Museum, volume marked 1723–1900, 42.

70. Ibid., 39.

71. *Public Advertiser*, May 2, 1764.

72. *Public Advertiser*, May 4, 1764. This is signed "Rusticus."

73. As a tract published in 1772 points out: "To rove in a Garden of Flowers without any Knowledge of the Vegetable System would give but a faint Taste of the

Pleasures of Flora. In the same Predicament is he, who visits a Collection of Pictures, with no other Requisite for judging of them, than the Faculty of Seeing" (*Candid Observations, on the Principal Performances Now Exhibiting at the New Room of the Society of Artists* [London, 1772], advertisement).

74. See Marcia Pointon, *Hanging the Head* (New Haven, 1993), esp. 159–75; M. Praz, *Conversation Pieces: A Survey of the Informal Group Portrait in Europe and America* (London, 1971); and for the origins of the scholarly commentary see G. C. Williamson, *English Conversation Pictures of the Eighteenth and Early Nineteenth Centuries* (New York, 1931); and R. Edwards, *Early Conversation Pieces from the Middle Ages to About 1730* (London, 1954), both of which place these pictures in the context of seventeenth-century Dutch group portraits.

75. The most informative discussion of Devis's work is in Ellen G. D'Oench, *The Conversation Piece: Arthur Devis and His Contemporaries* (New Haven, 1980), to which the present argument is much indebted.

76. See Harry Berger Jr., *Fictions of the Pose: Rembrandt against the Italian Renaissance* (Stanford, 2000), esp. 171–228. Berger notes that a "differential system of poses" determines both how one sits for a portrait and, at the same time, how one interprets oneself. The pose is, therefore, according to this fascinating account, what I would call a "technique of the subject."

77. Rouquet, *The Present State of the Arts in England* (London, 1755), 68.

78. The move from the bourgeois context of the provinces to the capital seems to have been decisive in another contemporary portraitist, the extremely popular George Romney. Although his pre-London portraits of the early 1760s were already moving in the direction he was to take once in London (where he moved in 1762), the contrast between his "metropolitan" commissions and the earlier provincial is striking. The canvases are far less hesitant—perhaps a function of the artist's growing confidence and skill—and the sitters thrust forward, almost bursting the immediate foregrounds in which they sit. In a quite remarkable way they almost inhabit the immediate space in front of the canvas, occupying the same continuum as the viewer. Above all, these sitters accept the gaze and comfortably return the look. These images can be found in Alex Kidson, *George Romney, 1734–1802* (London, 2002), the catalogue published in conjunction with the exhibition first mounted at the Walker Art Gallery in Liverpool.

79. This exhibition, *Art on the Line*, curated by David Solkin, allowed modern viewers the opportunity to stand in Chambers's purpose-built space and to witness a typical hang. An unforgettable experience, the most striking aspect of the show for me was the sense one had of being in the presence of people, viewers not only physically in the room but on the walls as well, the sense of being in the space of looking and of being looked at. Although by no means all the paintings hung were portraits, the overwhelming sense of being in a peopled space was intense. And, in terms of the success of particular submissions to the yearly shows it was made extremely apparent how "eye-catching" works made a claim for the space of the visible—how they were able to be seen—in far stronger terms than their less "eye-catching" neighbors. This of course raises the question of how to catch an eye,

something I will address in the chapters following; and the size of the image and indeed of the persons portrayed within the image are clearly significant.

80. See note 17 above.

81. The standard work on Wright remains Benedict Nicolson, *Joseph Wright of Derby: Painter of Light*, 2 vols. (London, 1968).

82. See David Fraser, "Joseph Wright of Derby and the Lunar Society," in *Wright of Derby*, ed. Judy Egerton (London, 1990), 15–23; and "Fields of Radiance: The Scientific and Industrial Scenes of Joseph Wright of Derby," in *The Iconography of Landscape*, ed. Denis Cosgrove and Stephen Daniels (Cambridge, 1988); for different approaches see David Solkin, *Painting for Money* (New Haven, 1993); and Stephen Daniels, *Fields of Vision* (Cambridge, 1993).

83. On the use of the orrery see Henry C. King and John R. Millburn, *Geared to the Stars: The Evolution of Planetariums, Orreries, and Astronomical Clocks* (Toronto, 1978); on scientific experiment see David Gooding, Trevor Pinch, and Simon Schaffer, *The Uses of Experiment: Studies in the Natural Sciences* (Cambridge, 1989); Simon Schaffer, "Self Evidence," *Critical Inquiry* 18 (winter 1992): 327–62; Barbara Maria Stafford, *Artful Science* (Cambridge, Mass., 1994).

84. It clearly worked in this respect since it is commented on in very favorable terms by the two exhibition reviews that have survived. See *A Critical Review of the Pictures, Sculptures, Designs in Architecture, Drawing, Prints & Exhibited at the Great-Room in Spring Gardens* (London, 1766), 17; and the anonymous review in the *London Chronicle*, May 17–20, 1766.

85. David Solkin places the image within the context of Shaftesburian aesthetics in his "ReWrighting Shaftesbury: The *Air Pump* and the Limits of Commercial Humanism," in *Painting and the Politics of Culture*, ed. John Barrell (Oxford, 1992); his emphasis on the moral qualities of the image, albeit a morality that is to be distinguished from the standard civic humanist account, is slightly altered in his later discussion of Wright's candlelights in *Painting for Money* (New Haven, 1993), where the emphasis is closer to my own in its development of the concept of the public sphere in relation to the visual arts. Both these accounts repay careful reading.

86. *Lecture on the Orrery* is in fact composed of portrait studies for which there is documentary evidence, but my point is not about the extension of the portrait genre; I mean to highlight the picturing of the look. On the evidence for the portrait studies in *Lecture on the Orrery* see Benedict Nicolson, *Joseph Wright of Derby: Painter of Light*, 2 vols. (London, 1968), 115; and David Fraser, "Fields of Radiance: The Scientific and Industrial Scenes of Joseph Wright of Derby," in *The Iconography of Landscape*, ed. Denis Cosgrove and Stephen Daniels (Cambridge, 1988), 138 n. 13.

87. These images have recently been discussed by David Solkin in terms of the creation and depiction of a public sphere specifically motivated by moral precepts developed within the discourse of civic humanism. In the course of this argument Solkin makes the point that *Gladiator* depicts visibility in its focus on the act of looking. I would certainly not disagree with this; indeed, my own discussion of these images has taken as its starting point Solkin's comments. Solkin is surely right in

suggesting that *Gladiator* makes us intently aware of ourselves in the activity of look-ing, since we look on the sculpture *as* we look on the three male figures gazing on the same sculpture. This acute sense of being made aware of the activity in looking at painted images is clearly intended to be educative—so moral in that sense—but I would wish to place the stress firmly on the visual and visualizing aspects of these images rather than on their participation within a discourse of ethics pervading eighteenth-century understandings of the public sphere.

88. On public punishments see Douglas Hay, "Property, Authority, and the Criminal Law," in *Albion's Fatal Tree: Crime and Society in Eighteenth Century En-gland*, ed. Douglas Hay et al. (Harmondsworth, 1977); for the theater see Leo Hughes, *The Drama's Patron: A Study of the Eighteenth Century London Audience* (Austin, 1971); for the masquerade see Terry Castle, *Masquerade and Civilisation* (London, 1986); for exhibitions see Malcolm Baker, "A Rage for Exhibitions," in *The Genius of Wedgwood*, ed. Hilary Young (London, 1995); and on shows in general see Richard D. Altick, *The Shows of London* (Cambridge, 1978); Roy M. Wiles, "Crowd Pleasing Spectacles in Eighteenth Century England," *Journal of Popular Culture* 1 (1967).

Chapter Two: Vauxhall Gardens

1. This metaphorics changes over time so that, for example, the early nineteenth century will witness a revolution in the basic premises of visuality that is coincident with changing technologies of visualization, some of which are mechanical devices, such as the camera, and some discursive or social practices. The most helpful account of this change is Jonathan Crary, *Techniques of the Observer* (Cambridge, Mass., 1990).

2. See *Memoirs of the Literary and Philosophical Society of Manchester*, 10 vols. (Warrington, 1785), 1:114–15: "Mere intellectual pleasures, however agreeable in themselves, by overstraining the mind, become at length painful. Organic enjoy-ments last only as long as we are in vigour. But the pleasures of the eye and ear, as Lord Kaims ingeniously observes, in his *Elements of Criticism*, holding the middle way between these two, are particularly fitted to occupy the mind without exhaust-ing it. They relax it after intense study, and restore it to its proper tone, after the sati-ety and disgust, caused by the mere pleasures of the senses." It is also worth noting that early visitors to exhibitions of paintings commented on the "glare" given off by some pictures. On this see Marcia Pointon, "Portrait! Portrait! Portrait!" in *Art on the Line*, ed. David Solkin (New Haven, 2001), 103.

3. Addison in his *Pleasures of the Imagination* papers gives an account of the ways in which the eye is led in and through architectural space: "Look upon the outside of a Dome, your Eye half surrounds it; look up into the Inside, and at one Glance you have all the Prospect of it; the entire Concavity falls into your Eye at once" (*The Spectator*, ed. Gregory Smith, 4 vols. [London, 1907], 3:290). See also *Memoirs of the Literary and Philosophical Society of Manchester*, 10 vols. (Warrington, 1785), 1:122–23: "modern architects . . . have placed, in the middle of their buildings, a principal

part, which, eminent above the rest, gives the sight a fixed point, from which it can glance over all the rest, and so enable the mind to get, at once, a clear and distinct idea of the whole."

4. Of course, the glance may lead on to the gaze; early commentary on paintings makes it clear that an image may seduce the eye into other pleasures. A newspaper review of West's submission in a 1769 exhibition states, "You cannot glance your eye upon the canvas without being insensibly led to examine the story" (press cuttings in the Victoria and Albert Museum, volume marked 1723–1900, 88).

5. For the study of optics in the period see John Yolton, *Perceptual Acquaintance from Descartes to Reid* (Minneapolis, 1984); G. N. Cantor, *Optics after Newton* (Manchester, 1983); *The Discourse of Light from the Middle Ages to the Enlightenment* (Los Angeles, 1983); Elsie C. Graham, *Optics and Vision: The Background of the Metaphysics of Berkeley* (New York, 1929); Michael J. Morgan, *Molyneux's Question: Vision, Touch, and the Philosophy of Perception* (Cambridge, 1977); G. N. Cantor, "The Historiography of 'Georgian Optics,'" *History of Science* 16 (1978): 1–21; Henry John Steffens, *The Development of Newtonian Optics in England* (New York, 1977).

6. For an account of the "metaphorology" of the visual see Barbara Maria Stafford, *Body Criticism* (Cambridge, Mass., 1991).

7. The language of gesture was not, of course, invented in this period. Nevertheless, the attention paid to a forensics of gestural symbolization was both detailed and fascinated. Within a voluminous literature see [Samuel Foote], *A Treatise on the Passions, so Far as They Regard the Stage* (London, 1747); *The New Art of Speaking, or a Complete Modern System of Rhetoric* (London, 1785); Aaron Hill, *The Art of Acting* (London, 1746).

8. One Andrew Skiddy of Chelsea wrote to John Strange in 1782 about the experience of the exhibition room: "there is a fashionable Rage which seems to prevail here for some late years, which is gratified at the moderate Expence of a Shilling a Visit. I mean the different Exhibitions of the Works of English Artists. . . . To these Places of Publick Resort, do People Flock in a forenoon to saunter about gazing at each other as at any other kind of Route, and now and then perhaps look with admiration on an *Outre* Piece, that on account of its staring Colours and sharp unnatural Angles would *attrape* their Notice sooner than the most chaste and most classical piece in your Collection" (cited in Martin Myrone, "The Sublime as Spectacle: The Transformation of Ideal Art at Somerset House," in *Art on the Line*, ed. David Solkin [New Haven, 2001], 79).

9. Adam Smith, *The Theory of Moral Sentiments*, ed. D. D. Raphael and A. L. Macfie (Oxford, 1976), 9.

10. For a discussion of Smith's text in terms of its theatrical registers see David Marshall, *The Figure of Theater: Shaftesbury, Defoe, Adam Smith, and George Eliot* (New York, 1986).

11. The most interesting discussion of the garden in ways that complement the present argument is in David Solkin, *Painting for Money* (New Haven, 1993); for other accounts see T. J. Edelstein, ed., *Vauxhall Gardens* (New Haven, 1983); David

Coke, *The Muse's Bower: Vauxhall Gardens, 1728–1786* (Sudbury, 1978); J. G. Southworth, *Vauxhall Gardens* (New York, 1941).

12. For a full account of these see Lawrence Gowing, "Hogarth, Hayman, and the Vauxhall Decorations," *Burlington Magazine* 95, no. 598 (Jan. 1953): 4–19.

13. The story of Hogarth's plan to showcase native contemporary painters is well known. He encouraged other artists (mainly from the St. Martin's Academy) to donate pictures to the foundation, and following the first show in 1747, the hospital became a popular venue for viewing art. Other semipublic spaces for the display of art were also being created at the same time. Many country houses, for example Burlington's Chiswick house, Houghton and Holkham in Norfolk, or Kedleston in Derbyshire, were built expressly to display art collections. These houses were visited, entrance fees often charged, and guidebooks written, all of which contributed toward the development of a recognizable "modern" form of tourism.

14. Joseph Addison, *Spectator* 383, May 20, 1712. The garden was suffused with Turkish allusions; on this see David Solkin, *Painting for Money* (New Haven, 1993), esp. 285 n. 6.

15. This is a good example of Tyers's eye for the main chance. Robert Wood's *The Ruins of Palmyra* (London, 1753) had been an instant success.

16. See Warwich Wroth, *The London Pleasure Grounds of the Eighteenth Century* (London, 1896), 301.

17. See J. G. Southworth, *Vauxhall Gardens* (Cambridge, 1941), 41.

18. Ibid., 33. The social discrimination of viewers was recorded in 1728:

"Well Sirs," quoth Joe Potter, "What have we here? a picture, I perceive; hem! haugh! Let me see," pushing his spectacles upon his forehead, and examining the landscape, by making a peep-hole of his half closed fist, like other learned connoisseurs, to take in the whole effect. "Hem! Haugh! Very well, Master Ben, very capital—upon-my-word!"

Now, be it known, this Benjamin, was Mr Jonathan Tyers' coachman, who was a dabbler in painting; and such a dauber—such a spoiler of canvas—O ye Gods! Joe Potter, a true Vauxhall connoisseur, where Bristol stones pass current for diamonds, could perceive no difference between a Wilson and a daub. (*Reminiscences of Henry Angelo* [London, 1728], 155)

19. *The Ambulator, or the Stranger's Companion in a Tour round London*, 2d ed. corr. (London, 1782), 195. This contemporary guidebook plunders sources without acknowledgment. It contains verbatim passages from the 1762 guide to the gardens, *A Description of Vaux-Hall Gardens* (London, 1762). Vauxhall was routinely described in guidebooks to the city. See *London and Its Environs Displayed*, 6 vols. (London, 1761), vol. 6.

20. The great avenue at Wimpole Hall was planted with elms circa 1718. Eighteenth-century viewers would be aware of the iconography of trees; the oak, for example, was strongly associated with patriotism since the timber was required in the construction of ships. On this see Stephen Daniels, "The Political Iconography

of Woodland in Later Georgian England," in *The Iconography of Landscape*, ed. Denis Cosgrove and Stephen Daniels (Cambridge, 1988); and Tom Williamson, *Polite Landscapes: Gardens and Society in Eighteenth-Century England* (Stroud, 1995).

21. From very early on in its history the gardens were associated with the miraculous illusion of being brought into visuality. *The Champion*, Aug. 5, 1742, contains the following account: "I was now (at Vauxhall) introduced to a place of a very different kind from that I had visited the night before—vistas, woods, tents, buildings, and company, I had a glimpse of, but could discover none of them distinctly, for which reason I began to repine that we [had] not arrived sooner, when all in a moment, as if by magic, every object was made visible—I should rather say illustrious—by a thousand lights finely disposed, which were kindled at one and the same signal, and my ears and my eyes, head and heart, were captivated at once" (press cutting in Wroth collection, Museum of London, 1:8).

22. This inability to articulate can be usefully contrasted with the imperative to speak in front of the canvas that characterizes early descriptions of exhibition going commented on in the previous chapter.

23. As *The Ambulator* states: "at the end of this walk is a beautiful painting; one is a building with a scaffold and a ladder before it, which has often deceived the eye very agreeably" (204).

24. The "truth" of representation was so beguiling that many visitors felt the need to touch the canvases in order to ascertain that they were two-dimensional images: "At Vauxhall . . . they have touched up all the pictures, which were damaged last season by the fingering of those curious connoisseurs, who could not be satisfied without *feeling* whether the figures were alive" (*Gentleman's Magazine* 25 [1755]: 127). I will argue below that the project of the gardens was to educate the viewer into feeling in a different way.

25. This is to point to the articulation between a private-public space and a public one. In other words even within the spacings of the spectacle the public is differentiated. Some of the supper boxes, for example, were described as "in the very focus of the public view," whereas others were deemed "for more genteel company" (Wroth press cuttings, 1:11).

26. This making oneself into a spectacle/spectator is a common feature of London pleasure grounds. Ranelagh, for example, created a similar environment in terms of the staging and staginess of spectacle. A contemporary tour through Middlesex described the garden in the following manner: "A Rotunda, as I may call it, is erected in the Gardens, to propagate sound instead of sense, and to feast the Eyes of Belles and beaus, who croud thither to become spectacles to one another, for the Benefit of the Proprietors of the Understanding" (quoted in Jacob Henry Burn, *Historical Collections Relative to Ranelagh Gardens* [London, 1760], 150).

27. Tyers was fully aware of the attraction of the mixing of ranks. On June 25, 1781, the Duke and Duchess of Cumberland advertised the fact that they were going to sup in the gardens, and this attracted a crowd of eleven thousand people. See *A Brief Historical and Descriptive Account of the Royal Gardens, Vauxhall* (London, 1822), 8.

28. Wroth press cuttings, 3:38. See also Pierre Grosley, *A Tour to London*, 2 vols.

(London, 1772), 1:153: "the pleasures of Vauxhall and Ranelagh unite both sexes and all ranks and conditions."

29. *A Description of Vaux-Hall Gardens* (London, 1762), 49.

30. [John Lockman], *A Sketch of Spring Gardens, Vauxhall in a Letter to a Noble Lord* (London, nd [1752]), 12–13.

31. Oliver Goldsmith, *The Citizen of the World; or Letters from a Chinese Philosopher, Residing in London, to His Friends in the East*, 2 vols. (London, 1762), 2:26 (letter 68). The gardens were famous for the illuminations—thousands of lamps lighting the walks and amusements. The 1822 guide claims that by that time the number of lamps was about twenty thousand. See *A Brief Historical and Descriptive Account of the Royal Gardens, Vauxhall* (London, 1822), 41.

32. The text is discussed in Kristina Straub, *Sexual Suspects* (Princeton, 1992) in relation to eighteenth-century spectacle and the theater.

33. It would seem to have been pretty common practice for "foppish" men to stare at women. A similar encounter is described by Fanny Burney in her novel *Evelina* (Oxford, 1982), esp. 29, 106.

34. The macaroni, insofar as he is a type within sentimentalism, presents a particularly good case of what Robert Markley calls "a masculinist complex of strategies designed to relegate women to the status of perpetual victims." See Robert Markley, "Sentimentality as Performance: Shaftesbury, Sterne, and the Theatrics of Virtue," in *The New Eighteenth Century*, ed. Felicity Nussbaum and Laura Brown (London, 1987), 211–12. For further discussion of the politics of male virtue see Randolph Trumbach, "Sodomy Transformed: Aristocratic Libertinage, Public Reputation, and the Gender Revolution of the Eighteenth Century," *Journal of Homosexuality* 19 (1990); Susan Staves, "A Few Kind Words for the Fop," *Studies in English Literature* 22 (1982): 413–28; G. J. Barker-Benfield, *The Culture of Sensibility* (Chicago, 1992), esp. 104–53; Susan D. Amussen, *An Ordered Society: Gender and Class in Early Modern England* (Oxford, 1988); Randolph Trumbach, "Sex, Gender, and Sexual Identity in Modern Culture: Male Sodomy and Female Prostitution in Enlightenment London," *Journal of the History of Sexuality* 2, no. 2 (1991).

35. *The Vauxhall Affray; or, the Macaronies Defeated* (London, 1773), 11.

36. On the contemporary disquiet about hermaphrodites see Barbara Maria Stafford, *Body Criticism* (Cambridge, Mass., 1991), esp. 265–66.

37. This effect, in the words of an early commentator, is one of "pleasing wonder." See [John Lockman], *A Sketch of Spring Gardens, Vauxhall in a Letter to a Noble Lord* (London, nd [1752]), 10.

38. The demands on the proprietors to keep refreshing the entertainments meant that over time some attractions were replaced or fell into neglect. The purpose of the gardens, however, remained pretty constant. In the early decades of the nineteenth century, for example, another marvel of self-presentation was introduced into the gardens. We learn from the *Gentleman's Magazine* in 1822: "Vauxhall gardens were reopened under the patronage of his Majesty . . . but the principal novelty is of a more expensive kind: it is called in the bills 'The Heptaplasiesoptron' and is formed at the end of the saloon. It consists of an illuminated area, with revolving pillars, around

which are entwined serpents, shaded under the foliage of palm trees. The centre is occupied by a cooling fountain; and looking glasses, skillfully placed in the background reflect both the ornamental objects and the spectators, with something approaching to magnificence of effect" (*Gentleman's Magazine*, June 1822, 558).

39. The gardens have long been acknowledged as providing a unique set of *visual* pleasures. John Lockman characterized those pleasures as stemming from the spectator's continual recomposing of the picture. See [John Lockman], *A Sketch of Spring Gardens, Vauxhall in a Letter to a Noble Lord* (London, nd [1752]), 17.

40. The war referred to was the Seven Years War. See *A Description of Vaux-Hall Gardens* (London, 1762), 24.

41. These paintings are described in *London Magazine, or Gentleman's Monthly Intelligencer* 32 (May 1763): 233–34.

42. Wroth press cuttings, 3:7.

43. Ibid.

44. Ibid.

45. *Scot's Magazine*, July 1739, 363.

46. See Brian Allen, *Francis Hayman* (London, 1987), 149; the same concerns are apparent in the second *Britannia* image, which, in case the audience was ignorant of the leading heroes of the war, spelled them out on a scroll held by fame: "Behind Britannia is fame, with a scroll in her hand, on which the names of our Heroes are mentioned, and which is attentively perused by a Hercules, who makes a most excellent companion to the British Lion; while, behind the Generals, an Obelisk rears its head, inscribed with the places where they merited the laurels they are receiving" (Wroth cuttings, 3:7).

47. The term *satisfaction* occurs with considerable frequency in early accounts of paintings. See, e.g., *Public Advertiser*, May 1766: "I was a few days ago at the exhibition in Spring Gardens, and really found many pictures in the room which gave me unspeakable satisfaction."

48. See Allan Ramsay, *The Investigator* (London, 1762), 56–58:

The leading principle of criticism in poetry and painting, and that of all the learned principles which is the most unexceptionally true, is known to the lowest and most illiterate of the people. Those experiments are easily made. Your Lordship has only to hide yourself behind the screen in your drawing room, and order Mrs Hannah to bring in one of your pictures by La Tour, and no less with the view of your seat by Lambert, and shall, fifty to one, express her approbation by saying, they are *vastly natural*. When she has said this, she has shewn that she knew the proper standard, by which her approbation was to be directed, as much, at least, as she would have done, if she had got Aristotle by heart and all his commentators. . . . In all this . . . it requires first eyes to see, and then judgment to compare the exhibited image with that of the absent object, which is stored up in the remembrance, and is plainly a reflective and compound operation of the mind. It is indeed so quick and instantaneous, that it often passes for a simple feeling or sentiment.

49. Charles Philipp Moritz, *Travels, Chiefly on Foot, through Several Parts of England, in 1782, Described in Letters to a Friend* (London, 1795), 42.

Chapter Three: The Leasowes and Hagley Park

1. The first major work of scholarship in the twentieth century on the complex of discourses we call the landscape arts is Elizabeth Manwaring, *Italian Landscape in Eighteenth Century England* (London, 1925). In a number of books since then, including classics such as Christopher Hussey, *The Picturesque* (London, 1927); Christopher Hussey, *English Gardens and Landscapes, 1700–1750* (London, 1967); W. J.Hipple Jr., *The Sublime, the Beautiful, and the Picturesque* (Carbondale, 1957); and the more recent John Barrell, *The Idea of Landscape and the Sense of Place* (Cambridge, 1972); and John Dixon Hunt, *The Figure in the Landscape* (Baltimore, 1976)—a substantial scholarly orthodoxy has grown up that is only now beginning to be reassessed and critically examined. See most recently the *Journal of Garden History* 13, nos. 1–2 (spring/summer 1993), an issue devoted to "rediscovering the British garden"; and Tom Williamson, *Polite Landscapes: Gardens and Society in Eighteenth-Century England* (Stroud, 1995).

2. Recent work has stressed the continuities between seventeenth-century gardens and the "new" English taste. See especially John Dixon Hunt, *Garden and Grove: The Italian Landscape Garden in the English Imagination* (London, 1986); Douglas C. Chambers, *The Planters of the English Landscape Garden* (New Haven, 1993); Charles H. Hinant, "A Philosophical Origin of the English Landscape Garden," *Bulletin of Research in the Humanities* 93 (1980): 292–306. The pervasiveness of this change to the natural has recently been challenged by Tom Williamson. See his *Polite Landscapes: Gardens and Society in Eighteenth-Century England* (Stroud, 1995), esp. 48–76.

3. See E. N. Hooker, "The Discussion of Taste, 1750–1770," *PMLA* (June 1934).

4. This should alert us, rather more forcefully than is often the case, to the difficulties of "reconstructing" historical landscapes, just as it should impress on us the problematic and conceptually complex *historical* nature of garden design and realization.

5. On this see Ronald Paulson, *Emblem and Expression: Meaning in English Art of the Eighteenth Century* (London, 1975); Tom Williamson and Liz Bellamy, *Property and Landscape: A Social History of Land Ownership and the English Countryside* (London, 1987); John Barrell, *The Dark Side of the Landscape* (Cambridge, 1980); and Ann Bermingham, *Landscape and Ideology* (Berkeley, 1986).

6. The stress on experience here is meant to signal a distance between the current project and examinations of the relations between social and political issues governing land use and *representations* of the landscape. This latter topic has been extensively researched; the most compelling account remains John Barrell, *The Dark Side of the Landscape* (Cambridge, 1980); see also Michael Rosenthal, *Constable: The Painter and His Landscape* (London, 1983).

7. This echo is not restricted to what I am calling the standard account—it was also a feature of the eighteenth-century connoisseur's thought about "landscape."

8. See Christopher Thacker, *The History of Gardens* (London, 1979), 185–97; John Dixon Hunt, *The Figure in the Landscape* (Baltimore, 1976), 194–95.

9. See John Harris, *The Artist and the Country House: A History of Country House and Garden View Painting in Britain, 1540–1870* (London, 1979); Linda Cabe Halpern, "The Use of Paintings in Garden History," in *Garden History: Issues, Approaches, Methods*, ed. J. D. Hunt (Washington, D.C., 1992); and Roy Strong, *The Artist and the Garden* (New Haven, 2000).

10. See Solomon Gessner, "Letter on Landscape Painting," in *New Idylls* (London, 1776), 96–97; Thomas Martyn, *The English Connoisseur*, 2 vols. (Dublin, 1767), 1:90; William Marshall, *A Review of the Landscape* (London, 1795), 14.

11. For an interesting reading of Switzer see James Turner, "Stephen Switzer and the Political Fallacy in Landscape Gardening History," *Eighteenth-Century Studies* 11 (summer 1978). It is, of course, well known that Alexander Pope had a serious interest in the construction of landscape gardens. For good accounts of this see Peter Martin, *Pursuing Innocent Pleasures: The Gardening World of Alexander Pope* (London, 1984); David Jacques, *Georgian Gardens: The Reign of Nature* (London, 1985); John Dixon Hunt, "Ut Pictura Poesis, Ut Pictura Hortus, and the Picturesque," in *Gardens and the Picturesque* (Cambridge, Mass., 1992), 105–36; John Dixon Hunt, *Greater Perfections: The Practice of Garden Theory* (London, 2000).

12. For a later account see Daines Barrington, "The Progress of Gardening," *Archaeologia* 7 (1785).

13. Walpole's essay was printed in 1771 with his *Anecdotes of Painting in England* but was not published until 1780. A separate edition of Walpole's *History of the Modern Taste in Gardening* was published in 1785, and a modern edition, edited by I. W. U. Chase, can be found in *Horace Walpole, Gardenist* (Princeton, 1943).

14. On the political leanings of Walpole's aesthetics see Richard E. Quaintance, "Walpole's Whig Interpretation of Landscaping History," *Studies in Eighteenth Century Culture* 9 (1979): 285–300; and Samuel Kliger, "Whig Aesthetics: A Phase in Eighteenth Century Taste," *ELH* 16 (1949): 135–50.

15. On Capability Brown see Dorothy Stroud, *Capability Brown* (London, 1950); E. Hyams, *Capability Brown and Humphrey Repton* (London, 1971); Roger Turner, *Capability Brown and the Eighteenth Century English Landscape* (London, 1985); Tom Williamson, *Polite Landscapes: Gardens and Society in Eighteenth-Century England* (Stroud, 1995), 77–99.

16. The narrative arrests itself: "At that moment appeared Kent" (25). On Kent and gardening see John Dixon Hunt, *William Kent, Landscape Garden Designer* (London, 1987); George B. Clarke, "William Kent in Stowe's Elysium," in *Furor Hortensis: Essays on the History of the English Landscape Garden in Memory of H. F. Clark*, ed. Peter Willis (Edinburgh, 1974); John Fleming, "William Kent at Rousham, an Eighteenth Century Elysium," *Connoisseur*, May 1963, 158–65; Christopher Hussey, "A Georgian Arcady—William Kent's Gardens at Rousham, Oxfordshire," *Country Life*, June 14, 21, 1946, 1084–85; Margaret Jourdain, *The Work of William*

Kent—Artist, Painter, Designer, and Landscape Gardener (London, 1948); Hal Moggridge, "Notes on William Kent's Garden at Rousham," *Journal of Garden History* 6 (1986): 187–226; Simon Pugh, *Garden—Nature—Language* (Manchester, 1988); H. A. Tipping, "Four Unpublished Letters of William Kent," *Architectural Review* 113 (1928): 180–83, 209–11; Peter Willis, "William Kent's Letters in the Huntington Library, California," *Architectural History* 29 (1986): 158–67; Michael I. Wilson, *William Kent: Architect, Designer, Painter, Gardener, 1685–1748* (London, 1984); Kenneth Woodbridge, "William Kent as Landscape Gardener. A Re-appraisal," *Apollo* 100 (1974): 126–37; Kenneth Woodbridge, "William Kent's Gardening. The Rousham Letters," *Apollo* 100 (1974): 282–91.

17. This is true even if, as Tom Williamson notes, the spread of Brownian parklands was slower and less extensive than has been suggested. See Tom Williamson, "Garden History and Systematic Survey," in *Garden History: Issues, Approaches, Methods*, ed. J. D. Hunt (Washington, D.C., 1992).

18. Examples of Walpole's description of the landscape in pictorial terms abound; see, e.g., his comments on Hagley Park in a letter to Richard Bentley in 1753: "there is such a pretty well in a wood, like the samaritan woman's in a picture of Nicolo Poussin! . . . In the meantime how rich, how gay, how picturesque the face of the country! The demolition of walks laying open each improvement, every journey is made through a succession of pictures" (quoted in Roger Turner, *Capability Brown and the Eighteenth Century English Landscape* [London, 1985], 163–64).

19. The most extensive discussions of this crisis can be found in John Barrell, *The Political Theory of Painting* (New Haven, 1986); and David Solkin, *Painting for Money* (New Haven, 1993).

20. Walpole's assessment reverberates throughout the subsequent history of the English landscape tradition. A nineteenth-century dictionary entry for Kent read: "He was a painter, an architect, and the father of modern gardening. In the first character, he was below mediocrity; in the second, he was a restorer of the science; in the last, an original, and an inventor of an art that realizes painting, and improves nature" (*An Illustrative Supplement to Pilkington's Dictionary of Painters* [London, 1895], 107–8).

21. The improvement of landscape went hand in hand with enclosure and engrossment so that a garden laid out in the 1720s, for example, might have extended to twenty or thirty acres; by the 1770s nine hundred acres had been added to the existing grounds at Luton Hoo. On this see Dorothy Stroud, *Capability Brown* (London, 1975), 143; Joan Bassim, "The English Landscape Garden in the Eighteenth Century: The Cultural Importance of an English Institution," *Albion* 11, no. 1 (spring 1974): 15–33, esp. 24; David Solkin, *Richard Wilson: The Landscape of Reaction* (London, 1982), 122–23.

22. In the notes to Mason's *Satirical Poems* Walpole explicitly states, "The English Taste in Gardening is thus a growth of the English Constitution, & must perish with it" (William Mason, *Satirical Poems*, ed. Paget Toynbee [Oxford, 1936], 45). The political reading of the landscape continued into the controversy among Price, Knight, and Repton, where again the notion of liberty is fully exploited in a politi-

cal dimension. For details of this debate see David Jacques, *Georgian Gardens: The Reign of Nature* (London, 1983), 150–56; and on Mason see John W. Draper, *William Mason: A Study in Eighteenth Century Culture* (New York, 1924).

23. This unilinear chronological model is beginning to yield to a more complex account of the interactions between the two "styles." Current thinking has it that the two commingled or coexisted more frequently than was supposed in the past.

24. Here again the sense of a chronological development is slightly misleading since "lay" practitioners were in charge of the layout of grounds from the beginning of garden design. On this see Douglas C. Chambers, *The Planters of the English Landscape Garden* (New Haven, 1993); Tom Williamson, "Garden History and Systematic Survey," in *Garden History: Issues, Approaches, Methods*, ed. J. D. Hunt (Washington, D.C., 1992).

25. William Marshall, *Planting and Ornamental Gardening* (London, 1785), 604. It should be pointed out that Marshall's text quotes verbatim Walpole's *History*, so at first glance the argument I am proposing looks strange; Marshall's understanding of the relationship between the natural and the artificial, or between nature and art, is distinct from Walpole's: where Walpole takes his cue from the high art tradition, Marshall recommends that the hand of art, although required in some cases, should be virtually invisible. His decision to reprint Walpole's text should be seen as much in terms of an attempt to borrow prestige as an indication of his assent to the pictorial tradition of landscape aesthetics. Indeed, as the later work makes clear, his position is antipictorial.

26. William Marshall, *A Review of the Landscape, Also of an Essay on the Picturesque* (London, 1795), 37–38.

27. This does not address the question of the private circulation of his manuscript, which had been available to those in the know for the intervening decade. Gray, e.g., requested a loan of the manuscript in 1771. For details on this see Malcolm Andrews, *The Search for the Picturesque* (Stanford, 1989), 86–107. On Gilpin see C. P. Barbier, *William Gilpin: His Drawings, Teachings, and the Theory of the Picturesque* (Oxford, 1963); and J. F. A. Roberts, *William Gilpin and Picturesque Beauty* (Cambridge, 1944).

28. William Gilpin, "Instructions for Examining Landscape," ms. in the Fitzwilliam Museum, Cambridge, 4.

29. On this see Malcolm Andrews, *The Search for the Picturesque* (Stanford, 1989).

30. The first account in these terms is in W. J. Hipple Jr., *The Sublime, the Beautiful, and the Picturesque* (Carbondale, 1957), which has been developed in Ann Bermingham, *Landscape and Ideology* (Berkeley, 1986), esp. 83–85; Allan Liu, *Wordsworth: The Sense of History* (Stanford, 1989), esp. 61–137; Sidney K. Robinson, *Inquiry into the Picturesque* (Chicago, 1991), esp. 73–89; Stephen Copley and Peter Garside, *The Politics of the Picturesque* (Cambridge, 1994).

31. For a good account of the Price, Repton, and Knight controversy see David Jacques, *Georgian Gardens: The Reign of Nature* (London, 1983), esp. 150–56.

32. George Mason, *An Essay on Design in Gardening*, 2d ed. (London, 1795), 190–92.

33. Girardin's treatise, for example, was translated from the French in 1783, and it presents pretty unambiguously the traditional view:

> Now it is only by considering the effect of [the most beautiful objects of nature] as a picture, that one can dispose pleasing objects to advantage; for the picturesque effect depends entirely upon the choice of the most agreeable forms, the elegance of outline, and keeping the distances; it consists in managing a happy contrast of light and shadow, in giving projection and relief to the objects, and producing the charm of variety, by showing them in different lights, different shapes, and under different points of view; also in the beautiful assemblage of colours, and above all, in that happy negligence which is the peculiar characteristic of grace and nature.
>
> It is not as an architect or gardener, but as a poet and painter, that landscape must be composed, so as to please the understanding and the eye. (R. L. Girardin and Victe D'Ermenonville, *An Essay on Landscape* [London, 1783], 14–15)

34. See A. Boersch, "Landscape: Exemplar of Beauty," *British Journal of Aesthetics* 11 (1971): 81–95.

35. Whately is here clearly thinking in pictorial terms; the composition of the canvas was a well-grounded theoretical component of art criticism. See, e.g., George Turnbull, *A Treatise on Ancient Painting* (London, 1740), 140.

36. This somatic register is present early on in the discussion of visuality. See Joseph Addison, *The Spectator*, ed. Gregory Smith, 4 vols. (London, 1907), 3:278: "Delightful scenes, whether in nature, painting or poetry have a kindly influence on the body, as well as the mind."

37. See Peter Willis, *Charles Bridgeman and the English Landscape Garden* (London, 1977); Kimmerly Rorschach, *The Early Georgian Landscape Garden* (New Haven, 1983); Max Shulz, "The Circuit Walk of the Eighteenth-Century Landscape Garden and the Pilgrim's Circuitous Progress," *Eighteenth-Century Studies* 15 (fall 1981): 1–25; Ronald Paulson, *Emblem and Expression: Meaning in English Art of the Eighteenth Century* (London, 1975), 19–34.

38. For a recent history of the mirror see Sabine Melchior-Bonnet, *The Mirror: A History*, trans. Katherine H. Jewett (London, 2001).

39. Other kinds of discussion of the garden can be found in David Jacques, *Georgian Gardens: The Reign of Nature* (London, 1983); Christopher Thacker, *The History of Gardens* (London, 1979); and John Dixon Hunt, *The Figure in the Landscape* (Baltimore, 1976).

40. Details of Shenstone's life are in Marjorie Williams, *William Shenstone: A Chapter in Eighteenth-Century Taste* (Birmingham, 1935); and E. Munro Purkis, *William Shenstone. Poet and Landscape Gardener* (Wolverhampton, 1931); Marjorie

Williams, *Shenstone and His Friends* (London, 1933); A. R. Humphreys, *William Shenstone: An Eighteenth Century Portrait* (Cambridge, 1937).

41. These distinctions were first made by Whately in his *Observations on Modern Gardening* and were developed in a seminal article by John Dixon Hunt, "Emblem and Expression in the Eighteenth Century Landscape Garden," *Eighteenth-Century Studies* 4 (spring 1971): 294–317. Current scholarship, however, has tended to blur the distinction both in terms of chronology and of type.

42. Discussions of the "circuit" can be found in Ronald Paulson, "The Pictorial Circuit and Related Structures in Eighteenth Century England," in *The Varied Pattern: Studies in the Eighteenth Century,* ed. Peter Hughes and David Williams (Toronto, 1971), 165–87; Max F. Shulz, "The Circuit Walk of the Eighteenth-Century Landscape Garden and the Pilgrim's Circuitous Progress," *Eighteenth-Century Studies* 15 (fall 1981): 1–25. The literature on Stourhead is substantial; see, e.g., Kenneth Woodbridge, *Landscape and Antiquity: Aspects of English Culture at Stourhead, 1718 to 1838* (Oxford, 1970); Michael Charlesworth, "On Meeting Hercules in Stourhead Garden," *Journal of Garden History* 9, no. 2 (1989): 71–75; and Edward Malins, *English Landscaping and Literature, 1660–1840* (New York, 1966), esp. 51–55; Christopher Hussey, *Great Gardens and Landscapes, 1700–1750* (London, 1967); D. Jarrett, *The English Landscape Garden* (London, 1978), 56–65; K. Rorschach, *Early Georgian Landscape Gardens* (New Haven, 1983), 74–79.

43. See Oliver Goldsmith, "The History of a Poet's Garden," *Westminster Magazine,* Jan. 1, 1773.

44. These thoughts can be found in William Shenstone, *The Works in Verse and Prose of William Shenstone,* 2 vols. (London, 1764), 2:125–47.

45. Sir John Dalrymple, "An Essay on Landscape Gardening," *Journal of Garden History* 3, no. 2 (April–June 1983): 147. On Shenstone's possessing a copy of Dalrymple's essay see Robert Williams's introduction.

46. James Turner has argued for a specific program of response: "I suggest . . . that Shenstone tried to design a system in which sex, land, morality, and their economic structure combine in such a way that we forget their mutual inapplicability, and come to feel that each can only be fully understood in combination with the others; for example, sex becomes moral when converted into thrifty landscape" ("The Sexual Politics of Landscape: Images of Venus in Eighteenth Century English Poetry and Landscape Gardening," *Studies in Eighteenth Century Culture* 11 [1982]: 343–66; 360). Turner's argument is committed to a reading of Shenstone's garden in terms of both literary expression and garden design and attempts to construct a composite form or text of the garden itself. His emphasis on reading, however, departs from the present focus of attention on the activity of looking, thereby diminishing the visual in favor of the readerly. This difference aside, Turner's argument requires careful consideration as the most adventurous discussion to date concerning the contemporary eighteenth-century experience of the garden. For the sexual connotations of landscape see "An Account of an Interview between Shenstone and Thomson, August 30, 1746," *Edinburgh Magazine; or Literary Miscellany,* n.s., 14 (1800): 287–89.

47. There are other contemporaneous accounts in manuscript; see, e.g., John Riely, "Shenstone's Walks: The Genesis of the Leasowes," *Apollo* 110 (Sep. 1979): 202–9.

48. The relations between art and nature are continuously investigated in the garden literature of the period. See David C. Streatfield and A. M. Duckworth, *Landscape in the Gardens and Literature of Eighteenth Century England* (Los Angeles, 1981).

49. Later, toward the end of the century, the garden had changed not only in material form. What it represented and how one responded to that representation had also changed. Thus, John Aikin, in his *Letters from a Father to His Son*, 3d ed. (London, 1796), complained: "The tumbling rills of the Leasowes were such miniature cascades, that they appeared more like stage scenery than objects of romantic nature" (150).

50. On the sources of Martyn's collection see Frank Simpson, "The English Connoisseur and Its Sources," *Burlington Magazine* 93, no. 583 (Oct. 1951).

51. It is interesting to note here that R. Patching, in his visit to the garden in 1757, had no such trouble with the "fairy"; he writes: "Two cascades are here remarkable for their Beauty and Simplicity; exceeding many Things of more Costly Workmanship, having the Advantage of unaffected Nature on their Side, and are indeed so elegantly rude, so rural and romantic, as must inspire the Beholder with a Notion, that the poetic Description of *Arcadia* and *Fairyland* are not altogether Fictions" (Resta Patching, *Four Topographical Letters* [London, 1757], 57–58).

52. Many guidebooks demonstrate the same fact by their translations from the classics. Perhaps the most overt example of this phenomenon is Joseph Baretti's *A Guide through the Royal Academy* (London, nd [1781]), which is aimed explicitly at those who do not "know the design, the history, and the names of the various Models that stand before them" (3). For a discussion of the "common knowledge" presumed in the recognition of classical statuary during the period see Malcolm Baker, "'Squabby Cupids and Clumsy Graces': Garden Sculpture and Luxury in Eighteenth-Century England," *Oxford Art Journal* 18, no. 1 (1995): 3–13.

53. A. Friedman, ed., *Collected Works of Oliver Goldsmith*, 5 vols. (Oxford, 1966), 3:206.

54. A corrective account of the garden and its changes is given by G. Lipscombe in his *A Journey into South Wales* (London, 1799). Lipscombe makes it clear that the real had impinged only too forcefully within the arcadian idyll. He comments in a rather deadpan way that the view from a particular seat has undergone some changes: "the view it formerly commanded of the valley near *Hales Owen*, is now excluded by the high banks of the *Stourbridge* canal" (300).

55. See E. G. Cox, *Reference Guide to the Literature of Travel*, 3 vols. (Seattle, 1935–49); tours that bear on the present discussion are George Beaumont, *A New Tour through England Performed in 1765, 6, and 7* (London, 1768); W. Jackson, *The Beauties of Nature Displayed* (Birmingham, 1769); Thomas Gray, *The Traveller's Companion in a Tour through England and Wales* (London, 1773); Thomas Quincy, *A Short Tour in the Midland Counties of England* (London, 1774); George Augustus Walpoole, *The New British Traveller* (London, 1784).

56. The following discussion of Shenstone's garden is indebted to the meticulous scholarship of John Riely, "Shenstone's Walks: The Genesis of the Leasowes," *Apollo* 110 (Sep. 1979): 202–9; Michael M. Rix, "Vicissitudes of a Landscape Garden," *Country Life* 107 (Nov. 3, 1950): 1490–91; Robin Paice, "The Leasowes—a Rediscovery," *Landscape Design* 19 (Aug. 1972): 11–13; H. F. Clark, "Eighteenth Century Elysiums," *Journal of the Warburg and Courtauld Institutes* 6 (1943): 165–89, esp. 175.

57. The standard account on this development remains Esther Moir, *The Discovery of Britain: The English Tourists, 1540–1840* (London, 1964).

58. For the most interesting account of this trend see Richard Hamblyn, "Landscape and the Contours of Knowledge: The Literature of Travel and the Sciences of the Earth in Eighteenth-Century Britain (Ph.D. diss., University of Cambridge, 1994).

59. Remarking of Holkham Hall in Norfolk, Richard Beatniffe noted that "the celebrated house of Thomas Wm. Coke . . . can be seen any day of the week, except Sunday, by Noblemen and foreigners, but on Tuesday only by other people" (Richard Beatniffe, ed., *The Norfolk Tour: or, Traveller's Pocket Companion*, 2d ed. [Norwich, 1773], 25).

60. The literature is substantial, but for examples of different kinds of account see William Watts, *The Seats of the Nobility and Gentry* (London, 1779); James Kennedy, *A Description of the Antiquities and Curiosities in Wilton House* (London, 1769); Richard Beatniffe, ed., *The Norfolk Tour: or, Traveller's Pocket Companion*, 3d ed. (Norwich, 1777); J. H. Pye, *A Peep into the Principal Seats and Gardens in and around Twickenham* (London, 1775); W. Toldervy, *England and Wales Described in a Series of Letters* (London, 1762); A. Young, *England Displayed* (London, 1789); W. Gilpin, *Observations on the River Wye, and Several Parts of South Wales* (London, 1782).

61. Much of the available pictorial evidence, such as engravings of country seats, gives the impression that these landscapes were populated. This does not include, of course, the country house portrait, which would most commonly have depicted only the owner (sometimes including his family) in his landscape.

62. *The Letters of William Shenstone*, ed. Marjorie Williams (Oxford, 1939), 183.

63. The political and ideological dimensions to garden design have been explored most fruitfully by Carole Fabricant in her "Binding and Dressing Nature's Loose Tresses: The Ideology of Augustan Landscape Design," *Studies in Eighteenth-Century Culture* 8 (1979): 109–35.

64. The various publications are *A Description of Hagley, Envil, and the Leasowes Wherein All the Latin Inscriptions Are Translated and Every Particular Beauty Described* (London, 1775?); *A Description of Hagley Park. By the Author of "Letters on the Beauties of Hagley, Envil, and the Leasowes"* (London, 1777); *A Description of Envil. By the Author of "Letters on the Beauties of Hagley, Envil, and the Leasowes"* (London, 1777); *A Description of the Leasowes. By the Author of "Letters on the Beauties of Hagley, Envil, and the Leasowes"* (London, 1777); *Letters on the Beauties of Hagley, Envil, and the Leasowes*, 2 vols. (London, 1777).

65. For a discussion of this see Maren-Sofie Rostvig, *The Happy Man: Studies in*

the Metamorphoses of an Ideal (Oslo, 1962–71); and Raymond Williams, *The Country and the City* (London, 1973).

66. The classic account of the binary division of gender as it relates to the gaze is Laura Mulvey, "Visual Pleasure and Narrative Cinema," *Screen* 16, no. 3 (autumn 1975): 6–18. As I mentioned in note 7 of my introduction, Mulvey problematized her model, which contrasts an objectifying and active male gaze with an objectified and passive female recipient of the gaze, in her "Afterthoughts on 'Visual Pleasure and Narrative Cinema' inspired by *Duel in the Sun*," *Framework* 6, nos. 15–17 (1981). For a good account of more recent work in this area see Constance Penley, *The Future of an Illusion: Film, Feminism, and Psychoanalysis* (London, 1989).

67. There are instances of female characters taking on masculine stereotypes within the civic humanist tradition. See, e.g., Spence's figuration of virtue as feminine with manly characteristics discussed in John Barrell, "'The Dangerous Goddess': Masculinity, Prestige, and the Aesthetic in Early Eighteenth-Century Britain," *Cultural Critique* 12 (1989): 101–31.

68. A certain asymmetry operates here since a corresponding expansion of femininity does not appear to be so easily identifiable in the period. Indeed, as Lynne Friedli notes, female roles in the period were typically restricted by the wife/mother/prostitute topos. See Lynne Friedli, "'Passing Women'—A Study of Gender Boundaries in the Eighteenth Century," in *Sexual Underworlds of the Enlightenment*, ed. G. S. Rousseau and Roy Porter (Manchester, 1987); Kaja Silverman, *The Threshold of the Visible World* (London, 1996), esp. 125–93.

69. The secondary material on Stowe is substantial, but see esp. George Clarke, "Grecian Taste and Gothic Virtue: Lord Cobham's Gardening Programme and Its Iconography," *Apollo* 107 (June 1973): 566–71; John Martin Robinson, *Temples of Delight: Stowe Landscape Gardens* (London, 1990); John Dixon Hunt, *Gardens and the Picturesque* (Cambridge, Mass., 1992), esp. chap. 3; M. J. Gibbon, "Gilbert West's Walk through the Gardens in 1731," *Stoic* 24 (March 1970); George Clarke, "Moral Gardening: The History of Stowe—," *Stoic* 24 (1970); M. J. Gibbon, "Stowe, Buckinghamshire: The House and Garden Buildings and Their Designers," *Architectural History* 20 (1977): 31–44. Stowe was such a marvel, of course, that it tended to set off all manner of speculative reactions in viewers. Gilpin, in his *Dialogue*, comments on this propensity of the garden itself to propel the spectator into fantasy: "I am a great Admirer of walking in a Shade; it is a kind of Emblem of the most agreeable Situation in Life, the retir'd one: Every fantastic View is hid from us, and we may if we please, be Poets, or Philosophers, or what we will" (William Gilpin, *A Dialogue upon the Gardens of the Right Honourable the Lord Viscount Cobham at Stow in Buckinghamshire* [London, 1748], 31).

70. On Hagley and its owner see Rosemary Davis, *The Good Lord Lyttleton: A Study in Eighteenth Century Politics and Culture* (Bethlehem, Pa., 1939).

71. See, e.g., R. J. Sullivan, *A Tour through Parts of England, Scotland, and Wales in 1778*, 2d ed., 2 vols. (London, 1786); N. Spencer, *Complete English Traveller* (London, 1771); and William Marshall, *Planting and Rural Ornament*, 2 vols. (London, 1796).

72. Adam Smith, *The Theory of Moral Sentiments*, ed. D. D. Raphael and A. L. Macfie (Oxford, 1976), 146–47.

Chapter Four: Kedleston Hall

1. See Leslie Harris, "Kedleston and the Curzons," in *Robert Adam at Kedleston*, ed. Gervase Jackson Stops (London, 1987), 9.

2. Burlington was, of course, the most renowned patron architect. See John Harris, *The Palladian Revival: Lord Burlington, His Villa and Garden at Chiswick* (New Haven, 1995), esp. 18–32; L. Schmidt, *Thomas Coke, First Earl of Leicester: An Eighteenth Century Amateur Architect* (Holkham, 1980); Richard Wilson and Alan Mackley, *Creating Paradise: The Building of the English Country House, 1660–1880* (Hambledon, 2000).

3. For details of the various designs see Leslie Harris, *Robert Adam and Kedleston* (London, 1987), esp. 15–25; John Harris, *The Architect and the British Country House, 1620–1920* (Washington, 1985), 154–55; and David King, *The Complete Works of Robert and James Adam and Unbuilt Adam* (Oxford, 2001), esp. 172–74. Other indispensable works on Kedleston include John Hardy and Helena Hayward, "Kedleston Hall, Derbyshire," *Country Life* 163 (1979); *Kedleston Hall* (London, 1988); and Gervase Jackson Stops, *The Country House in Perspective* (London, 1990). Kedleston is also discussed in the major works on Robert Adam. See, e.g., John Swarbrick, *Robert Adam and His Brothers* (London, 1915); Arthur T. Bolton, *The Architecture of Robert and James Adam*, 2 vols. (London, 1922); Joseph and Anne Rykwert, *The Brothers Adam: The Men and the Style* (London, 1985); Eileen Harris, *The Genius of Robert Adam: His Interiors* (New Haven, 2001).

4. Of course the history of construction needs to be taken into account here; this yields up another story, one that moves the center of the controlling intention away from Adam toward his craftsmen collaborators. The ceiling in the hall, for example, was designed by Adam but not realized. The decoration of this room took place eight years after the completion of the other state rooms and was executed following the designs of George Richardson.

5. On these craftsmen see the following titles by Geoffrey Beard: "Robert Adam's Craftsmen," *Connoisseur Yearbook* (1958), 26–32; "New Light on Adam's Craftsmen," *Country Life* 131 (1962): 1098–1100; *The Work of Robert Adam* (London, 1978); *Craftsmen and Interior Decoration in England, 1660–1820* (Edinburgh, 1981).

6. It is important to note here that alterations to whatever one might be able to understand as the "original" plans began even before the building was complete. Buildings of such complexity do not get built in a day. There are changes of mind, and practical and economic constraints inevitably come to bear on the completion of the project. The best account of these alterations is in Eileen Harris, *The Genius of Robert Adam: His Interiors* (New Haven, 2001), 19–39.

7. See Leslie Harris, "The Picture Collection at Kedleston Hall," *Connoisseur*,

July 1978, 208–17; Eileen Harris, *The Genius of Robert Adam: His Interiors* (New Haven, 2001), 25.

8. Adam drew up a plan in collaboration with Scarsdale in April 1761 for the decorative aspects of the dining room, which included setting all the pictures in this room into walls with gilt frames. See Eileen Harris, *The Genius of Robert Adam: His Interiors* (New Haven, 2001), 35.

9. Iain Pears, *The Discovery of Painting* (New Haven, 1988); see also L. W. Lippincott, *Selling Art in Georgian London: The Rise of Arthur Pond* (London, 1983).

10. See Francis Russell, "The Hanging and Display of Pictures, 1700–1850," in *The Fashioning and Functioning of the English House*, ed. Gevase Jackson Stops, Gordon J. Schochet, and Lena Cowen Orlin (Washington, 1989); and Marcia Pointon, *Hanging the Head* (New Haven, 1993), esp. 13–36.

11. Adam, in fact, mocked his predecessor Athenian Stuart's first plans for the ensemble hang. He wrote that Stuart "wanted to fitt frames for Sir Nathaniel's pictures but not having or rather I suppose, not being willing to confine his great genius to the size of the pictures, he cutts 3 foot off the length of the best pictures and 2 foot off the height of others to make then answer and draws all the pictures and colours them in his drawings" (cited in Leslie Harris, *Robert Adam and Kedleston* [(London), 1987], 28). Adam must have changed his mind on this since his own drawings and detailed designs also show specific pictures in precise positions on the walls.

12. Adam to Scarsdale, April 23, 1761, q.v. Eileen Harris, *The Genius of Robert Adam: His Interiors* (New Haven, 2001), 35.

13. The articulation between the interior of the house and the landscape grounds outside also needed to be considered. William Marshall, for example, states, "The improvement and the rooms from which they are to be seen should be in *unison*. Thus, the view from the drawing-room should be highly embellished, to correspond with the beauty and elegance within: every thing here should be feminine—elegant—beautiful—such as attunes the mind to politeness and lively conversation. The breakfasting room should have more masculine objects in view: wood, water, and an extended country for the eye to roam over; such as allures us imperceptibly to the ride or the chace" (*Planting and Ornamental Gardening* [London, 1785], 616).

14. See my *The Discourse of the Sublime: Readings in History, Aesthetics, and the Subject* (Oxford, 1989), chap. 8.

15. *The Polite Arts, Dedicated to the Ladies, by Cosmetti* (London, 1767), 22.

16. It was updated in 1770, 1778, and 1796.

17. See James Kennedy, *A New Description of the Pictures, Statues, Busts, Basso-Relievos. . . . at Wilton* (London, 1758); *A Description of the Villa at Strawberry Hill* (Strawberry Hill, 1774); *A Description of Holkham House* (Norwich, 1775); *New Description of Blenheim* (Oxford, 1789); and for contemporary bibliographies see John Harris, *A Country House Index and List of British Country House Guides* (London, 1979); and John Vaughan, *The English Guide Book, 1780–1870* (Newton Abbot, 1974). For accounts of visits to these houses see Adrian Tinniswood, *A History of Country House Visiting* (Oxford, 1989); and Ian Ousby, *The Englishman's England* (Cambridge, 1990).

18. See E. J Climenson, *Passages from the Diaries of Mrs Philip Lybbe Powys of Hardwick House, Oxon, A.D. 1756 to 1808* (London, 1899), 165.

19. On this total design see Damie Stillman, *The Decorative Work of Robert Adam* (London, 1967).

20. On Adam's furniture designs see Eileen Harris, *The Furniture of Robert Adam* (London, 1963); and Clifford Musgrove, *Adam and Hepplewhite and other Neo-Classical Furniture* (London, 1966).

21. This history has a vast secondary literature; works particularly germane to the present argument include Allen B. Sprague, *Tides in English Taste, 1619–1800*, 2 vols. (Cambridge, Mass., 1937); W. J. Bate, *From Classic to Romantic, Premises of Taste in Eighteenth Century England* (Cambridge, Mass., 1946); M. Brownell, *Alexander Pope and the Arts of Georgian England* (Oxford, 1978); E. Croft-Murray, *Decorative Painting in England, 1537–1837*, 2 vols. (London, 1962–70); L. E. A. Eitner, *Neoclassicism and Romanticism, 1750–1850*, 2 vols. (Englewood, 1970); R. Gill, *Happy Rural Seat: The English Country House and the Literary Imagination* (New Haven, 1972); M. Girouard, *Life in the English Country House* (New Haven, 1978); Christopher Hussey, *English Country Houses: Early, Mid, and Late Georgian*, 3 vols. (London, 1954–58); James Lees-Milne, *The Age of Adam* (London, 1947); H. E. Steegman, *The Rule of Taste from George I to George IV* (London, 1936); Charles Saumarez Smith, *Eighteenth-Century Decoration: Design and the Decorative Interior in England* (London, 1993).

22. The pavilions on the north side were to have been matched by a pair on the south. See the Plan of the Principal Floor c. 1764–65 in Leslie Harris, *Robert Adam and Kedleston* ([London], 1989), 24.

23. See Eileen Harris, *The Genius of Robert Adam: His Interiors* (New Haven, 2001), 35.

24. For the standard account of eighteenth-century British architecture see John Summerson, *Architecture in Britain, 1530–1830*, 8th ed. (London, 1991); see also Albert E. Richardson, *An Introduction to Georgian Architecture* (London, 1949); Christopher Hussey, *English Country Houses: Early, Mid, and Late Georgian*, 3 vols. (London, 1954–58); E. Kaufman, *Architecture in the Age of Reason* (Cambridge, Mass., 1955); John Summerson, "The Classical Country House in Eighteenth Century England," *Journal of the Royal Society of Arts* 107 (July 1959); P. Collins, *Changing Ideals in Modern Architecture, 1750–1950* (London, 1965); J. Mordaunt Crook, *The Greek Revival: Neo-Classical Attitudes in British Architecture, 1760–1870* (London, 1972); Rudolph Wittkower, *Palladio and English Palladianism* (London, 1974); and John Archer, *The Literature of British Domestic Architecture, 1715–1842* (Cambridge, Mass., 1985).

25. For an archaeology of the style see Steven Parissien, *Adam Style* (London, 1992).

26. The literature on the grand tour is substantial; see esp. Jeremy Black, *The British Abroad: The Grand Tour in the Eighteenth Century* (Stroud, 1992); P. Adams, *Travellers and Travel Liars, 1660–1800* (Berkeley, 1962); C. L. Batten, *Pleasurable Instruction: Form and Convention in Eighteenth Century Travel Literature* (Berkeley, 1978); J. Burke, "The Grand Tour and the Rule of Taste," in *Studies in the Eighteenth Century*, ed. R. F. Brissenden (Canberra, 1968); B. Ford, "The Englishman in Italy,"

in *The Treasure Houses of Britain: Five Hundred Years of Private Patronage and Art Collecting*, ed. Gervase Jackson Stops (New Haven, 1985); C. Hibbert, *The Grand Tour* (London, 1987); A. Moore, *Norfolk and the Grand Tour* (Norwich, 1985); and I. Pears, *The Discovery of Painting: The Growth of Interest in the Arts in England, 1680–1768* (New Haven, 1988).

27. The following account is largely indebted to John Fleming, *Robert Adam and His Circle in Edinburgh and Rome* (London, 1962).

28. See Damie Stillman, "Robert Adam and Piranesi," in *Essays in the History of Architecture Presented to Rudolph Wittkower*, ed. Douglas Fraser, Howard Hibbard, and Milton J. Lewine (London, 1967).

29. John Fleming, *Robert Adam and His Circle in Edinburgh and Rome* (London, 1962), 139.

30. Quoted in ibid., 139–40.

31. Ibid., 140.

32. Adam to his mother, March 1, 1755; cited in ibid., 145.

33. John Fleming, *Robert Adam and His Circle in Edinburgh and Rome* (London, 1962), 152. Subsequent quotations from Adam's letters as recorded in this source are cited parenthetically by page number in the text.

34. On these drawings see A. A. Tait, "The Picturesque Drawings of Robert Adam," *Master Drawings* 9 (1971): 161–71; Alistair Rowan, *Robert Adam* (London, 1988); Robert Oppé, "Robert Adam's Picturesque Compositions," *Burlington Magazine* 80 (1942): 56–59; A. A. Tait, *Robert Adam and Scotland: The Picturesque Drawings* (Edinburgh, 1972).

35. See Alistair Rowan, *Robert Adam* (London, 1988), 82.

36. For information on these artists and artisans see Geoffrey Beard and Christopher Gilbert, *Dictionary of English Furniture Makers, 1660–1840* (London, 1986); Helena Hayward and Peter Kirkham, *William and John Linnell* (London, 1980); John Fowler and John Cornforth, *English Decoration in the Eighteenth Century* (London, 1978); Geoffrey Beard, *Georgian Craftsmen and Their Work* (London, 1966); *Craftsmen and Interior Decoration in England, 1660–1820* (Edinburgh, 1981); Wendy Wassyng Rowarth, ed., *Angelica Kauffman: A Continental Artist in Georgian England* (London, 1992); R. Gunnis, *Dictionary of British Sculptors, 1660–1851*, rev. ed. (London, 1968); and on Adam and his "stable" of regular collaborators see Alistair Rowan, "After the Adelphi: Forgotten Years in the Adam Brothers' Practice," *Journal of the Royal Society of Arts* 122 (1974): 659–78.

37. The brothers, by means of an act of Parliament in 1776, held the patents to "Adam's New Invented Patent Stucco." A rival material was marketed by John Johnson, and the Adam brothers took him to court in 1778. The case was heard by a friend and patron of the brothers, Lord Chief Justice Mansfield, who duly found for the plaintiffs. The Adelphi project nearly bankrupted the company; for details see the standard literature on Adam.

38. On Stuart see David Watkin, *Athenian Stuart: Pioneer of the Greek Revival* (London, 1982).

39. This "total" design may have been exaggerated in some accounts of Adam

interiors. As David King points out: "it is doubtful if Adam installed more than half-a-dozen patterned pavements or designed more than three dozen carpets." See David King, *The Complete Works of Robert and James Adam* (Oxford, 2001), 29.

40. See Geoffrey Beard, "Robert Adam and His Craftsmen," *Connoisseur,* July 1978, 181; and for an account of William Adam and Co. see Alistair Rowan, "William Adam and Company," *Journal of the Royal Society of Arts* 112 (1974): 659–78.

41. The Adam brothers produced designs for eight interiors between 1773 and 1780 that could be called Etruscan; of these the most well known is the so-called Etruscan Room at Osterley, designs for which were produced between 1772 and 1779. See John Wilton-Ely, "Pompeian and Etruscan Tastes in the Neo-Classical Country-House Interior," in *The Fashioning and Functioning of the British Country House,* ed. Gervase Jackson Stops, Gordon J. Schochet, and Lena Cowen Orlin (Washington, 1989), 51–73.

42. For Kent see Michael I. Wilson, *William Kent: Architect, Designer, Painter, Gardener, 1685–1748* (London, 1984); P. Hodson, *William Kent: A Bibliography and Chronology* (Charlottesville, 1924); M. Jourdain, *The Work of William Kent* (London, 1948).

43. *Le Antichita di Ercolano* started appearing in 1757 and continued to be published sporadically thereafter; the Adam brothers' library contained a copy of Martyn and Lettice, *Antiquities of Herculaneum,* listed in David Watkin's catalogue of the auction of the library. See also David Watkin, *Thomas Hope and the Neoclassical Idea* (London, 1968); J. M. Crook, *The Greek Revival, Neoclassical Attitudes in British Architecture, 1760–1870* (London, 1972).

44. The coffered dome in the saloon at Kedleston, for example, has clear precedents in Kent's work at both Houghton and Holkham.

45. Robert and James Adam, *The Works in Architecture* (London, 1773), i.

46. The Adelphi scheme had nearly bankrupted the brothers, and various schemes were launched, including a lottery, in order to help them out of their financial situation. It was within this climate that the *Works* was planned and first published, as a way of stimulating fresh demand for the "authentic" Adam design. The publication of these designs was to supplement the earlier volume on the ruins at Spalatro and to stake a claim for the brothers' architectural genius to stand alongside the publication of similar source books. These included R. Castell, *The Villas of the Ancients Illustrated* (London, 1728); W. Chambers, *Designs of Chinese Buildings* (London, 1757); R. Wood, *The Ruins of Palmyra* (London, 1753); R. Wood, *The Ruins of Balbec* (London, 1757); and J. Stuart and N. Revett, *Antiquities of Athens* (London, 1762). All of these books except Chambers's were in the Adam library.

47. On the social and economic contexts for building in the period see Richard Wilson and Alan Mackley, *Creating Paradise: The Bulding of the English Country House, 1660–1880* (Hambledon, 2000).

48. John Fleming, *Robert Adam and His Circle in Edinburgh and Rome* (London, 1962), 257–58.

49. Dedication to Robert Adam, *Ruins of the Palace of the Emperor Diocletian at*

Spalatro in Dalmatia (London, 1763). The text to this volume was probably written by William Robertson. See J. Fleming, "The Journey to Spalatro," *Architectural Review* (Feb. 1958): 105.

50. The debates over the relative merits of Roman and Greek style were in full swing by the time Adam returned to London in 1758. Stuart and Revett were certainly instrumental in bringing the debate home, but perhaps even more important, the Society of Dilettanti had promoted the dissemination of classical taste by means of its sponsored archaeological surveys of antique sites. For a history of the society see L. Cust and S. Colvin, *The History of the Society of Dilettanti* (London, 1898).

51. Adam's success in promoting the style can be gauged from the incredible number of commissions the brothers received in the first ten years of practice, thereby bringing about an almost complete change in the look of the landowning elite's habitat. Bolton compiled an index of the drawings in the Soane collection by client so that it is possible to collate the commissions received by the Adam brothers according to place, social rank of the client, and extent of the work planned. Of course not all the drawings resulted in completed work, and some of the work was carried out without supervision from the Adam brothers. Nevertheless the figures are quite astounding. For the decade 1760–1770 the company made drawings for ninety-six clients, sixty-two of whom were nobility. See Arthur T. Bolton, *The Architecture of Robert and James Adam*, 2 vols. (London, 1922).

52. Giles Worsley argues that the Adam brothers merely built on and adapted Palladian principles. See Giles Worsley, "Adam the Palladian," in *Adam in Context*, ed. Giles Worsley (London, 1993), 6–13.

53. *The Works in Architecture of Robert and James Adam*, ed. Robert Oresko (London, 1975), 47.

54. For similar reasons Adam advocated the use of curving lines in moldings. See ibid., 51.

55. Adam was, in fact, very aware of his scholarly credentials—he was self-conscious about his abilities as a historian of ancient culture. This is why he had his cousin William Robertson write the introduction to the Spalatro volume, and Robertson for his part pointed out the fanciful nature of many of Clerisseau's drawings from the antique. Adam, however, was doing something rather different from the likes of Robert Wood or James Stuart. On this see Eileen Harris, *British Architectural Books and Writers* (Cambridge, 1990), 76.

56. G. Piranesi, *Diverse maniere d'adornare i cammini* (Rome, 1769), 33; see also W. Rieder, trans., "Piranesi's *Diverse Manners*," *Burlington Magazine* 115 (1973): 308–17.

57. Adam had a lifelong interest in these "picturesque" capriccio renditions. His first publication was to have been a book of "garden scenes," prepared in 1756 but never published. On this see A. A. Tait, *The Landscape Garden in Scotland, 1735–1835* (Edinburgh, 1980), 97–98.

58. The following capriccio is based on John Plumptre, "A Journal of a Tour into Derbyshire in the Year 1793," ms. in Cambridge University Library; Arthur Young,

The Farmer's Travels through the East of England, 4 vols. (London, 1771), 1:215–17; Richard Joseph Sullivan, *A Tour through Parts of England, Scotland, and Wales in 1779,* 2d ed. (London, 1785), 39–44; Geoffrey Scott and Fred A. Pottle, eds., *Private Papers of Boswell,* 18 vols. (New Haven, 1930–34), 13:32.

59. The full extent of the scheme at Kedleston is 363 ft.; this compares with 667 ft. at Castle Howard and 856 ft. at Blenheim. See on this John Swarbrick, *Robert Adam and His Brothers* (London, 1915), 91.

60. See John Harris, *The Architect and the British Country House, 1620–1920* (Washington, 1985), 38.

61. See Arthur T. Bolton, *The Architecture and Decoration of Robert Adam* (London, 1920), 15. The extent to which our immersion in this knowing culture is required by Holkham is underlined by the sculpture gallery, an imposing room displaying classical portrait sculptures. This room can lay claim to being the first sculpture gallery in England, and its presentation clearly demands an educated eye.

62. Adam writes in *The Works:* "In the year 1762, the Duke of Northumberland came to the resolution of fitting up the apartments of Syon House in a magnificent manner. He communicated his intentions to me, and having expressed his desire that the whole might be executed entirely in the antique style, he was pleased, in terms very flattering, to signify his confidence in my abilities to follow out his idea" (cited in John Swarbrick, *Robert Adam and His Brothers* [London, 1915], 157).

63. Gervase Jackson Stops reads these details in terms of the Curzon family's lineage as if they were proclaiming themselves to be descended from the antique gods. See "A British Parnassus: Mythology and the Country House," in *The Fashioning and Functioning of the British Country House,* ed. Gervase Jackson Stops, Gordon J. Schochet, and Lena Cowen Olin (Washington, 1989), 223–25.

64. The move toward this sentimental response is grounded in eighteenth-century theories of association in architecture. John Adam's unpublished essay of 1762 joined this debate, which was much concerned with the theory of character and propriety in architectural style. See G. L. Hersey, "Associationism and Sensibility in Eighteenth Century Architecture," *Eighteenth-Century Studies* 4 (fall 1970): 71–89; John Archer, "Character in English Architectural Design," *Eighteenth-Century Studies* 12 (spring 1979), 339–71; "The Beginnings of Association in British Architectural Esthetics," *Eighteenth-Century Studies* 16 (spring 1983): 241–64.

65. Horace Walpole, "Horace Walpole's Journals of Visits to Country Seats," *Walpole Society* 16 (1927–28): 64.

66. This progress through a series of "public" rooms was common for the period, although the precise sequence of rooms changed from house to house. See Mark Girouard, *Life in the English Country House* (New Haven, 1978); Christopher Hussey, *English Country Houses: Mid Georgian, 1760–1800* (London, 1955).

67. These were in place by the time of the 1769 catalogue but were later altered to the present design, representations of the four continents.

68. Scarsdale, *Catalogue of His Pictures, Statues, etc. . . . at Kedleston* (Kedleston, 1769), 2.

69. Robert Adam, *Ruins of the Palace of the Emperor Diocletian,* 8.

70. Such contemporary workings of antique schemes, most especially the adaptation of Roman public architectural forms for domestic settings in Britain, were not without critics. See, e.g., [Allan Ramsay] *The Investigator* (London, 1782), 52: "The present taste of architecture was formed, not upon the palaces and dwelling houses of the antient Greeks and Romans, of which there were no vestiges at the revival of the arts, but upon their temples and other public buildings, from which the ornamental part has been borrowed and applied to domestic use, in a manner abundantly absurd."

71. He was thus not so different from the eminent tourists who bought up similarly "imaginative" and picturesque representations of classical ruins while in Rome or Venice. For the popularity of Clerisseau's "ideal" ruins see Thomas J. McCormick, "An Unknown Collection of Drawings by Charles Louis Clerisseau," *JSAH* 22 (Oct. 1963): 119–26.

72. On Adam's use of this divide between the exterior and interior see James Lees-Milne, *The Age of Adam* (London, 1947), 10.

73. We should recall that the original intention had been to construct a sculpture gallery in this room.

74. *The Polite Arts, Dedicated to the Ladies, by Cosmetti* (London, 1767), 22.

Chapter Five: The Sentimental Look

1. Seen from one perspective, this alternative version of the aesthetic has never gone away; it has merely been sidelined. Within the technical literature on aesthetics and its historical formation a distinction is often made between theories of beauty and taste—those developed with some vigor during the eighteenth century in Britain—and theories of the aesthetic and of art. The latter asks questions of the kind: "What is art?" "What is the value of art?" "What kinds of entities are artworks?" Although the latter have preoccupied philosophical aesthetics for nearly a century now, the former still make claims on our attention. For a good introduction to these debates see George Dickie, *Introduction to Aesthetics: An Analytic Approach* (Oxford, 1997); and for a survey of the technical literature see Robert Stecker, *Artworks: Definition, Meaning, Value* (University Park, Pa., 1997). I have made arguments on behalf of the return to the affective in my *Art Matters* (Cambridge, Mass., 2001).

2. A good introduction to this work is Lynn Hunt, ed., *The New Cultural History* (Berkeley, 1989).

3. Within the field of literary studies impetus for this kind of work has been provided by new historicism. See H. Aram Veeser, ed., *The New Historicism Reader* (London, 1994). Much recent work has seen itself in opposition to the new historicist approach (if indeed there can be said to be a singular approach) and promotes a return to "real" objects and their histories. Some objects of recent historical inquiry include tears, the potato, and the book. See Tom Lutz, *Crying: The Natural and Cultural History of Tears* (New York, 1999); Larry Zuckerman, *The Potato* (London,

1999); Adrian Johns, *The Book of Nature: Print and Knowledge in the Making* (Chicago, 1998).

4. Holkham was very substantially designed by its owner, Lord Leicester, one of the foremost amateur architects of the first half of the eighteenth century, in consultation with William Kent and the elder Mathew Brettingham. On the construction of the house see James Lees-Milne, *Earls of Creation: Five Great Patrons of Eighteenth-Century Art* (Harmondsworth, 1962), 221–63.

5. In fact the last touches were not complete until the mid-1770s. See ibid., 263.

6. Of course, the century continued to develop new spaces, entertainments, purposes, and uses for visual culture. For a good account of the many distractions on offer see Richard D. Altick, *The Shows of London* (Cambridge, Mass., 1978); and for a good account of one of the most spectacular visual diversions, the panorama, see Bernard Comment, *The Panorama* (London, 1999).

7. The statistics for turnpike acts show the fevered activity around midcentury: there were 37 during the 1730s and again during the 1740s; this number rose to 170 per decade for both the 1750s and 1760s. See J. R. Ward, *The Finance of Canal Building in Eighteenth-Century England* (Oxford, 1974), 164. And for a general account of the importance of turnpikes see E. Pawson, *Transport and Economy: The Turnpike Roads of Eighteenth-Century Britain* (London, 1977).

8. For an account of the increase in tourist activity during this period see Adrian Tinniswood, *A History of Country House Visiting* (Oxford, 1989), esp. 88–108.

9. Richard Warner, *A Tour through the Northern Counties of England and the Borders of Scotland*, 2 vols. (London, 1802), 1:117.

10. And I do mean to imply that Robert Adam had a significant part to play in this story and, at the same time, was merely a mouthpiece or focal point giving expression to a culturally dispersed set of interests. He was, as I have remarked, made by those interests and brilliantly exploited their making. It is significant for this argument that Adam worked on a number of houses and estates that both had and were to acquire considerable cultural importance during the 1760s and after. Along with Kedleston these included Lansdowne House (alterations carried out in 1762), Bowood (1760–64), Kenwood (1767–69), Harewood (1759–71), Luton Hoo (c. 1766), Osterley (1761), Saltram (1768–69), and Syon (1762–69), a list that reads like a roll call of the arbiters of taste for the period.

11. The unlettered public were, of course, admitted to Stowe. Famously, Viscount Cobham would take tea on Sundays in the garden, having invited the locals to stroll around and populate his landscape.

12. For a full account see Joyce Townsend, *Turner's Painting Techniques* (London, 1993).

13. Jonathan Crary, "The Blinding Light," in *The Sun Is God*, ed. Mark Francis (London, 2000), 24.

Index